Edvard Munch: The Modern Life of the Soul

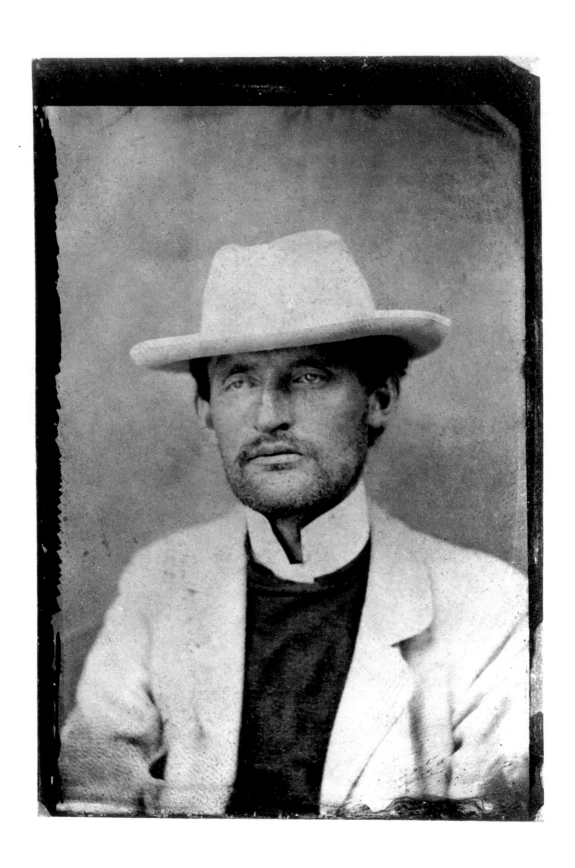

Edvard Munch
The Modern Life of the Soul

Edited with an

Introduction by

Kynaston McShine

Essays by

Reinhold Heller

Patricia G. Berman

Elizabeth Prelinger

Tina Yarborough

The Museum of Modern Art, New York

Published on the occasion of the exhibition
Edvard Munch: The Modern Life of the Soul,
organized by Kynaston McShine, Chief Curator
at Large, The Museum of Modern Art, New
York, February 17–May 8, 2006.

The exhibition is made possible by
Debra and Leon Black.

Additional funding is provided by
Marie-Josée and Henry Kravis and by the
Blanchette Hooker Rockefeller Fund.

Major support is provided by an indemnity
from the Federal Council on the Arts and the
Humanities.

This publication is made possible by the
Blanchette Hooker Rockefeller Fund and by
Harry Irgens Larsen and the Patricia P. Irgens
Larsen Charitable Foundation Inc.

Produced by the Department of Publications
The Museum of Modern Art, New York
Edited by Harriet Schoenholz Bee with
David Frankel
Designed by Steven Schoenfelder
Production by Christina Grillo
Printed and bound by Dr. Cantz'sche
Druckerei, Ostfildern-Ruit, Germany
Printed on 150 gsm Galaxi Supermat
Typeset in Aldus and Avenir

Library of Congress Control Number:
2005937655
ISBN 0-87070-455-9 (clothbound)
ISBN 0-87070-456-7 (paperbound)

Published by The Museum of Modern Art
11 West 53 Street, New York NY 10019
www.moma.org

Distributed in the United States by D.A.P.,
Distributed Art Publishers, Inc., New York

Distributed outside the United States by
Thames & Hudson, Ltd., London

Printed in Germany

Front cover: Edvard Munch. *The Dance of Life.*
1899–1900. Oil on canvas, 49⅜ x 75⅜" (125 x
191 cm). The National Museum of Art, Archi-
tecture, and Design/National Gallery, Oslo

Back cover: Edvard Munch. *Self-Portrait by the
Window.* c. 1940. Oil on canvas, 33⅛ x 42½"
(84 x 108 cm). Munch Museum, Oslo

Frontispiece: Edvard Munch, c. 1902

Contents

Foreword

THIS PUBLICATION and the exhibition it accompanies, *Edvard Munch: The Modern Life of the Soul,* is devoted to the work of the renowned Norwegian painter and graphic artist Edvard Munch, whose work was first exhibited in the United States in 1912. The occasion was a group exhibition of contemporary Scandinavian art at the American Art Galleries in New York, and subsequently shown at The Albright Gallery in Buffalo, and in Toledo, Chicago, and Boston. Munch was also represented in the famous Armory Show in New York of 1913 with a selection of prints, and his graphic work was often exhibited in this country. But it was not until 1951, seven years after the artist's death, that his first retrospective, a touring exhibition including paintings, watercolors, and prints, was held here at The Museum of Modern Art. It surveyed Munch's entire career and extraordinary vision from the early naturalism of the 1880s to the vibrant unforgiving emotional late works of the 1940s.

Munch's art explores a full range of internal human experience and emotion from birth to death as reflected in his own deeply agitated life. It also evokes the external world in memorable images of haunting Nordic landscapes and romantic moonlit scenes. Spanning the late nineteenth and early twentieth centuries and emerging from a nation outside the European cultural mainstream, his unique body of work made an important contribution to the history of modernism both as an important precursor, together with the art of Vincent van Gogh, of German Expressionism and as a prescient herald of the age of psychology.

As part of the celebration of the centennial of Norway's existence as an independent state, the exhibition was conceived and organized under the auspices of the Royal Norwegian Ministry of Foreign Affairs, which afforded The Museum of Modern Art the unique opportunity to work together, in extraordinary cooperation and good will, with the Munch Museum, Oslo, the Norwegian National Gallery, and the Bergen Art Museum. On behalf of the Trustees and the staff of the Museum, I wish to express our deepest appreciation to their directors and staffs.

The Federal Council on the Arts and the Humanities, through the Arts and Artifacts Indemnity Act, provided insurance coverage for the foreign loans, which was essential to the realization of the exhibition. Warm thanks are also owed Debra and Leon Black, Marie-Josée and Henry Kravis, the Blanchette Hooker Rockefeller Fund, and Harry Irgens Larsen and the Patricia P. Irgens Larsen Charitable Foundation Inc. for generous support of the exhibition and publication.

Much thought and effort have gone into the organization of this exhibition and publication, and the Museum is deeply grateful to all who have given unsparingly of their time and skill. We especially thank the authors who have written the essays in this publication for their fine contributions. I would also like to thank the members of the Museum staff who with enthusiasm contributed their talents toward the realization of this major endeavor. Kynaston McShine, Chief Curator at Large, conceived and organized the exhibition and its publication. He deserves our admiration and respect for having expertly brought this project to fruition.

Finally, the most essential element of any exhibition of this scope is the generosity and participation of the lenders, without whose cooperation an exhibition, however well conceived, cannot be realized. In this instance their response has been extraordinary, and represents their high regard for the work of Edvard Munch. On behalf of the Museum and the public who now have the opportunity of enjoying the exhibition and book on this grand master of modern art we express our deep appreciation.

Glenn D. Lowry
Director
The Museum of Modern Art

Acknowledgments

EDVARD MUNCH, in an unprecedented gesture on his death at the age of eighty in 1944, bequeathed his estate of approximately 1,100 paintings, 4,500 drawings, and 18,000 prints to the city of Oslo. This remarkable bequest, now on deposit at the Munch-Museet, Oslo, includes a vast archive which has made it possible for scholars, curators, and the public to mine this extraordinary legacy in the preparation of exhibitions, scholarly theses, and articles, and to analyze his works in thorough and imaginative ways. Through the early purchases and gifts of collectors, the Nasjonalgaleriet in Oslo (now the Nasjonalmuseet for Kunst, Arkitektur og Design) and the Rasmus Meyers Samlinger, Bergen Kunstmuseum, also amassed significant and substantial collections. There can be no serious exhibition and publication of any aspect of the oeuvre of Edvard Munch without the goodwill and generous cooperation of these repositories of Norwegian art.

This exhibition and its accompanying publication are no exception. The complex organization of both has been achieved through their selfless involvement in the project. On behalf of the Trustees of The Museum of Modern Art, we are immeasurably grateful to their directors, curators, and administrators for their gracious assistance and hospitality. Personally, I cannot thank them enough.

The indispensable link among the three Norwegian museums and The Museum of Modern Art was facilitated by The Royal Ministry of Foreign Affairs of Norway and The Royal Norwegian Consulate General in New York. Special thanks go to Ann Ollestad, Director General for Press and Cultural Relations; Arne Gjermundsen, Deputy Director General for Press and Cultural Relations; Liv Morch Finborud, Consul General; and Eva Vincent, former Consul/Director Norwegian Information Service, and her successor Kristin Iglum, Deputy Consul General. Their enthusiasm for this project on the occasion of the centennial of Norway's independence was a catalyst that has made it an additional pleasure for The Museum of Modern Art to participate in this auspicious celebration.

At the Nasjonalgaleriet, my thanks go to its Director Sune Nordgren, and to Marit Lange, Anniken Thue, and Sidsel Helliesen as well as many others who helped us in the assembly of the loans. At the Bergen Kunstmuseum, the kind collegiality of Audun Eckhoff, Director, and Knut Ormhaug is duly noted.

The Munch-Museet's wholehearted and considerable involvement in this project is noteworthy. In a very difficult time for them, they were magnanimous in their efforts for this project. Taking into account the fragility of many of Munch's works, their task of organizing the majority of the loans for this exhibition was formidable.

They have also had to be a principal resource of fact and information for the organizers of this exhibition and publication. Their entire staff has to be deeply thanked but especially Acting Director Lise Mjos, Gunnar Sorensen, Magne Bruteig, Arnt Fredheim, Frank Høifødt, Karen Lerheim, Nils Messel, and Gerd Woll.

Many other lenders of both paintings and prints, have made a special effort to be cooperative. This has allowed for a comprehensive study of Munch and added a great deal to seeing his development as this exhibition presents it. We are particularly grateful to the Kunsthalle Bremen and its Director, Wulf Herzogenrath, for allowing us to show publicly for the first time outside Bremen the newly discovered *Young Girl with Three Male Heads*, c. 1898. Another indispensable work in this show is *Mermaid*, 1896, recently acquired by the Philadelphia Museum of Art and hardly ever presented publicly since its commission. I thank Anne d'Harnoncourt, Director, and Joseph Rishel, Senior Curator of European Painting and Sculpture, for allowing us to display a very unusual facet of Munch's work.

Other institutions whose directors and curators are owed special thanks are: at the Ateneum taidemuseo Helsinki, Soili Sinisalo; at the Behnhaus/Dragerhaus, Museum für Kunst und Kulturgeschichte der Hansestadt, Lübeck, Dr. Thorsten Rodiek; at the Göteborgs Konstmuseum, Birgitta Flensburg; at the Hamburger Kunsthalle, Uwe M. Schneede and Andreas Solzenburg; at Harvard University's Fogg Art Museum, Thomas W. Lentz; at the Kunstmuseum Bern, Matthias Frehner; at the Moderna Museet in Stockholm, Lars Nittve; at the Museum of Fine Arts, Boston, Malcolm Rogers and George Shackleford; at the National Gallery of Art, Washington D. C., Earl A. Powell and Alan Shestack; at the Neue Nationalgalerie, Berlin-Tiergarten, Peter-Klaus Schuster; at the Offentliche Sammlung, Kunstmuseum Basel, Bernhard Mendes Burgi; at the Statens Museum for Kunst, Copenhagen, Alles Helleland; and at The Frances Lehman Loeb Art Center, Vassar College, James Mundy. My personal thanks go to Nina Ohman, Director of the Thielska Galleriet in Stockholm.

Several private collections, some of which are anonymous, have lent works to the exhibition. Catherine Woodard and Nelson Blitz Jr., New York, and Sarah G. Epstein and Lionel C. Epstein of the Epstein Family Collection in Washington D.C. are owed our thanks.

We have on occasion reproduced in the Plates and the Catalogue sections of this book essential works that were unavailable to the exhibition.

Among others who have cooperated in providing information and been very generous with their time are Michael Findlay of Acquavella Galleries and David Tunick of David Tunick Fine Art. In facilitating our Federal Indemnity application, which is essential to this exhibition, we thank Richard Lahne of the United States Department of State and Alice Whelihan, Indemnity Administrator, National Endowment for the Arts.

A special word of gratitude for their interest and support goes to Matthew Armstrong, Kerstin and Pontus Bonnier, Kaare Berntsen, Ivor Braka, Christopher Burge, Riva Castleman, Patrick Cooney, Arne Eggum, Jens Faurschou, Ben Frija, Ulf Linde, David Nash, John Tancock, and Eugene V. Thaw.

Personally, I have benefited largely from the counsel of Patricia Gray Berman, the Barbara Morris Caspersen Associate Professor of Humanities and Professor of Art at Wellesley College. Her knowledge of Munch's work is comprehensive; she has been a gracious and invaluable support in the preparation of the exhibition and of this volume. The perceptive essays included in this volume add significantly to the literature on Munch. Considerable thanks for their distinguished contributions to this book are owed Patricia Berman; Reinhold Heller, Professor and Chair of the Department of Art History, The University of Chicago; Elizabeth Prelinger, Keyser Family Professor of Art History at Georgetown University; and Tina Yarborough, Associate Professor of Art History and Interdisciplinary Studies at Georgia College and State University.

We are indebted to many other scholars' expertise and knowledge of Munch's work, which are reflected throughout this volume, notably in the Selected Bibliography, list of exhibitions, and catalogue texts.

An exhibition and publication of this scale owes its existence to the very crucial assistance of the staff and resources of very many departments of The Museum of Modern Art. We are most fortunate to have benefited from the dedication and enthusiasm of these colleagues.

My foremost gratitude is to Glenn D. Lowry, Director, who has strongly supported this project from its inception with conviction and has generously provided indispensable counsel. I am deeply grateful. Special indebtedness is owed Jennifer Russell, Senior Deputy Director for Exhibitions, Collections, and Programs. With her customary Museum professionalism, she has played a crucial role in the administration of this project. Her characteristic conscientiousness and attention to detail have very much benefited this exhibition's organization. Her diplomacy and expertise were particularly helpful in the negotiations with our colleagues in Norway. We thank her.

Once again, particular thanks go to Michael Margitich, Senior Deputy Director of External Affairs, and his staff for their tireless efforts in seeking financial support

for this exhibition. We owe thanks as well to Mary Lea Bandy and her successor, Peter Reed, Senior Deputy Director for Curatorial Affairs, for providing essential and effective advice when needed. James Gara, Chief Operating Officer, has been invaluable in attending to the fiscal planning of this project.

The coordination of many aspects of the administrative details of this exhibition has been expertly managed by Maria DeMarco Beardsley and Carlos Yepes, especially the complicated task of securing the Federal Indemnity. We owe them thanks. The Department of Collection Management and Exhibition Registration, particularly Ramona Bannayan and Susan Palamara, have discreetly and proficiently coordinated a daunting volume of works of art for assembly and disassembly. They have our sincere appreciation. Jerome Neuner and David Hollely, with untiring attention to detail, have helped in providing and enhancing the installation in the Museum galleries. The Department of Conservation has given the care and attention that all the loans entrusted to the Museum deserve. Their patience and meticulousness is very much acknowledged. The goodwill and genuine enthusiasm of the preparators must also be gratefully noted.

The Department of Painting and Sculpture has been most cooperative, and I especially thank John Elderfield, Chief Curator of Painting and Sculpture. Preliminary research for this exhibition was undertaken by Ruth Perez-Chaves, and we thank her for her imaginative insights and valuable assistance. Research on the role that prints occupy in Munch's oeuvre has been facilitated by the Department of Prints and Illustrated Books. For the duration of this show, a special program of Norwegian films, including some documentaries on Munch, will be shown; it is organized by Jytte Jensen of the Department of Film and Media.

Several educational programs, including a symposium, audio guides, and brochures relevant to the exhibition, are presented by the Department of Education. The Museum's Library has been the source of much useful documentation and its staff has been willingly helpful. I am also grateful to Stephen Clark, Deputy General Counsel, for very measured advice. The Department of Marketing and Communications is thanked for their essential efforts to disseminate information regarding the exhibition. Skillfully and graciously, the Department of Programming and Special Events organized events related to the opening of the exhibition and some subsequent occasions. We extend sincere thanks.

The preparation of this book has been a formidable and complex task. I am profoundly indebted to the members of the Department of Publications for their dedication to this undertaking. The contribution of David Frankel, Managing Editor, has been invaluable. His deep commitment to this volume, essential knowledge, and much valued advice have enriched the book in many remarkable ways. The complex production of this book was overseen by Christina Grillo with exemplary patience. I also acknowledge Marc Sapir for his contributions in the planning of the book. The appropriately elegant and intelligent design of this book is the product of the sensitivity and astuteness of Steven Schoenfelder. He has my admiration. With clarity, rigor, and thoughtfulness Harriet Schoenholz Bee has expertly edited this book. I owe her profound thanks.

I have cited many at the Museum who have worked on this exhibition and book. However, there are three colleagues who have been most intimately involved with it—Michael Cary, Claire Gilman, and Jane Panetta—to whom the Museum and I are quite indebted. They have been exemplary in their professionalism, thoroughness, and intelligence. Despite his many other duties, Michael Cary has with sensitivity, constant good humor, and a devoted and untiring commitment made an indispensable contribution to this enterprise. My thanks to him is immeasurable.

Claire Gilman has worked on this project almost from the beginning, demonstrated research ability, thoroughness, and attention to detail. She has handled many of the particulars of the exhibition organization and compiled the Chronology for the book. Her critical insights have been an essential contribution. Jane Panetta, a more recent arrival, has been an admirable liaison with the rest of the Museum, especially in relation to the ancillary activities, and has compiled the Selected Bibliography for the book. She has demonstrated a serious dedication and enthusiasm to this project for which I am grateful.

My deep gratitude for their generosity in supporting this endeavor is owed Debra and Leon Black, Marie-Josée and Henry Kravis, the Blanchette Hooker Rockefeller Fund, and the Harry Irgens Larsen and the Patricia P. Irgens Larsen Charitable Foundation Inc.

Neither exhibition nor book would have been possible without the formidable support of the entire cast above. Finally, it has been a humbling privilege to have worked on *Edvard Munch: The Modern Life of the Soul*. I have been enlightened by the emotions that it forthrightly presents. Above all, it is my hope that Edvard Munch is deservedly acknowledged.

Kynaston McShine
Chief Curator at Large
The Museum of Modern Art

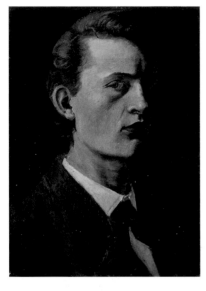 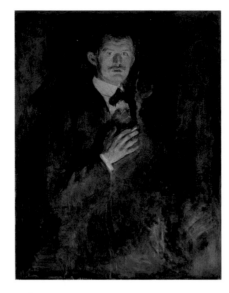

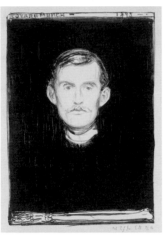 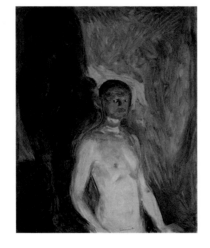 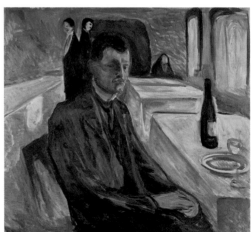

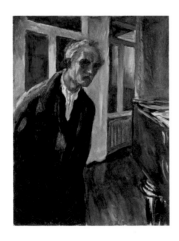 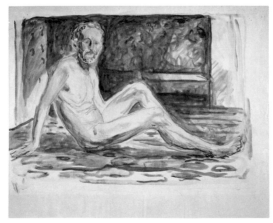 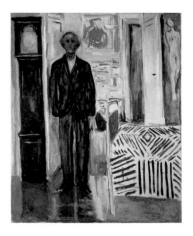

Introduction

Kynaston McShine

Edvard Munch is the modern poet and philosopher in painting. At the same time, he is passionately emotional, perhaps more so than any other modern artist. The extremes of joy and pain all come to him, and human emotions are presented in his work with a naked rawness that still startles more than a century after his vision was formed. His iconic constructions depicting events and moods from his own life create indelible images that occupy our minds. Munch's painting, as in *The Dance of Life*, encompasses a litany of emotions that covers life from birth to death. The narrative of Munch's life and work, rooted in the nineteenth century, somehow transforms, through his own will and force, his personal experiences into an extraordinary examination of what he terms "the modern life of the soul"—birth, innocence, love, sexual passion, melancholy, anger, jealousy, despair, anxiety, illness, and death. His exploration of the range of modern experience in palpable psychological terms reflects an existential agitation.

Munch's career begins in his native Norway, far from the centers of artistic innovation of his time; as a young artist in the 1880s he is working in the academic traditions of portraiture and genre painting. He knows the work of such French artists as Claude Monet and Pierre Puvis de Chavannes, and he paints youthful pictures that are essentially imitative of Impressionism; he also is steeped in the naturalism of his first teachers, the genre painter Christian Krohg and the classical sculptor Julius Middelthun. By the end of the decade he is in Paris where he is introduced to Symbolist philosophy and aesthetics, and later in Berlin he becomes part of an avant-garde group involved in the promotion of free love and various types of mysticism. Soon his paintings become more expressionistic, to the degree that he eventually can be considered, along with Vincent van Gogh, as the godfather of German Expressionism, as practiced by such artists as Emil Nolde and Ernst Ludwig Kirchner.

Through his own personal complexity, fraught with physical illness and emotional instability as well as traumatic family losses, he turns decisively from the customary appearance of reality to the depiction of psychological urgency. He breaks from the representation of physical surfaces into something harsher

Selected Self-Portraits by Edvard Munch, left to right: 1881–82 (plate 1), 1895 (plate 37), 1894–98 (plate 36), 1895 (plate 32), 1903 (plate 147), 1906 (plate 148), 1923–24 (plate 150), 1933–34 (plate 153), 1940–42 (plate 155)

and more profound, an exploration of psychological experience and passion that immediately demonstrates a modernity of attitude and thought. At the close of his first decade as an artist Munch proclaims that art should be dedicated to human emotion: "There should be living people who breathe and feel, suffer and love."

His extraordinary self-portraits, which punctuate his entire career, afford a key avenue through his work, together making up a history of self-perception matched in completeness by few other artists outside Rembrandt (see plate 143). Munch's first *Self-Portrait*, of 1881–82 (plate 1), is also one of his very first surviving paintings; it is only the year before—in 1880, at the age of seventeen—that he writes in his diary: "I have in fact made up my mind to become a painter." From this early work to his late *Self-Portrait: Between the Clock and the Bed* (plate 155), of 1940–42, when he was in his late seventies, Munch thoroughly charts both his inner and his exterior life. These works are marked by shifts in self-presentation over time, from the early, worldly bohemian to the dark, private, insulated modern existential man. Munch moves from brooding young aesthete to victim of disastrous love affairs, from extrovert to introvert, to lonely middle-aged wanderer, to merciless observer of his own physical decay. Now pensive, now overwrought, now frail in the awareness of illness and old age, he intimately traces his every psychological and physical shift through the sensitive registers of his expressive shaping of form and flowing of color.

Munch lets us see in him a touch of arrogance; in paintings like the *Self-Portrait with Cigarette* (1895; plate 37), an air of the dandy hangs around him. But what separates the painter of modern life from the dandy, as Charles Baudelaire, whom he admired, defined it in "The Painter of Modern Life," is the "insatiable passion . . . for seeing and feeling," which emerges quickly in Munch's art. He is just as fascinated by his exterior surroundings—by landscape, by family, by the everyday life of working people in city and village, by the gatherings of his fellow intellectuals in Norway's capital of Kristiania and in Berlin. He is aware of his Norwegian identity and influences, which he conveys through representations of the northern landscape and the traditions of Scandinavian mythology as primal forces, evoking such muses of Nordic mysticism as *Mermaid* (1896; plate 48), or such evocative scenes as *Mystery of the Beach* (1892; plate 43) and *The Yellow Log* (1911–12; plate 112). Yet, at the same time,

Edvard Munch. *Kristiania-Boheme II*. 1895. India ink, watercolor, gouache, and pencil on paper, 9¹³⁄₁₆ × 16⁵⁄₁₆" (25 × 41.5 cm). Munch Museum, Oslo

he always returns to the personal intensity of his experiences and sensations of the drama of life. His images persistently fluctuate between outer involvement in the social world and internal silence. Certain works show real despair, be it over the trials and losses that human relations bring, or the irrational but absolute suffering of the inner life. In *Golgotha* (1900; plate 98), for example, Munch actually shows himself as Christ on the cross, facing a crowd, which eerily includes depictions

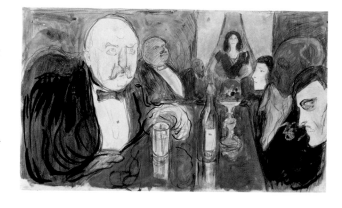

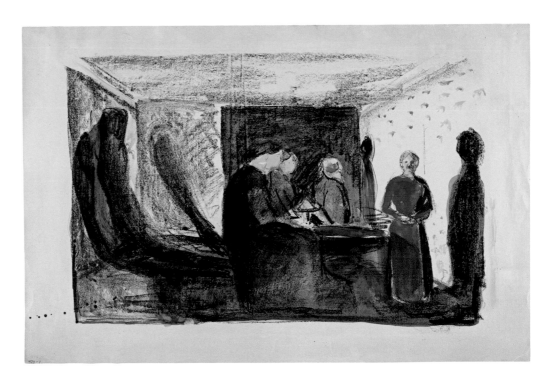

Edvard Munch. *Ghosts: Family Scene*. 1919. Lithograph with watercolor additions, comp: 16¼ × 24⅞″ (42.5 × 62.5 cm). Munch Museum, Oslo

of many of his friends and acquaintances, people he knows personally whom he casts as unsympathetic and indifferent, like the mocking crowd in James Ensor's *Christ's Entry into Brussels in 1889*.

Known by some as the "hermit of Ekely," Munch is actually well traveled and cosmopolitan in his outlook, and does not lead a totally isolated studio existence. He is very aware of the workings of the world as a social community; from his early days he is an eager participant in the bohemian intellectual circles of Kristiania, and until he is in his forties he travels widely in Europe and lives for long periods abroad. He is intimately familiar with the cosmopolitan artistic and literary world centered in Berlin, and of contemporary innovation in Paris (van Gogh and Gauguin, and later Matisse, seem present in his work); he illustrates books of poetry, designs programs and sets for the stage, and counts among his acquaintances poets and playwrights, scientists and doctors, as well as painters. He is part of a vital community, in other words—yet in his painting, even when he examines a crowd, as in *Evening on Karl Johan Street* (1892; plate 79), each person seems haunted and alone. The street is peopled by ominous, ghostly presences, faceless individuals. This is not the pleasant city of Impressionist painting, which influences Munch early on; he focuses on the conflict between the individual and the temptations and degeneracy of urban life epitomized by the crowd.

Munch also explores private pain and trauma in an astonishingly open manner, infusing the universal with the personal. His many paintings and prints of the death of his young sister Sophie or references to the early death of his mother express themes that haunt him throughout his life. The deathbed is the theme of several works, most monumentally *Death in the Sick Room* (1893; plate 87) and *The Sick Child* (1896; plates 17 and 18). The haunted quality of the artist's

world is powerfully apparent in *Red Virginia Creeper* (1898–1900; plate 94), its vacantly staring protagonist visually outweighed by the blood-red vine on the house behind him, or, most famously, a work often regarded as the quintessential modern existential image, *The Scream* (1893; plate 84).

The complex ambiguity of Munch's thinking emerges even in the theme of the windows that often appear behind or to the side of him in his self-portraits. On the one hand, the window is a source of light, both actual and allegorical, yet on the other, this transparent screen is in his hands peculiarly claustrophobic: he tells us that there is a world beyond, but that neither he nor we are in it. He sees himself as foremost among the doomed and sick, and unable to get outside the window into the light of the sun, which represents vitality and well-being. Obsessed by individual suffering, it is as if somehow he foreshadows the entire modern condition, influencing a whole thread of modern art through Nolde and Kirchner to Willem de Kooning and Jasper Johns.

Munch's portraits of children prove to be some of his most charming and sentimental images (plates 103 and 104). Nevertheless, during the same years that he is describing sledding in the snow (plate 109), or villagers watching a galloping horse (plate 110), he is also painting scenes of diurnal tragedy such as *The Drowned Boy, Warnemünde* (1908; plate 108) or *The Coffin Is Carried Out* (1904; plate 106). As T. S. Eliot writes of the playwright John Webster: Munch "saw the skull beneath the skin." This fateful theater is enacted in the most literal way in *Four Ages of Life* (1902; plate 105), which stages the span of woman's life in a singular image: young girl, young woman, full adult, old age.

There is also gentleness and pleasure, passion and joy in Munch, albeit often mitigated by the overall *melancholia* and duality he sees in life. For example, his murals for the Festival Hall at the Royal Frederiks University (now the University of Oslo) express a healing power in nature and a value in the continuity among generations, through the central painting of the sun (plates 117–127). This optimism can also be seen in Munch's paintings of nude bathers, who celebrate the life-giving sun as part of the Nietzschean vitalist philosophy popular at the time.

In intimate relations, Munch is aware of the tension between romantic and erotic ties, and he has a fraught sense of the interplay of vulnerability and power in human connection. His art deepens through illness (his own and other people's), loss, and the anxiety of family dramas. Some paintings are theatrical in their placement of figures: the tensions among the characters, their lack of communication, seem to reflect the dramas of Henrik Ibsen. Sometimes, too, there is a symbolic abstraction of individuals that again recalls theatrical archetypes.

Many of Munch's paintings, as well as his innovative lithographs, etchings, and woodcuts, are exhibited, in an ever changing but thematically consistent set of images that comprise what can be termed his overall statement, the *Frieze of Life*. This is first exhibited in a newly ambitious form at the 1902 Berlin

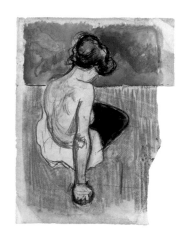

Edvard Munch. *Seated Nude.* 1896. Pastel, watercolor, and pencil on paper, 24⁷⁄₁₆ × 18¾" (62 × 47.7 cm). Munch Museum, Oslo

Secession, and includes many of his best-known works, such motifs such as the Madonna and the Vampire, Puberty, The Kiss, and Melancholy, and most importantly a work he called *Metabolism*, which depicts the entire life cycle: life becoming death, and death, in turn, nourishing life (plate 96). It is a major part of his ambition to show all the stages of life and to show the world as one spiritually connected system. In certain thematically comprehensive pictures, Munch encompasses a lifespan of naïveté, erotic tension, and inevitable decline: among these are a newly discovered work that was long hidden behind another canvas, *Young Girl with Three Male Heads* (c. 1898; plate 46), and in one of Munch's greatest works, *The Dance of Life* (1899–1900; plate 100), which evokes the moonlit summer nights of the north, the passions of lovers, and people enjoying the shore—but also foretells their fragile and tragic futures. The mutable *Frieze of Life* along with Munch's many other related paintings and the large body of graphic work assure him an essential and even fundamental place in the canon of modern art.

Munch's statement "I do not paint what I see but what I saw" suggests that he understands his work as the product not of an empirical, observational process but of the cumulative emotion of the mind's eye. Intentionally and consciously, between seeing something in the world and realizing it in paint, he passes it through a mental filter from which it later emerges transformed in the intensity of the remembered moment. Like van Gogh and Gauguin before him and the Expressionists after him, Munch often uses color not for naturalistic description but to convey authenticity of feeling. Meanwhile his loose, flowing brushstrokes shape figures whose contours pulsate with lines and movements in the scene surrounding them. Understanding the world as a place of agitation and stress, Munch makes that vision literal; the emotional states that concern Munch are often disruptive—anxiety, jealousy—but he also knows quieter moods, like melancholy, loneliness, or, more positively, the shared solitude of lovers, as in *The Kiss* (1897; plate 51), where the couple seem to melt into each other in an erasure of their separate identities.

The uniquely modern anxiety of identity crystallizes in the lonely figure on the road along the fjord in *Despair* (1892; plate 83) and then in the painting that immediately grew out of it, *The Scream* (1893; plate 84). Over the past century the latter image has become a remarkable icon, familiar everywhere, communicating so strongly and so universally just because it is so deeply personal. The wild red sky is a correlative of the figure's emotions: hopelessness and panic. The "loud, unending scream piercing nature" confronts us with the frightful possibilities of the modern self. The skull-like head—a memento mori—looks out at us, engaging our attention, and invokes a singular emotion of modernity. It is Munch's great triumph that in so many works he is able to pictorialize an extraordinary range of intense human passion and in so doing delineate the life of the modern soul.

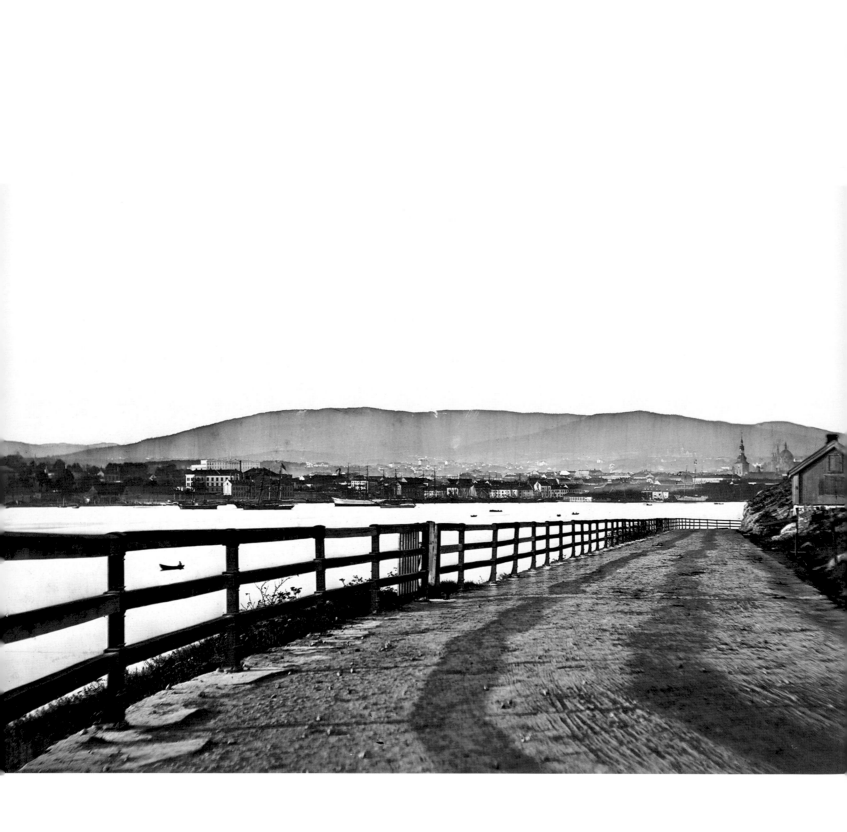

"Could Only Have Been Painted by a Madman"—Or Could It?

Reinhold Heller

If you look carefully at the central red streak in the sky of what is probably the first painted version of Edvard Munch's most famous image, *The Scream* (1893; plate 84), now in the collection of the National Gallery in Oslo, you will find, scratched in pencil, the handwritten comment: *"Kan kun være malt af en gal mand! (Could only have been painted by a madman!)"* (figure 1).[1] There is some question as to whether the handwriting is Munch's own or if a visitor to one of Munch's exhibitions in the 1890s or early 1900s left the inscription.[2] Far more significant than the issue of graffiti authorship, however, is the very fact of the inscription's continued existence. For us, today, to whom *The Scream* has become a much-replicated popular icon, it is far more revealing that Munch never attempted to remove this penciled graffito from his most celebrated painting, although he could easily have erased it or painted over it. Instead, he left it as an apparently desired final commentary, as a textual confirmation of the authenticity of the state of mind the image seems to project. It is as if Munch allowed a sign, albeit a subtle and not immediately visible one, to be posted with each display of *The Scream*, proclaiming: "Mad Artist at Work."

Since Munch repeatedly defended himself against charges of insanity and mental illness, especially during the 1890s and early 1900s, but also thereafter,[3] while at the same time fearing that he was genetically marked precisely by these,[4] it seems incongruous that he would let stand—indeed, endorse—just such a charge in regard to the image that, more than any other by him, is considered to embody a state of extreme psychological disturbance. If we assume that he would have wished to create a certain distance between himself and the distorted configurations and colorations of *The Scream* in order to affirm his "healthy" psyche, we must also ask ourselves about the meaning of his insistence on exactly the opposite, on the confluence of his person, his psychological or mental state, and the image he produced. Why must the artist be a "madman," and how does this equation of artist and image affect our understanding of *The Scream* and of Munch's art in general? Or, alternatively, is the transparently symbiotic relationship between Munch's biography and his imagery, confirmed by virtually all critical and art historical evaluations of his art today, a

Ljabroveien, the road between Kristiania and Nordstrand, at Ekeberg Heights, Kristiania, c. 1870

17

consciously generated construct, at least partially manufactured or endorsed by Munch himself; and how has this influenced the critical evaluation of his art? Would it be useful for us to try to separate, or at least isolate, Munch's imagery from his personality and life story, and for us to view them as parallel rather than as inextricably intertwined, the one dependent on the other? Has biography eclipsed the work itself? If so, how and why did this happen?

I.

To address such questions, I first want to review and re-examine the genesis of Munch's image of *The Scream* and its relation to his biography and psychological life. That such a link exists seems undeniable; all studies and commentaries on Munch's art posit it, and Munch's own comments seem to confirm it, as does the penciled inscription scratched onto the 1893 painting. Nonetheless, I want to ask how accurate and significant this art-historical linkage is: how was it constructed, and what does it signify beyond the possibility of a simple equation?

Munch himself is primarily responsible for the perception of an overlap of the image and the biography. Since the very first conceptions that led to *The Scream*, he insisted that what he depicted was his own experience, and that it represented his own psychological state of despair and anxiety, bordering, so he felt, on insanity. Even as he made the first sketch of the motif in a sketchbook, late in 1891 or early in 1892 (figure 2), Munch simultaneously wrote about its origins in his personal experience, much as if he felt that the pictorial image was incomplete and required a verbal accompaniment or explanation: "I was walking along the road with two friends. The sun set. I felt a tinge of melancholy. Suddenly the sky became a bloody red. I stopped, leaned against the railing, dead tired [my friends looked at me and walked on] and I looked at the flaming clouds that hung like blood and a sword [over the fjord and city] over the blue-black fjord and city. My friends walked on. I stood there, trembling with fright. And I felt a loud, unending scream piercing nature."[5]

The text is dated "Nice, January 22, 1892." Despite the specificity of date and place, this is not a diary entry, as is often stated.[6] At least, if the visual setting along the Kristiania Fjord depicted in the images of *The Scream* is to be believed, the text written in Nice records an event that took place previously, while Munch was in Norway.[7] Instead of the immediate record of an event,

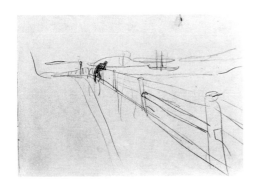

Figure 2. Edvard Munch. *Despair* (from Ljabrochaussé). 1891–92. Pencil on paper. Munch Museum, Oslo

such as a diary concerned with the present might contain, this is a reminiscence. But it is not a reminiscence quickly jotted down with little prior thought; textual changes inject the visually emotive quality of color, and extraneous detail is eliminated—Where did this take place? When? Who was involved? What led up to the experience? Munch uses a careful staccato rhythm as he skillfully, cumulatively lists events, moving from concise records of mundane actions (walking) and everyday occurrences (the sun setting) to the unexpected and sudden culmination of the "scream piercing nature." All of these are indicative of nuanced, thoughtful writing such as might result after several prior drafts of the text (none exist) or a process of mental editing to distill the experience to its most effective verbal formulation. It was written less for the benefit of the author, as a diary might be to record events and keep memories alive, than for the benefit of an audience that could, through manipulation of the text, re-experience empathetically, or at least recognize, the full power of the original psychological experience and come to terms with the art involved. Verbally suggestive and emotive, Munch's brief text is a prose poem. It follows in its form contemporary Symbolist and "decadent" literary practice, such as that which young Norwegian poets adapted and practiced then as well.[8]

II.

Throughout his career, Munch complemented his work in the visual arts with varied literary projects. Among these are fragments, never published and never announced by him publicly, of a project for a pseudoautobiographical novella, rooted in his romance with Milly Ihlen Thaulow during the mid-1880s. Fictionalized as "Mrs. Heiberg" by Munch (at the time, she was married to Captain Carl Thaulow, brother of the painter Frits Thaulow and a cousin to Munch himself), she later was divorced, had a brief acting and singing career, and married the actor Ludvig Bergh.[9] In 1890, Munch described her as the woman who totally transformed his attitude toward life, its forces, and its meaning:

What a deep mark she has left on my mind, so deep that no other image can ever totally drive it away. Was it because she was so much prettier than the others? No, I do not even know if she was pretty; her mouth was large. She could seem repulsive. The other one, tall and pale, was far more attractive, with her dazzling young skin, her blond hair that a slight breeze blew over her eyes, and her eyes that were so full of loyalty. . . . Was it because we shared the same opinions? We did not really know each other. And yet—Was it because she took my first kiss, that she took the sweetness of life from me? Was it because she lied, deceived, that one day she took the scales from my eyes so that I saw Medusa's head, saw life as a great horror? And everything that previously I had seen in a rose-colored mist now seemed empty and grey to me?[10]

Highly dramatic in its presentation, self-consciously literary with its self-questioning and euphemistic references, the characterization of "Mrs. Heiberg" casts Munch in a passive and naïve role. He—or, more accurately, the male

narrator and protagonist surely modeled on Munch himself—appears as a victim deprived of his childlike innocence and naïveté in other texts as well, which construct isolated scenes from the illicit romance. Deprived of narrative consistency, the disconnected semifictional text fragments share a focus on the narrator's extreme moods and emotions, which swing between the elation of sexual initiation to the debilitating despair of jealousy in response to the varied provocations offered by "Mrs. Heiberg." For example, he describes an encounter with her on Kristiania's main thoroughfare, Karl Johan Street, one afternoon:

And then finally she came. He felt long before that she had to come. . . . He saw only her pale, slightly plump face, horribly pale in the yellow reflections from the horizon and against the blue [sky] behind her. Never before had he seen her so beautiful. How lovely was the bearing of her head, a bit sorrowful. She greeted him with a weak smile and went on. . . . He felt so empty and alone. . . . He worked himself into a frenzy. Suddenly everything seemed strangely quiet. The noise from the street seemed far away, as if coming from somewhere up above. He no longer felt his legs. They no longer wanted to carry him. All the people walking by looked so strange and odd, and he felt as if they were all staring at him, all these faces pale in the evening light.[11]

Munch's concern with rendering what is fundamentally a pathology of emotional, quasipsychotic responses to events and experiences, as well as the terse economy of his description, have strong kinship with the introspective content and the technique employed by the Norwegian author Knut Hamsun in his premier novel *Hunger*, first serialized in 1888. While precedents for fictionalized semiautobiographical writings, often in a diarylike rendering, abound during the nineteenth century, both Munch and Hamsun had as the immediate precursor for their literary form, Hans Jæger, the charismatic leader of the Kristiania Bohème. A loose collection of experimental Norwegian writers and artists— Munch among them—of the 1880s, the Bohème was united through the personal charisma of Jæger and by his ideology of utopian anarchism, free love, and the rejection of bourgeois Christian morality as its primary tenets.[12] In his lengthy book *Fra Kristiania Bohêmen* (*From Kristiania Bohemia*) (1885) and in shorter semiautobiographical novellas during the 1880s, Jæger established the controversial prototypes for the fictionalized, autobiographical writing that Hamsun and Munch emulated in inverse versions of a *Bildungsroman*, tracking not the education and maturation of an individual but, rather, his deconstruction, his progressive psychological disintegration.

III.

Munch's projected novella was never completed and remained scattered textual fragments, some revised several times, in various notebooks, sometimes accompanied by drawings visualizing a scene that later served as the basis for a painting. The drawing associated with the account of Munch's search for "Mrs. Heiberg" among passersby on Karl Johan Street, for example, was translated by him into the painting *Evening on Karl Johan Street* in 1892 (plate 79); in

the process, the biographical incidentals of the drawn scene and the texts were largely suppressed or eliminated.

It is tempting to see *The Scream*, too, in the context of this fragmented narrative of failed, disturbed love, sexual tension, and infidelity. Moreover, there is significant justification for doing so. When Munch first exhibited the painting in Berlin in 1893, under the title *Despair*, it was the concluding image of the six-painting study for the Love series that traced the relationship of woman and man from first attraction through sexual fulfillment, jealousy, and despair,[13] a thematic development clearly rooted in the "Mrs. Heiberg" narrative but mutated from the specifics of it into a universal commentary on the nature of love itself. *The Scream* remained constant as a central motif thereafter, while Munch continuously expanded and altered the series, shifted the order of the paintings, introduced new motifs or variations on prior ones, and also settled on calling it the *Frieze of Life*.[14] Nonetheless, the linkage to Munch's "Mrs. Heiberg" narrative, whether his own experience or poetically transformed, may be too readily drawn, and be a testimony more to the narrative cohesion of Munch's *Frieze of Life* than to any original placement within his story of a "perverse love," to borrow the title of one of Jæger's novels.

Among the notebooks in which Munch wrote his drafts for the "Mrs. Heiberg" novella, an account of the experience of *The Scream*, such as is described in the text of January 22, 1892, is not included. At no time does this particular experience enter into the narrative text that Munch was patching together in disparate fragmentary scenes. Instead, the January 1892 text remained isolated, neither connected nor overtly related to other texts in order to join in a story of an illicit romantic liaison and its traumatic psychological results. At no point is a connection drawn to "Mrs. Heiberg" or the relationship of the narrator to her as a cause or a participant in the sunset scene. Lacking textual narrative context, it is a single, lone experience condensed into the evocative format of a prose poem, aimed more at engendering a mood in a reader than at enumerating the details or causes of an event associated with others in a novella.

This is of more than incidental significance. In 1892 Munch was working less on the "Mrs. Heiberg" novella than on a number of such prose poems that synthesize and concentrate experiences into short emotive verbal images. As with the first *Scream* text, they accent the visual, not the narrative. Indeed, Munch linked them with large drawings; often he wrote them on a sheet of paper next to or under a related picture. A variant on *The Scream* text, thus, appears directly next to a charcoal drawing of the scene, *Despair* (1891–92; plate 82), the sky accented with slashing swatches of deep red gouache thickly applied without modulation or shading to provide the visual equivalent of the "scream piercing nature."[15]

Precisely what Munch intended to do with these image-text combinations is not clear. He was planning, at the time, to illustrate collections of poetry by the Danish poet Emanuel Goldstein and the Norwegian poets Vilhelm Krag and

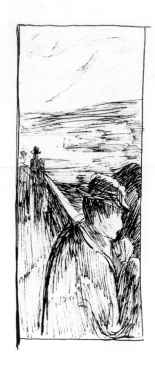 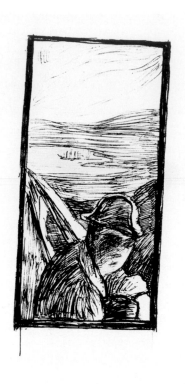

Figure 3. Edvard Munch. *Two Vignettes (Despair)*. 1891–92. Pen and india ink on paper. Munch Museum, Oslo

Sigbjørn Obstfelder, and several suitable vignettelike drawings for these appear in his sketchbooks, including two small renditions of the Despair/Scream motif (figure 3).[16] Neither the sketchbook vignettes nor the larger drawings, with their difficult-to-read handwritten texts, often with words scratched out or written over, are of a quality or degree of finish that would make them suitable for publication using the reproductive techniques of the 1890s, however, and they were drawn before Munch began making his own prints. With his own prose poems appended, the drawings clearly ceased to be appropriate illustrations for the poetry of his friends. It is improbable that, with their roughly written texts and corrections, he would have considered them suitable for exhibition either. I believe it is most likely that Munch's drawings represent a project for a collection of his own images and prose poems modeled on the books for which he was asked to provide vignettes. He did not realize such a project then, however, just as he never completed the drawings for the poetry of Goldstein, Krag, and Obstfelder. It is even more significant for Munch's own development as an artist, moreover, that these text-associated drawings became the basis for paintings in 1891–92 and thereafter, but the texts—other than the titles—were eliminated so that the images were made to stand on their own, using only the power of their pictorial qualities and the narrative sequence in which Munch might display them to communicate their content to their audiences.

IV.

If the recollections of the Norwegian painter Christian Skredsvig, who accompanied Munch during his stay in Nice in the winter of 1891–92, are reliable, from

the time Munch first began work on this image, it was recognized as being in some fashion autobiographical, as representing a personal experience: "For some time Munch had been wanting to paint the memory of a sunset. Red as blood. No, it actually *was* coagulated blood. But not a single other person would see it the same way as he had; they would all see nothing but clouds. He talked himself sick about that sunset and about how it filled him with great anxiety. He was in despair because the miserable means available to painting never went far enough. 'He is trying to do what is impossible, and his religion is despair,' I thought to myself, but still advised him to paint it—and that was how he came to paint his remarkable *Scream*."[17]

Skredsvig cast himself in the heroic role of artist-midwife who aided Munch in realizing, or giving birth to, his most notable painting even as Munch himself, deeply despondent, was prepared to give up in his efforts. Essentially, Skredsvig self-servingly describes himself as having saved Munch (the young, uncertain, still emerging artist of 1892) from himself (the despairing individual) to enable him to become Munch (the celebrated artist of *The Scream*). Whether or not this grand historical intervention is fully accurate, it offers two significant insights into Munch's image. First, like Munch himself, Skredsvig asserts that what is depicted corresponds to Munch's personal experience of a sunset. The ethos of realist-naturalism is at play here, which demanded that the artist represent only the realm of visible objects as experienced by him and to which Skredsvig himself adhered.[18] More interesting and revealing, however, is that Skredsvig recognized the source of Munch's anxiety and despair, not in the sunset motif of the image nor in his response to the sunset with red skies of coagulated blood, however traumatic such an experience may have been, but, rather, in the inability to transmit visually to a viewer precisely the effect of such an experience. A painting of a sunset faithfully rendered could be seen by its viewers only as a collection of colored clouds, more or less dramatic depending on their configuration and the effects of reflected and refracted light from the setting sun. The technical painterly means that naturalism, realism, and Impressionism made available to him—"the miserable means available to painting"—were insufficient for Munch to render a comprehensible image, Skredsvig indicates. Indeed, Skredsvig himself considered the obstacles to the task to be insurmountable.

Munch's initial painting of his sunset scream, *Despair* (1892; plate 83), probably painted while Skredsvig was in Nice with him, serves almost as an illustration of this contention. As basic stylistic technique, Munch significantly modified Impressionism's divided brushstrokes, using them not only to render tonalities of light but also to congregate into directional fields, as in the perspectival diagonal of the railing, and—in one of his earliest efforts to apply the stylistic principles of Paul Gauguin and his Synthetist followers—into outlines of figures and landscape forms in the painting. The general blue-green tonality of the landscape and the shadowy figures on the road correspond to the practice

of James McNeill Whistler's Nocturnes, while maintaining overt linkage to the atmospheric color experienced at dusk. The luridly colored red and yellow sky appears in coloristic contrast, painted like the landscape in extended, blending strokes of the brush so as to render the illusion of clouds streaked across a sky. And therein lies the problem, as recognized by Skredsvig: the clouds appear as renditions of clouds, no matter how intense their color (although they might also be read, of course, as a chaos of streaked oil paint). Even when viewed in association with the foreground figure turned toward the railing and the skyline of the city below, they do not render the "great anxiety" that saw "coagulated blood" or that, in Munch's poeticized recollection, participated in the "scream piercing nature." In order to communicate this, Munch resorted to words.

The Scream prose poem was an admission of inadequacy and failure. Only through it could Munch transform *Despair*'s sunset scene with figures into a rendition of the great scream in nature. Through yet another verbal aid—the title *Despair*—Munch might point otherwise baffled viewers into recognizing at least the apparently desperate mood of the blank-faced, slightly bowed fore-ground man who turns toward the view of city and fjord, and possibly also lead them to recognize the aura of death traditionally associated with sunsets.[19] The clouds, however, remained clouds, red certainly, but clouds nevertheless, and no scream passed through nature. "The miserable means available to painting," as Skredsvig observed, seemed inadequate. The despair Munch then experienced was not the despair he projected in the prose poem, with its clouds like blood, which he was trying to depict, but, rather, it was despair at the inadequacy of a naturalistically oriented art to resolve the task he set himself. Munch's despair in 1892 was a despair of form in painting; it was a despair of artistic style.

V.

Painterly form and style in themselves never were of interest to Munch. The nineteenth-century doctrine of art for art's sake, as well as modernism's Kantian demand for self-containment and self-referentiality, had no appeal for him. The style, form, and means of an artwork had their sole justification in their ability to communicate the content of the work to an audience and were thus mutable from one image to the next. "When seen as a whole," Munch observed, "art derives from a person's desire to communicate with another. All means are equally good."[20] Communication was primary; all else was subordinated to it. There was no single Munch style at any time; therefore, he altered his approach from one image to the next, letting the content give shape to form each time, never fixing on a single look for his works.

The primacy of communication combined with his inability to achieve it pictorially while working on the Despair/Scream motif in 1892 thus signified a fundamental inadequacy for him in his work and approach. He was, at the time, especially under the influence of French Post-Impressionist art, already making

a transition from the naturalist-oriented works of the 1880s and adopting an anaturalistic, or even antinaturalistic, approach.[21] The outlines employed in the painting *Despair* and the general suppression of detail in it, for example, testify to this, as they posit a vocabulary of artifice rather than the naturalistic emulation Munch rejected as thoughtless—and idea-less, content-less—"detail painting."[22] As he continued to work on the motif during the year, Munch made the charcoal sketch mentioned earlier (plate 82). He included the painting's dark frame, changed the format slightly to give greater vertical accent, simplified the landscape further, flattened the outlined forms even more, and increased the bulk of the foreground figure that leans against the railing. Instead of sketching in the clouds atmospherically, however, he took a brush loaded with deep red gouache and slashed the color in two broad, unmodulated, coarsely diagonal strokes into the area of the sky. In a notebook, he commented on the effort: "When the clouds of a sunset have the effect of a bloody blanket when one is in a disturbed state of mind, then it certainly is of no use to paint some sort of ordinary clouds. It is necessary to go the direct way and paint the actual impression one had. In the painting [one must] paint the clouds as blood. The impact of a painting depends on what it says."[23]

Indeed, the splotches of gouache do have the appearance of blood in the context of the charcoal drawing, and thus fulfill Munch's intent to depict subjectively how something is seen "according to one's mood." However, even with a blood-smeared sky, the other component of the prose poem, the scream felt to be passing through nature, remains lacking, and Munch again resorted to attaching his text, somewhat altered, to the drawing. Words remained a necessary crutch to fully communicate the content of the image.

Munch's wrestling with the motif and how to paint it continued throughout 1892 and the beginning of 1893. The time was extremely significant biographically as well as for his career, as he moved from France, returned to Norway, and then received the fateful invitation to exhibit in Berlin, where he remained until late in the summer of 1893.[24] His antinaturalist stylistic attitudes became radicalized during this time, particularly as he applied the practices of Post-Impressionist artists in an increasingly more personal and original fashion to his paintings and, further, as he associated with the writers and artists of Berlin's *Zum Schwarzen Ferkel* (The Black Piglet) circle, including the Swedish playwright August Strindberg and the Polish novelist and essayist Stanislaw Przybyszewski, both passionate in experimentation with a new subjective semi-autobiographical art and literature akin to Munch's own, as well as with personal studies of human psychological pathology.[25] Within this milieu, Munch finally developed the motif of *The Scream* in a manner that satisfied his own demands of it. He abandoned the remnants of naturalistic atmospheric effects and illusion still present in *Despair*, and replaced the heavy, melancholic foreground figure with the screaming specter of a depersonalized humanoid crea-

ture, first in a large pastel (figure 4), then in the painting that ultimately received the inscription "Could only have been painted by a madman!" (1893; plate 84).

VI.

What is most striking about *The Scream* is how drastically it departs from Munch's preceding works conceptually and in execution, even from the most radical among them, such as *Melancholy* (1891; plate 66). While Synthetist-like flattening and outlining of forms, simplification of color schemes, and manipulation of spatial relationships are seen there, in no painting prior to *The Scream* did Munch transform the landscape so astonishingly into antagonistic segments—the swirling forms of the fjord and sky, set off against the sharp non-curving of the straight road and railing without transition to generate a tense spatial ambiguity—as in this work. In no earlier painting were colors so harsh, clashing, and coarsely applied. In no other did he mix mediums—oil paint, gouache, tempera, pastel, charcoal, and pencil—so freely and arbitrarily in defiance of all accepted rules of unity and harmony. And in no prior painting did he deprive the figure so drastically of personal identity and bodily presence, its entire undulating anti-anatomy trapped into the gesture of hands raised to a colorless head, the singular O of its mouth the sole stable form in the entire image. There are no sketches that precede the painting, other than the large pastel. The painting, indeed, gives the illusion of rapid execution, impetuous with its jumbled streaks of color and mediums atop each other, vying with each other, augmenting still further the sense of instability and disjuncture that the composition projects. It is as if the image had been produced in a state of frenzy, spontaneously, even unconsciously, and without rational artistic control—indeed, much as a "madman" might be thought to work and produce art without regard for aesthetic principles, effects of beauty, or pictorial coherence. The very act of painting the image, according to such a perception, is an end in itself, a therapeutic process more than an artistic one. It is as if Munch depicted his anxieties in order to gain control over them.

Despite such indices of impetuosity, however, the painting is the product of a lengthy working process, extending back over two years, during which Munch sought the solution to how the "scream piercing nature" could find visual form and how it might be liberated from textual dependency.[26] He achieved it only in conscientiously pushing and bending the practices, styles, and formal vocabularies of contemporary painting into an unanticipated direction personally defined by him. It is, however, difficult to find art-historical sources for the image. There are kinships in composition, form, and coloration to works by various contemporary artists, but none that could be recognized as a prototype or direct model for Munch's *Scream*.[27] In fact, *The Scream* embodies a degree of originality and uniqueness seldom seen in the history of modern art. Once we realize this, once

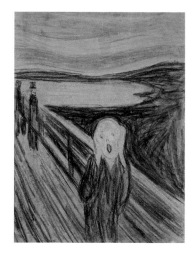

Figure 4. Edvard Munch. *The Scream*. 1893. Pastel on cardboard. Munch Museum, Oslo

we are aware of the labor and achievement of *The Scream*, the image's *art* begins to outweigh even the content of despair and anxiety it communicates to us in fulfillment of Munch's dictates. It is the firm artistic control Munch had over his image and his bold invention that impress.

There is one additional possible source for the stylistic features and technical practice of Munch's image that deserves attention. Since the 1830s, many artists had sought out varied alternatives to the increasing turmoil, persistent change, and uncertainty of modern urban civilization. Most turned to remote villages in Europe, forming artist colonies in Pont-Aven in Brittany, in Worpswede in Germany, and in Skagen in Denmark, for example. A few, like Gauguin, went to even more exotic "primitive" locales, in Tahiti and elsewhere. Munch, according to a perceptive critic and member of *Zum Schwarzen Ferkel* in Berlin, chose a different route and found his Tahiti by turning inward, through introspection, self-analysis, and contemplation of human psychology and erotic pathology.[28] Abnormal states of mind—states of mind thought to border on insanity and resulting from deep spiritual and personal crises or "drunken experiences" induced by alcohol, cigarettes, sex, or even sunsets—similarly, were the prime concerns of Strindberg, Przybyszewski, and other *Zum Schwarzen Ferkel* artists and writers. While there is no conclusive evidence for it, they likely also had an interest in the art of the mentally disturbed. Works by the Swedish artists Ernst Josephson and Carl Fredrik Hill, who both suffered mental breakdowns—usually diagnosed as schizophrenia—after initially successful careers as painters, and who continued to make drawings and paintings after their breakdowns, were known to Strindberg and various Swedish artists in Berlin, and it is probable that their works were shown to other members of the circle, including Munch.[29] Furthermore, Przybyszewski, as a sometime medical student, may have had access to patients' artworks. What is certain is that by the late 1890s, all three—Strindberg, Przybyszewski, and Munch—were deeply interested in the art of mental patients.

I am not proposing that Munch was directly influenced by Josephson's or others' drawings when he painted *The Scream*, however. What Munch gained from the study of such work was an understanding of it and the diverse types of imagery generated by those who were termed *mad*. He may well have gained from it a greater willingness to reject the last vestiges of naturalism and illusionism, which still haunted his art when he arrived in Berlin. But what finally sets *The Scream* apart is that Munch painted as his audience—the publics of Scandinavia, France, and Germany he was addressing—believed a madman would paint, informed by varied popular illustrated books and articles on mental illness, degeneracy, and the relationship between genius and madness that appeared with increasing frequency during the 1880s and 1890s.[30] The ability of Munch to channel widely held convictions, transform them through his imagery, and then re-present them to the public is an aspect of his work that is still little

recognized. It contributes to the phenomenon of the content and impact of his art often being understood or appreciated for its power even by critics, contemporary to Munch as well as later, unsympathetic to him or unwilling to accept his stylistic approaches.[31] The image of anxiety and madness, as we might imagine it, is embodied in *The Scream*. The penciled inscription "Could only have been painted by a madman!" offers both confirmation and solace: the world depicted is "mad," the viewer is not.

VII.

Munch could not leave the image alone, however. In its radical appearance, its formal and stylistic practices, it surpassed not only earlier works but others contemporary with it. Indeed, seen today in the totality of Munch's oeuvre, *The Scream* continues to stand out in terms of how uncharacteristic it is of his work generally, by how unique it is. If, as in a recent exhibition, we can see a large body of Munch's work as being "after *The Scream*,"[32] we can, likewise, categorize others as "before *The Scream*," leaving *The Scream* itself as an isolated fulcrum, a phenomenon around which everything else collects but which nothing matches. It is not an exaggeration to claim that *The Scream* is the least characteristic and representative of Munch's images.

Munch realized this. In various ways he sought to suppress or modify precisely the image's uniqueness. Above all, he attempted to subsume it within the series of his *Frieze of Life* cycle. Insertion into a serial sequence had dual consequences, as it forced the image to be viewed in the close context of others so that they mutually modified each other, and it necessarily forced *The Scream* to be part of the larger totality of Munch's recent works, not allowing it to be isolated and separated. *The Scream*, however, resisted such efforts.

When Munch first exhibited the painting in 1893, it formed the final image of the group of studies for a series on Love that he planned, and, as such a final statement, it offered a radical conclusion of anxiety, despair, and loss of identity to the sequential narrative of love's beginnings, fulfillment, and disruption into jealousy. In the expanded *Frieze*, however, Munch positioned it as a transition from a narrative of love and life to a narrative of death and survival (figure 5). He found it necessary to repeat aspects of *The Scream*'s image—for example, the distressed frontal foreground figure in *Red Virginia Creeper* (1898–1900; plate 94) or the striped sky and setting in *Angst* (1894; plate 81)—in neighboring images in order to keep a sense of visual coherence and continuity, in effect, in order to mute the impact it would have alone. In the radicality of its formal solutions and the content they transmit, *The Scream* demands an independence Munch was unwilling to grant it. He seems never to have exhibited the paintings of *The Scream* separately from the serial context that subdued the image, chaperoned it, and gave it an apparent contextual narrative meaning free of biographic justification or explication.[33]

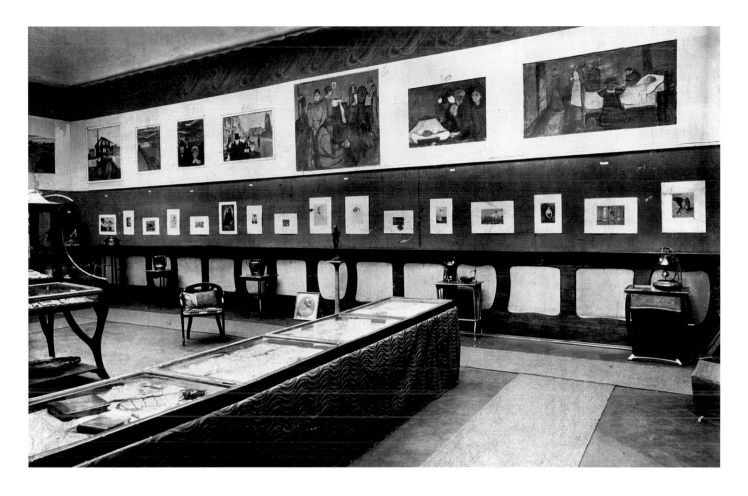

Figure 5. Exhibition of Edvard
Munch's *Frieze of Life*, at P. H.
Beyer & Sohn, Leipzig, 1903:
Wall showing *Red Virginia
Creeper, The Scream, Angst,
Evening on Karl Johan Street,
Death in the Sick Room, By the
Deathbed,* and *Dead Mother
and Child*

VIII.

Perhaps, in that drive toward independence is also contained the unique attach-
ment to text Munch displayed with this work. After painting *The Scream* in
1893, he stopped revising its associated prose poem, and did not link it to the
painting as he had to the earlier *Despair* imagery. Location in the serial sequence
of the painting series Love substituted for the textual explication.[34] However,
when Munch began to translate some of his Love themes into lithographs in
1895 in Berlin, he reintroduced the text for *The Scream* and printed the title and
succinct inscription, "I felt the great scream through nature," in German
beneath the image (plate 86).[35] Similarly, when the lithograph was reproduced in
the French Symbolist periodical, *La Revue blanche*, at the end of the year, he
accompanied it with a French version of his prose poem (page 227).[36]

Even as he forced *The Scream* to integrate with his other works by placing
it into a serial context to comment on the conditions of human existence, Munch
did not dissociate it from its text, and thus made it the major exception to the
rule of pictorial self-containment he imposed on his paintings after 1892. It is
as if Munch did not trust this powerful image to be self-explanatory. As he lib-
erated his other images from textual association, or allowed them to comple-
ment or explain each other visually and pictorially by presenting them in serial
"friezes,"[37] *The Scream* continued to demand verbal commentary, judging from
Munch's insistence that text accompany it.

Not only that, but unlike motifs that depend on the "Mrs. Heiberg" narrative, in which Munch sought to represent, as he phrased it, the underlying "eternal powers" that unite all human lives and, therefore, avoided the specificity of individual likeness (even as facial features often retained a degree of kinship to people Munch knew, for example, members of his family), for *The Scream* he announced, through the attached texts, that the experience was his own, that it was he who felt the great scream in nature.[38] Unlike the insistent fictionalization of the "Mrs. Heiberg" accounts, with altered names and a text largely written in the third person, the several *Scream* prose poems all immediately begin by identifying Munch himself as the subject: "*I was walking along the road.*"

Ironically, within the world of Munch's works of the 1890s, this is the image, whether painting or lithograph, in which the figure is the most drastically de-individualized. In the *Scream* images, the figure loses all characteristics of human anatomy and individuation. Consisting of nothing but a wide-open mouth, gaping eyes, and the nostrils' two holes, the face and head with skull-like contours lack all identifying features. The figure defies human anatomy itself as, wormlike, it twists and bends with the curves of the landscape and sky. *The Scream* is, if this is possible, egolessness personified. And yet, Munch insisted that the audience of his art recognize him in *The Scream*. Through his texts, he restored identity to the depersonalized. In the process, he also generated a necessary tension in the viewer's understanding of *The Scream*, as the seemingly universal ironically became personal, and vice versa, demanding a persistent state of uncertainty, a lack of closure whose unease mirrors that of the anxiety the image visually represents.

IX.

The process of multiple mutation and recycling of his imagery is fundamental to any understanding of Munch's work and his achievements. In our consideration of the relationship between Munch's life and his written, as well as visual, imagery, especially as revealed through *The Scream*, it is important to realize that both verbal texts and visual images are highly mediated, and that the primary mediating force is the submission to conscious, determined, and goal-oriented artistic formation by Munch himself in order to maximize their communicative capacity for an audience. To consider Munch's work as primarily personal, confessional, or therapeutic is, therefore, an error. The admonition Munch attached in 1929 to his earlier writings, as he was reading through them, but which critics and scholars have almost consistently ignored, applies equally to his visual imagery: "These . . . are partly actual experiences, partly poetic experiences. I do not intend to present my experiences through them. They are intended to seek out the hidden powers . . . within the machinery that is called a human life, and their conflict with other human lives. When I collect these now, they will be marked by my current spiritual state. . . . How difficult it is to determine what

is unauthentic, what is concealed deceit, self-deception, or the fear of showing myself in my true light."[39]

As he remarks, Munch conceived of his art as fundamentally didactic, as transmitting content and meaning. Thus a process akin to self-analysis, the examination of his own "soul," served him as the basis for a revelation of the "hidden powers" of human life and interpersonal conflict. But the very process of ordering these, of shaping them, necessarily transformed them and marked them with "my current spiritual state"; they lost "authenticity" or truth-value in terms of narrating his past biography, but they simultaneously gained in their revelatory impact.

When he allowed the penciled inscription "Could only have been painted by a madman!" to stand on the painting *The Scream*, or when he placed, beneath the lithograph image, the bald statement, "I felt the great scream through nature," Munch permitted his audience to be misled. However, he did so only to make the art-fiction of the images more readily believable and acceptable in its eccentricity. Similarly, he applied a formal—or antiformal, formless—stylistic vocabulary of radical distortion that recalled the appearance of artworks by persons deemed "mad." The wording of the associated texts, meanwhile, clearly articulated that the "madness" visually presented both in form and content was situated in the past, in a temporal moment clearly divorced from the viewer's present and presence. If the work was to offer an image of pathological despair and anxiety, the "madness" of the artist should serve to testify to the validity of the representation, to make the otherwise unacceptable image acceptable, but the audience—as well as, significantly, the artist working and exhibiting "after *The Scream*"—also had to be protected from a too-ready identity with the deranged image. Munch adopted the epithet of madness as testimony to the sincerity of his art. Nonetheless—in an effort replete with contradictions and possibly doomed to fail—he also attempted to separate himself and his artistic identity from the specter of madness. His personal biography and experience, insofar as they served as sources for his images, were transformed, synthesized, manipulated, falsified, and fused—as he sought to construct a pictorial realm that, visually, would offer optimal communication of the content of his images.

Notes

This essay is dedicated to the memory of Trygve Nergaard. Unless otherwise indicated, all translations into English are my own.

1. Reinhold Heller, *Edvard Munch: The Scream* (New York: Viking Press, 1973): 87. Identification of the handwriting as Munch's own is also offered in Ragna Thiis Stang, *Edvard Munch: The Man and His Art* (New York: Abbeville Press, 1979): 106; and Arne Eggum, "Major Paintings," in *Edvard Munch: Symbols and Images* (Washington, D.C.: National Gallery of Art, 1978): 39.

2. Also open to question is whether the orthography of the inscription is the Norwegian of the end of the nineteenth and early twentieth centuries or Danish. Munch exhibited this version of the painting consistently, until it was purchased during the early 1900s by the Norwegian collector Olaf Schou, who donated the painting to Kristiania's National Gallery in 1910. Whether or not Munch also exhibited the version of the painting in the collection of the Munch Museum (stolen from there on August 22, 2004, and, as I write this, sadly still missing) prior to 1910 is not clear and remains a matter of debate among Munch scholars, as does the date of the painting itself. See the extended and often acrimonious exchange among Arne Eggum, Pål Hougen, Frank Høifødt, Marit Lange, and Paul Nome in *Aftenposten* (December 2000–April 2001); all but Eggum posit a date after 1893 for the Munch Museum painting.

3. For a discussion of attacks on Munch during the 1890s that questioned his sanity and accused him of both physical and mental illness as well as "degeneracy," see Patricia G. Berman, "Edvard Munch's *Self-Portrait with Cigarette*: Smoking and the Bohemian Persona," *Art Bulletin* 75 (no. 4, December 1993): 627–646.

4. Compare Munch's often-cited remark: "Sickness, insanity, and death were the dark angels that stood watch at my cradle and since then have followed me throughout my life." The comment was first published by the anatomy professor who befriended Munch late in the artist's life, Karl E. Schreiner, "Minner fra Ekely," in *Edvard Munch som vi kjennte ham: Vennene*

forteller (Oslo: Dreyer, 1946): 17.

5. Munch manuscript T2760, Munch Museum; cited and trans. by Heller, *Scream*: 65 and 107. (Passages in brackets were crossed out by Munch as he revised the text.)

6. In Heller, *Scream*, I incorrectly identify the text as a diary entry, following the common practice in Munch studies of identifying many of his writings as diaries. Recently, they have also been identified somewhat ambiguously as his "literary diaries," a term also used by Munch at times (e.g., by Marit Lande, *På sporet av Edvard Munch—mannen bak mytene,* [Oslo: Messel Forlag, 1996]). Although he did impose titles such as "Diary of a Madman" on some of his manuscripts during the 1920s and 1930s, Munch referred to them most frequently as *optegnelser* (jottings, written records or recollections) and, indeed, did not keep a diary or journal, properly understood as written records of a day's events or concerns, except during his teen-aged years.

7. The similarity of the geographical setting between Kristiania on its fjord and Nice on its Mediterranean bay may have played a role, at least subconsciously, in Munch's revival of the *Scream* experience while he wintered in southern France; cf. Lande, *På sporet av Edvard Munch*: 109.

8. For more extensive discussions of Munch's relationship to Symbolist and "decadent" poets in the early 1890s, see Reinhold Heller, "Edvard Munch's *Night*, the Content of Autobiography, and the Aesthetics of Decadence," *Arts Magazine* 53, (October 1978): 80–105. I have not had access to Hans Martin Frydenberg Flaaten's unpublished treatise, "Edvard Munchs 'Skrik': En studie av maleriets kunstteoretiske og litterære bakgrunn i perioden 1891–92," University of Oslo, 2004.

9. The identity of Munch's "Mrs. Heiberg" was established by Trygve Nergaard, "Refleksjon og visjon: Naturalismens dilemma i Edvard Munchs kunst, 1889–1894," unpublished M. A. thesis, University of Oslo, 1968: 77 and n. 163. Also see Lande, *På sporet av Edvard Munch*: 66–77.

10. Munch manuscript T2770 (EM II), Munch Museum; the text is not dated, but follows immediately upon one dated February 4, 1890.

11. Munch manuscript T2761 (EM I), Munch Museum; cited and trans. in Reinhold Heller, *Munch: His Life and Work* (Chicago: University of Chicago, 1984): 40.

12. The most extensive and informative study of the Kristiania Bohème is Halvor Fosli, *Kristianiabohemen: Byen, miljøet, menneska* (Oslo, 1994). Munch's relationship to the Bohème and Jæger is discussed extensively in most studies of his biography and work of the 1880s and 1890s. See, particularly, "Hans Jæger og Edvard Munch," *Nordisk tidskrift* (no. 2, 1976): 89–115; (no. 3, 1976): 188–215; and Heller, *Munch: Life and Work*: 32–44.

13. See Reinhold Heller, "Love as a Series of Paintings and a Matter of Life and Death," in *Munch: Symbols and Images*: 97.

14. The *Frieze of Life* was a mutable concept for Munch, subject to repeated shifts, in terms of images included in it. I would argue, moreover, that perpetual change, offering no conclusion and remaining forever in the process of formation, may be a fundamental aspect of Munch's concept of the *Frieze* itself, reflecting the mutating process of life itself. The literature on the *Frieze* is extensive, but see, particularly, my, "Edvard Munch's Life Frieze: Its Beginnings and Origins," Unpublished Ph. D. dissertation, Indiana University, 1969; idem, "Love as a Series of Paintings and a Matter of Life and Death: 87–11; idem, "Form and Formation of Edvard Munch's Frieze of Life" in Mara-Helen Wood, ed., *Edvard Munch: The Frieze of Life* (London: National Gallery, 1992): 25–37; Arne Eggum, *Edvard Munch: The Frieze of Life from Painting to Graphic Art* (Oslo: J. M. Stenersens Forlag, 2000); and Gunnar Sorenson, et al.; *Edvard Munchs Livsfrise: En rekonstruksjon av utstillingen hos Blomqvist 1918* (Oslo: Munch Museum and Labyrinth Press, 2002).

15. The text, with Munch's editorial changes, is translated in Heller, *Scream*: 107.

16. For discussions of these vignettes, see, most notably, Trygve Nergaard, "Despair," in *Munch: Symbols and Images*: 113–141; also Heller, *Munch: Life and Work*: 86–89. Also, see above, n. 2.

17. Christian Skredsvig, *Dager og nætter blandt kunstnere* (Oslo, 1943): 152, 3rd ed.; cited and trans. in Heller, *Scream*: 66. Skredsvig's recollections were first collected in book form in 1909.

18. Compare Hans Jæger's rejection of Christian Krohg's novel *Albertine* on the basis that Krohg had not personally experienced the life of a prostitute rendered in it, while

pointing to the painting *Struggling for Existence*—a view of a group of women and children in a snowy Norwegian street as they struggle with each other to reach up for loaves of bread being doled out to them from a window—as exemplary because, "You stood there, overwhelmed by the sight, and said to yourself that you had to present *that* picture to the public, because just as *you* were overwhelmed by the sight, so the public should be overwhelmed by it": Hans Jæger, "Vor literatur. Albertine og naturalismen," *Impressionisten* 4 (April 1887): n.p.; cited and trans. by Heller, *Munch: Life and Work*: 41.

19. For some of these traditional readings of sunsets, see Heller, *Scream*: 91–92.

20. Munch manuscript, Munch Museum; cited in Pål Hougen, ed., *Edvard Munch: Tegninger, skisser og studier.* (Oslo: Oslo Kommunes Kunstsamlinger, 1973): 5.

21. Munch's relationship to French art receives extended investigation in the exhibition catalogue *Munch et la France* (Paris: Musée d'Orsay, 1991).

22. See Munch's insistence in 1891 that, "The detail painters call it . . . honest to depict this or that chair or this or that table with photographic accuracy. . . . They call it dishonest to try to represent an emotional mood": Munch manuscript T2761, Munch Museum; in Hougen, *Munch: Tegninger*: 10.

23. Munch manuscript N59, Munch Museum; in Ibid.

24. For an account of this time and Munch's artistic development during it, see Heller, *Munch: Life and Work*: 93–113.

25. The most extensive discussion of Munch and the *Zum Schwarzen Ferkel* milieu remains Carla Lathe, "The Group *Zum Schwarzen Ferkel*: A Study in Early Modernism," unpublished thesis, University of East Anglia, Norwich, 1972. See also the exhibition catalogue *Munch und Deutschland* (Stuttgart: Verlag Gerd Hatje, 1994).

26. Recent much-publicized efforts to link Munch's painting to the eruption of Mount Krakatoa in Indonesia on August 26–27, 1883, which spread volcanic dust into the atmosphere that caused exceedingly dramatic sunsets to be recorded from New York to London to Oslo, are problematic, among other reasons because the documentation from Munch's writings is either unreliable or incorrectly used, and contradicting evidence is ignored. See Donald W. Olson, Russell Doescher, and Marilyn Olson, "When the Sky Ran Red," *Sky & Telescope* (February 2004).

27. For consideration of some parallel images, see Heller, *Scream*: 81–85. Similarly, figures screaming in pain, most usually physical pain, can be found repeatedly in the history of art extending back at least to Ancient Greece, and nineteenth-century writing—from poetry, dramas, and novels to sociological and psychological studies—abounds in references to the scream of, in, or through nature, but in neither the visual nor the written form do these take on the particular sense of all-transforming, all-pervasive anxiety found in Munch's imagery.

28. See Franz Servaes, in Stanislaw Przybyszewski, ed., *Das Werk des Edvard Munch* (Berlin: S. Fischer Verlag, 1894): 40.

29. August Strindberg includes Ernst Josephson, under the pseudonym "Syrach," in his novel *The Gothic Room* (1904). He knew the artist from the 1880s and apparently visited him shortly before leaving Sweden for Germany in 1892. Another of the *Zum Schwarzen Ferkel* regulars, Gustav Pauli, organized the first retrospective of Josephson's work in Stockholm in 1892–93. Cf. Göran Söderström, *Strindberg och bildkonsten* (Borås: Forum, 1990): 187–189; 2nd printing.

30. For an incomplete but indicative survey of aspects of this popular literature, see John M. MacGregor, *The Discovery of the Art of the Insane* (Princeton: Princeton University Press, 1989): 91–160. Also compare Sander L. Gilman, *Difference and Pathology: Stereotypes of Sexuality, Race, and Madness* (Ithaca, N.Y.: Cornell University Press, 1985): ch. 10, "The Mad as Artist": 217ff.

31. Compare the intriguing example of Clement Greenberg's question and plea: "How does [Munch's] illustration manage to carry so strongly and convey so intensely? I wish some non-'formalist' critic would enlighten me here, if only a little bit. I am eager to learn"; "Complaints of an Art Critic," *Artforum* (October 1967); repr. in Clement Greenberg, *The Collected Essays and Criticism, Vol. 4: Modernism with a Vengeance, 1957–1969*, ed. John O'Brian (Chicago: University of Chicago Press, 1993): 272

32. Elizabeth Prelinger, *After the Scream: The Late Paintings of Edvard Munch* (Atlanta: High Museum of Art; New Haven: Yale University Press, 2002).

33. Munch did sell two paintings of *The Scream*, and, thus, they left his control and were displayed, as well as sent to exhibitions from time to time, as isolated images by their owners. Munch displayed his own version of *The Scream* in his studios consistently in varying arrangements of his *Frieze of Life* series.

34. The text Munch added to the pastel commissioned by Arthur von Franquet in 1895 is unique among Munch's paintings. As no others display such a plaque, it is likely that Franquet requested it.

35. The lithograph impression in the collections of the Staatsgalerie Stuttgart, formerly in Arthur von Franquet's collection, also displays, on its verso, two versions of the prose poem in Norwegian with German translations. Cf. Heller, *Scream*: 104–105 and 107–108.

36. Cited and trans. in Heller, *Scream*: 105 and 108.

37. Compare Munch's recollection that it was the experience of seeing his paintings together in exhibitions that caused him to recognize their pictorial interrelationships: "When they were brought together, suddenly a single musical note went through them and they became completely different from what they had been. A symphony resulted . . . It was in this manner that I began to paint friezes." (Munch manuscript N45, Munch Museum; cited in Heller, "Love as a Series of Paintings," 90.

38. The success of Munch's tactic is indicated in that frequently scholars and critics treat *The Scream* as a self-portrait. The print of *The Scream* was included in the recent exhibition of his self-portraits organized by Iris Müller-Westermann, for example: see *Munch by Himself* (Stockholm: Moderna Museet, 2005): 43 and 200.

39. Munch manuscript T2787, Munch Museum, entry dated February 15, 1929; cited and trans. in Heller, *Munch: Life and Work*: 174.

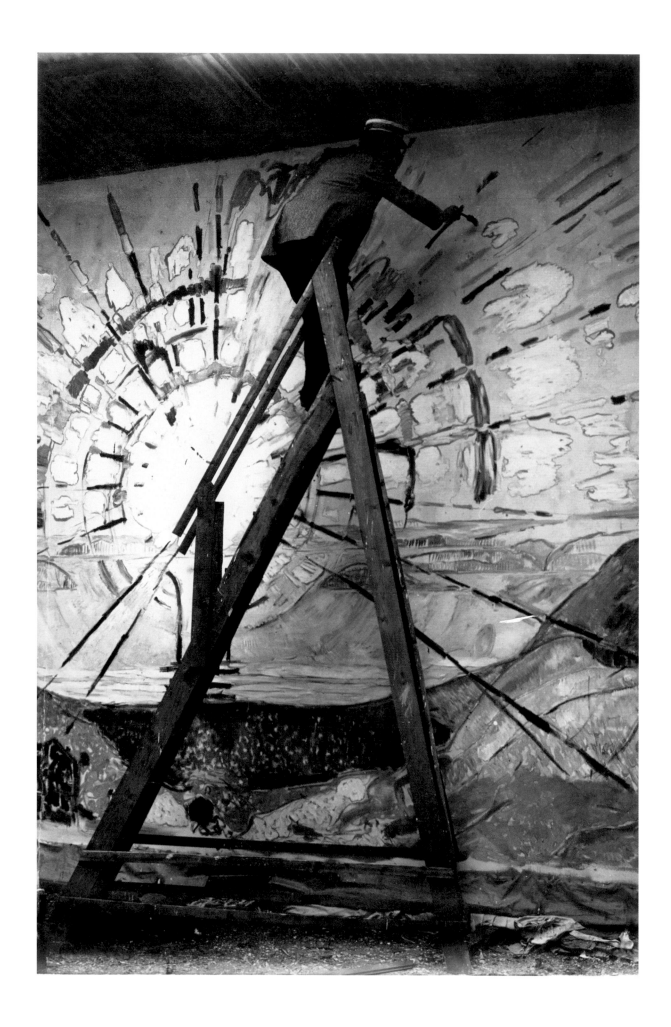

Edvard Munch's "Modern Life of the Soul"

Patricia G. Berman

Edvard Munch is the first to undertake the representation of the soul's finest and most intense processes, precisely as they appear spontaneously, totally independent of every mental activity, in the pure consciousness of individuality. His paintings are virtually chemical preparations of the soul created during the moment when all reason has become silent, when every conceptual process has ceased to operate; preparations of the animalistic, reason-less soul as it winds and curls upward in wildest storms, and shrinks in dusk-filled states of retreat, and screams in wild cramps of pain, and howls for hunger.

—Stanislaw Przybyszewski, 1894[1]

In the 1880s, under the influence of the anarchist writer Hans Jæger and his bohemian coterie in Kristiania (now Oslo), Edvard Munch rebelled against his father's pietistic Lutheranism. Munch's diaries contain references to his disaffection from his father in that period,[2] and to his memories of his father's religious fervor, of "fear of eternal damnation in the fires of Hell, as impressed upon us as children."[3] Consequently, we have come to understand Munch's bohemian identity—urban, rebellious, alienated, and even criminal—as antithetical to a spiritual orientation. Munch suggested as much in a diary entry associated with his 1898–99 drawing *The Empty Cross* (figure 1): "The Bohemian period ushered in Free Love—God—and everything is overturned, everything races in a wild and witty dance of life—A blood red sun shines in the heavens—The Cross was empty."[4]

The Empty Cross, which exists in several variations, represents a monk surrounded by scenes of sexual commerce. In the background stands a cross under which figures pray fervently, and, to the right, in a reference to the Last Judgment, people founder in an angry sea.[5] In another text, the artist provides a further exegesis of this motif: "The sun shines purple over the world as through a sooted Glass—The Cross on the hill in the Background is empty—And weeping Women pray towards the empty Cross—Lovers—The Whore—The Drunkard—and below the Criminal—And to the right—a cliff towards the Sea—People

Edvard Munch painting *The Sun* in Kragerø, 1911.

Figure 1. Edvard Munch. *The Empty Cross*. c. 1898–99. India ink and watercolor on paper. Munch Museum, Oslo

totter down towards the Cliff—And cling to the Edge, Terrified—There is a Monk amidst the Chaos—bewildered. And with a Child's Terrified Eyes—he asks Why? Whereto?—It was me now—Love and Vice raved in the Town—The Horror of Death lurked—And the Cross was empty."[6]

On first consideration, this image, and its accompanying testimony by the artist, might suggest a Nietzschean void, the eclipse of God by an unbridled modernity. However, debate about religion and its role in contemporary culture were at the center of Munch's bohemian circles both in Kristiania in the 1880s and in Berlin in the 1890s. When, in the 1890s, Munch initiated the sequencing of his paintings into the mutable narrative that he later identified as the *Frieze of Life*, he defined his project as the assertion of "moods, impressions of the life of the soul, and together they represent one aspect of the battle between man and woman, that is called love."[7] At the 1902 Berlin Secession, the *Frieze of Life* included twenty-two paintings, among them *Madonna* (1894–95; plate 60), *Metabolism* (1899; plate 96), and *Golgotha* (1900; plate 98), images that bring together references to Christian tradition with emblems of modernity.[8] Munch later recalled the series as constituting "the *modern* life of the soul."[9]

This phrase provides access to subtle but significant meanings in Munch's most revolutionary works. In pairing *modern* and *soul*, Munch asserted that the soul has temporality and that it is a dynamic phenomenon, subject to the instabilities of modernity. Throughout the literature of the Symbolist period, the notion of the *soul* was deployed to poeticize artistic hermeticism and idealism, and as a means of symbolizing a transcendent imagination.[10] Joseph August Lux's *Kultur der Seele* (1916), for example, inventoried the topicality of the soul in that period; on its cover is the image of a conventionalized winged airborne spirit. The motifs constituting Munch's *Frieze of Life*, representing his "modern" soul, could not be more different. Earthbound, loosely rendered, exaggerated in

line and color, overtly sexual and psychological, Munch's works were resolutely experimental in character. In the words of his colleague, the Polish writer Stanislaw Przybyszewski, Munch was the first "who did not want to project a psychical, naked process through mythology, i.e., through sensual metaphors, but directly in his color equivalents. . . . Munch is the naturalist of the phenomena of the soul par excellence."[11] Variously representing chemical, physiological, sexual, and pathological identities, the modern soul was a place of resistance and site of regeneration for vanguard intellectuals at the fin de siècle. Spirituality and social aberrancy were not considered antithetical within this culture, nor within Munch's work. They were mutually informed ideals, constituting what Przybyszewski termed the "naked soul."[12] Thus, Munch's "modern life of the soul" defines a complex philosophical system whose inherent contradictions shaped his bohemian identity. The artist may have rejected pietism, but, in doing so, he helped to shape the terms of fin-de-siècle vanguard spiritual culture.

In the 1880s, Munch circulated within a group of artists and writers in Kristiania known as the Kristiania Bohème. The writer Hans Jæger and the painter and critic Christian Krohg were among its guiding spirits.[13] Munch chronicled this community in several works, among them *Tête-à-Tête* (1885; plate 10) and *Kristiania-Boheme II* (1895; plate 13), which locate this subculture in its habitual café environment. From within this circle, Krohg and Jæger founded a journal called *The Impressionist*, an underground forum for leftist politics, international literature, and the arts, published irregularly between 1886 and 1890.[14]

In 1890, the writers Gerhard Gran and Jørgen Brunchorst expanded this effort when they founded the journal *Samtiden* (The Contemporary Age), Norway's first official journal of literature, culture, and politics. Cosmopolitan in its selection of authors and issues, *Samtiden* was, as Reinhold Heller notes, a "Nordic equivalent to the newly revived *Mercure de France*," the chief organ in Paris for Symbolist theory and literature.[15] The problem of religion and spiritualism in modern urban culture appeared as one of the predominant themes in *Samtiden* in the 1890s.[16] Its first issue carried a highly influential article titled "Fra det ubevidste Sjæleliv" (From the Unconscious Life of the Soul) by Knut Hamsun, who had recently completed his novel *Hunger* (1890), a book startling in its psychological disclosure, its stream-of-consciousness style, and in its description of the urban environment as predatory and ruinous. In this article and in lectures that followed its publication, Hamsun called for literature that would expand the known territory of consciousness by challenging authors to narrate intimate images of modernity. Eliding the notion of *soul* with the unconscious mind, Hamsun proposed the profundity of the modern experience as a form of psychological aberrancy:[17]

For today's restless, curious, and receptive people fewer and fewer of nature's many secrets remain hidden. More and more people, sensitive people leading profound lives, often find them-

selves in the most unusual spiritual state, rapture. It is an utterly inexplicable, mute and strange kind of rapture, one in which they appear to be addressed from afar, from the sky, or the sea. Enveloping its victims, it seems to appear out of nowhere. At the same time, it produces an excruciatingly well-developed sense of hearing, permitting a vaguely perceived awareness of sounds. It also leads to an almost unreal ability to gaze into, and unlock, the mysteries of heretofore dark and forbidden worlds. Finally, while in this rapture, they also experience an acute sense of danger. Yet most of us are unable to fathom the meaning of these spiritual events.[18]

The terms of this hypersensitivity, the literary equivalent to and interpretation of the unconscious, had, in turn, been shaped by the emerging literatures of experimental and depth psychology in the 1880s.

As such, the "modern" soul became a catchphrase in Scandinavia for the "breakthrough generation," the writers of the 1880s and 1890s who rejected naturalist description and embraced interior subjective experience as the foundation of literary investigation.[19] Indeed, an 1894 issue of *Samtiden* included the article "The Modern Soul," by Raphael Chandos, in which the phrase was applied to the authenticity and individuality of the new generation of writers and intellectuals.[20] "A great moral revolution," he wrote, affected by the rise of "mystical currents unknown to our fathers," liberated the emerging generation from institutional authority.[21] To Chandos, "Whereas previous generations [dominated by the Church] . . . lived in naiveté . . . Our actions stand in unison with our words, and our words with our innermost thinking."[22]

"Truth," as conveyed by individuals, and not mediated by any institution, was also a central tenet of Munch's intellectual circle in Berlin in the 1890s. When both Hamsun and Munch independently moved to Berlin in the mid-1890s, they joined the bohemian circle of writers, artists, and medical researchers who convened at Türke's Wine Bar, known as *Zum Schwarzen Ferkel* (The Black Piglet). There they found colleagues who celebrated intellectual freedom, foremost among them Przybyszewski and the Swedish playwright August Strindberg. Much like Munch's circle in Kristiania, the group *Zum Schwarzen Ferkel* embodied what the literary critic Georg Brandes (a sometimes habitué of the café) termed "aristocratic radicalism,"[23] the notion of a select group of inspired intellectuals who were capable of changing social and aesthetic standards by virtue of their distance from society.

As a means of distancing himself from "normal" culture, Munch often asserted that illness and anxiety were central to his work. Through such statements as the canonical, "Without anxiety and illness, I would have been like a ship without a rudder,"[24] liberally dispersed to critics and biographers, Munch asserted that mental and physical disintegration were the creative starting points for his investigations.[25] Such a cultivated posture of alterity was shared by Munch's colleagues in Berlin. One of their areas of collective investigation was modern spiritualism outside the boundaries of conventional Western religions. To that end, Strindberg, Przybyszewski, and others engaged in the study of

mystical texts, new pseudoreligions, and mysticism in this period, in an attempt to reanimate Christian beliefs through their vanguard ideas and experiences.[26] When Przybyszewski wrote about the complexity of modern spiritualism, he acknowledged the conjunctions of "Faith in the divinity of Christ and in the blasphemies of Strauss and Renan. Faith in the immaculate conception of the Virgin Mary and in the most primary facts of embryology."[27] Friedrich Strauss and Ernst Renan were among the most influential positivist writers who applied modern empiricism to the study of sacred Christian stories, seeking historical "fact" in place of sacred "metaphysics."[28] In a world increasingly shaped by Charles Darwin, Karl Marx, and empirical sciences, by the rise of nation-states, and, most pointedly, by the urban experience, the Church was seen by many critics as irrelevant. Moreover, institutionalized religions were assailed for their participation in social oppression as well as their lack of responsiveness to the new material sciences.[29]

Przybyszewski's definition of modern belief as an unstable conjunction of "blasphemy" and "divinity" was likewise articulated in Munch's images in the *Frieze of Life*. The most theatrical example is *Madonna* (1894–95; plate 60) (alternately titled *Loving Woman*), which represents a naked woman, broad of shoulder and narrow of hip, eyes closed and bent arms thrown up and back to push the chest area toward the viewer. Lit from above, her facial contours are exaggerated by shadow, suggesting the skull under her flesh. The crimson halo that frames her head collides with the image of her undulating body. This coalescence of sacred and sexual themes echoes Munch's objectives for his work of this period, to examine procreative sexuality in its sacral dimensions, as the bond "linking thousands of generations who are dead and the thousands of generations to come."[30] The painting was, moreover, apparently displayed in a wood frame that included the representation of a fetus and a decorative band of spermatozoa. While the frame is lost, Munch repeated the effect of this unified ensemble in graphic versions of the motif beginning in 1895 (plate 59). By representing the woman as though she were viewed from the perspective of her lover,[31] Munch defined the sexual act as biological and cosmic.[32] In 1896 the Norwegian poet Sigbjørn Obstfelder attached this sacral identity to *Madonna* in an important article published in *Samtiden*: "The desire to concentrate on this human quality, to understand in a new way that which our daily life has—relegated to a minor position, and to show it in its original enigmatic mystery—this attains its greatest heights here in Munch's art and becomes religious. Munch sees woman as she who carries the greatest marvel of the world in her womb. He returns to this concept over and over again. He seeks to depict that moment when she first becomes conscious of this in all its gruesomeness."[33]

Obstfelder, one of Munch's closest intellectual and artistic associates in the 1890s,[34] was also a critical interpreter of the soul in relation to modernity. In *A Priest's Diary*, written in fragments throughout the 1890s but published only

posthumously, he wrote: "There is something weak, something sickly and ingratiating in Christianity that repels me and which I feel cannot be the truth. . . . I feel that Christianity has removed God from the earth."[35] In an attempt to liberate spiritual belief from organized religion, he asserted a biological theology in an impassioned voice drawn from the writings of Friedrich Nietzsche, one that also inflected Munch's work throughout his life:

Through the microscope, under X-rays, everywhere I see a plexus, a design. The lowest organisms are themselves the design, infusoria, plants. With keener vision one would see—across the world, throughout the earth, within all nature, behind the veil of fleshy tissue—a splendid design of curving, sweeping lines, with the interstices filled with colour. . . . Do you see it?. . . Do you see the temple reaching out over all space, the tabernacle of the universe?. . . Just look at those long straight threads linking member to member, those most visible to the human eye . . . when they embrace and couple, seize hold of each other, cross each other, fusing two into one or from two forming thousands. . . . Vibrating, seething, surging, bubbling, fermenting. Wanting the new, in a frenzy to create new worlds, new realms of beauty, new galaxies, and every minute there are new harmonies of lines, every second, every thousandth of a second, or every millennium until perhaps they stop and pause among the new cosmic images which emerged from that dance of life, the new tabernacles that tremble with life's astonishment, the astonishment of being. . . . Everything out there is within me. My soul, my body emerged from the volcanic eruption of the worlds."[36]

Obstfelder's imagery repeats the formulation of a system of belief broadly known as monism, which began as a series of attempts by positivist biologists and philosophers to reconcile Christian theology with modern empirical science. The best known of these investigators was Ernst Haeckel, at the University of Jena. He first received recognition for his experiments in comparative zoology in the 1860s. By the mid-1890s, however, in *Monism: As Connecting Religion and Science* (1894) and other studies, he proposed that positivist science revealed, rather than disproved, religious mystery. His ideas were compelling to many scientists and philosophers because they seemed to offer a rationalist concept of a unified "spirited" universe.[37] A number of Munch's closest colleagues in Berlin, including Strindberg and Przybyszewski, were attracted to Haeckel's research.[38] Haeckel's sweeping description of a vast and mysterious web of interconnected energies and morphologies had particular resonance in Northern Europe where Neo-Lutheran clergy had advanced the "infallible certainty" of the cycle of nature as the basis of mystery.[39] In Norway, such resonance with advanced scientific thinking provided among young intellectuals a kind of resistance to the deeply conservative pietistic movement that had arisen there after 1848.[40] Haeckel's science thus offered traditionalists, empiricists, and mystics a means of reconciliation.[41]

Munch's work of the 1890s and thereafter echoes Obstfelder's—and Haeckel's—notion of a plexus, nature as the manifestation of unified organic and metaphysical cycles of life and death. His diaries ceaselessly repeat notions

Figure 2. Edvard Munch. *Metabolism/Life and Death.* 1897. Lithograph. Munch Museum, Oslo

Figure 3. Jan Toorop. *Linienspiel*. 1893. Gemeentemuseum Den Haag

of "crystallization," "vibrations," and cyclical renewal,[42] as do works such as *Metabolism/Life and Death* (1897; figure 2), in which the decaying body of a woman nourishes animal and vegetal growth, including a tree that shelters a living and obviously fecund woman.[43] These notions also in part shaped the monumental image of the *The Sun* (plate 115; page 34), whose radiating energies vitalize the figures that populate Munch's murals at the University of Oslo (then the Royal Frederiks University) Festival Hall (1909–16; plates 117–127). Here Munch merged biological theism with a nationalist rhetoric about the formative soil of the nation to shape the most important public art project of his career.[44]

Cyclical decay and renewal, implicated in the generative body, is also emblemized in *Metabolism* (1899; plate 96), a painting which drew particular critical attention. In 1918, he claimed that this motif was a crucial link in the *Frieze of Life*, as "vital as a buckle is for a belt."[45] *Metabolism*, the largest painting that Munch incorporated into his *Frieze of Life*, depicts the nude figures of a man and a woman, recognizably Adam and Eve, separated by a tree trunk and isolated in a dense forest through which fragments of blue water and sky may be glimpsed. As it appears today, the central tree emerges from a system of roots and skulls carved into the decorative frame that houses the painting.[46] In 1903, however, when exhibited in Leipzig (page 231), the painting included the representation of a large plant rising from the carved roots and supporting a human fetus, repeating Symbolist representations of biological mysticism. In form, this configuration echoed elaborate Art Nouveau decorative ensembles, such as the Dutch painter Jan Toorop's *Linienspiel* (1893; figure 3), which integrated the frame both functionally and thematically into the work by continuing a motif across the boundaries of the canvas.[47] Its theme of cyclical decay and rebirth, the

biological transformation of matter, mediated between traditional Christian and post-Darwinian systems of belief. When Munch competed for the commission to paint the Festival Hall murals, he stated that *Metabolism* was a starting point.[48]

Such freethinking by Obstfelder, Przybyszewski, Haeckel, and Munch was the product of their urban experience. At the time of Munch's birth in 1863, fifteen percent of Norwegians lived in large towns and cities, and by 1891, nearly one out of five Norwegians lived in cities.[49] As Sharon Hirsh has noted, Kristiania grew precipitously in the later decades of the nineteenth century, owing both to the opportunities offered by a new industrial infrastructure and the annexation of several contiguous suburbs.[50] As opposed to the historical growth of cities until the mid-nineteenth century, which developed by accretion, forming neighborhoods and districts, the engineering of long, wide boulevards systematized and homogenized the urban landscape in cities throughout Europe. Munch had represented this phenomenon in his vertiginous Neo-Impressionist–derived *Rue Lafayette* (1891; plate 21) and a year later in *Evening on Karl Johan Street* (1892; plate 79).

Such radical shifts in demographics, living conditions, and the distribution of wealth stimulated the emergence of the field of urban sociology, and the city itself became a site of "dissection."[51] In light of such prodigious growth, social scientists of the period concluded that "the growth of large cities constitutes perhaps the greatest of all the problems of modern civilization."[52] In the writings of influential social scientists, such as Ferdinand Tönnies, who established the normative categories of *Gemeinschaft* and *Gesellschaft* (community and society) in his eponymous study of 1887, the detrimental effects of the city, in which morality breaks down, were interpreted.[53] For the sociologist Emile Durkheim, the city was a site of disorganization, of "anomie." Durkheim noted the replacement of traditional notions of religion with new modes of expression and perception, in which "individual souls give rise to a being, a psychic being, if you will, but one that constitutes an individuality of a new genre."[54] In his 1903 essay, "The Metropolis and Mental Life," Georg Simmel made the claim that urban living necessitated accommodations in the individual that included the secularization of and sensitivity to all aspects of knowledge: "The psychological basis of the metropolitan type of individuality consists in the *intensification of nervous stimulation* which results from the swift and uninterrupted change of outer and inner stimuli. . . . Metropolitan life, thus underlies a heightened awareness and a predominance of intelligence in metropolitan man. . . . It is the function of the Metropolis to provide the area for this struggle and its reconciliation."[55] This cosmopolitanism, this sense of stimulation to which the intellect must accommodate, produced, in the words of Chicago sociologist Louis Wirth, "a breeding ground of biological and cultural hybrids."[56]

Munch's images of the city capitalize on this emerging "crisis of the city," most directly in *Evening on Karl Johan Street* (plate 79). Likewise, the ex-

Figure 4. Edvard Munch. *Metabolism*. c. 1898. Watercolor, charcoal, and gouache on paper. Munch Museum, Oslo

traordinary strangeness of *The Scream* (1893; plate 84) is enhanced by the topographic specificity of the Kristiania harbor, with its merchant ships and the cityscape, seen in miniature, located at the center of the composition. The painting's deepest expressions of dread and dissolution, and its radically skewed perspective and heightened color and touch are punctuated by the material reminder of the everyday. Likewise, the enigmatic image of the "golden city" carved into the frame of *Metabolism*—a recognizable view of Kristiania— raises the specter of the metropolis. In a sketch of the motif from c. 1898 (figure 4), Munch had incorporated the city as the predominant background element, encoding Adam and Eve with urban "anomic."

The city itself was a significant theme in Munch's work. The turbulent, polycultural, crowded, constantly changing city of Berlin in particular, which had experienced almost unparalleled growth between Germany's unification in 1871 and the turn of the century, provided a leitmotif. Berlin was assailed by social scientists and architectural preservationists of the period as an unstable morphology, a monstrosity of materialism and eclecticism. Munch's colleague Walter Rathenau wrote: "The sites of soullessness are terrifying. The wanderer who approaches the metropolis in the twilight from the depths of the country experiences a descent into open tracts of misfortune. . . . This is the nighttime image of those cities that are praised and applauded as places of happiness, of longing, of intoxication, of the intellect, that depopulate the countryside, that kindle the desire of those excluded to the point of criminality."[57]

Munch's images of Berlin anchor this notion of the city as both consuming and aberrant, and also as an elevated intellectual and emotional experience. The creation and reception of Munch's self-portraits, such as *Self-Portrait with Cigarette* (1895; plate 37), and those of his literary colleagues, among them *Dagny Juel Przybyszewska* (1893; plate 30), *Portrait of Julius Meier-Graefe* (c. 1895; plate 29), *The Author August Strindberg* (1892; plate 28), and especially *Stanislaw Przybyszewski (with Skeleton Arm)* (1893–94; plate 31), are indebted to this social formation. In their confrontational gazes, theatrical isolation, and extravagant lack of affect, these figures were seen as decadent avatars of the fin de siècle.[58] The Parisian literary movement known as the "decadence" advocated a rejection of scientific positivism in art and literature in favor of the cultivation of subjective experience. Further, it maintained a rhetoric of moral deformity and illness as sources of artistic redemption.[59] This formulation was repeated throughout the literature of the 1890s, and it anchored the Norwegian writer Erik Lie's designation of the fin de siècle itself as "the newest and most bizarre tendencies in literature and art . . . the century's disease," at a juncture, "when

genius and madness are so closely allied."[60] As articulated by Stanislaw Przyb-yszewski: "That which is normal is stupidity, and 'degeneration' is genius."[61]

Munch's *Golgotha* (1900; plate 98) is one particularly poignant site where the artist exercised such rhetoric. *Golgotha* represents the scene of crucifixion set against an explosively rendered apocalyptic sky. Below the vulnerable central figure, which has been identified as a self-portrait,[62] surges a crowd of gro-tesques, which include caricatures of figures from Munch's life.[63] In the early 1890s, Munch had sketched a scene of crucifixion (figure 5) in which the protag-onist was an elderly bearded man whom Frank Høifødt identifies as the artist's father.[64] In the painting, the caricatured face appears in the crowd. Across the sky runs a serpentine streak of red, reminiscent of Munch's 1893–94 works *The Scream* and *Angst* (plates 84 and 81). This formal element evokes, and conse-quently attaches, the emotional content of those motifs onto the scene of cruci-fixion.[65] In addition, Munch inscribed the painting with the date and place of its production: "Kornhaug Sanatorium 1900," a high mountain health spa in central Norway, where he sought treatment for a lung condition in 1899–1900. Such an inscription was highly unusual in Munch's work, and it articulates his desire to equate the image with his autobiography.[66] Mapping "Kornhaug" onto "Gol-gotha," the historical site of Jesus' crucifixion, Munch provided a symbolic geog-raphy for his identity as a fin-de-siècle practitioner of artistic self-confession and self-fashioning. By staging the private self, while cagily enacting the most urgent and recognizable discourses of the day, Munch made a performative can-vas. It is precisely such an image that represents the "modern life of the soul"— direct, experimental, self-confessional, depicting alienation and redemption through exalted pain.

Such modern reinterpretations of Christian sacred imagery were wide-spread among members of Europe's avant-garde in the 1880s and 1890s. In those decades, such artists as Paul Gauguin and James Ensor created allegorical self-portraits as Jesus as a way of articulating the sacral and agonistic sources of artistic independence, and Munch was likely aware of these works.[67] Ensor cre-ated a large body of biblical imagery in the 1880s, in particular in 1885–88, and most spectacularly in his monumental *Christ's Entry into Brussels in 1889* (1888; figure 6).[68] Ensor's identification with Jesus is directly expressed in *Cal-vary (Ensor on the Cross)* (1886; Collection Mr. and Mrs. Freddy Huyghe), in which the artist represented himself, naked and vulnerable, as a martyr to his critics. Like Ensor's self-image as Jesus, Munch's painting rearticulates familiar themes of bohemian and "decadent" tropes of sacrifice and isolation, helping to secure the fin-de-siècle identity of the modern artist as agonist and visionary,[69] the terms of the literary "modern life of the soul."

In the years after the turn of the century, Munch repeatedly mapped such complex meditations in diagrams that bear close relationships to his earlier works and to mystical texts. One appears to be a pseudoscientific rendering of

Figure 5. Edvard Munch. Untitled sketch (detail). c. 1890s. Munch Museum, Oslo

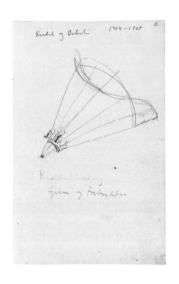

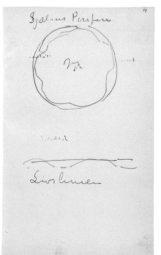

waves fanning out as if from a prism, bounded by curves measuring their angles of incline and surmounted by sigmoidal lines (figure 7). In place of the color spectrum, however, Munch identified the outwardly radiating zones as "kindness, love, patience, hatred, fear, and courage." Above this configuration is the ironic inscription "Credit and Debit 1908–9," and below are written the phrases "Growing Strength" and "Genius and Crime," the latter a reference to the work of Italian criminologist Cesare Lombroso.[70] In the second diagram (figure 8), the artist encased the word "I" (*jeg*) in wavering concentric circles and located it between the phrases "At the Periphery of the Soul" and "The Life Line," in a configuration reminiscent of his 1895 lithographic *Self-Portrait (with Skeleton Arm)* (plate 32). These drawings were interspersed with grotesque caricatures of his old bohemian colleagues and his former lover, Tulla Larsen.[71] In a lengthy analysis, written into the same notebook some twenty years later, Munch created a gloss on these drawings, referring to his earlier self in the third person:

Many of the notes made by my insane friend are "mad," and are interesting because they shed light upon his condition. As with Leonardo's anatomic drawings, we are discussing the anatomy of the soul, the mechanisms of the soul. When I write down these notes accompanied by drawings, it is not in order to describe my own life. It is important for me to study the various inherited phenomena that form the life and destiny of a human being, especially the most common forms of madness. I am making a study of the soul, as I can observe myself closely and use myself as an anatomical testing-ground for this soul study. The main thing is to make an art work and a soul study, so I have changed and exaggerated, and have used others for these studies. It would therefore be wrong to look upon these notes as confessions. I have chosen—in accordance with Søren Kierkegaard—to split the work into two parts—the painter, and his distraught friend, the poet. Just as Leonardo da Vinci studied the recesses of the human body and dissected cadavers, I try to dissect souls. He was forced to note his findings in mirror writing, as at that time it was forbidden to dissect human bodies. Now it seems that the dissection of phenomena pertaining to the soul is viewed similarly, as disgusting, frivolous and indecent. . . . All in all, one could say that I am a skeptic, but not a disbeliever, and I do not deride religion.[72]

This passage was prefaced by the words: "These notes, in their present form, are not suitable for the public." Munch titled the notebook "The Diary of the Mad Poet,"[73] an acknowledgement of three seemingly diaristic texts: *Notes of a Madman* by Nikolai Gogol (1835), Feodor Dostoevski's *Notes from Underground* (1864), and Guy de Maupassant's *Diary of a Madman* (1885). It is clear from this passage that Munch viewed himself as an experimental mediated subject. As both artist and poet, he established a kind of double narration that allowed him to enact his biography as performance. His work may have been grounded in the facts of his own often-troubled biography, but his project was to poeticize these circumstances, to perform them as avatars of the "modern life of the soul."

The artist created further mystical diagrams between the 1910s and 1930s and collected them into a portfolio titled "The Tree of Knowledge of Good and Evil." The portfolio included a number of his older graphic works and sketches that were interspersed with poetic texts in which traditional Christian beliefs, esoteric ideas, physiological musings, and erotic narratives intermingled. On many of the pages, the text is meticulously written in crayons whose colors change every few words or lines (figure 9). Having the artful appearance of Sonia Delaunay's kaleidoscopic calligraphy of the 1910s, the text seems to have been consciously crafted for public consumption. Munch's friend Christian Gierløff suggested as much when he reminisced, perhaps humorously, about this text as well as "The Diary of the Mad Poet": "He wanted to write *The Notes of a Madman*. Yes, and *The Tree of Knowledge*. . . . Then everyone would learn what it meant to be insane, an insane young man!"[74] Within this notebook are several drawings representing variations on the artist's earlier diagram of "the soul's periphery," among them one illustrating *Mankind and Its Three Centers of Energy* (figure 10). Meandering lines at the top of the page and jagged lines at the bottom, like those representing the surface of an angry sea, bracket three sets of interlocking concentric circles. Munch accompanied this drawing with the phrases: "Ether Vibrations. The Brain. The Heart. The Instincts. Earth Vibrations." With its similarity to well-known esoteric texts, such as *Atalanta Fugiens* (1617), the sketch translates speculations about the relationship between mind and body, which the artist had encountered in his Berlin milieu, into a specifically contemporary idiom.[75] The artist repeated the structure in a sketch loosely based on Da Vinci's *Vitruvian Man*, reprising motifs that he had used earlier in the Festival Hall. The central nude male figure stands on a summarized landscape and at the epicenter of radiating lines suggestive of *The Sun* (plate 122), and he is surrounded by figures derived from the murals *Spirits in the Flood of Light* (plate 123) and, to the right, *Men Reaching Toward the Light* (plate 124). The drawing is accompanied by the text: "Notes of a Madman—Man and the Circles of man—the periphery rises above—in ethereal vibrations—and down below, the vibrations of the earth."[76] Written by a "madman," like his diagrams from 1909, defining a philosophical system indebted to both science and mystical

Figure 9. Edvard Munch. *The Earth Struck Flames.* 1920s. Colored crayon on paper. Munch Museum, Oslo

Figure 10. Edvard Munch. *Mankind and Its Three Centers of Energy.* 1920s. Crayon on paper. Munch Museum, Oslo

religion, these texts appear as self-conscious summaries and extensions of the themes and motifs that Munch pursued throughout his career.

When Munch proclaimed that the "modern life of the soul" was central to his work, he also demonstrated that a doubled identity—the genius and the criminal, the madman and the narrator, authentic and performing selves—was essential to his project. Locating humanity between the "soul's periphery" and the dynamism of the Earth in his diagrams in the twentieth century, Munch drew upon and amplified the rhetoric of modern urban instability—Hamsun's unconscious soul—the artist who suffers and who, through his "criminality," redeems the new urban culture. "My earlier invalid's mentality had a very favorable effect on my work," Munch wrote in 1913.[77] By exploiting it, Munch was able to perform and narrate his sacralized dramas as the poet and the artist, challenging the viewers of his day to embrace the uncertainty of their historical moment.

Notes

Wellesley College generously supported research for this essay. I wish to thank Alice T. Friedman, Tina Yarborough, Sam Engelstad, Mac Gillespie, and Robert Lubar for their invaluable advice.

1. Stanislaw Przybyszewski, "Psychic Naturalism," in *Neue Deutsche Rundschau. Freie Bühne* (1894); repr. in idem, ed., *Das Werk des Edvard Munch* (Berlin: S. Fischer Verlag, 1894): 16–17; trans. in Reinhold Heller, *Munch: His Life and Work* (Chicago: University of Chicago Press, 1984): 106.

2. See Heller, *Munch: Life and Work:* 32ff.

3. Munch notebook N45; trans. in Poul Erik Tøjner, *Munch in His Own Words* (Munich: Prestel Verlag, 2001): 171. As Heller demonstrated, it was Munch's father's death in 1889 that occasioned the artist's commitment to psychological rather than naturalistic representation, as proclaimed in what has been called his "St. Cloud Manifesto." See Reinhold Heller, "Edvard Munch's *Night*, the Content of Autobiography, and the Aesthetics of Decadence," *Arts Magazine* 53, (October 1978): 80–105.

4. Munch sketchbook T2759: 14, Munch Museum; quoted in Frank Høifødt, "Det Tomme Kors. Fin-de-Siècle og Endeperspektiv paa liv og kunst," unpublished M.A. thesis, University of Bergen, 1988: 60. My translation.

5. As Heller notes, the central figure is associated with the artist himself because the word *monk* in Norwegian is *munk.* Heller, *Munch: Life and Work:* 165.

6. Munch sketchbook T2730: 10ff., trans. in Magne Bruteig, "Above Were the Heavenly Stars," in *Edvard Munch: Smertens Blomst/Blossom of Pain* (Lemvig: Museet for Religiøs Kunst, 2005): 32. A thorough analysis of this motif and its biographical and literary contexts is provided in Høifødt, "Det Tomme Kors."

7. Munch manuscript N30, Munch Museum; trans. in Reinhold Heller, "Form and Formation of Edvard Munch's Frieze of Life," in Mara-Helen Wood, ed., *Edvard Munch: The Frieze of Life* (London: National Gallery, 1992): 33.

8. The evolution of the concept of the Frieze, its changing contents and literary affiliations, and its exhibition history, are exhaustively documented in Reinhold Heller, "Edvard Munch's Life Frieze: Its Beginnings and Origins," unpublished Ph.D. dissertation, Indiana University, 1969. Heller's subsequent publications have enriched our understanding of this painting sequence and its significance for European painting.

9. Munch wrote: "I have worked on this frieze for about 30 years with lengthy interruptions. The first, loose sketches date from 1888–9. *The Kiss,* the so-called *Yellow Boat, The Street, Man and Woman,* as well as *Anxiety,* were originally painted in 1890–1 and exhibited together for the first time in 1892. . . . In the following year, the series developed with the addition of new works . . . and it was exhibited as an independent frieze in a private gallery [in Berlin]. It was exhibited in the 1902 Berlin Secession where it was refined and installed around the huge entry hall—*motifs from the modern life of the soul.*" Edvard Munch, "Livsfrisen," in *Livs-Frisen av Edvard Munch* (Kristiania: Blomqvist Kunsthandel, 1918): 1. My italics. A reconstruction of this exhibition is ventured, and extensive analyses of its motifs provided, in Gunnar Sorenson, et al.; *Edvard Munchs Livsfrise: En rekonstruksjon av utstillingen hos Blomqvist 1918* (Oslo: Munch Museum and Labyrinth Press, 2002). The 1902 Berlin Secession catalogue lists Munch's series as "Frieze: Cycle of Moments from Life." See *Katalog der Fünften Kunstausstellung der Berliner Secession* (Berlin: Paul Cassirer, 1902): 32–33.

10. On the history of pre-Freudian psychology, see Henri Ellenberger, *The Discovery of the Unconscious: The History and Evolution of Dynamic Psychiatry* (New York: Basic Books, 1970); and Eli Zaretsky, *Secrets of the Soul: A Social and Cultural History of Psychoanalysis* (New York: Alfred A. Knopf, 2004). For the implications of early psychiatry for the Symbolist movement, see Feliz Eda Burhan, "Vision and Visionaries: Nineteenth Century Psychological Theory, the Occult Sciences, and the Formulation of the Symbolist Aesthetic in France," unpublished Ph.D. dissertation, Princeton University, 1979; and Debora Silverman, *Art Nouveau in Fin-de-Siècle France: Politics, Psychology, and Style* (Berkeley: University of California Press, 1989).

11. Przybyszewski, "Psychic Naturalism": 26; trans. in Carla Lathe, "Edvard Munch and the Concept of 'Psychic Naturalism,'" *Gazette des Beaux-Arts* 121 (March 1979): 136.

12. For an in-depth discussion of this concept as it emerged in the work of Przybyszewski and shaped Polish modernism, and as it related to Munch, see Katarzyna Nowakowska-Sito, "Expression of the 'Naked Soul' and European Art at the Turn of the Century," in Piotr Paszkiewicz, ed., *Totenmesse: Modernism in the Culture of Northern and Central Europe* (Warsaw: Institute of Art/Polish Academy of Science, 1996): 27–40.

13. Munch later attributed the genesis of his most important work to his participation in the Kristiania Bohème: "When will the history of the Bohemian period be written, and who is there capable of writing it? It would take a Dostoevsky, or a blend of Krohg, Hans Jæger and myself, perhaps. Who will describe the Russian period in that Siberian town which Oslo was then and still is? For many artists it was a testing-time and a touchstone." Quoted in J. P. Hodin, *Edvard Munch* (New York: Oxford University Press, 1972): 34–35. The milieu of the Kristiania Bohème is analyzed in excellent detail by Halvor Fosli, *Kristianiabohemen: Byen, miljøet, menneska* (Oslo: Det Norske Samlaget, 1994). On the romantic idealization of bohemian cultures of the nineteenth century, see Jerrold Seigel, *Bohemian Paris: Culture, Politics, and the Boundaries of Bourgeois Life, 1830–1930* (New York: Penguin Books, 1986).

14. Hans Jæger, the left-wing writer who dominated radical Kristiania art politics in the 1880s, was a leader and chronicler of the fledgling bohemian milieu in the mid-1880s. On the basis of his books, including *Fra Kristiania Bohêmen (From Kristiania Bohemia)* (1885), which chronicled the marginalized artists who modeled their intellectual lives on the literary vanguard in Paris, and *Sick Love* (1893), which promoted the doctrine of free love (the right of both men and women to control and determine their sexuality), Jæger was viewed as one of the leading figures of oppositional youth culture in Kristiania. The first issue of *The Impressionist* appeared while Jæger was jailed on obscenity charges for *Fra Kristiania Bohêmen,* and just as Krohg published *Albertine* (1886), the sympathetic and politicized story of a rural girl's

descent into urban prostitution. Through this journal, the term *Impressionism* became a signifier of emotional and social engagement, suggesting the possibilities of social transformation within a small conservative social milieu. See Anne Siri Bryhni, *Bohem mot Borger: Et utvalg from Hans Jægers og Christian Krohgs "Impressionisten"* (Oslo: Universitetsforlaget, 1971): 7–17.

15. Heller, *Munch: Life and Work:* 70.

16. A representative sample includes: Knut Hamsun, "Fra det ubevidste Sjæleliv" (From the Unconscious Life of the Soul; 1890); T. Parr, "Religion go Religiøsities" (Religion and Religiosity; 1892); George Higginbotham, "Videnskab og religion" (Science and Religion; 1890); Frances Power Cobbe, "De to religioner" (The Two Religions; 1890); Leo Tolstoi, "Kirke og stat" (Church and State; 1891); G. Armauer Hansen, "Unitarismen" (Unitarianism; 1891); Gaston Dechamps, "Det religiøse maleri paa salongerne i 1891" (Religious Paintings in the 1891 Salons; 1891); Friedrich Naumann, "Kristelig Socialisme" (Christian Socialism; 1894); Theodor Madsen, "Sjælelivs-skildringen i vor tids litteratur" (The Representation of the Life of the Soul in Contemporary Literature; 1894); Kristian B. R. Aars, "Sjælen og legemet" (The Soul and the Body; 1895); Johan L. Alver, "Er der en Gud?" (Is There a God? 1896); Dr. George Fasting, "Religionene kaar I vore dag" (The Condition of Contemporary Religion; 1896); and, in addition, articles on Charles Darwin, Friedrich Nietzsche, Jules Michelet, Ernest Renan, and Paul Bourget. The place of religion, and the meaning of the soul, in modern arts and society was also a critical question within the Student Organization of the Royal Frederiks University (later the University of Oslo), one of the chief public sites for discussion of the new literature. See Fredrik B. Wallem, *Det Norske Studentersamfund gjennem hundrede aar, 1813–1913* (Kristiania: H. Aschehoug, 1916): 922ff.

17. Robert Ferguson, *Enigma: The Life of Knut Hamsun* (London: Hutchinson, 1987): 118.

18. Knut Hamsun, "Fra det ubevidste Sjæleliv," *Samtiden* 1 (1890): 332.

19. The term derives from the lectures and publications of the Danish literary and cultural critic Georg Brandes, especially his influential *Det moderne Gennembruds Mænd*

(The Men of the Modern Breakthrough; 1883).

20. The article originally appeared in the *Le Revue bleue* (August 18, 1894).

21. Raphael Chandos, "Moderne Sjæle," *Samtiden* 5 (1894): 347.

22. Ibid.: 348.

23. The term was first used by Georg Brandes in a foundational article analyzing the work of Friedrich Nietzsche: "Aristocratic Radicalism," *Deutsche Rundschau* (April 1890).

24. Munch to K. E. Schreiner; quoted in Ragna Thiis Stang, *Edvard Munch: The Man and His Art* (New York: Abbeville Press, 1979): 22.

25. As Heller noted, such statements must be understood as rhetorical postures as well as genuine sentiments of despair. Reinhold Heller, "Sickness as Rudder," unpublished paper presented at the College Art Association, February 17, 1994. I would like to thank Professor Heller for providing his text.

26. Jeffrey Howe, "Nocturnes: The Music of Melancholy, and the Mysteries of Love and Death," in idem, ed., *Edvard Munch: Psyche, Symbol, and Expression* (Boston: McMullen Museum of Art, Boston College, 2001): 68.

27. Stanislaw Przybyszewski, *Wybo'r Pism*, elaborated by R. Taborski (Wrocław, 1966): 70; quoted in Nowakowska-Sito, *Naked Soul:* 34.

28. See, for example, Friedrich Strauss, *The Life of Jesus Critically Examined* (1835) (New York: Calvin Blanchard, 1855); and Ernst Renan, *Life of Jesus* (1863) (Boston: Little, Brown, 1915). These biographies of Jesus attempted to retrieve a "historical" Jesus from Christian "mythology."

29. Owen Chadwick, *The Secularization of the European Mind in the Nineteenth Century* (Cambridge: Cambridge University Press, 1975): 156. See also Jennifer Michael Hecht, *The End of the Soul: Scientific Modernity, Atheism, and Anthropology in France* (New York: Columbia University Press, 2003): 2. The challenge of positivist philosophers, scientists, and social theorists established a discourse so powerful that Leo XIII, assuming the papacy in 1878, issued *Aeterni Patris*, the encyclical of the following year that called upon the Church hierarchy to reconcile science with revelation, and in 1891, *Rerum Novarum* (On Capital and Labor), suggesting a new "corporatist" relationship among Church, government, busi-

ness, and labor. See *The Great Encyclical Letters of Pope Leo XIII*, pref. John. J. Wynne (Cincinnati: S. J. Benziger, 1903): 34–57.

30. Wood, *Frieze of Life:* 74.

31. Arne Eggum, *Edvard Munch: Livsfrisen Fra Maleri til grafikk* (Oslo: J. M. Stenersens Forlag, 1990): 188.

32. For an analysis of the implications of this image, particularly in regard to attention paid to modern urban experience, see Stephen Schloesser, S. J., "From Spiritual Naturalism to Psychical Naturalism: Catholic Decadence, Lutheran Munch, *Madone Mystérique*," in Howe, *Psyche, Symbol, and Expression:* 75–110.

33. Sigbjørn Obstfelder, "Edvard Munch," *Samtiden* 7 (1896): 21, trans. in Reinhold Heller, "Love as a Series of Paintings," in *Edvard Munch: Symbols and Images* (Washington, D.C.: National Gallery of Art, 1978): 105. Heller has noted the similarity of this analysis to Munch's so-called "St. Cloud Manifesto": "A strong naked arm—a tanned powerful neck a young woman rests her head on the arching chest She closes her eyes and listens with open and quivering lips to the words he whispers into her long, flowing hair. I would like to give it form as I now saw it, but in the blue haze. These two in that moment when they are not themselves, but only one of the thousands of sexual links tying one generation to another generation. People should understand the sanctity, the grandeur of it, and would take off their hats as if in church. I would make a number of such paintings. No longer would interiors, people who read and women who knit, be painted. There would be living people who breathe and feel, suffer and love." Also trans. in Heller, *Munch: Life and Work:* 64

34. Høifødt, "Det Tomme Kors": 19ff.

35. Sigbjørn Obstfelder, *A Priest's Diary*, trans. and intro. James McFarlane (Norwich: Norvik Press, 1987): 5.

36. Ibid.: 5 and 39–41.

37. Hecht, *End of the Soul:* 183. Haeckel's 1899 *Riddle of the Universe* became one of the most widely read, serialized, and bowdlerized tracts of its day. For its implications for racialist and eugenic theory throughout Europe, see Hecht, *End of the Soul*, 183ff. See also Christoph Kockerbeck, "Naturästhetik um 1900," in *Die*

Lebensreform: Entwürfe zur Neugestaltung von Leben und Kunst um 1900 I (2001): 183–186.

38. For an analysis of Munch's work in relation to monism, see Shelley Wood Cordulack, *Edvard Munch and the Physiology of Symbolism* (Madison, N.J.: Fairleigh Dickinson University Press, 2002).

39. Nicholas Hope, *German and Scandinavian Protestantism 1700–1918* (Oxford: Clarendon Press, 1995): 441.

40. Ibid.: 515. In the Norway of Munch's youth, the Lutheran Church was reshaped by arguments about the relationship of the church to the nation. In the period preceding Norway's independence from Sweden in 1905, Lutheranism was especially politicized as it was allied to party politics (Ibid.: 585). Because the history of Lutheranism in Norway was inextricably bound to the Danish colonization of that country under the Reformation, the question of an "authentic" church was critical to the nation-building intellectuals. On the history of the Lutheran church in Norway and its relationship to the nation-state, see Thorkild Lyby and Ole Peter Grell, "The Consolidation of Lutheranism in Denmark and Norway," in idem, ed., *The Scandinavian Reformation from Evangelical Movement to Institutionalisation of Reform* (Cambridge: Cambridge University Press, 1995): 114–143.

41. Munch's interest in and knowledge of occult literature and ideas during his Berlin period is detailed in Carla Lathe, "The Group *Zum Schwarzen Ferkel*: A Study in Early Modernism, unpublished Ph.D. dissertation, University of East Anglia, 1972: esp. 108–127. On the emergence of new religions and mystical systems of belief at the turn of the century, see Ruth Brandon, *The Spiritualists: The Passion for the Occult in the Nineteenth and Twentieth Centuries* (New York: Alfred A. Knopf, 1983).

42. Tøjner, *Munch in His Own Words:* 102ff., translates a number of such references.

43. This image was originally rendered in conjunction with Munch's illustrations for an 1896 edition of Charles Baudelaire's *Les Fleurs du Mal.* See Gerd Woll, *Edvard Munch: The Complete Graphic Works* (New York: Harry N. Abrams, 2001): 125.

44. On the murals for the University at Kristiania, a project that preoccupied Munch from 1909 to 1916, see Patricia G. Berman, "Monumen-

tality and Historicism in Edvard Munch's University of Oslo Festival Hall Murals," unpublished Ph.D. dissertation, New York University, 1989; Gerd Woll, *Monumental Projects 1909–1930* (Lillehammer: Lillehammer Art Museum, 1993); and Tina Yarborough, "Exhibition Strategies and Wartime Politics in the Art and Career of Edvard Munch, 1914–1921," unpublished Ph.D. dissertation, University of Chicago, 1995.

45. Writing in 1918, Munch attached a particular importance to *Metabolism*: "I envisioned the frieze as a poem of life, love, and death. The subject of the largest painting, the man and woman in the wood, perhaps lies somewhat outside the range of ideas expressed in the other pictures, but its role in the frieze is as vital as a buckle is for a belt. It is a picture of life, as well as of death, it shows the wood feeding off the dead and the city growing up behind the trees. It is a picture of the powerful constructive forces of life." Munch, "Livsfrisens tilblivelse": 2; trans. in Stang, *Munch: Man and Art:* 116. The variations and dating of this text are analyzed in Lasse Jacobsen, "Livs-frisen og livsfrisens tilblivelse—Maleren Griper til Sverdet og pennen," in Sorenson, *Edvard Munchs Livsfrise:* 62–66. As Høifødt recently noted, the painting operated not only as a kind of nexus for the narrative of the *Frieze of Life*, but also for a range of issues, autobiographical, social, and theological. Frank Høifødt, "Edvard Munchs *Stoffveksling*—Frisens 'beltspenne,'" *Kunst og Kultur* 3 (2001): 124–146.

46. Munch repainted the composition, likely in 1918, removing the plant, reconfiguring the figures' anatomies, and intensifying some areas of color throughout the composition, transforming a Whistlerian palette into something closer to contemporary Expressionism. Høifødt proposes that Munch withdrew this important painting from his exhibitions for nearly a decade because his ex-lover Tulla Larsen was the model for Eve. Høifødt, *Stoffveksling:* 137–140.

47. See Eva Mendgen et al., *In Perfect Harmony/Bild und Rahmen 1850–1920* (Amsterdam: Van Gogh Museum; Vienna: Kunstforum Wien, 1995): 222.

48. After Munch entered the competition to paint a mural cycle for the Festival Hall, built to celebrate the Royal Frederiks University

centennial in 1911, he had singled out *Metabolism*, this time as the point of intersection between his public art and his private production: "Both the Frieze of Life and the University murals come together in the large Frieze of Life picture of man and woman in a wood with the golden city in the background." Stang, *Munch: Man and Art:* 235.

49. Adna Ferrin Weber, *The Growth of Cities in the Nineteenth Century: A Study in Statistics* (1899) (Ithaca: Cornell University Press, 1965): 111.

50. Sharon L. Hirsh, *Symbolism and Modern Urban Society* (New York and Cambridge: Cambridge University Press, 2004): ch. 3, "The Destructured City."

51. Marshall Berman has traced the multivalent implications of urban conglomeration in *All That Is Solid Melts into Air: The Experience of Modernity* (New York: Simon and Schuster, 1982).

52. J. S. Mackenzie, *Introduction to Social Philosophy* (1890): 101; quoted in Weber, *Growth of Cities:* 2.

53. Ferdinand Tönnies, *Gemeinschaft und Gesellschaft: Abhandlung des Communismus und des Socialismus als Empirischer Culturformen* (Leipzig: Fue's Verlag, 1887).

54. Emile Durkheim, *Les Règles de la method sociologique* (Paris, 1894): 127; quoted in Hecht, *End of the Soul:* 283. On early sociological writings that would have been known to Munch's generation, see Elisabeth Pfeil, *Großstadtforschung: Entwicklung und Gegenwärtiger Stand* (Hannover: Gebrüder Jänecke Verlag, 1972): 38–64 (2nd ed.).

55. Georg Simmel, "The Metropolis and Mental Life" (1903), in Richard Sennett, ed., *Classic Essays on the Culture of Cities* (New York: Appleton-Century-Crofts, 1969): 60.

56. Louis Wirth, "Urbanism as a Way of Life," in Sennett, *Classic Essays:* 150. I would like to thank Edward Ahearn for introducing me to this text.

57. Walter Rathenau, *Zur Mechanik des Geistes* (Berlin: S. Fischer Verlag, 1913): 260; trans. David Frisby, "Social Theory, the Metropolis, and Expressionism," in Timothy O. Benson, ed., *Expressionist Utopias: Paradise, Metropolis, Architectural Fantasy* (Los Angeles: Los Angeles County Museum of Art, 1994): 65.

58. See Heller, *Munch: Life and Work:* 93–94; and his "Affæren Munch, Berlin 1892–1893," *Kunst*

og Kultur 52 (1969): 175–191. Arne Eggum, *Edvard Munch: Paintings, Sketches, and Studies* (Oslo: J. M. Stenersens Forlag, 1984): 137, summarizes attacks against the artist in Kristiania.

59. Barbara Spackman, *Decadent Genealogies: The Rhetoric of Sickness from Baudelaire to D'Annunzio* (Ithaca: Cornell University Press, 1989). In that decade, the medical condition known as neurasthenia—a sapping of the life force by urbanization and over cultivation—first diagnosed in the 1870s, was absorbed into art criticism, providing a medical explanation rooted in the anxiety of the city for the overly refined nerves of the "decadents." See E. T. Carlson, "Medicine and Degeneration: Theory and Praxis," in J. E. Chamberlin and Sander L. Gilman, *Degeneration: The Dark Side of Progress* (New York, 1985): 130. See also Marijke Gijswijt-Hofstra and Roy Porter, *Cultures of Neurasthenia from Beard to the First World War* (Amsterdam and New York: Rodopi, 2001), especially Joachim Radkau, "The Neurasthenic Experience in Imperial Germany: Expeditions into Patient Records and Side-looks upon General History" (199–217); and Heinz-Peter Schmiedebach, "The Public's View of Neurasthenia in Germany: Looking for a New Rhythm of Life" (219–238).

60. Erik Lie, "Om Fin-de-Siècle digtningen," *Samtiden* (1893); repr. Oyvind Pharo, ed., *Fin de Siècle: Tidsskriftet Samtiden i 1890-Årene* (Oslo: Aschehoug, 1990): 124.

61. Stanislaw Przybyszewski, *Auf der Wegen der Seele* (Berlin, 1897); quoted in Carla Lathe, "Munch and Modernism in Berlin 1892–1903," in Wood, *Frieze of Life:* 42.

62. Reinhold Heller identifies the crucified man as "an artist, his face an amalgam of Przybyszewski and Munch himself," Heller, *Munch: Life and Work:* 173. Arne Eggum further identifies both this figure and the "pale man shown in profile in the foreground" as possessing Munch's features. Eggum, *Munch: Paintings, Sketches, and Studies:* 167. Most recently, Iris Müller-Westermann has analyzed this image as a self-reference in *Munch by Himself* (Stockholm: Moderna Museet, 2005).

63. See Iris Müller-Westermann, "Golgotha," in Wood, *Frieze of Life:* 104; and idem, *Munch by Himself:* 66–70.

64. Høifødt, "Det Tomme Kors": 61.

65. When *Golgotha* was included in Munch's exhibition at the 1902 Berlin Secession as part of the *Frieze of Life*, it was installed beside *The Scream*. On the hanging sequence and criticism of this exhibition, see Jan Kneher, *Edvard Munch in seinen Ausstellungen zwischen 1892 und 1912* (Worms: Wernersche Verlagsgesellschaft, 1994): 151.

66. At the turn of the century, high mountain retreats such as Kornhaug Sanatorium were popular destinations for rest cures—the clean air was seen as a panacea for the "decaying" urban intelligentsia. On the sanatorium, and for an interpretation of *Golgotha* in the light of Munch's inscription, see Patricia G. Berman, "Edvard Munch's Bohemian Identity and the Metaphor of Pain at the Fin de Siècle," in *Edvard Munch* (Tokyo: Setagaya Art Museum, 1997): 211–215.

67. J. A. Schmoll gen. Eisenwerth, "Zur Christus-Darstellung um 1900," in Roger Bauer et al., eds., *Fin de Siècle: Zu Literatur und Kunst der Jahrhundertwende* (Frankfurt am Main: Vittorio Klostermann 1977): 403–404 and 411–412. Arne Eggum has suggested that *Golgotha* may have been inspired directly by Ensor's works, which Munch had likely viewed over the previous several years. See Arne Eggum, "James Ensor and Edvard Munch, Munch and Reality," in Frank Patrick Edebau, Arne Eggum, and Martin Urban; *James Ensor, Edvard Munch, Emil Nolde* (Regina, Saskatchewan: Norman MacKenzie Art Gallery, 1980): 27ff. Eggum notes that Munch received a letter, dated February 1, addressed to Kornhaug Sanatorium, informing him that he and Ensor were shortly to be considered together in a critical article.

68. A survey of these works, and a list of Ensor's religious motifs from 1877–1900 is provided in Julius Kaplan, "The Religious Subjects of James Ensor, 1877–1900," *Revue Belge d'archeologie et d'histoire de l'art* 35 (1966): 175–207. On *Christ's Entry into Brussels in 1889*, see Patricia G. Berman, *James Ensor: Christ's Entry into Brussels in 1889* (Los Angeles: Getty Museum Studies in the History of Art, 2002).

69. Charles Baudelaire had famously equated modern artistic expression with the isolation and mission of a redeemer: "In the poetic and artistic order, the true prophets are seldom preceded by forerunners. The artist stems only from himself. . . . He has been his own king, his own priest, his own God." Charles Baudelaire, *Art in Paris, 1845–62: Salons and Other Exhibitions*, trans. Jonathan Mayne (London: Phaidon Press, 1965): 127.

70. In addition to their contributions to criminology, sociology, and eugenics, Cesare Lombroso's writings, particularly *The Man of Genius* (1888), helped to shape the terms of artistic genius as a form of deviance. The link between genius and madness and criminality was also secured, infamously, in the work of Hungarian physician Max Nordau, especially in *Paradoxes* (1896) and *Degeneration* (1894). Their ideas, in turn, had been inspired by the writings of Arthur Schopenhauer and Friedrich Nietzsche.

71. Munch's relationship with Larsen has been the subject of enormous interest and analysis in the Munch literature. Their relationship ended abruptly when they had a confrontation in 1902, and Munch was wounded by a pistol shot. Larsen became a central subject of Munch's work, both directly and in allegorical form, for the next several years, including the bitter *Death of Marat* (1907). On Munch's relationship with Tulla Larsen, see Frank Høifødt, "Kvinnen, Kunsten, Korset. Edvard Munch anno 1900," unpublished Ph.D. dissertation, University of Oslo, 1995.

72. Munch manuscript T2734, Munch Museum: 373–374. Trans. in Tøjner, *Munch in His Own Words:* 183.

73. Munch sketchbook T23/4, Munch Museum.

74. Gerd Woll, "The Tree of Knowledge of Good and Evil," in *Edvard Munch: Symbols and Images* (Washington, D.C.: National Gallery of Art, 1978): 235.

75. Høifødt, "Kvinnen, Kunsten, Korset": 226, calls attention to the traditional tripartite division of the body, and he elaborates the designations of Munch's "zones" based on other of the artist's writings.

76. Munch manuscript 2547-a25, Munch Museum; trans. in Tøjner, *Munch in His Own Words:* 118.

77. Edward Munch, in a letter to Eberhard Grisebach, dated 17.2.1913, in Stang, *Munch: Man and Art:* 262.

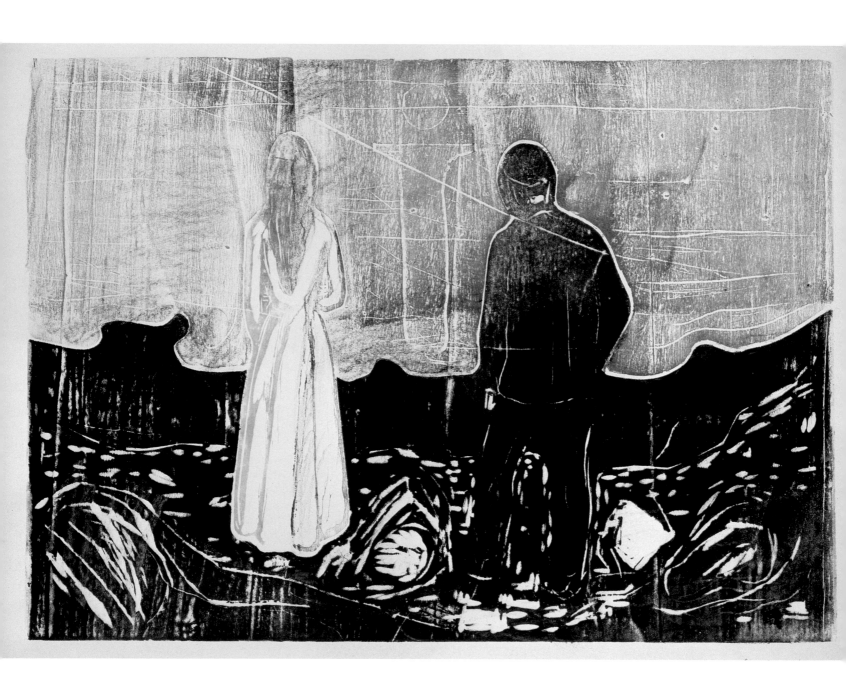

Metal, Stone, and Wood: Matrices of Meaning in Munch's Graphic Work

Elizabeth Prelinger

The painter Edvard Munch ranks as one of the greatest printmakers of all time. In some 750 separate images made throughout his career, the innovative artist displayed a virtuosic mastery of every graphic technique, including intaglio, lithography, woodcut, and mixed mediums. Prints played an essential role in Munch's oeuvre, as they did in the work of such artists as Edgar Degas and Paul Gauguin. Although Munch made prints of many subjects, perhaps most importantly, he reworked into graphic form the motifs of love, death, and anxiety already realized in the famous paintings from his monumental series the *Frieze of Life*. The printed versions were not, however, simple transcriptions of these paintings. Instead, in a brilliant display of artistic intuition and technical experimentation, Munch derived fresh interpretations of his motifs, as he scratched them into metal plates, brushed them onto lithographic stone, and carved them into blocks of wood. In the transformation of these simple materials into subtle ideas, Munch's prints became "an integral part of his artistic oeuvre."[1]

The prints selected for this volume and accompanying exhibition chronicle Munch's progress from the time he became a graphic artist in the autumn of 1894 with the lithograph *Puberty* (plate 45), to the end of his life, when he printed the woodcut *Kiss in the Field* (1943; plate 156). In addition to being a sort of historical survey, however, this assemblage intentionally highlights singular examples of Munch's most experimental prints. In some cases, these impressions represent rare versions of a composition, such as *Two Human Beings (The Lonely Ones)* (1899; plates 54 and 55), a woodcut to which he eventually added forms made from stencils. In other cases, such as *Separation II* (1896; plate 67), the artist pulled an impression from the matrix and then used it as a template for trying out color effects. On occasion, Munch used ink and watercolor to add compositional elements that alter the story, as in *Melancholy III* (1902; plate 65), and sometimes decorative borders that comment in various ways on the central scene, as in *The Woman II* (1895; plate 73).

The often hand-colored impressions shown here thus present a very particular view of Munch as a graphic artist. In fact, this aspect of his oeuvre would not have been known during his lifetime to more than a few connois-

Edvard Munch. *Two Human Beings (The Lonely Ones)*. 1899. Woodcut. Epstein Family Collection, Washington, D.C.

seurs, among them the German judge Gustav Schiefler, who published the first catalogue raisonné of Munch's prints in two volumes, the initial volume appearing in 1907 and the second in 1928.[2] Significantly, many of the experimental sheets come from the collection of the Munch Museum in Oslo, confirming that they remained in the artist's studio at the time of his death in January 1944. Although, late in his life, Munch often hand-colored and dedicated an impression to a friend as a gift, most of the unusual sheets from the Munch Museum appear to have been working proofs for the artist's personal reference or sheets that, for some reason, were not considered to be appropriate for sale. Reflecting a modernist sensibility, these rare versions and touched proofs are especially valued today as expressions of Munch's restless creative process, even if they do not strictly prove to be the most enlightening examples of his goals or methods as a graphic artist.

That said, one might argue that it was surprising for Munch to discover the graphic arts so comparatively late in his career. When he made his first attempts, he was thirty-one years old and well known, even notorious, for his intensely psychological paintings, which had been exhibited in Norway and Germany. But Munch, who was so deeply concerned with expressive means, quickly discerned the central place that printmaking could take in his work. And the time was right: the graphic mediums were in the midst of enthusiastic revivals that had started in the 1880s and reached full bloom during the decade of the 1890s.[3] The artist realized that the production of multiple impressions of his important themes from the *Frieze of Life* series would communicate his philosophy to as many people as possible. Furthermore, he was famously canny as a businessman, and he knew that the prints would find a market more easily than more expensive canvases. Indeed, both these reasons account for the presence of so many prints by Munch in the United States. But, most importantly, Munch valued expression over all else and recognized that printmaking allowed him to search extensively for new ways to realize his ideas.

Munch's obsession with conveying abstract and universal human ideas and experiences in his art revealed his involvement with the aesthetic of Symbolism, which pervaded poetry, literature, music, and the visual arts in the West from about 1885 to 1910. In reaction against the Impressionists' goal of capturing fleeting effects of nature that passed before their eyes, the Symbolists turned inward. Like his contemporaries Paul Gauguin, Vincent van Gogh, and Edouard Vuillard, for example, Munch rebelled against what he perceived to be the superficiality of realism, naturalism, and Impressionism. In his famous "St. Cloud Manifesto" of 1889 he wrote, "No longer would interiors, people who read and women who knit be painted. There should be living people who breathe and feel, suffer and love."[4] Munch proceeded to declare his independence from naturalism, as is seen, for example, in *Girl Kindling a Stove* (1883; plate 8). He adopted a more simplified, flattened style that treated the visible world merely as a start-

Figure 1. Paul Gauguin. *Nave Nave Fenua (Fragrant Isle)*, from *Noa Noa (Fragrance)*. 1893–94. One from a series of ten woodcuts. The Museum of Modern Art, New York. Gift of Abby Aldrich Rockefeller

ing point for the revelation of the inner life of humanity.[5] This is evident in *Night in St. Cloud* (1890; plate 20), an early example of the Symbolist approach that characterized most of his painting. Here, Munch chose the muted blues of a then-current aesthetic called "mood painting" in order to evoke a moment of intense private introspection.[6] The barely delineated figure melts into the vague atmospheric light; he is anonymous, and universal. Munch artfully suggested grief and isolation through color and through the arrangement of the composition.

Printmaking offered the Symbolist artists even more opportunities than painting to reject the world of appearances and to simplify or distort objects for expressive purposes. In order to signal the presence of underlying meanings, genuine reality, they exercised what the Symbolist artist Maurice Denis termed the "subjective deformation of nature."[7] Interestingly, by the 1890s, such French critics as André Mellerio had recognized this phenomenon. He noted that, unlike the Impressionists, the "new generation of artists" was enthralled by printmaking.[8] Referring to Symbolists such as Gauguin and Munch, Mellerio observed that these painters seemed to discern in the graphic arts a special potential for evoking essences, emotions, and ideas, and for exploring nonimitative visual goals in ways that painting could not. For example, Symbolist artists felt freer to explore expressive effects in the more private, less formal, and (usually) smaller format of prints. They rejected the sheen of the new photographic reproductions used in advertising and illustration, embracing instead the hand-made craft quality of original prints, which suggested the intimate presence of the maker. They also permitted their ideas to dictate departures from valued traditional craft methods, expanding the definition of "graphic." Ultimately, their quest for expressivity trumped convention, signaling the coming of age of the modern print.

Munch began to make intaglio works and lithographs in Berlin in 1894. He had won several scholarships to study painting in Paris, but he had received little, if any, formal training in printmaking methods.[9] He was involved with the German *Jugendstil* publication *Pan*, which promoted the graphic arts, and depended on his friends in that circle for instruction. As his interest in the graphic arts increased, he also spent time at the professional printing shops in Berlin, such as Sabo, Angerer, and Felsing, which pulled impressions for artists. There he learned techniques from the printers themselves, and was initiated into the nuances of inks and papers.[10] In Paris, in 1896, Munch frequented the lithography studios, picking up the intricacies of color printing that he later applied to his woodcuts as well.[11] It is likely that in Paris he also had the opportunity to examine a set of wood relief prints by Gauguin (figure 1), who invented some of the woodcut methods that Munch used to such great effect in his own work.[12]

From the beginning, Munch comprehended the ways in which the effects of a particular graphic medium differed not only from those of painting, but also from those of other print mediums. He first explored this phenomenon in the early intaglio prints made in Berlin with the support of such patrons as Julius Meier-Graefe, who commissioned a portfolio from the artist, partly so Munch could find an audience for the themes from his paintings.[13] Munch used the techniques of drypoint, etching, and aquatint on copper plates to accomplish this. One example is *Kristiania-Boheme II* (1895; plate 13), a bar scene from Munch's bohemian existence as a young artist in Kristiania (Oslo).

Munch had made a compositional drawing in gouache in which intense reds evoke the jealousy and sexual passion that animated his circle of friends. For the etching, however, an aspect of the challenge was to imbue the motif with the same ideas but not necessarily by means of expressive symbolic color. This was a complex task for an artist of whom a friend observed: "Munch writes poetry with colour. He has taught himself to see the full potential of colour in art. . . . His use of colours is above all lyrical. He feels colours and he reveals his feelings through colours; he does not see them in isolation. He does not just see yellow, red and blue and violet; he sees sorrow and screaming and melancholy and decay."[14]

In the print, Munch retained the original composition of the drawing, then used seemingly haphazard calligraphic lines to evoke the smoky interior of the tavern, oppressive with alcohol and desire. At the left, the artist himself, only his face visible, masklike and deathly pale, sits across the table from his looming rival. In the background, behind the sharply receding edge of the table, the contested femme fatale stands triumphant. It is the agitated line that becomes the carrier of meaning; the etching needle successfully conveys the crackling atmosphere of the love triangle. Munch ultimately chose to heighten the claustrophobic moodiness by adding aquatint tone to many areas.[15] This resulted in a scene that is far more portentous than the original drawing (see page 13).

Aquatint was a prevalent contemporary device for creating tonal effects on a metal plate. The German print critic Curt Glaser noted its unprecedented popularity, sarcastically observing: "Cycles of etchings poured out in the hundreds in which the eternal rewarding themes of women and Love and Death and the Beyond were treated with much deep meaning and aquatint."[16] Very much in the German style, Munch did the same, although a comparison with his contemporary Max Klinger demonstrates how far Munch departed from the rendering of precise detail that the intaglio method so successfully permits. For Munch, tone referred to the colored planes of painting, but also created mood, albeit monochromatic, in a graphic context. For *The Woman II* (1895; plate 73), of which he had already made a painting, Munch progressively added shading to the plate through aquatint and open bite (where the plate is simply immersed in the acid), until he was satisfied with the mysterious notes of dark and light. The shadowy scene is difficult to read; at the right, three "subjectively

deformed" ominous trees create a compositional tension with the moon and path of light on the water at the left. The triad of trees seems to refer to the three women, or perhaps it is a single woman represented in three stages of her life: young virgin, mature woman at the height of her sexual powers, and old woman dressed in mourning.[17] This particular impression is especially interesting because the artist left an unprinted border across the top edge of the sheet. On it he painted three female heads, in blue, red, and yellow gouache, joining them with strands of serpentine hair. Munch never incorporated these masklike heads into the plate. But this impression, a dramatic late state, hand-colored, was important to the artist, who kept it in his own collection until his death.[18]

Munch sometimes printed his intaglio plates directly in colored ink. A very rare example is *Young Woman on the Beach (The Lonely One)* (1896; plate 47). It is a burnished aquatint made on a prepared zinc plate with drypoint and accented with graphite by the artist. The plates were mechanically grained, and all that the artist had to do was smooth away the surface with a tool called a burnisher. These works, of which Munch made only a handful and in very small numbers of impressions, could be tricky to ink and print, however, and the artist had the plates professionally done, first in Paris and later in Berlin.[19] The versions in color are the earliest and rarest; after 1906 they were printed in monochrome.[20] In *Young Woman on the Beach*, under the artist's direction, the printer achieved a subtle blend of melancholy blues tempered by their chromatic complement, orange, for a vivid contrast. The forms of the rocks on the beach are virtually abstract, creating the sense of otherworldliness often linked with Symbolism, and adding to the feeling of alienation the artist associated with loneliness.

The image of the solitary woman is one half of the motif of *Two Human Beings (The Lonely Ones)*, where she is joined by a man, who also faces out toward the water. Such was the significance of the theme to Munch and so numerous were the choices for rendering it in varied forms that he experimented with the image throughout his career. After conceiving the painting, of which he produced several versions, he reworked it into an intaglio print and then, still searching for powerful variants, into a woodcut (plates 54 and 55).

Munch made more lithographs than any other kind of print during his career. Originally, his extraordinary facility for drawing, recognized by his teachers in Paris, was responsible for this easy way to create a reproducible picture. As seen in the black-and-white print of *Puberty* (1894; plate 45), and, for example, the portraits of Stéphane Mallarmé and August Strindberg (plates 26 and 27), he had merely to take the greasy lithographic crayon and/or brush and lithographic ink (tusche) and draw, paint, or scratch on the smooth surface of the special limestone. What was difficult was the chemical preparation and printing of the stone, which was usually carried out by a professional master printer. Munch always tried to be present at the print shop, observing: "Impressions printed without the presence of the artist are not original prints."[21] In Paris, the

shop of Auguste Clot produced a number of Munch's best-known and technically most complex works, such as *The Sick Child* (1896; plate 17). Munch eventually owned his own presses and often prepared and printed his own stones, many of which remain in the Munch Museum today.[22]

As effectively as Munch used color for Symbolist purposes, he also understood the power and subtlety of black as a conveyor of ominous moods. His *Self-Portrait (with Skeleton Arm)* (1895; plate 32) represents a terrifying glimpse into his intimations of mortality and a serious contrast to paintings such as *Self-Portrait with Cigarette* of the same year (plate 37). Using heavy black tusche, he painted onto the stone his disembodied head floating in nothingness. The skeletal arm across the bottom edge and his name at the top evoke a tombstone; at the time Munch was thirty-one.

The artist even attempted to render *The Scream* in black and white (1895; plate 86). This might seem to be a particularly strange experiment since the painted image resonates with violent colors and the blood-red sky appears in the artist's prose poem describing the experience. But in the black-and-white version Munch poignantly allowed the language of the bold, serpentine lines to speak, creating a sense of written music, however dissonant.[23] The visual impact of this composition did not prevent the artist from also using it as a template for hand-coloring, creating an image closer to the painted version (1895; plate 85).

Color lithography came closer to imitating the paintings, and Munch used it for reworking important motifs. Large colorful advertising posters made by fine artists, including Henri de Toulouse-Lautrec (figure 2), Alphonse Mucha, and Jules Chéret (figure 3) decorated the city of Paris, creating a fresh taste for eye-catching public imagery. An aspect of Munch's choice of this commercial medium for his serious themes may, in fact, have been that the color lithograph could provide a posterlike format, a kind of promotion of his urgent themes. Munch also did not wish to abandon the color that carried such meaning in his paintings, and he ceaselessly pursued alternate methods to print it successfully. Oddly, the result was that the artist co-opted one of the most modern printing technologies to serve as a vehicle for fin-de-siècle pictures of soul-wrenching experiences instead of the more common scenes of contemporary urban gaiety.

A distinction exists between the lithographs that Munch printed in black and then hand-colored and those that he conceived chromatically from the start and then printed in multiple colors. The hand-colored sheets are like drawings and, in Gerd Woll's words, "gave even fairly insignificant impressions printed in large editions an extra dimension, making them unique in a way that contradicts the very nature of the print."[24] Nonetheless, Munch himself would have recog-

Figure 2. Henri de Toulouse-Lautrec. *Jane Avril.* 1893. Lithograph. The Museum of Modern Art, New York. Gift of A. Conger Goodyear

Figure 3. Jules Chéret. *Olympia Anciennes, Mont Agnes Russes, Boulevard des Capucines.* 1892. Lithograph. The Museum of Modern Art, New York. Given anonymously

nized that the hand-colored impressions were largely experimental. The process of hand-coloring would negate one of the reasons for making prints: their identical reproducibility and reasonable prices. Indeed, as he attempted an inventory of his studio, the artist was well aware of the problem of not having numbered his impressions or recorded editions.[25] So except for special gifts or sales, many sheets remained in his studio, where he kept them for personal reference and individual significance.

Among several notable examples of touched proofs shown here is one print, *Evening on Karl Johan Street* (1896–97; plate 78), which exists in a unique impression. It reproduces a painting in which a throng of ghostly figures moves toward us, while a solitary man, probably the artist, walks in the opposite direction down Kristiania's main street (1892; plate 79). Blue watercolor conjures the wintry twilight, and touches of orange suggest the warmth and community inside the inaccessible buildings that line the street. As we saw in *The Woman II* (plate 73), Munch again drew a border of little faces that peep out of the bottom edge of the sheet, witnesses to a sense of pervasive modern alienation. We can only wonder why there are no other known impressions of this exceptionally forceful scene.

The artist devoted much time and experimentation to the femme fatale depicted in the painting *Madonna* (1894–95; plate 60). It is one of his most spectacular and representative pictures, a commingling of the essences of love and death. When it was first exhibited as a painting, according to Arne Eggum, it was probably in a "frame with painted or carved spermatozoa and embryos."[26] The sexually explicit picture caused a scandal, however, and the frame was removed. But the sperm and the contorted fetus were critical to the artist's linkage of procreation with death and with the fearsome power of woman, so he made a lithograph in stark black-and-white that included a border with the male symbols.

After printing the keystone (drawing) in brown, green, and red as well as black, Munch appears to have decided that the image did not convey its full import without additional color. In one impression, he brushed in watercolor and gouache by hand to test the effect of the printed color he was considering. Now the spermatozoa slither in a bloody stream of life and death, a hot contrast to the cool blues in the swirling background. To reproduce this striking effect, Munch prepared two further stones from which to print the red border and halo and the underlying blue background, although the keystone with the drawing remained the dominant element of the composition (see plate 59).[27]

Munch printed many of his lithographs in monochrome and then sometimes used them for coloring. But the work that Munch considered his greatest, however, defied a coloring-book style; it was constructed from intertwined calli-

graphic skeins of printed lines. *The Sick Child* (1896; plate 17), his first color lithograph, distills to its essence the eponymous painting (1896; plate 18), which depicts the illness of his cherished sister Sophie, who died from tuberculosis at the age of fifteen.

More than his other themes, *The Sick Child* was the subject of obsessive reworkings: paintings, etchings, and a range of differently colored lithographs. In the lithographic process, each color requires a separate stone; different sections of the multicolored image had to be drawn, painted, or scratched on individual stones. When the stones were printed in a sequence—and Munch varied the sequence as well as the choice of colors and papers—the result was an integrated color *composition*, that is, an image conceived from the start in and for color. The artist, thus, separated onto a number of stones aspects of the child, the pillow, the vertical strip of background, and the scratched horizontal lines that evoke the sucking breath of death.[28] He then instructed the French printer Auguste Clot to send the stones through the press in sets of different color variations for each impression. Each sheet emphasizes a different mood. The red, blue, and yellow of the impression shown here (plate 17) are intentionally piercing and sharp, a kind of flashing realization of impending disaster.

By contrast, an impression printed largely in black with strands of bloody hair (figure 4) conveys the deep grief and hopelessness of the death of a child. Like many of Munch's prints, *The Sick Child* is, therefore, best understood when considered in the context of its myriad variations. When many impressions of the motif are assembled—the exact image but handled differently—the range of human emotion becomes manifest, as well as the Symbolist appreciation for the subtlety of the individual response to universal experience.

Munch seems to have found the most satisfying expression for his ideas in the woodcut. Again, he found himself to be part of a wave of artists who were experimenting with the medium at the fin de siècle, but his work was, without doubt, the most creative. Moreover, in certain woodblock prints, the artist succeeded in fusing medium with meaning such that the form could be construed to determine the content.[29]

The artist did not attempt to carve into wood until 1896, when he was in Paris and, possibly, under the influence of Gauguin's work.[30] Yet when he did, choosing yet again a theme from the *Frieze of Life* called *Angst* (1896; plate 80), he immediately grasped the potential of the richly grained planographic surface of the block and the rough gouges of the knife. Rejecting the richly colored painted version (1894; plate 81), Munch abandoned the picturesque, however terrifying, in favor of a ghostly monochrome. The hacked-out, flattened, and dehumanized figures seem to emerge from the graveyard of the block as they converge relentlessly upon us.

This departure from the relatively refined techniques of etching and lithography suggested a new command of material in the service of an idea. First,

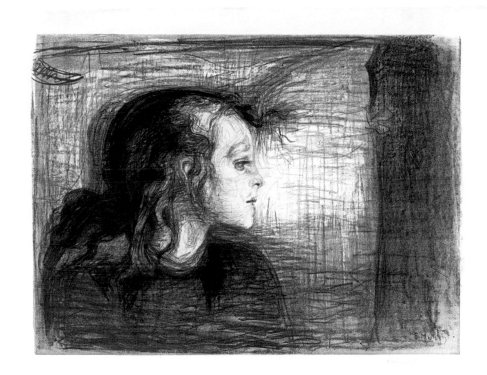

Figure 4. Edvard Munch. *The Sick Child*. 1896. Lithograph. The Museum of Modern Art, New York

Munch used the qualities of the soft side grain of the board to carve out the simplest and most direct, often crude, forms. He thus underscored their symbolic, rather than imitative, role in the picture. Second, the artist adapted a technique that had most likely been invented by Gauguin.[31] This was the sawing of the woodblock into sections, inking them separately with different colors, reassembling them, and printing a multicolored impression in one step. Not only did this method avoid the time-consuming process used by Japanese woodblock artists, who used one block per color—and numerous colors—but it permitted an unprecedented linkage of process and idea.

Two examples of the strategies Munch used to carve meaning directly into the wood matrices are *Two Human Beings (The Lonely Ones)* (1899; plates 54 and 55) and *The Kiss III* (1898; plate 52). The former, a motif of a man and a woman standing on the beach facing the water, with no hint of communication between them, abounded with emotional ambiguities that the artist could exploit visually. First, Munch cut the scene into wood. Then he took a fretsaw and separated the land from the sea, which made it possible to ink the two puzzle pieces, so to speak, with different colors and then print the entire block at once. The artist printed many impressions of this stark image, choosing black for the land and figures, and a greenish gray for the sea. He also inked the block with a variety of unnaturalistic hues, which remind the viewer that the reality of the scene exists more in the imagination than in the physical world.

Munch consequently realized how he might manipulate the block to affirm the utter detachment of the figures in the most incontrovertible fashion. He took up his fretsaw once again and sawed out the form of the woman. In these

versions, one can discern the line above her head that betrays where he had to cut into the block to extract her (page 52). The resulting piece of wood was, like a paper doll, quite literally separate both from the land, and from the lonely man. Munch printed that form with the other pieces, but now she was technically, as well as psychologically, severed from her environment.

The Kiss III represents the culmination of Munch's quest for a matrix that carried meaning in its very configuration. A kiss was a popular fin-de-siècle theme and was treated by such artists of the time as Auguste Rodin, Gustav Klimt, Peter Behrens, and countless others. It did not come so easily to Munch, who struggled with the motif over many years, for example, altering the setting and the position of the figures. He painted the theme, made etchings and drawings, and finally seemed to locate its richest realization in this woodcut version.

This time, Munch used two blocks, one printed over an impression from the other. He had experimented successfully with this method in *Evening: Melancholy I* (1896; plate 64), among others, in this case sawing each block into two more pieces. But now Munch did not even carve into the background block; its exquisite grain, printed in a soft gray, represents a pure state of nature. Then, after many trials, the artist sawed out the embracing couple from yet another block and printed this single template over the background.[32] In other words, he cut the unity of the man and woman directly out of the wood matrix. Moreover, it is so subtly integrated that one can discern the grain within the form of the couple, syncopated against the design of the bottom layer. Here, Munch transcended the anecdotal details of a relationship; the print is virtually abstract, an iconic symbol of human love. This is a "pure" print, if one may call it that, complete in itself, its meaning derived not just from what is depicted but from the graphic materials themselves. In Munch's hands, two simple blocks of wood have been transmuted into a universal statement of unsurpassed profundity.

Munch's prints represent a collaboration of the highest order between the artist and his materials. It is even tempting to question whether the painted versions of *The Kiss* can rival the stark concision of the silent eloquent woodcut. But, in fact, the graphic work is deeply entwined both visually and psychologically with the paintings and drawings, and is integral to Munch's exploration of his many themes. The prints, thus, form a crucial thread in the intricate fabric of the artist's vision. Without a consideration of these remarkable works, our understanding of Munch's message, in its power as well as its subtlety, can only remain incomplete.

Notes

1. Gerd Woll, *Edvard Munch: The Complete Graphic Works* (New York: Harry N. Abrams, 2001): 6.

2. Gustav Schiefler, *Verzeichnis des graphischen Werks Edvard Munchs bis 1906* (Berlin: E. Cassirer, 1907); and idem, *Edvard Munch. Das graphische Werk 1906–26* (Berlin: Euphorin Verlag, 1928).

3. See, for example, Jacquelynn Baas and Richard S. Field, *The Artistic Revival of the Woodcut in France, 1850–1900* (Ann Arbor: University of Michigan Museum of Art, 1984); Phillip Dennis Cate and Sinclair Hamilton Hitchings, *The Color Revolution: Color Lithography in France, 1890–1900* (New Brunswick, N.J.: Rutgers University Art Gallery, 1978); and Frances Carey and Antony Griffiths, *The Print in Germany, 1880–1933: The Age of Expressionism* (London: The British Museum, 1984).

4. Edvard Munch, cited in Reinhold Heller, *Munch: His Life and Work* (Chicago: University of Chicago Press, 1984): 64.

5. See Maurice Denis, *Théories, 1890–1910: Du Symbolism et de Gauguin vers un nouvel ordre classique* (Paris: L. Rouart and J. Watelin, 1920): 207–208.

6. See Ragna Thiis Stang, *Edvard Munch: The Man and His Art* (New York: Abbeville Press, 1979): 75.

7. Denis, *Théories:* 207, 208.

8. André Mellerio, "La Rénovation de l'Estampe," *L'Estampe et L'Affiche* (no. 1, March 15, 1897): 4–5.

9. See Woll, *Complete Graphic Works:* 10, esp. n. 15, regarding speculations about Munch's possible teachers.

10. Ibid.

11. Ibid.: 12–13.

12. Bente Torjusen, "The Mirror," in *Edvard Munch: Symbols and Images* (Washington, D.C.: National Gallery of Art, 1978): 198–200.

13. See Woll, *Complete Graphic Works:* 11 and n. 17.

14. Sigbjørn Obstfelder, "Edvard Munch—An Experiment," *Samtiden* (1896): 17–22; quoted in Stang, *Munch: Man and Art:* 51, n. 17.

15. See Woll, *Complete Graphic Works:* 55–56.

16. Curt Glaser, *Die Graphik der Neuzeit* (Berlin, 1922): 466; cited in Carey and Griffiths, *Print in Germany:* 12–13.

17. The image has also been referred to as *Sphinx* and *Woman in Three Stages* in the literature.

See Woll, *Complete Graphic Works:* 59.

18. For an explanation of the development of the print and a large reproduction, see Ibid.: 59–61.

19. See Ibid.: 76–82. Woll has, for the first time, identified Porcaboeuf as the French printer of these plates.

20. See Ibid.: 77.

21. Edvard Munch, undated letter to Hudtwakker (MM N219); cited in Ibid.: 21.

22. See Reinhold Heller, *Edvard Munch: The Scream* (New York: Viking Press, 1973): 103–109.

23. See Elizabeth Prelinger, "Music to Our Ears? Munch's *Scream* and Romantic Music Theory," in Marsha L. Morton and Peter L. Schmunk, eds., *The Arts Entwined: Music and Painting in the Nineteenth Century* (New York: Garland Publishing, 2000): 209–225.

24. Woll, *Complete Graphic Works:* 22.

25. See comments by the artist in Ibid.: 23 and n. 87.

26. *Symbols and Images:* 49.

27. See Woll, *Complete Graphic Works:* 69–72; and Elizabeth Prelinger and Michael Parke-Taylor, *The Symbolist Prints of Edvard Munch: The Vivian and David Campbell Collection* (Toronto: Art Gallery of Ontario; New Haven: Yale University Press, 1996): 99–105.

28. For the printing complexities of this lithograph, see Woll, *Complete Graphic Works:* 90–99.

29. See Paul Valéry, "Mallarmé," in *Ecrits divers sur Stéphane Mallarmé* (Paris: Editions de la N.R.F., 1950): 142: "Le 'fond' n'est plus cause de la forme, il en est l'un des effets." Also see Prelinger and Parke Taylor, *Symbolist Prints:* 7.

30. See Torjusen, "The Mirror": 198–200.

31. See Baas and Field, *Artistic Revival:* 109–110.

32. See Woll, *Complete Graphic Works:* 138–140, for an explanation of the states and versions.

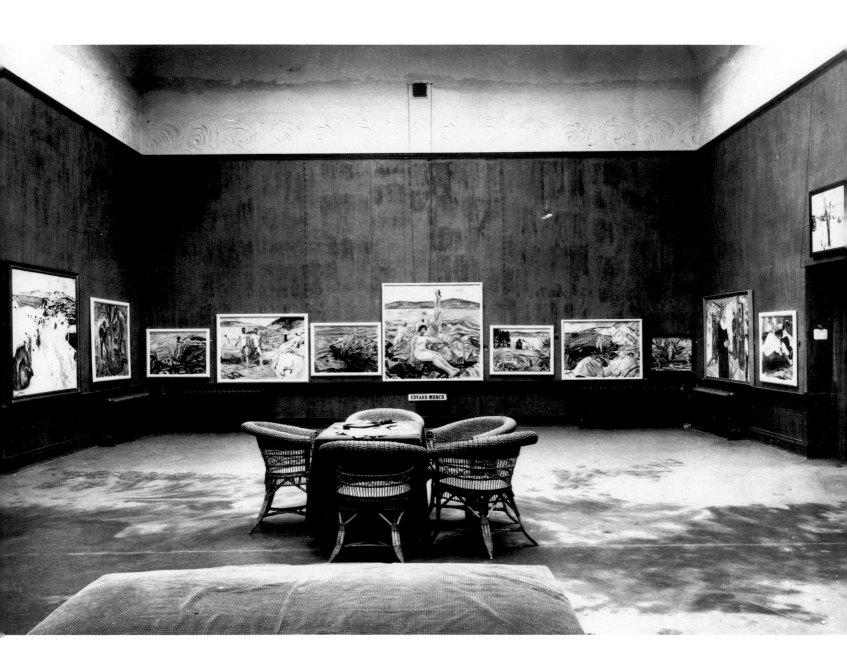

EDVARD MUNCH

Public Confrontations and Shifting Allegiances: Edvard Munch and the Art of Exhibition

Tina Yarborough

When seen as a whole, art derives from a person's desire to communicate himself to another. I do not believe in an art which is not forced into existence by a human being's desire to open his heart. All art, literature, and music must be born in your heart's blood. Art is your heart's blood.

—Edvard Munch, 1890[1]

Indeed, I now have such an intense demand for my prints that I must raise my prices. . . . Voilà l'homme de commerce! [Behold the businessman!].

—Edvard Munch, 1913[2]

In 1908 Edvard Munch suffered from what can best be described as a breakdown, and sought medical treatment for nervous exhaustion and alcoholism in the Copenhagen clinic of Dr. Daniel Jacobson. Following his treatment, the artist returned to Norway where he lived until his death during World War II, dividing his time among a number of properties in Kristiania (Oslo) and along the Kristiania Fjord. Virtually all of the literature on Munch describes his final decades as those of an artist who lived a hermit-like existence, enmeshed in the life of his studio and increasingly unresponsive to external artistic or political trends.[3] A close look at his work and, particularly, the many exhibitions that he organized or orchestrated during his last three decades suggests a different story.

In fact, after his return to Norway, Munch's painting showed a noticeable change, becoming more lyrical and saturated than it had been in the 1890s, when he had lived primarily in Germany. For example, *The Yellow Log* (1911–12; plate 112) demonstrates a new emphasis on the external physical environment transformed through the sensuous effects of rich colors and reflected lights. Here Munch's sharp, exaggerated perspective transposes a forest woodland into a dynamic synergy between nature and labor,

Installation view, Munch exhibition, Blomqvist gallery, Kristiania, October 1915. Munch's *High Summer*, 1915, is visible in center.

represented in the vitality of the felled yellow logs and their reflections in the surrounding snow.

As Munch experimented with such imagery, he also increased his effort to position his work within the European art market. "Despite all his idealism about art's function as a carrier of 'sacred' messages," as Reinhold Heller has pointed out, Munch "did not reject the commercial value of art."[4] Munch had been attentive and responsive to the expectations of his audience, and to criticism of his work, since the 1880s. His desire for popular and critical appeal had in part prompted the formulation of his painting sequence, the *Frieze of Life*, in 1892–93, which then preoccupied him for much of his career.[5] This painting series represents a remarkable coalescence of his creative idealism and the business of art. With the *Frieze of Life* Munch assumed unprecedented control over his own exhibitions in the sequencing of his motifs, and, by extension, the way his audience viewed his works.

Such artistic control was even more apparent during the years of World War I when, like artists everywhere in Europe, Munch encountered dramatic changes in public taste, critical expectations, and patronage. In response to these developments, Munch attempted to manage his career to the point at which a noticeable shift in the signification of his art and his creation of a new public persona become evident. Munch clearly had not lost his bearings after his hospitalization in 1908 nor did he become an unworldly hermit; instead, he retooled his career, shifting everything from his palette to his rhetoric, and even many of his social contacts. In fact, by the war's end, critics used adjectives such as *bourgeois,*[6] *calm,*[7] *harmonious,*[8] *wholesome, bright, vigorous, cheerful,*[9] and *happy*[10] to describe Munch's pictorial innovations. Certainly, these are not the descriptors usually associated with a lone, introverted, eccentric Nordic artist, who, as one scholar recently wrote, made "human agony the motivation of his art."[11] The shifts in Munch's art and persona are further indicated by several recent exhibitions that highlight Munch's late work, demonstrating that in the early twentieth century his art evidenced stylistic changes toward a new lyrical luminosity and heightened color sensitivity.[12] When contrasted with his art of the 1890s, this shift effects a basic dualism in his production, and, as the antithetical adjectives attest, Munch had consolidated a new style and public image through his visual responses and exhibition strategies by the end of World War I.

This essay examines Munch's responses to his audience in the early years of World War I in order to demonstrate the historical contingency of his art and the manner in which he negotiated his way between conflicting notions of traditionalism and modernism, nationalism and cosmopolitanism, and individualism and collectivity—notions radicalized by structural shifts in the art world that became acute during the war. The nationalist and political tensions exacerbated by the wartime crisis are encoded in much of the work Munch produced and exhibited during the war and, thus, elucidate the transformations in his art

and career. In turn, the artist's repositioning of his art and persona during the war established the terms of his production in the postwar years, leading to the full flowering of his later lyrical expressionism.

"Finally total victory," was the way Munch's biographer, friend, and patron Curt Glaser described the artist's career in 1913, the year before World War I began.[13] Munch had achieved public success on the continent, especially in Germany, and his career was on the rise in Norway, particularly after he secured his first public commission in 1914 to decorate the Festival Hall at the Royal Frederiks University in Kristiania (later the University of Oslo).[14] But, with the outbreak of war, the base of Munch's economic support collapsed. Because of trade and travel restrictions, Munch's extensive and long-cultivated network of galleries, friends, and patrons in Germany could no longer assist him as they had before the war, and he was confined to Scandinavia. As an international artist, Munch was caught in a cultural divide amid nationalist tensions. He faced an increasingly Francophilic Norwegian art market and public, while also experiencing the loss of his profitable market in Germany. Heralded after the 1912 Sonderbund Exhibition in Cologne as the "greatest Germanic artist now living,"[15] Munch saw, after the outbreak of hostilities, that a new strategy was necessary to maintain a position of influence at home. To be "Germanic" in post-1914 Norway was suddenly to be associated with an enemy, so in order to promote a new and more compatible public image, Munch orchestrated a series of exhibitions, which according to the artist were meant to "rescue" his position in the Norwegian art market,[16] where a critical consensus coalesced around a "new" Munch. Thus, Munch's wartime production and exhibition strategies are particularly illuminating as a cultural matrix upon which nationalist tensions and modernist aesthetics converged.

Munch provided the public with its first overview of his recent work in October 1915 in an exhibition of forty-eight paintings, "each one a thrill to experience," according to one critic.[17] Described as his "richest and most comprehensive in many years . . . the most versatile and complete,"[18] the exhibition included primarily new works, paintings which critics declared as evidence that Munch, in his fifty-second year, had reached new heights in a continued prodigious production. Typical of the critical reception was the response of Pola Gauguin, a critic and painter, the son of Paul and friend of Munch, who reminded the public that despite his age, Munch's career was not in decline: "[Munch's exhibition] is a special experience for anyone who sees this artist as one of art's great pioneers, because you get the sense that Munch is far from being past his prime. Indeed, quite the contrary he is now working with an uncontrollable ferocity and his art is at its greatest strength. This exhibition seems like a mighty crescendo that sets each thread in its nervous system in motion, but maintained and held together with an enormous exertion of will and talent, like an integrated and beautiful harmony."[19]

Among the paintings perceived in this way were Munch's depictions of workers and seasonal labor, which, both in motifs and painterly technique, suggested a new strength and vigor, terms that had been applied to the artist since his recovery. The symbolic power of Munch's monumental *Workers in the Snow* (1913–14; Munch Museum, Oslo), for instance, was easily transferred to the artist. The determined, forward-moving men armed with their tools were like the artist himself furiously painting, producing mural designs for the Festival Hall commission and easel paintings for his individual exhibitions, confirming that Munch had reached a new harmony in his career as in his art.

But, as Pola Gauguin implied, Munch's avant-garde status in Norway was precarious; his position had been challenged by a group of younger painters who had studied in Paris with Henri Matisse, adopting Paul Cézanne's structure combined with Matisse's classical decorative ideals as their own.[20] The students considered themselves in the vanguard of a new national art, and critics declared them Norway's new colorists, whose art personified the national and decorative tendencies then resonating both in the revival of Norwegian peasant art and in modern French painting. Their popularity in the Norwegian art world was firmly established when they allied themselves with the Lysaker artists, a group of Norwegian naturalist painters who espoused a conservative, moralistic national art in harmony with the imagined ethnic purity of folk painting.[21] Calling them "The 14," a reference to the number of artists, the press touted their new alliance.[22] When Norway held a centenary Jubilee Exhibition in May 1914 to celebrate its one-hundred-year-old constitution and its recent independence from Sweden, critics praised their paintings and pronounced "The 14" as harbingers of a new day in Nordic art, reflecting the country's new nationhood. These artists imbued their images of the nation's landscapes with a passion for freedom; their selection of moments from Norway's precolonial past supplied paligenetic values intended to facilitate the nation's legitimacy.

Classical civic virtues, collectivity, and *morality* were thus co-opted as critical terms in the art world, replacing *cosmopolitanism, individuality*, and *fantasy*, terms that had been associated with Munch's work from the 1890s.[23] The pressure of this new nationalistic rhetoric became particularly intense when the war began, and Norway experienced an economic boom born of its neutrality. However, at the same time, a kind of cultural warfare emerged in which Norway was in no way neutral; from the beginning, Norway's cultural allegiance was to the French.

With a conscious eye toward the changing circumstances of Norwegian cultural politics, Munch presented himself to his Norwegian public with a new persona, one to be compared with what he referred to as "all those other Norwegian painters."[24] For his installation in the 1915 exhibition at the Blomqvist gallery in Kristiania, Munch chose almost no works related to his symbolic and expressive "Germanic art" of the 1890s—that which had been produced in Berlin or had

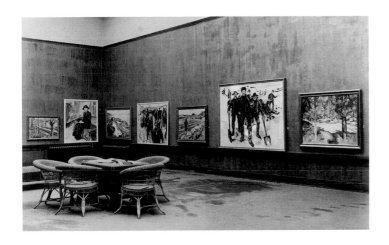 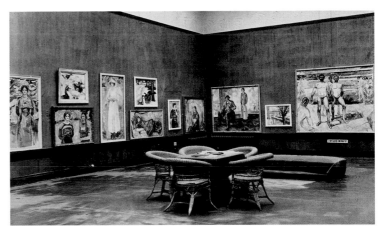

been likened by his critics to German modernism, such as *The Scream* (1893; plate 84) and *Ashes* (1894; plate 74). Instead, Munch concentrated on recent portraits, Nordic landscapes, and seasonal scenes (figures 1 and 2). These paintings responded directly to the new hegemony of the young Matisse students with whom Munch's work was immediately compared. In palette and touch, however, such paintings as *The Yellow Log* (1911–12; plate 112) eclipse the spectral brightness and pictorial architecture of the Norwegian students. Jappe Nilssen, Munch's friend, long-time supporter, and the critic for *Dagbladet*, saw Munch's work as more alive and genuine and noted his obvious influence in the work of the other artists: "Nearly everything considered fresh and vigorous in the younger generation is associated with [Munch's] art."[25] Even though most of Munch's images advanced the reigning nationalist ideologies in their Norwegian iconography, should there have been any doubt, his new works underscored his patriotism and framed a new national identity removed from his years of cosmopolitan traveling and Germanic affinities. Thus, when confronted with a changed market, Munch strategically shifted his stylistic emphasis to reflect the dominant aesthetic.

In this regard, Munch's winter landscapes from his home in Kragerø can be seen as his response to the nationalist landscapes of "The 14," especially those by Henrik Sørensen, their leading theorist and painter, whom Munch allegedly called "the Norwegian Jesus."[26] Sørensen's 1910 painting *Kviteseid in Telemark* (1910; Vinji Billedgalleri, Vinjesvingen) is one of several landscapes depicting the rural Telemark region—where, in 1910, Sørensen led a small artist colony to paint Norwegian scenes unspoiled by industrialization and urbanism.[27] Such landscapes synthesized the enduring values of rural folk culture with the modernism of Matisse and Cézanne, conjoining modern art and modern French painterly ideals with a Nordic love of nature. Dubbed "Parisian-Telemark romanticism,"[28] these landscapes were seen as images of "Norway in microcosm."[29] Since Norway's independence in 1905, such paintings, inscribed with a nostalgic vision of a utopian agrarian past, were popularized as emblematic of a new national identity—an ideal community, unspoiled by materialism. Although the

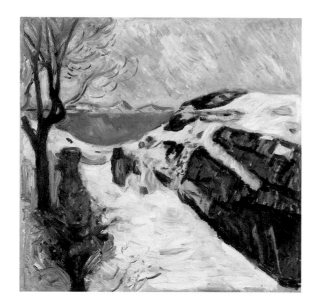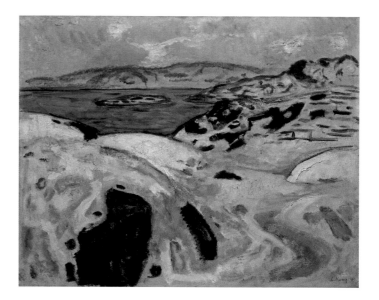

Telemark paintings were a tribute to Norway's recent independence and the eternity of its landscape, they also represented growing conservative political trends and the mythic appeal of the rural landscape and peasantry as a kind of secular religion.

With these images from Telemark in mind, Munch exhibited snow scenes from Kragerø and landscapes from the fertile grounds surrounding his Hvitsten farm. Like Sørensen's landscapes, Munch's Kragerø scenes (figures 3 and 4) and such dynamic images as *Galloping Horse* (1910–12; plate 110) reflect Cézanne's compositional studies. Critics praised Munch's fully developed pictorial structure, his "elegant coloring," and his "tightly chiseled, wonderful winter landscapes."[30] Munch's deliberate choice of place—Kragerø and Hvitsten—rather than one of the inner districts of the Telemark region, distanced his art from the moralistic and nationalistic rhetoric of "The 14." At the same time, as Patricia Berman has demonstrated in connection with Munch's Festival Hall images (1909–16; plates 117–127), Munch was aware of "painting at the service of the nation."[31] Although his landscapes and seasonal scenes certainly resonated as nationalist, Munch's choice of place pointedly distinguished his work from that of "all those other Norwegian painters." Nonetheless, it was Munch's summer scenes that were the most highly acclaimed paintings in the 1915 Blomqvist exhibition.

On one wall, which immediately confronted viewers upon their entrance into the exhibition, Munch prominently installed several Norwegian summer pictures (see page 64). Mesmerized by their light, shining "like a pearl,"[32] an array of fjord bathing scenes set in the long days of the Nordic summer sun stunned the critics. Munch's new painterly French luminosity was never more apparent than in his bathing scenes, which seemed almost Impressionist in the way sunlight flickered from the nude bodies to the landscape, fjord, and sky. One of Norway's major newspapers characterized the summer pictures: "Here

Figure 3. Edvard Munch. *Winter Landscape, Kragerø.* 1910. Oil on canvas. Munch Museum, Oslo

Figure 4. Edvard Munch. *Winter on the Fjord.* 1915. Oil on canvas. The National Museum of Art, Architecture, and Design/National Gallery, Oslo

is the person, the free person, happy in the sun, happy with life, at one with nature."[33] Munch's scenes evoked a new twentieth-century Norway, no longer troubled by the dark days of tuberculosis, but healthy and independent; like a tourist ad, they provided "the thrilling mood of the warm Norwegian summer."[34] Nilssen enthusiastically advised Norway's National Gallery to buy the largest summer scene before it was otherwise sold: "So many of Munch's best works are sold to foreign lands and lost forever to our country. Do not let some foreigner now also grab this one out from under our nose; because this painting sums up all the rich joy of Munch's beauty, his full sovereign mastery. *High Summer*, so to say, presents the whole Munch. We cannot afford to lose it."[35]

Munch hung *High Summer* (figure 5), a depiction of women sunbathing on the coast of the Kristiania Fjord, as the centerpiece on the wall of bathing pictures. His clear, balanced compositional integrity was almost classical in its

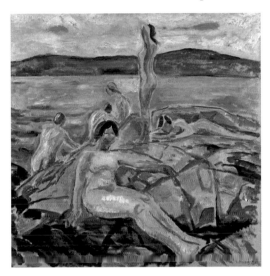

Figure 5. Edvard Munch. *High Summer*. 1915. Oil on canvas. The National Museum of Art, Architecture, and Design/ National Gallery, Oslo

symmetry: a tall, standing figure confidently presides over the rocky terrain, as the reclining foreground figure, a classical *repoussoir*, leads the viewer into the summer sunbathing scene.[36] Significantly not the peasants of Telemark, these are Munch's figures of the new body politic, depicted as a natural part of the rocky coast on which they sunbathe, the deep pink tones of the figures converging with the granite rocks—the visual rhetoric of the flesh of the land. Peacefully tied to the environment, their casual attitude suggests a proud contentment, in harmony with nature and satisfied with the nation.

Munch's colors further corroborated the ideology of national regeneration through allusions to French modernism. His bright colors, especially the dominance of rose-pink and lavender, echoed those used by the French painters Pierre-Auguste Renoir and Henri Matisse;[37] Munch's simplified forms, the sensation of sunlight flickering across the rocky coast and the nude bodies recalled earlier bathing images by these French artists. In *High Summer* Munch transformed their paradisical landscapes into seemingly everyday experience in Norway, identified with a particular love of nature and freedom, as his technique and the sensuality of his colors grounded his neonaturalism in the new Norwegian national identity and its legitimacy in French modernism.

At a time when Norwegian critics and artists were celebrating the exploitation of decorative color as a hallmark of a new Norwegian school of painting, Munch's bathing images and Nordic scenes presented his personal manifesto of national and artistic identity. Where landscape had previously supplied a symbolic background to many of his existential narratives, Munch now reasserted landscape as an autonomous subject. Through the heightened color resonance and luminosity of his bathing scenes, Munch reaffirmed his talents in Norway's Francophilic art market, while his seasonal images and regional scenes assured his success as a Nordic landscape painter and colorist *par excellence*.

It is instructive to note how strongly Munch was pressured to maintain this visual rhetoric by the negative responses he received from his second, or revised, installation at Blomqvist's. One month later, in an effort to reclaim recognition for his past art, Munch added to his exhibition a number of prints and a second group of paintings. The newly installed paintings were reworked bohemian motifs from the 1890s, which elicited very negative criticism, indicating a clear preference for Munch's newer works, those unrelated to his Germanic art. One critic insisted that Munch's second installation disturbed the mood of unity and peace. He concluded that even if newly painted, the motifs had been shown too many times before: "A good thing cannot be repeated too often, but one reproduction of a bad work is already two times too many."[38] Munch's reprises were labeled unimproved reproductions.[39] Another critic chastised Munch for the narrative expressionism in *Death of Marat II* (1907; plate 136), describing the painting as a failed illustration, sarcastically noting that "despite all the sensation and the picture's historic title. . . this great painter is no historian."[40] Even though the critical response to Munch's reworked motifs was harsh, his paintings sold. His October debut had been a marketing success, and by shifting his style with a French inflection, Munch had reestablished a dominant position in the Norwegian art market.

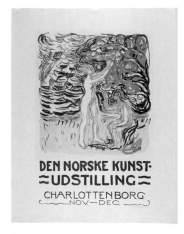

Figure 6. Edvard Munch. *Neutralia/Poster for Nordic Exhibition, Copenhagen.* 1915. Lithograph. Munch Museum, Oslo

At the same time, to further demonstrate his new inspiration and productivity, Munch exhibited several of his Festival Hall designs at the Artists' Autumn Exhibition in Copenhagen. In addition, he contributed nineteen paintings (some taken from his first Blomqvist installation) to a large Nordic exhibition at Copenhagen's Charlottenborg Palace. There, Munch's lithograph *Neutralia* (figure 6), printed in colors similar to those of *High Summer*, was used for the exhibition poster. *High Summer* and several of Munch's winter landscapes received critical praise in Copenhagen, as they had at Blomqvist's. The exhibitions were reviewed in the German press, where a new Munch was also observed: "Out of the gypsy has grown a well-groomed bourgeois."[41] But as if to reassure the German public that Munch was still the same artist they had known, the critic added, "In his inner self, however, Munch has not changed, he hates everything traditional [and] he remains a seeker of new paths."[42] The new path Munch actually sought during the early years of World War I, as he humorously remarked in a letter written on his birthday in 1913, was that of a businessman.

Munch continued his successful re-entry into Norway by opening a large exhibition in Bergen in February 1916, reportedly the largest he had ever held, although many of the works had been shown at Blomqvist's the previous October. Several critics in Bergen praised Munch's new works and described a positive change: "Munch's technique has indeed changed. . . . His uncommon color language . . . resonates as never before."[43] Not all critics, however, agreed that Munch's new works expressed a superior command of color. Interestingly, it

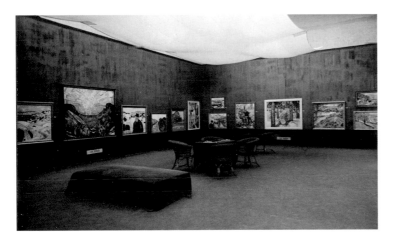 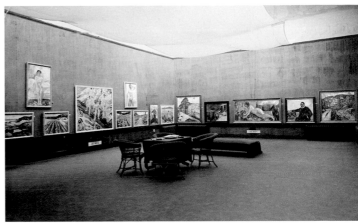

was Einar Lexow, the curator of the Bergen Museum and avid supporter of
"The 14," who was more reserved, advising that one need not "fall into ecstasy
before every single work Munch produces. . . . There are, oddly enough, some
totally careless works among them."[44] Lexow also found fault with Munch's
reprises because they lacked the power and intensity of the originals, suggesting
that Munch's "energetic and supple brushstrokes had been replaced by some
steamy color treatment that dampened and weakened the color's resonance."[45]
Like many critics, Lexow observed a different Munch, but stated that "for the
moment Munch finds himself in a less good period."[46] For Lexow the best artists
were the new younger painters of "The 14," whom he promoted in articles and
exhibitions.[47]

Amid the pro-French mood in Norway in September 1916, Munch unveiled
his Festival Hall paintings. By then, the final acceptance was anticlimactic for
Munch who had struggled the entire first half of his life to win support in his
home country. Two weeks after the unveiling of the Festival Hall paintings, as if
to assure the public that he was truly inexhaustible, Munch held another large
exhibition at Blomqvist's, presenting his easel production simultaneously with
his mural paintings. As he had the year before, Munch exhibited new works,
which now included numerous paintings from the environs surrounding his new
Ekely estate, to which he had moved the previous April (figures 7 and 8).[48]

Again, critics were impressed by his prolific productivity. Nilssen, from
the vantage of his friendship, lauded his abilities and insisted on Munch's inde-
pendence and uniqueness. One can hear Munch's own voice in Nilssen's attempt
to establish continuity in Munch's style by claiming a consistent newness: "This
exhibition represents an incomparable energy and ability to work. And [Munch]
always seems new to us. He is never the same from one year to the next. He
possesses an ability for self-renewal that is most welcome in Germanic and
Scandinavian painting. . . . [Munch] is not attached to any school or any direc-
tion, because he himself is one of those who advances and creates his own school
and forges his own direction. . . . Now everyone in this country who thinks they
love art is at Munch's side."[49]

Munch owed this new popularity to his most recent works. Carl Bang, like critics from the Bergen exhibition, also noticed the change in Munch's technique: "Munch has found a completely new way—or in a new way—to paint—towards greater simplification, greater strength and breadth and more intense light. He goes about things in a completely different manner. . . . He juxtaposes colors in such a way that they intensify each other in order to achieve the utmost yield. At the same time as his color is so warm and intense, he manages to attain a blinding daylight, such as no one else has done so far."[50]

As Bang pointed out, Munch's new technique consisted of a "blinding" luminosity, intensified by harmoniously juxtaposed colors. Nilssen concurred that Munch's new works represented a greater concern with color and light. He singled out Munch's painting *Girl on the Edge of the Bed* (figure 9) as "one of the best pictures Munch had ever painted," exemplary of "the high level of color intensity that Munch effected by coalescing color in light."[51] In *Girl on the Edge of the Bed* Munch repositioned his earlier *Puberty* motif into a painterly surface of rich, warm colors that heighten the young woman's surroundings. She is framed by a bright red-orange headboard and golden walls that are intensified and poetically harmonized by the green and blue bedcovers and shadows below the green rectangular windowlike form. Munch has rendered the nude very summarily and, instead, uses her body as a reflection of light and all the colors of her bed and room, including the greens and lavender in her hair and eyes. Seated pensively on the edge of her bed, Munch's nude faces a blinding light, but the mood of *Puberty* (1894–95; plate 44) has here become the dazzling, free play of the raw, sensuous effects of color and light. By the time of the exhibition, the painting had already been purchased by Richard Bergh, the director of the Swedish National Museum, for the national collection in Stockholm.[52]

Munch responded to the critics in this work, and in his exhibitions he focused on the most critically successful motifs, works from his years in Norway painted in a new, luminous, and decorative color. Munch's style, as he presented it in his 1915 and 1916 exhibitions, and as many critics noted, had indeed changed. Avoiding his earlier production, he clearly intended his new works to redress the issue of his Germanness.

Munch's stylistic experimentation, which coincided with developments in the Norwegian sociopolitical scene and the context of World War I, reflects, as has been said, the collapse of his international network and his wartime isolation in Norway. There, wartime conditions forced Munch to compete with the Francophilic Matisse students, whose art was considered by many to be a sign of a

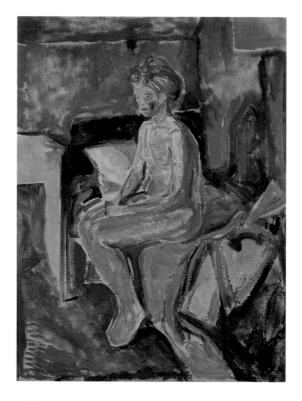

Figure 9. Edvard Munch. *Girl on the Edge of the Bed*. 1916. Oil on canvas. Moderna Museet, Stockholm

coming golden age in Norwegian painting. Munch's individualist and bohemian motifs, in response, were subordinated to a more classicizing bourgeois order represented in vibrant colors and decorative surfaces. Caught in the cultural divide between Germanic and French interests, Munch embraced an increasingly conservative modernism by shifting his orientation away from existential Germanic motifs and toward the prevailing Francophilic tastes, thus resulting in a clearly articulated stylistic duality. Critics identified Munch with a noticeable change in his art, describing him as a new man. Interestingly, though, as we can see in Nilssen's review, Munch continued to emphasize his singularity: defining himself as a unique phenomenon in the art world, not attached to any school or style. Thus, by attempting to drive the critical responses to his art, Munch also distanced himself from the prevailing trends, changed but consistently new. And it is this aspect of Munch's art and persona that remains an important part of his legacy.

Without the help of his former support network, Munch had carefully negotiated art markets in a state of flux while maintaining his creative idealism. By doing so, Munch represents an early variation on the trope of the modern artist—becoming a market-savvy individualist as well as a consistently developing artist who remained sincere in his convictions. Munch's art continued to represent his "heart's blood," the struggle of his creative spirit, or genius, despite necessary adjustments to his oeuvre.[53] By the end of World War I, however, he envisioned the "modern life of the soul" to include the business of exhibitions and the need to look after his own legacy.

Munch's work in the 1920s was shaped by the terms of his exhibition strategies of the previous decade; his saturated color, gestural lines, and themes drawn from nature continued to elaborate his visual and ideological affiliation with French artistic modernism. Far from the "hermit of Ekely" acting in silent dialogue with his own past production, Munch emerged in the postwar years as a vital, culturally aware painter as well as exhibition strategist. It was not so much Munch's "breakdown" and "recovery" that shaped his later forays into color and lyrical classicism, but the ways in which those events of 1908 were seen by his critics as a gulf separating the "old" cosmopolitan Munch from the "new" reinvigorated artist, whose themes resonated with a national consciousness. The emphasis placed on this gulf by his many biographers of the 1920s and 1930s,[54] in fact, occluded the signal importance of the politics of the war years to Munch's postwar reorientation. To revisit Munch's exhibition strategies and to note their relation with nationalist politics in the war years is to understand the brilliance of the artist as a participant in the art world and a complex historical figure who shaped twentieth-century art beyond the confines of an existential myth. His 1920s work may be seen as a "return to order," resonating with a broader, Europeanwide retrenchment and, at the same time, responding to the particular exigencies of his nation, and his reputation.

Notes

As always, I am especially grateful to the Munch Museum for its generous research assistance. I also wish to thank Reinhold Heller, Patricia Berman, Laura Lindenberger, and Richard Lou for their invaluable advice.

1. As cited and trans. in Reinhold Heller, *Munch: His Life and Work* (Chicago: University of Chicago Press, 1984): 86. Also see Poul Erik Tøjner, *Munch in His Own Words* (Munich: Prestel Verlag, 2001): 133–134.
2. Edvard Munch to Sigurd Høst, December 12, 1913 (the artist's fiftieth birthday).
3. See Ragna Thiis Stang, *Edvard Munch: The Man and His Art* (New York: Abbeville Press, 1979): 253; "People who particularly admire [Munch's] earlier work often maintain that he no longer achieved the same depth of psychological insight." Also see Iris Müller-Westermann, *Munch by Himself* (Stockholm: Moderna Museet, 2005): 104, and "Chapter 6: 1922–44: The Hermit of Ekely." Munch's breakdown has been extensively studied and published by various scholars in various disciplines: art history, literature, psychoanalysis. The best synopsis of these years in English remains Reinhold Heller, "The Years of Crisis and Success, 1900–1914," in idem, *Munch: Life and Work:* 174–212.
4. Ibid.: 68.
5. See, for example, Reinhold Heller, "Form and Formation of Edvard Munch's *Frieze of Life*" in Mara-Helen Wood, ed., *Edvard Munch: The Frieze of Life* (London: National Gallery, 1992): 25–37.
6. Felix Hollænder, "Unterwegs," *Berliner Tageblatt* (November 16, 1915).
7. Jappe Nilssen, "Edvard Munchs grafik," *Dagbladet* (October 18, 1917).
8. Ibid.
9. Arnulf Øverland, "Edvard Munch," *Verdens Gang* (March 3, 1918).
10. "Udstilling. Edvard Munch," *København* (November 11, 1917).
11. Kirsten Xani, "Works for People—Anxiety, Illness and Death as Themes of *The Frieze of Life*," in Rosemarie E. Pahlke, ed., *Munch Revisited: Edvard Munch and the Art of Today* (Bielefeld: Kerber Verlag, 2005): 50.
12. For two of these exhibitions, see

Christian Gether et al., *Echoes of the Scream* (Copenhagen: Arken Museum of Modern Art, 2001), and Elizabeth Prelinger, *After the Scream: The Late Paintings of Edvard Munch*, (Atlanta: High Museum of Art; New Haven: Yale University Press, 2002): esp. 52–70. For interesting analyses of Munch's thematic variations, see Klaus Albrecht Schröder and Antonia Hoerschelmann, eds., *Edvard Munch: Theme and Variation* (Vienna: Albertina; Ostfildern-Ruit: Hatje Cantz, 2003).
13. Cited in Heller, *Munch: Life and Work:* 212.
14. For a detailed analysis of the competition for the Festival Hall commission see Patricia G. Berman, "Monumentality and Historicism in Edvard Munch's University of Oslo Festival Hall Murals," unpublished Ph.D dissertation, New York University, 1989. Also see Gerd Woll, "From the *Aula* to the City Hall: Edvard Munch's Monumental Projects, 1909–1930," in idem, *Edvard Munch: Monumental Projects, 1909–1930* (Lillehammer: Lillehammer Art Museum, 1993).
15. Walther Halvorsen, "Edvard Munch. Hans betydning i samtidens kunst," *Verdens Gang* (March 26, 1912).
16. In April 1915, in an uncharacteristic publicity attempt, Munch solicited an interview with a reporter from the newspaper *Verdens Gang* in which he stated that he intended to rescue his market from the "bad times" by selling some paintings and exhibiting that fall. For the full text of that interview, see L'homme, "Jeg traf Edvard Munch," *Verdens Gang* (April 23, 1915). Also see, Tina Yarborough, "Exhibition Strategies and Wartime Politics in the Art and Career of Edvard Munch, 1914–1921," unpublished Ph.D. dissertation, University of Chicago, 1995.
17. Jappe Nilssen, "Ny utstilling av Edvard Munch," *Dagbladet* (October 23, 1915).
18. Ibid.
19. "Edvard Munch," *Ukens Revy*, no. 44 (1915): 723.
20. For information regarding the Norwegian Matisse students see Marit Werenskiold, *De Norske Matisse-Elevene: Læretid og Gjennombrudd 1908–1914* (Oslo: Gyldendal Norsk Forlag, 1972). Also see Nils Messel, "Fra Munchs Have til Matisses atelier," *Kunst og Kultur* 72, no. 3 (1989): 122–136.
21. For a discussion on the moral-

istic and nationalist debates surrounding the Lysaker artists, see Patricia G. Berman, "Norwegian Craft Theory and National Revival in the 1890s," in Nicola Gordon Bowe, ed., *Art and the National Dream* (Dublin: Irish Academic Press, 1993): 155–68. Also see *Kunst og Kultur* 65, no. 3 (1982); the entire issue is devoted to the Lysaker artists.
22. The seven Matisse students were Henrik Sørensen, Jean Heiberg, Axel Revold, Per Deberitz, Severin Grande, Rudolph Thygesen, Einar Sandberg, and the seven Lysaker artists were Erik Werenskiold, Oluf Wold-Torne, Thorvald Erichsen, Lars Jorde, Kristin Holbø, Wilhelm Wetlesen, and Dagfin Werenskiold.
23. For the transvaluation of some of these critical terms see Henrik Sørensen, "Thorvald Erichsen og Oluf Wold-Torne," *Kunst og Kultur*, no. 1 (1911): 242–251; repr. in Marit Lange, "Kommentar til Sørensen," *Kunst og Kultur* 64, no. 1 (1981): 30.
24. L'homme, "Jeg traf Edvard Munch."
25. Nilssen, "Ny utstilling av Edvard Munch."
26. Rolf E. Stenersen, *Edvard Munch: Close-up of a Genius*, trans. and ed. by Reidar Dittman (Oslo: Gyldendal Norsk Forlag, 1969): 107.
27. For information concerning Sørensen and the artists' colony in Telemark, see Svein Olav Hoff, "Norsk agrarpopulisme med fransk tilsnitt," *Kunst og Kultur* 72, no. 3 (1989): 156–170. Hoff points out the importance of Telemark and Kviteseid to many artists, but especially to members of "The 14." To name a few, Sørensen painted three landscapes with Telemark as the focus; two landscapes from Telemark are central to Einar Sandberg's production; and Severin Grande exhibited five works from Telemark in 1911. Thorvald Erichsen had renewed the interest in the area in his art at the beginning of the century.
28. Sørensen, "Thorvald Erichsen og Oluf Wold-Torne": 251; repr. in Lange, *"Kommentar":* 32.
29. Hoff, "Norsk agrarpopulisme": 167.
30. Nilssen, "Ny utstilling av Edvard Munch."
31. Patricia G. Berman, "Edvard Munch's Peasants and the Invention of Norwegian Culture," in Berit I. Brown, ed., *Nordic Experiences: Exploration of Scandinavian Cultures* (Westport, Conn.: Greenwood Press, 1999): 230.
32. Nilssen, "Ny utstilling av

Edvard Munch."

33. L. W. B., "Edvard Munchs utstilling hos Blomqvist," *Morgenposten* (October 30, 1915).

34. Nilssen, "Ny utstilling av Edvard Munch."

35. Ibid. The National Gallery did not immediately purchase *High Summer*, supposedly because of insufficient funds; however, in 1915 it was purchased by Olaf Schou, who donated it to the National Gallery in 1916.

36. For more information on the model Munch used in his bathing images at this time, see Arne Eggum, *Munch og Hans Modeller: 1912–1943* (Oslo: Munch Museum, 1988): 34–35. For a discussion of Munch's male bathing images of 1907, see Patricia G. Berman, "Body and Body Politic in Edvard Munch's Bathing Men," in Kathleen Adler and Marcia Pointon, eds., *The Body Imaged: The Human Form and Visual Culture since the Renaissance* (Cambridge: Cambridge University Press, 1993): 71–83.

37. For an interesting comparison to Matisse, see the painting *Small Seated Nude* (c. 1909; Musée de Grenoble), illustrated in Judi Freeman, *The Fauve Landscape* (New York: Abbeville Press, 1990). 316, pl. 336. Arne Eggum compares Munch's pink shade to that of Renoir; see Heller, *Munch: Life and Work*: 249.

38. Kristian Haug, "Edv. Munch," *Aftenposten* (November 5, 1915).

39. Ibid.

40. "Munch som 'historiemaler,'" *Tidens Tegn* (November 3, 1915).

41. Hollænder, "Unterwegs."

42. Ibid.

43. Per Ksvold, "Fra Kunstforeningen. Edw. Munch," *Bergens Tidende* (February 26, 1916).

44. Finar Lexow, "Edvard Munch i Kunstforeningen," *Arbeidet* (February 12, 1916).

45. Ibid.

46. Ibid.

47. See Einar Lexow, "De 14," *Kunst og Kultur* 4, no. 3 (1914–15): 51–61.

48. As the war continued to interrupt normal business channels, foreign art dealers turned to the booming Scandinavian markets for sales. Officially, among museums, and, privately, among individual collectors, French art and culture was more than just a means of legitimacy; it also represented Norway's unofficial political allegiance. In 1916, Norway publicly shifted its economic policies to assist the Allied powers; Germany responded by tor-pedoing Norwegian boats. Political tensions strained, and in Norway public hostility toward Germany worsened. As he sought continued exposure throughout this political malaise, critics constantly compared Munch's new works to those from the 1890s, pitting the new against the old.

49. Nilssen, "Edvard Munchs store nye utstilling," *Dagbladet* (October 2, 1916).

50. [Carl Bang], "Edvard Munch," *Morgenbladet* (October 7, 1916).

51. Nilssen, "Edvard Munchs store nye utstilling." Nilssen was also taken with the lush scenes of the plowed fields around Ekely.

52. Letter from Richard Bergh, September 27, 1916, Munch Museum Archive. Also see letter from Bergh dated October 16, 1916. Due to the shortage of museum funds to purchase foreign art and Bergh's plan to defer the second half of the 6,000 kroner payment until the next year, the painting was not acquired by the Swedish National Museum until 1917.

53. I use the term *genius* here because it has been a commonplace in the literature since the publication of Stenersen, *Close-up of a Genius*.

54. Munch was mythologized extensively in the 1930s, which saw numerous publications celebrating his seventieth birthday, and in the 1940s after his death. See especially Jens Thiis, *Edvard Munch og hans samtid; Slekten, Livet og Kunsten Geniet,* (Oslo: Gyldendal Norsk Forlag, 1933), and Pola Gauguin, *Edvard Munch* (Oslo: Gyldendal Norsk Forlag, 1933); rev. 1946 (both eds. are appreciative defenses of Munch and his art). Also see Stenersen, *Close-up of a Genius*.

Edvard Munch: Plates

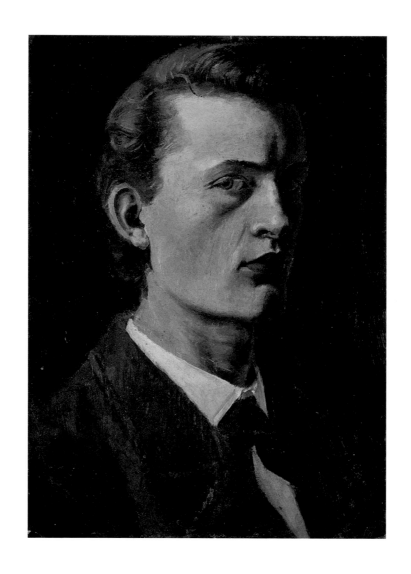

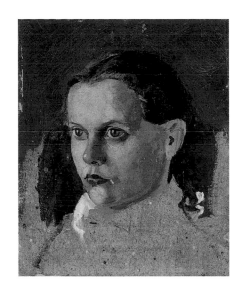

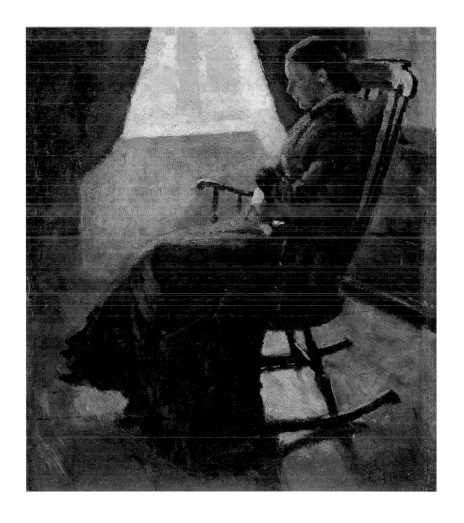

PLATE 2

Laura Munch. 1880–81

Oil on paper glued to board

7¹⁄₁₆ × 5⅞" (18 × 15 cm)

PLATE 3

Karen Bjølstad in the Rocking Chair. 1883

Oil on canvas

18½ × 16⅛" (47 × 41 cm)

PLATE 4
Interior with the Artist's Brother.
1883
Oil on cardboard
20¼ × 14" (51.5 × 35.5 cm)

PLATE 5
My Brother Studying Anatomy.
1883
Oil on cardboard
24⁷⁄₁₆ × 29½" (62 × 75 cm)

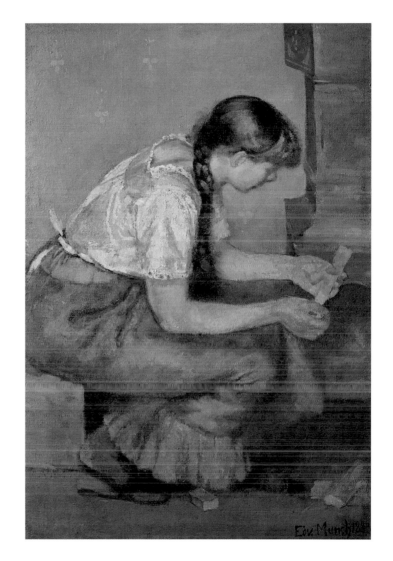

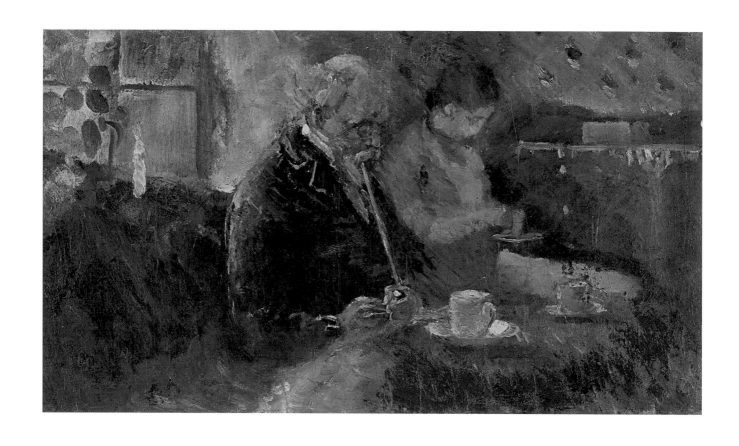

PLATE 9
At the Coffee Table. 1883
Oil on canvas
17¹³⁄₁₆ × 30⁵⁄₁₆" (45 × 77 cm)

PLATE 10
Tête-à-Tête. 1885
Oil on canvas
$26 \times 29^{15}/_{16}$" (66×76 cm)

85

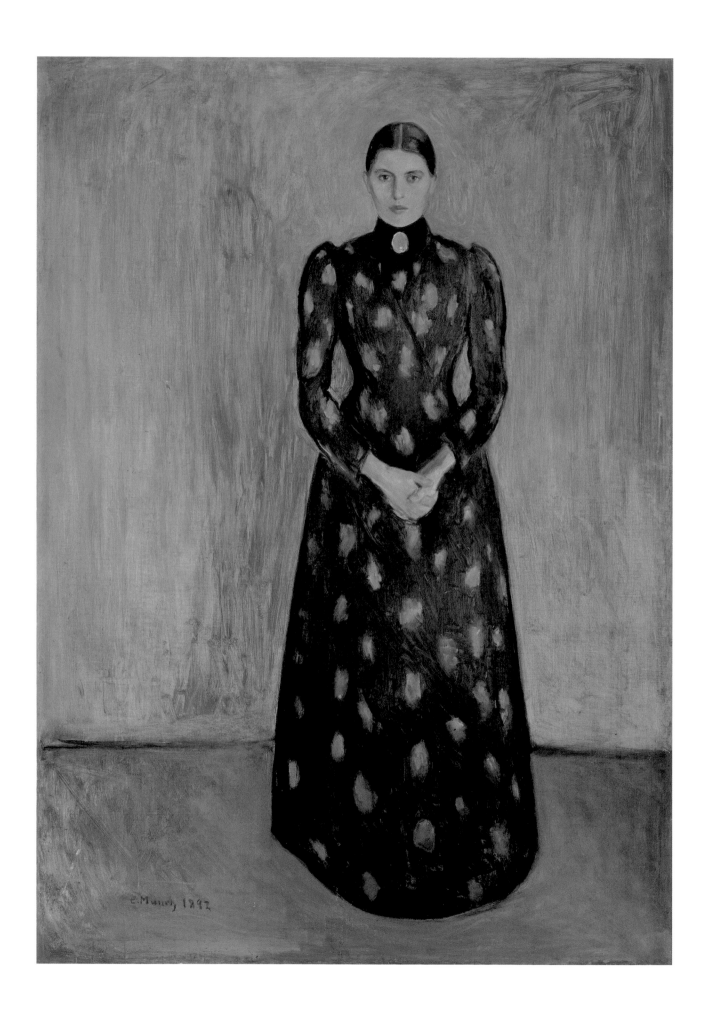

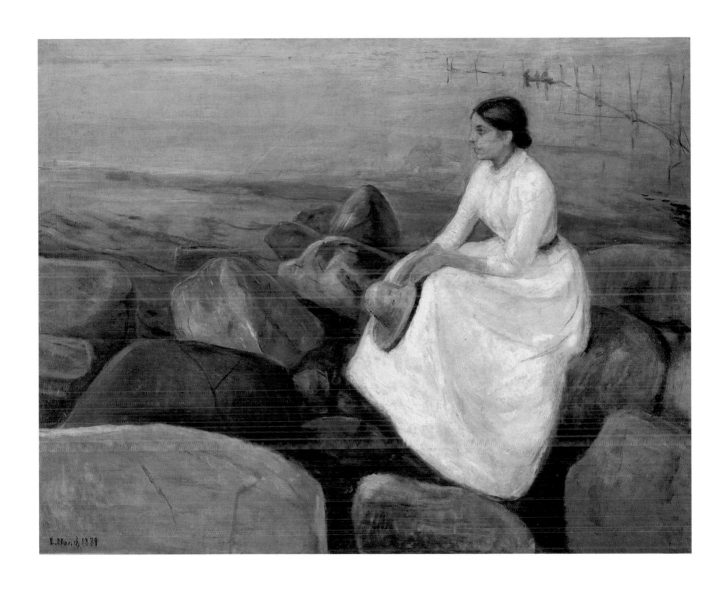

PLATE 11 (opposite)
The Artist's Sister Inger. 1892
Oil on canvas
67¹⁵⁄₁₆ × 48¼" (172.5 × 122.5 cm)

PLATE 12
Summer Night/Inger on the Beach. 1889
Oil on canvas
49¼ × 63¹¹⁄₁₆" (126.4 × 161.7 cm)

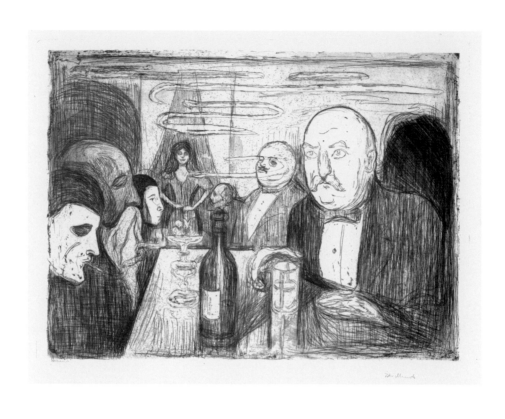

PLATE 13
Kristiania-Boheme II. 1895
Etching and drypoint
Plate: 11⅛ × 15⁷⁄₁₆" (29.5 × 39.2 cm)

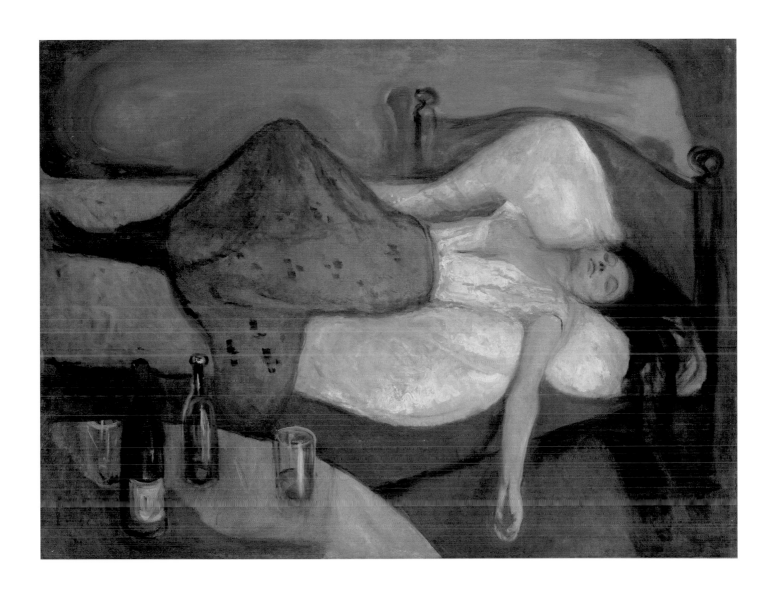

PLATE 14
The Day After. 1894–95
Oil on canvas
45¼ × 59¹³⁄₁₆" (115 × 152 cm)

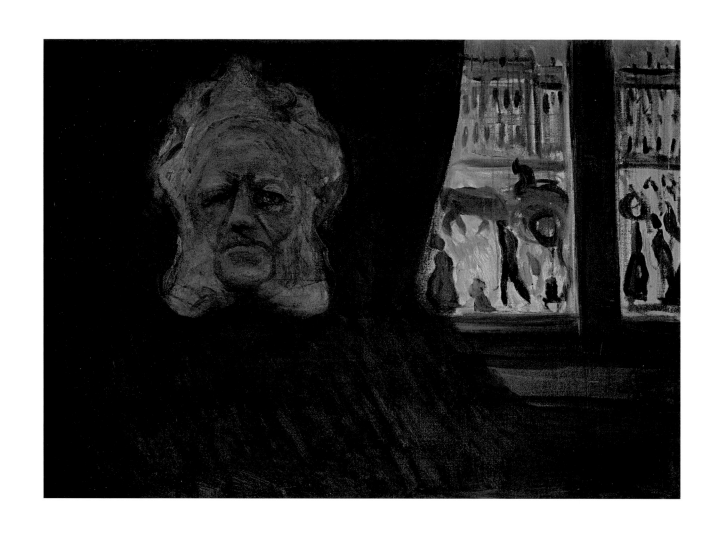

PLATE 15
Ibsen in the Grand Café. 1898
Oil on canvas
28⅜ × 39⅜" (72 × 100 cm)

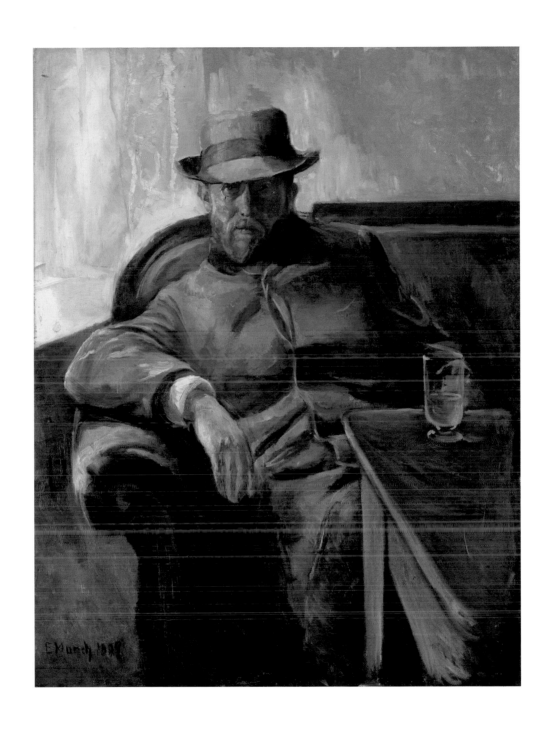

PLATE 16
Portrait of the Author
Hans Jæger. 1889
Oil on canvas
42¹⁵⁄₁₆ × 33¹⁄₁₆" (109 × 84 cm)

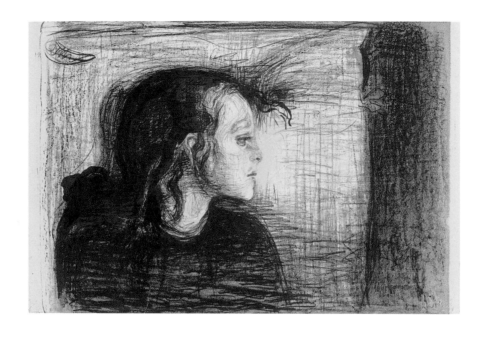

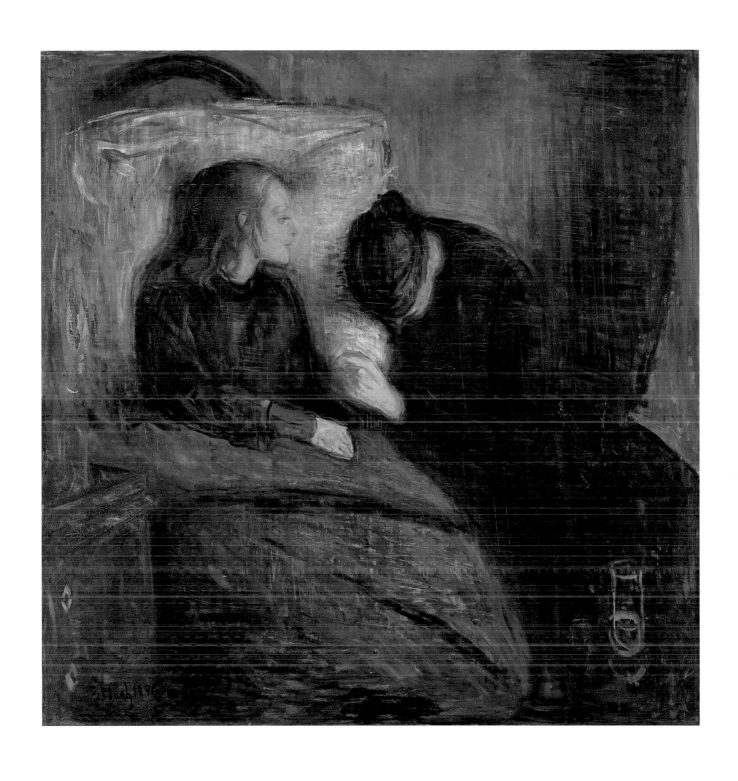

PLATE 18
The Sick Child. 1896
Oil on canvas
47¾ × 46½" (121.5 × 118.5 cm)

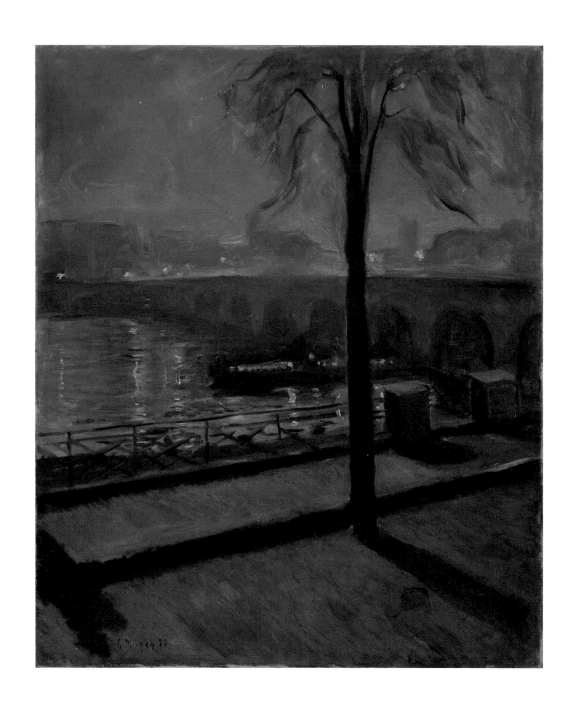

PLATE 19
The Seine at St. Cloud. 1890
Oil on canvas
24 × 19⅝" (61 × 49.8 cm)

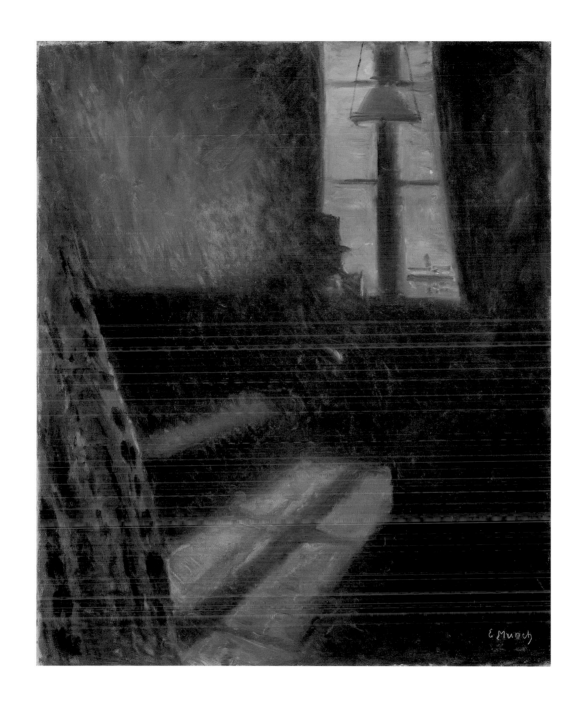

PLATE 20
Night in St. Cloud. 1890
Oil on canvas
25⅛ × 21¼" (64.5 × 54 cm)

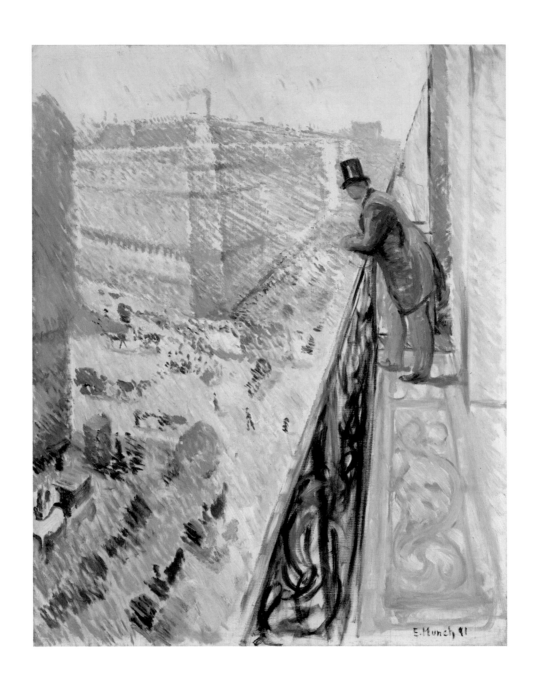

PLATE 21
Rue Lafayette. 1891
Oil on canvas
36¼ × 28¾" (92 × 73 cm)

96

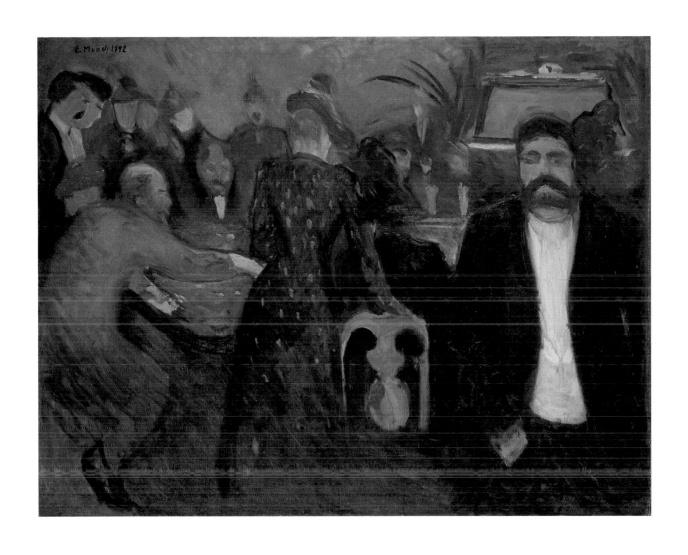

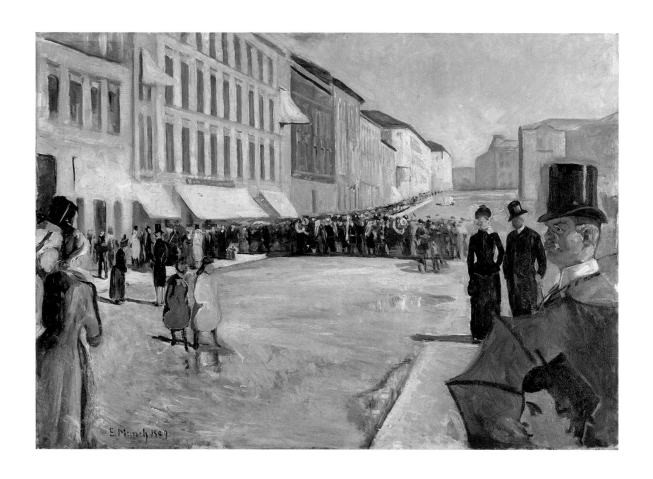

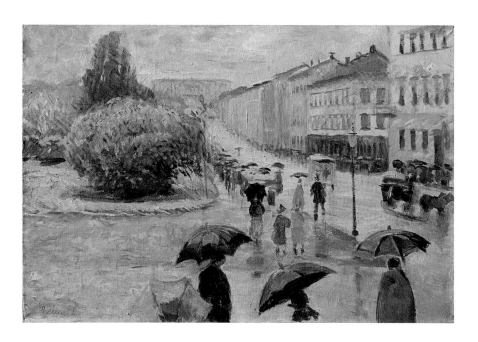

PLATE 23
*Military Band on
Karl Johan Street.* 1889
Oil on canvas
39¹⁵⁄₁₆ × 55⁵⁄₁₆" (101.5 × 140.5 cm)
(NOT IN EXHIBITION)

PLATE 24
Karl Johan Street in Rain. 1891
Oil on canvas
14¹⁵⁄₁₆ × 21⅝" (38 × 55 cm)

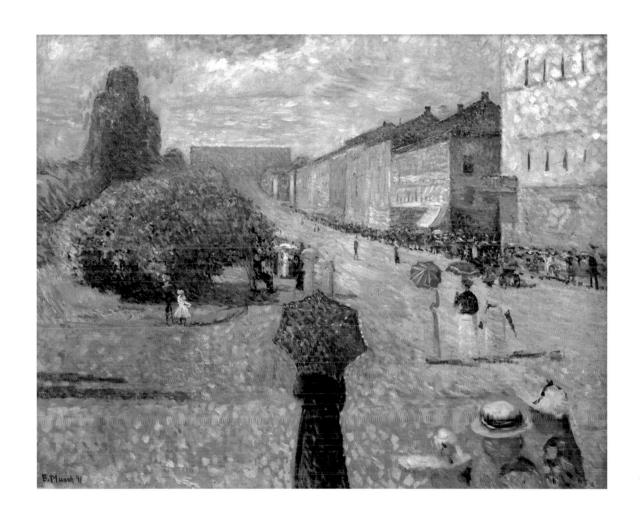

PLATE 25
Spring Day on Karl Johan Street. 1891
Oil on canvas
31½ × 39⅜" (80 × 100 cm)

PLATE 26
Stéphane Mallarmé. 1896
Lithograph
Comp.: 20½ × 11¼" (52.1 × 29.8 cm)

PLATE 27
August Strindberg. 1896
Lithograph
Sheet: 25½ × 19⁵⁄₁₆" (64.8 × 49 cm)

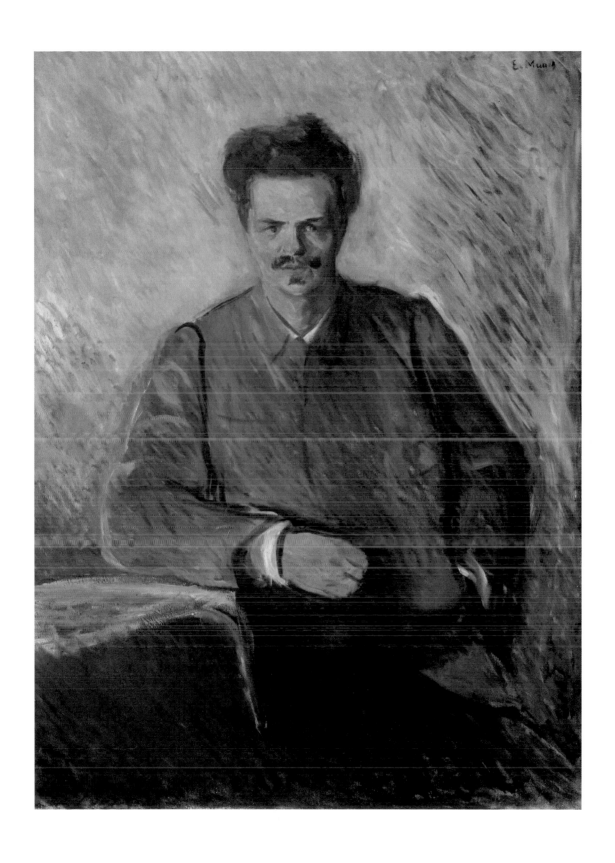

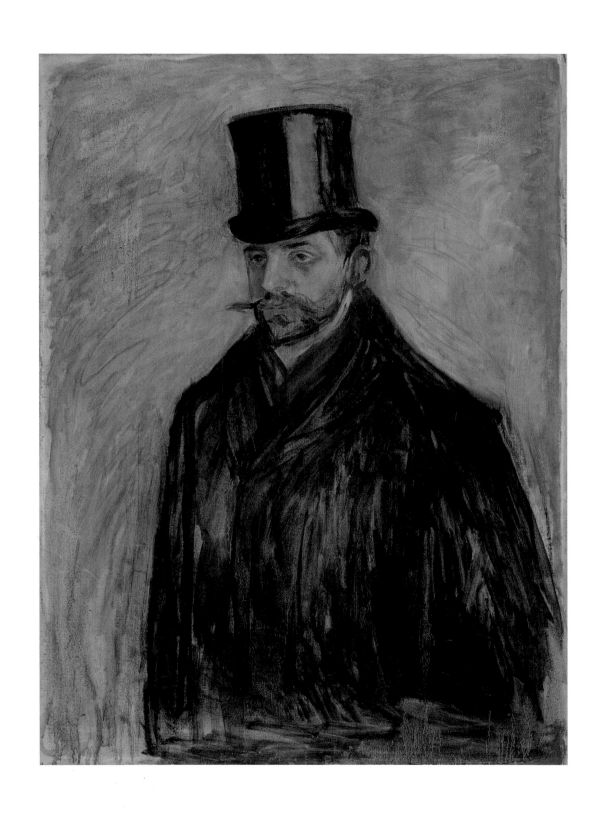

PLATE 29
Portrait of Julius Meier-Graefe. c. 1895
Oil on canvas
39⅛ × 29½" (100 × 75 cm)

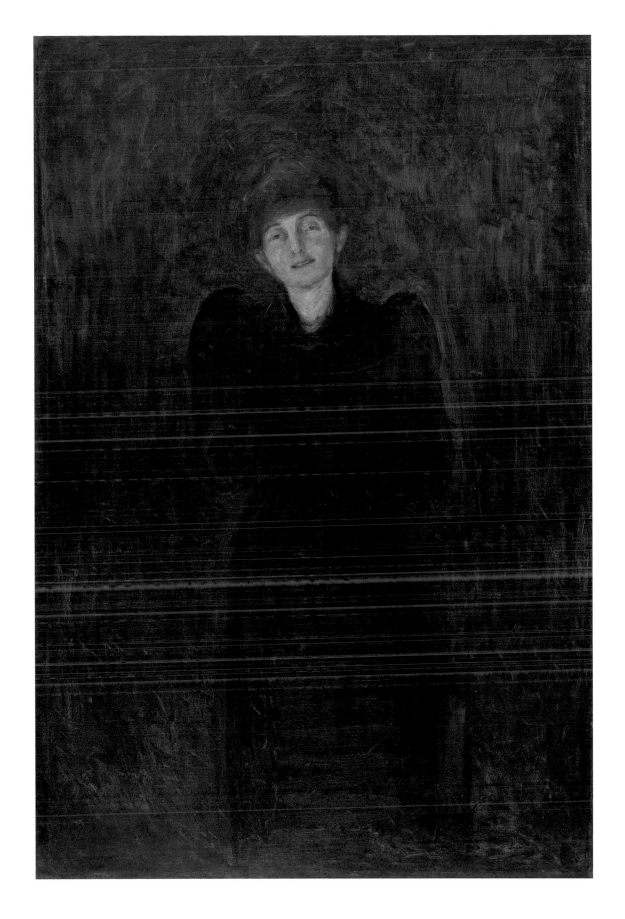

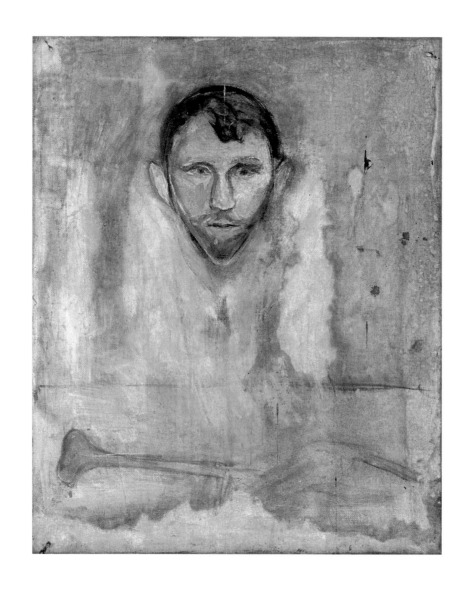

PLATE 31
Stanislaw Przybyszewski (with Skeleton Arm). 1893–94
Tempera on canvas
29½ × 23⅝" (75 × 60 cm)
(NOT IN EXHIBITION)

104

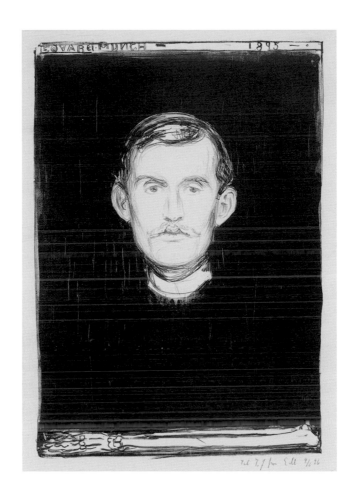

PLATE 32
*Self-Portrait (with
Skeleton Arm).* 1895
Lithograph
Comp.: 18 × 12⅛"
(45.7 × 32 cm)

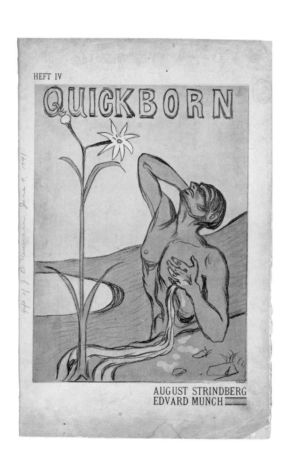

PLATE 33
Blossom of Pain, cover of the
journal *Quickborn.* 1899
Letter press and lithograph
Sheet: 12⅞ × 8⁷⁄₁₆" (32.7 × 21.5 cm)

PLATE 34
Blossom of Pain. 1898
Woodcut
Comp.: 17⁷⁄₁₆ × 13" (44.3 × 33 cm)

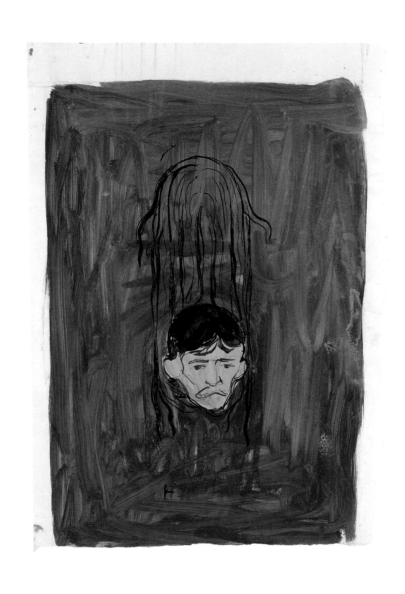

PLATE 36
Self-Portrait: Salome Paraphrase. 1894–98
Watercolor, india ink, and pencil on paper
18⅛ × 12¹³⁄₁₆" (46 × 32.6 cm)

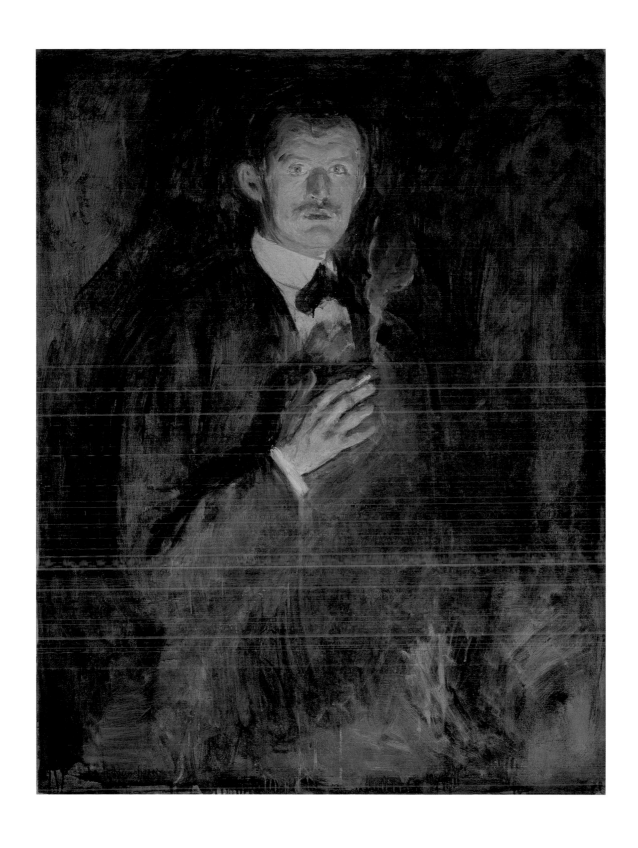

PLATE 38
The Voice/Summer Night. 1893
Charcoal on wove paper
19¹¹⁄₁₆ × 25½" (50 × 64.7 cm)

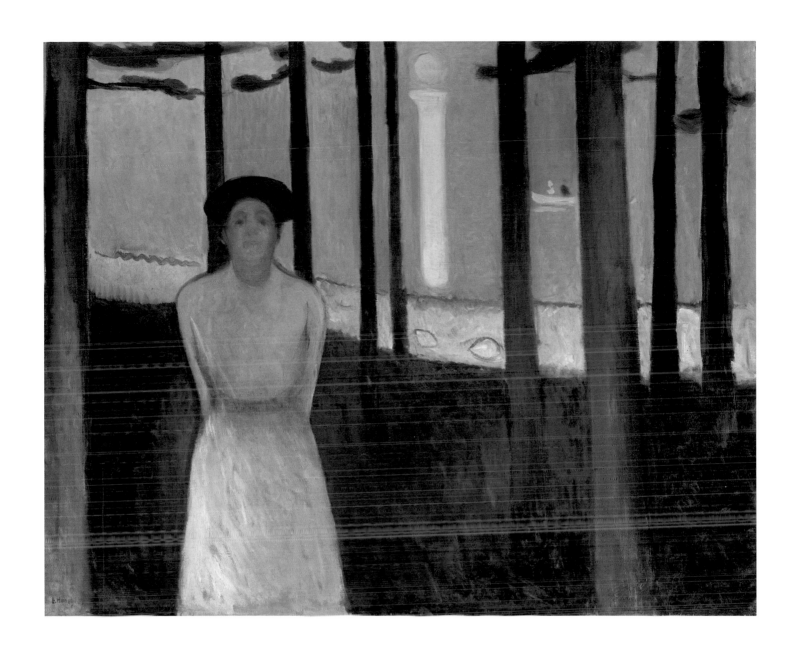

PLATE 39
Summer Night's Dream
(The Voice). 1893
Oil on canvas
34⅝ × 42½" (87.9 × 108 cm)

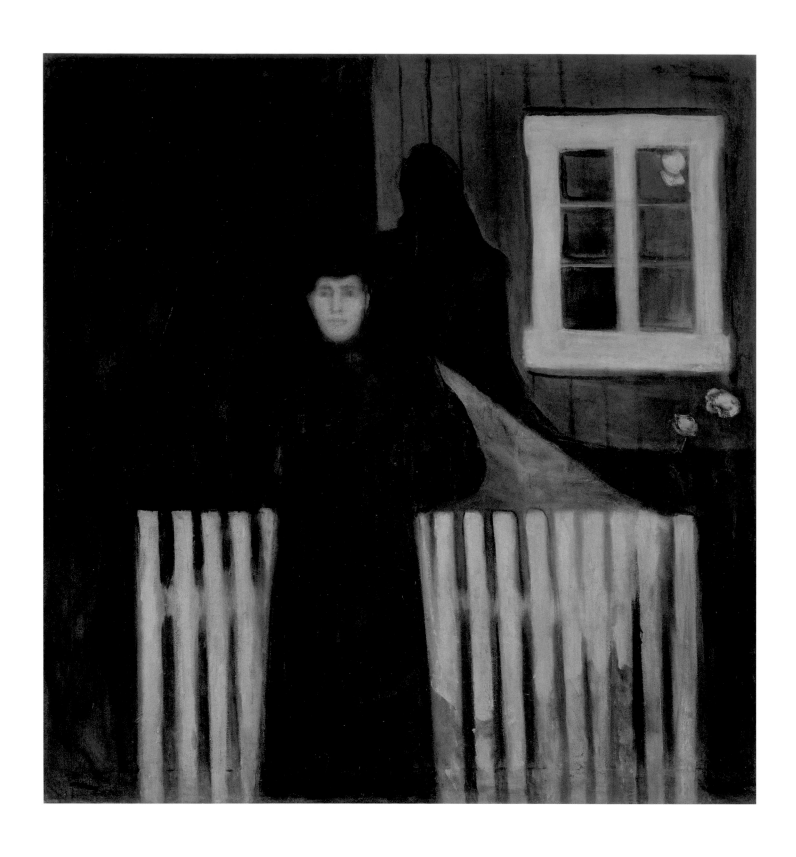

PLATE 40
Moonlight. 1893
Oil on canvas
55⁵⁄₁₆ × 53¹⁵⁄₁₆" (140.5 × 137 cm)

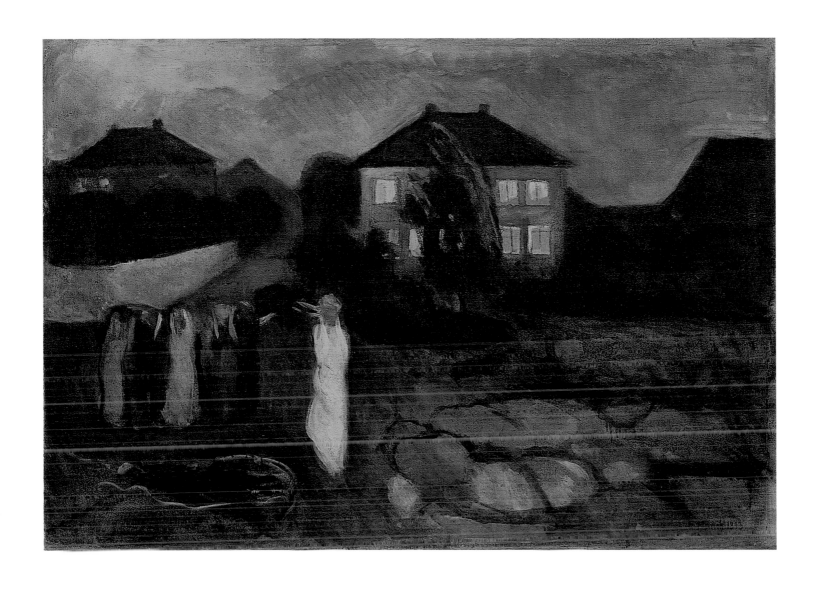

PLATE 41
The Storm. 1893
Oil on canvas
36⅛ × 51½" (91.8 × 130.8 cm)

113

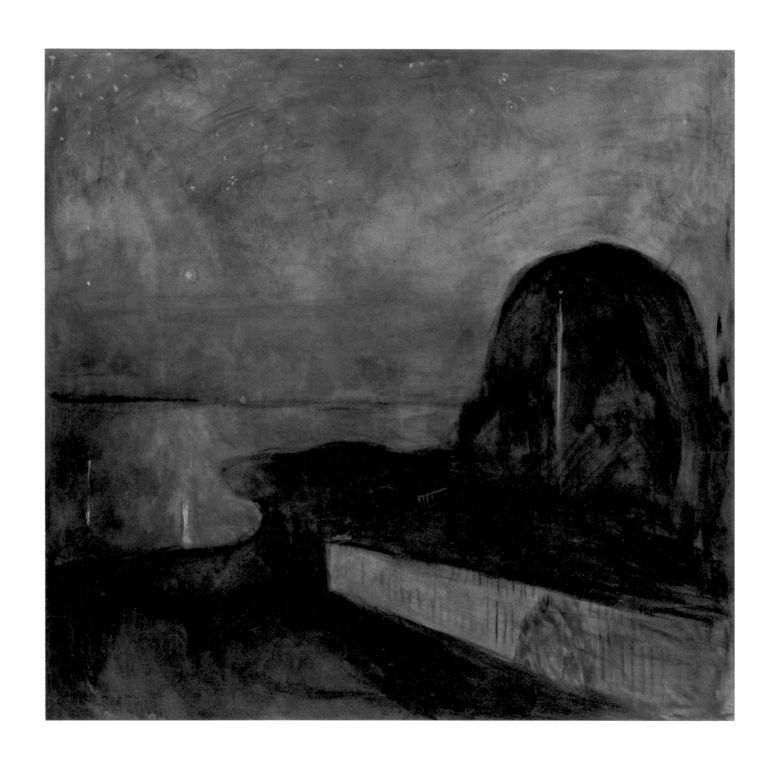

PLATE 42
Starry Night. 1893
Oil on canvas
53⅛ × 55⅛" (135.2 × 140 cm)
(NOT IN EXHIBITION)

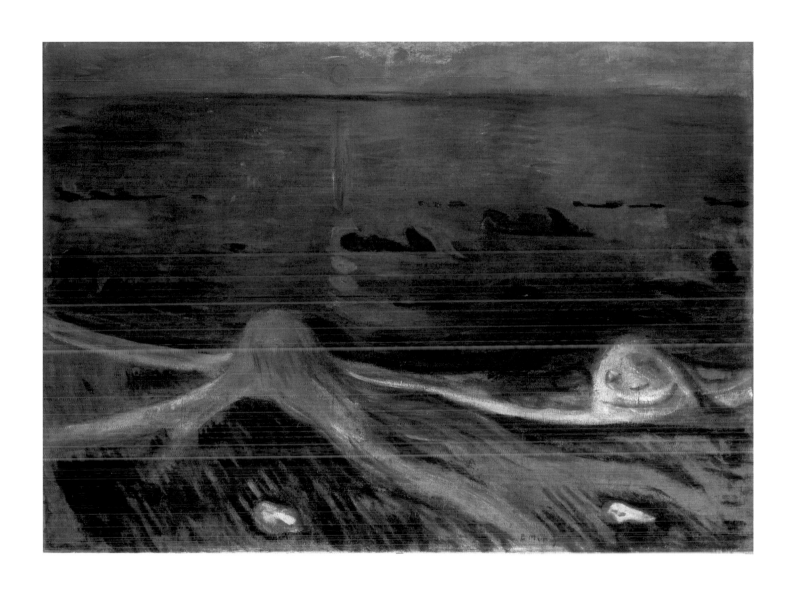

PLATE 43
Mystery of the Beach. 1892
Oil on canvas
39⅜ × 55⅛" (100 × 140 cm)

115

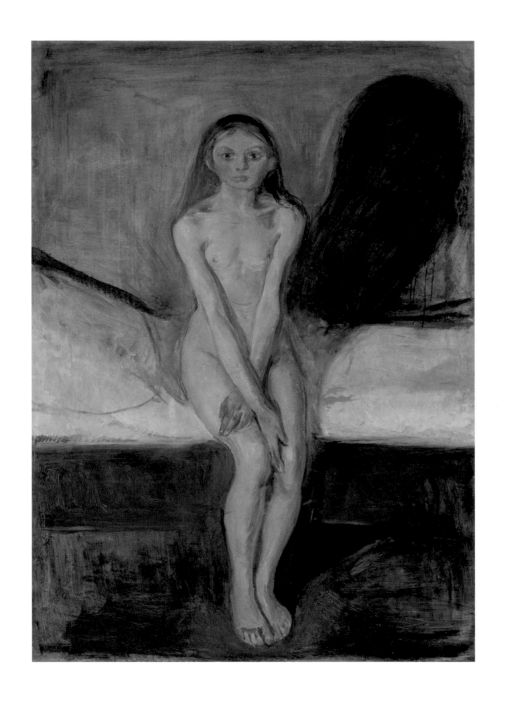

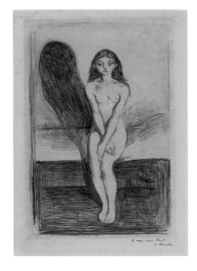

PLATE 44
Puberty. 1894–95
Oil on canvas
59⅛ × 43⁵⁄₁₆" (151.5 × 110 cm)
(NOT IN EXHIBITION)

PLATE 45
Puberty. 1894
Lithograph
Comp.: 16⅛ × 10¹¹⁄₁₆" (41 × 27.2 cm)

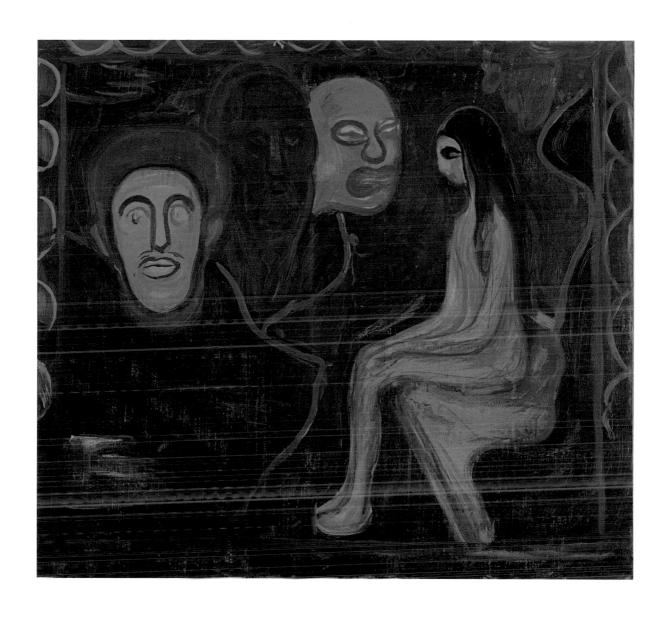

PLATE 46
*Young Girl with Three
Male Heads.* c. 1898
Oil on canvas
35⁷⁄₁₆ × 39⅛" (90 × 100 cm)

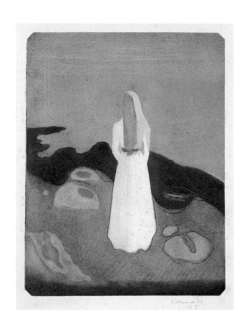

PLATE 47
*Young Woman on the Beach
(The Lonely One)*. 1896
Aquatint and drypoint with
graphite additions
Plate: 11⅛ × 8⅜" (28.3 × 21.3 cm)

118

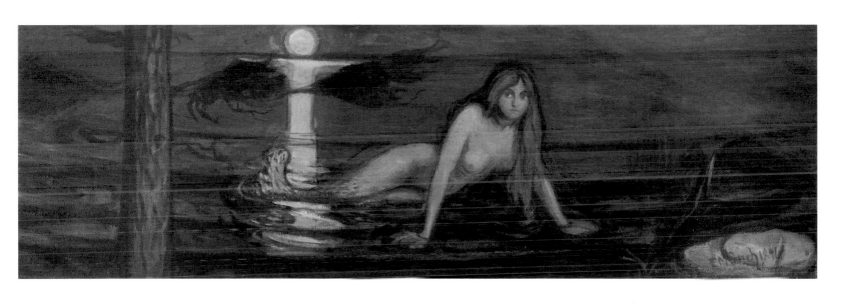

PLATE 48
Mermaid. 1896
Oil on canvas
39½" × 10' 6" (103 × 320 cm)

119

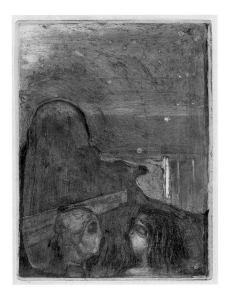

PLATE 49
The Kiss. 1892
Oil on canvas
28¼ × 36¼" (73 × 92 cm)

PLATE 50
Attraction I. 1895
Etching and drypoint with
watercolor additions
Plate: 12¹¹⁄₁₆ × 9¹³⁄₁₆" (32.3 × 25 cm)

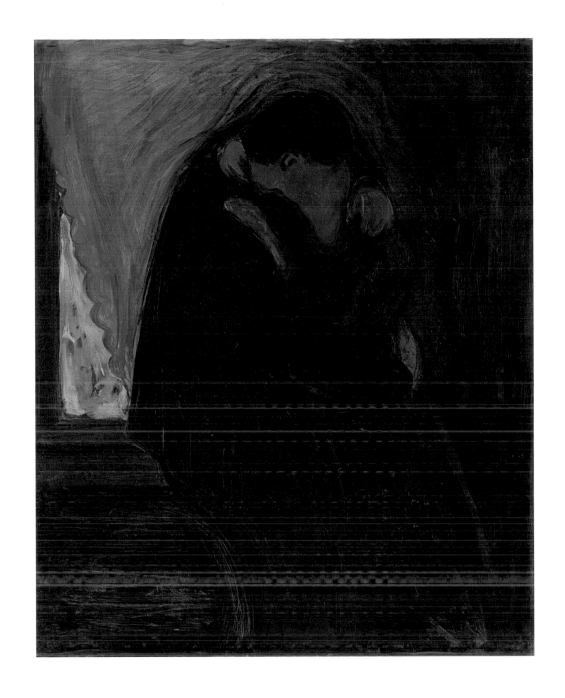

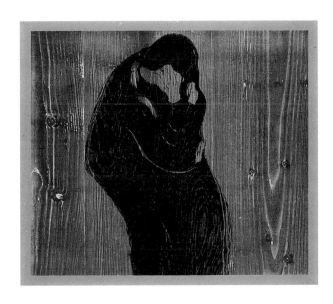

PLATE 51
The Kiss. 1897
Oil on canvas
39 × 31⅞" (99 × 81 cm)

PLATE 52
The Kiss III. 1898
Woodcut
Comp.: 15⅞ × 18¹⁄₁₆" (40.3 × 45.8 cm)

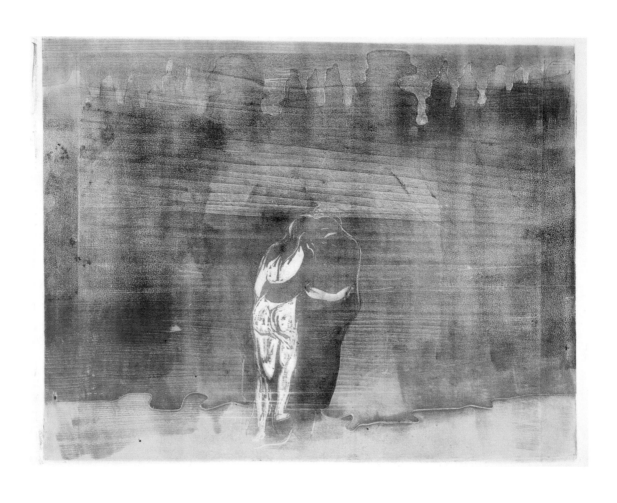

PLATE 53
Towards the Forest I. 1897
Woodcut
Comp.: 20⁷⁄₁₆ × 25⅝" (51.9 × 65.1 cm)

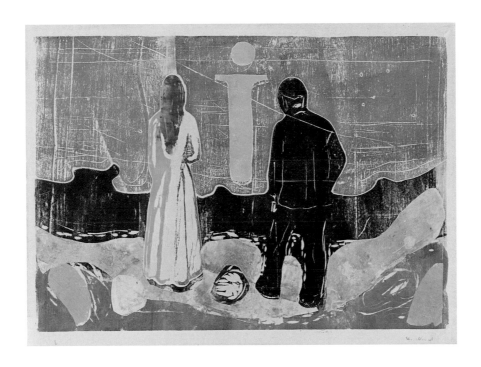

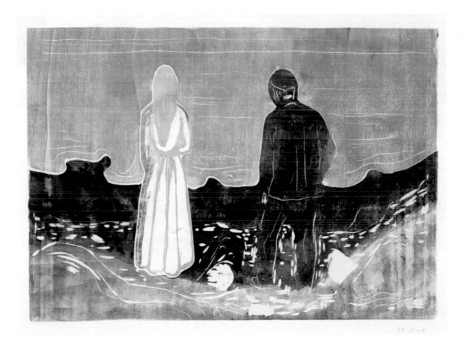

PLATE 54
Two Human Beings (The Lonely Ones). 1899
Woodcut
Comp.: 15½ × 21⅞" (39.4 × 55.5 cm)

PLATE 55
Two Human Beings (The Lonely Ones).
1899–1917
Woodcut
Comp.: 15⁹⁄₁₆ × 22" (39.5 × 55.9 cm)

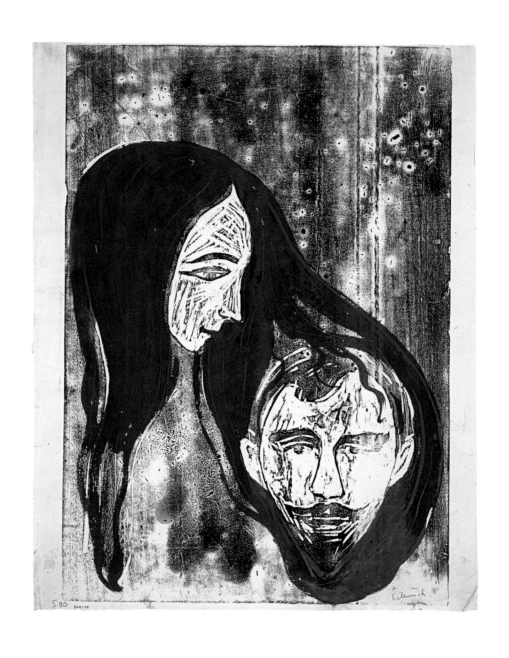

PLATE 56
Man's Head in Woman's Hair. 1896
Woodcut with watercolor additions
Comp.: 21⁷⁄₁₆ × 15⁵⁄₁₆" (54.5 × 38.5 cm)

124

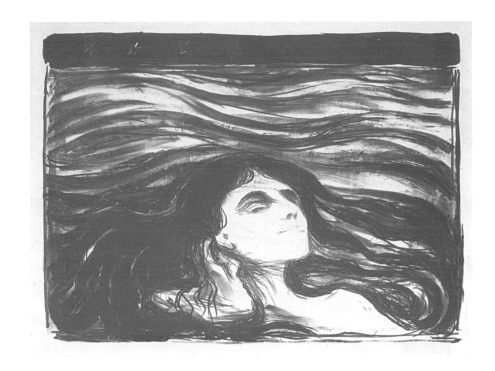

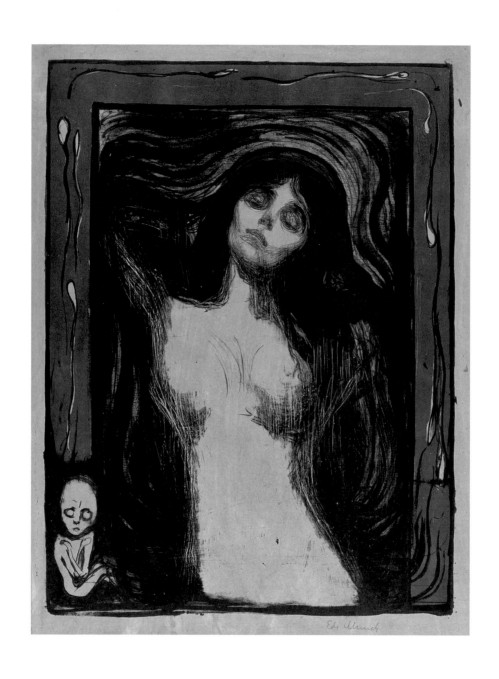

PLATE 59
Madonna. 1895–1902
Lithograph
Comp.: 23⅞ × 17%₆" (60.6 × 44.6 cm)

126

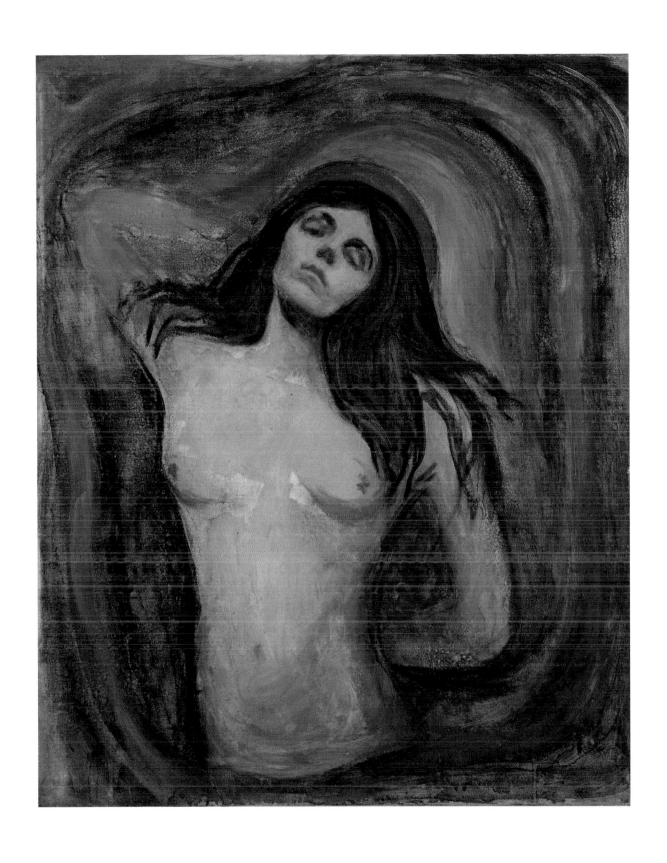

PLATE 60
Madonna. 1894–95
Oil on canvas
36⅝ × 29⅛" (93 × 74 cm)

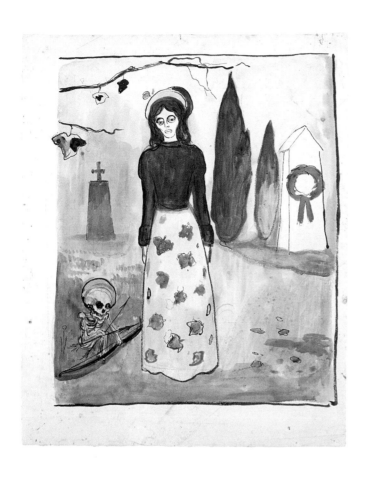

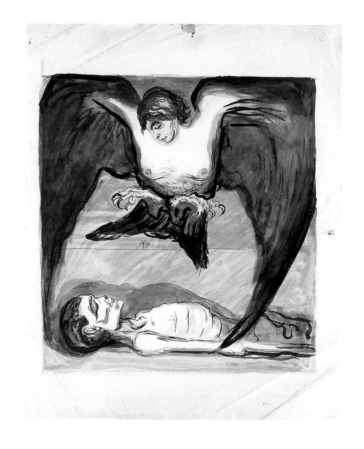

PLATE 61
Madonna at the Churchyard. 1896
India ink, watercolor, and crayon on paper
22 1/16 × 17 5/8" (56 × 44.8 cm)

PLATE 62
Harpy. 1898
India ink, watercolor, gouache, and crayon
on paper
21 15/16 × 17 5/8" (55.8 × 44.8 cm)

128

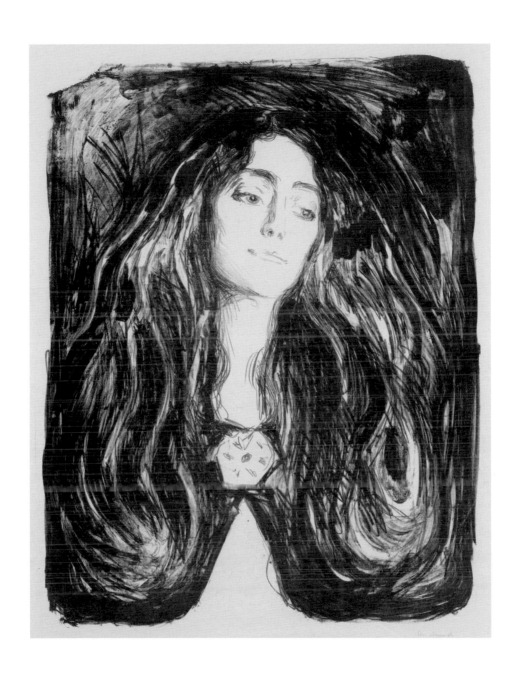

PLATE 63
The Brooch: Eva Mudocci. 1903
Lithograph
Comp. (irreg.): 23¼ × 18⅛"
(60.3 × 46.7 cm)

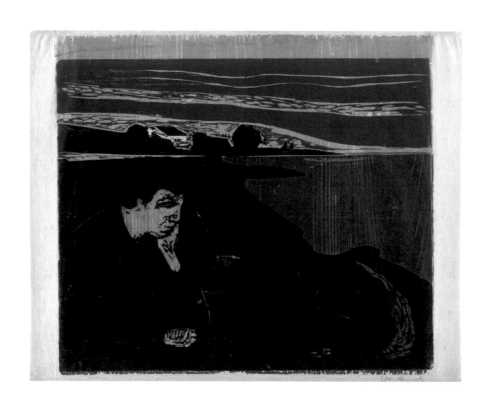

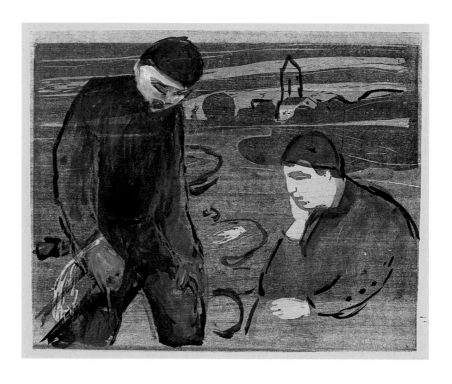

PLATE 64
Evening: Melancholy I. 1896
Woodcut
Comp.: 16¼ × 18" (41.2 × 45.7 cm)

PLATE 65
Melancholy III. 1902
Woodcut with watercolor additions
Comp.: 15⁵⁄₁₆ × 18½" (38.5 × 47 cm)

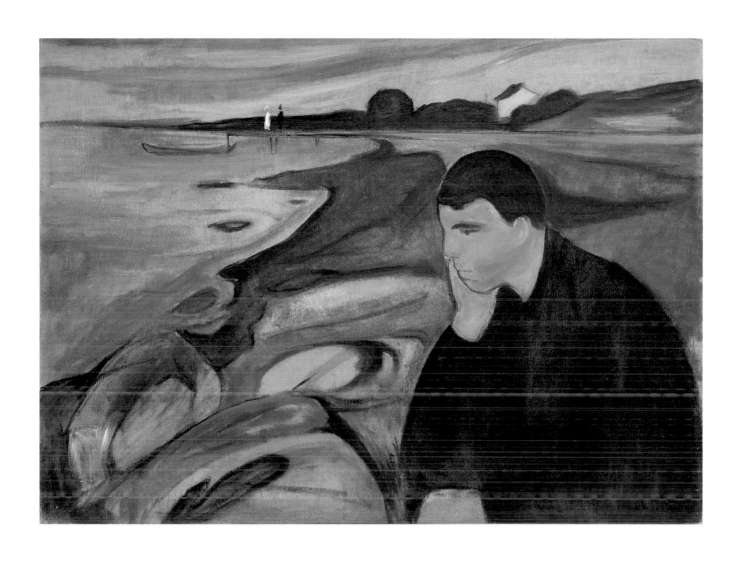

PLATE 66
Melancholy. 1891
Oil on canvas
28¼ × 38½" (72 × 98 cm)

131

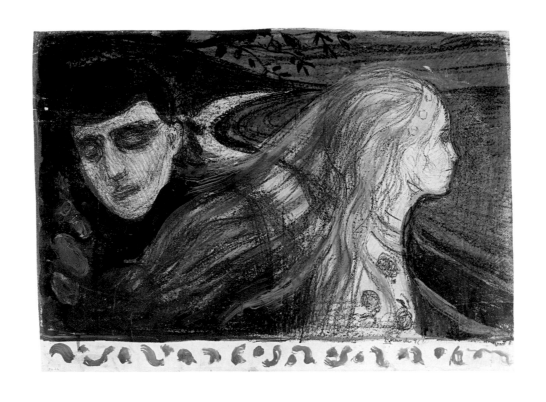

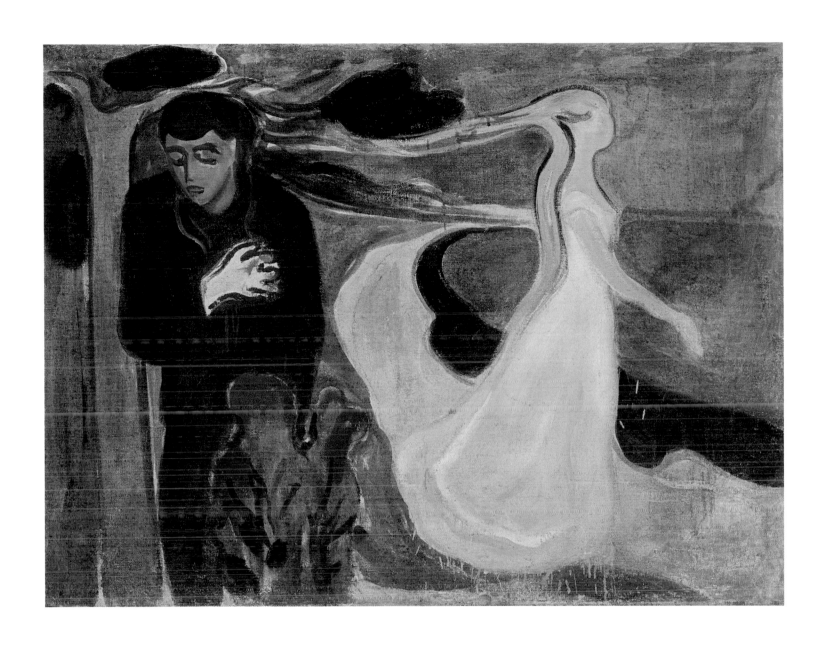

PLATE 68
Separation. 1896
Oil on canvas
38 × 50" (96.5 × 127 cm)

133

PLATE 69
Ashes I (upper part). 1896
Lithograph with watercolor
additions
7¹³⁄₁₆ × 16⁷⁄₁₆" (19.5 × 41.8 cm)

PLATE 70
Ashes I (lower part). 1896
Lithograph with watercolor
additions
11¾ × 16⅜" (29.8 × 41.6 cm)

PLATE 71
The Maiden and the Heart.
Separation. Salome. 1895–96
Pencil and india ink on paper
9¹³⁄₁₆ × 23¼" (25 × 59 cm)

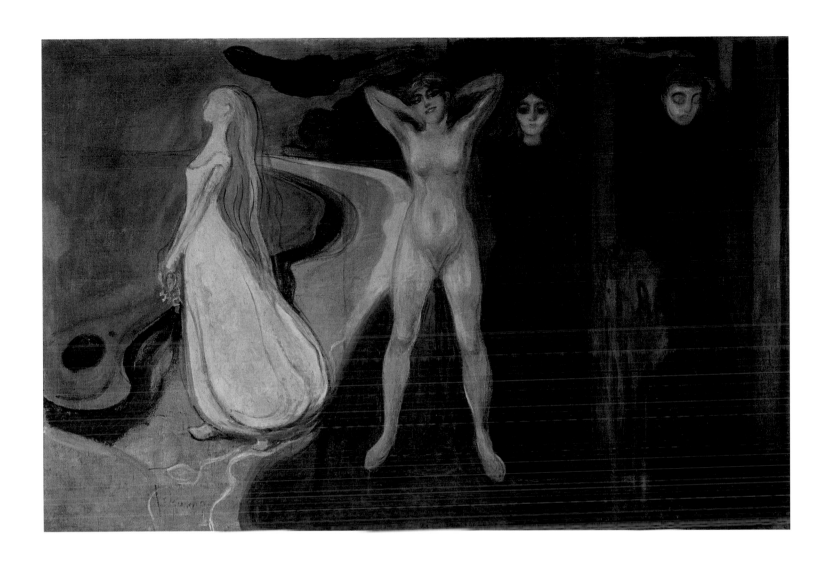

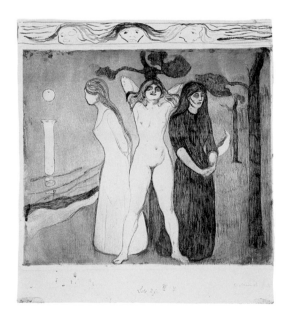

PLATE 72
The Woman in Three Stages. 1894
Oil on canvas
64⁹⁄₁₆ × 98⁷⁄₁₆" (164 × 250 cm)
(NOT IN EXHIBITION)

PLATE 73
The Woman II. 1895
Aquatint and drypoint with gouache
and watercolor additions
Sheet: 14⅞ × 13½" (37.8 × 34.3 cm)

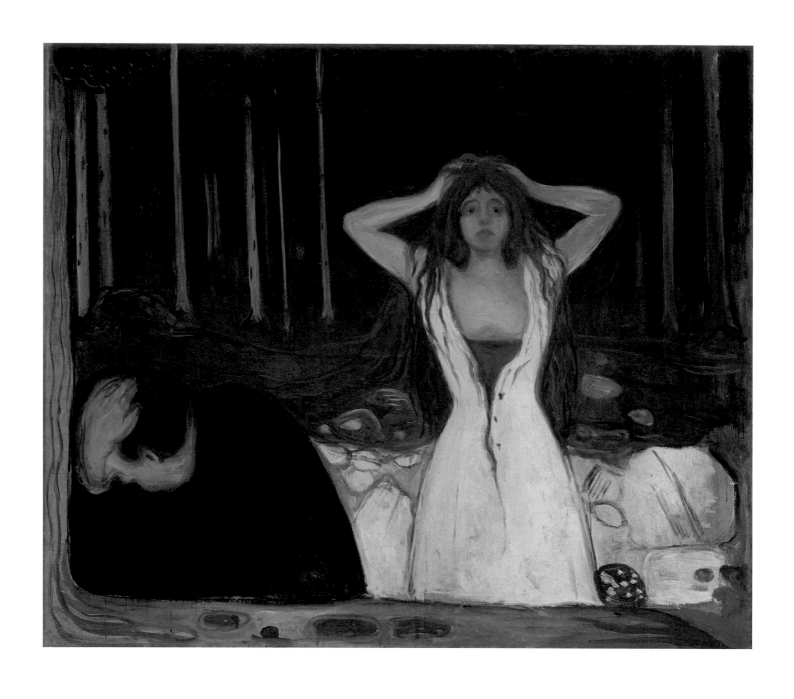

PLATE 74
Ashes. 1894
Oil on canvas
47⁷⁄₁₆ × 55½" (120.5 × 141 cm)

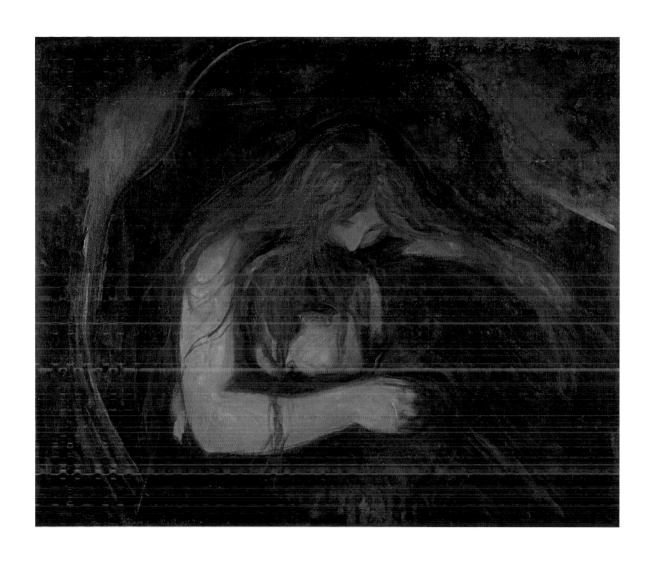

PLATE 75
Vampire. 1893–94
Oil on canvas
35¼ × 42⅞" (91 × 109 cm)

137

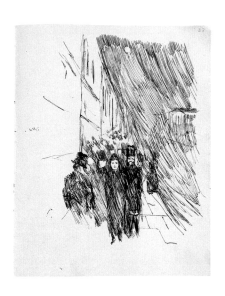

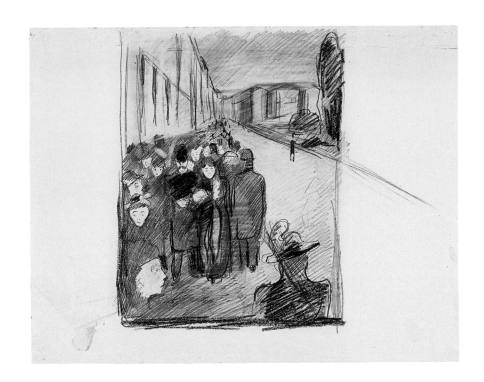

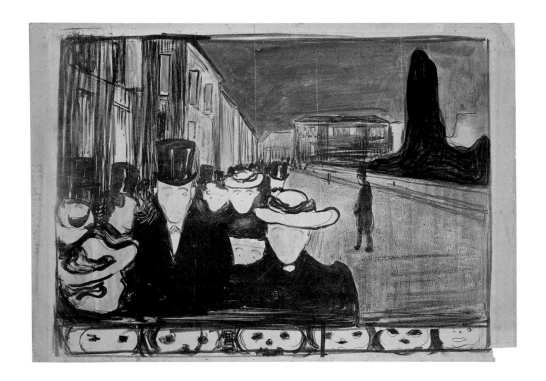

PLATE 76
Street Scene. 1889
Ink on paper (from the illustrated diary)
8¼ × 6⁹⁄₁₆" (21 × 16.6 cm)
(NOT IN EXHIBITION)

PLATE 77
Scene from Karl Johan Street. 1889
Pencil and crayon on paper
14⁹⁄₁₆ × 18½" (37 × 47 cm)

PLATE 78
Evening on Karl Johan Street. 1896–97
Unique lithograph with watercolor additions
Sheet: 21¹⁄₁₆ × 26¹⁵⁄₁₆" (53.5 × 68.5 cm)

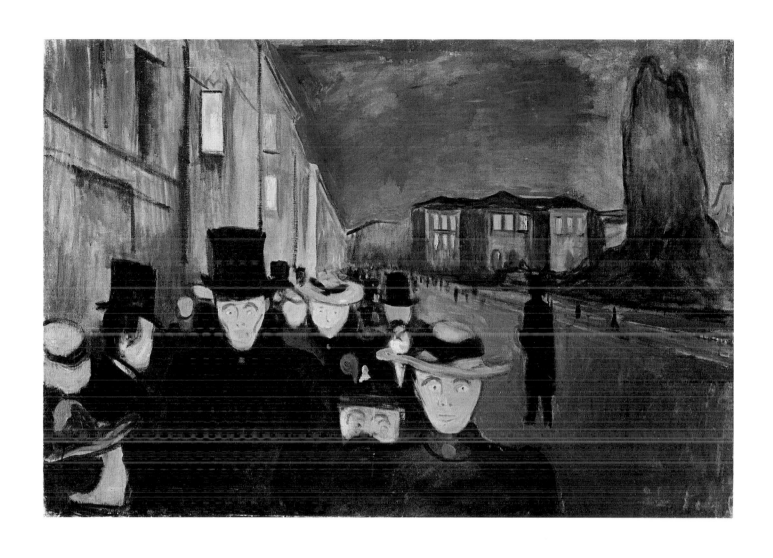

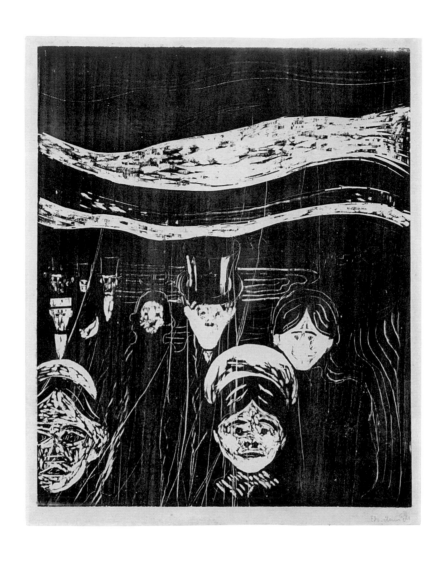

PLATE 80
Angst. 1896
Woodcut
Sheet: 19⅜₁₆ × 15¼"
(49 × 40 cm)

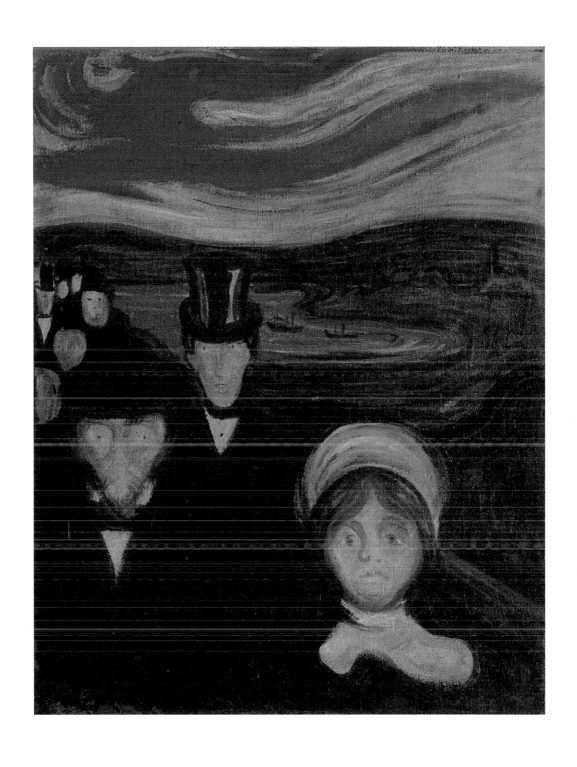

PLATE 81
Angst. 1894
Oil on canvas
37 × 29⅛" (94 × 74 cm)

141

PLATE 82
Despair. 1891–92
Charcoal and oil on paper
14⁹⁄₁₆ × 16⅝" (37 × 42.2 cm)

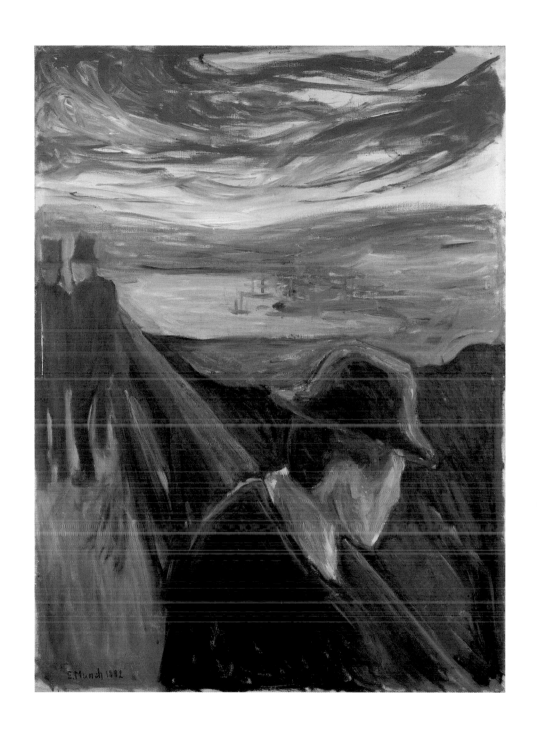

PLATE 83
Despair. 1892
Oil on canvas
36¼ × 26½" (92 × 67 cm)

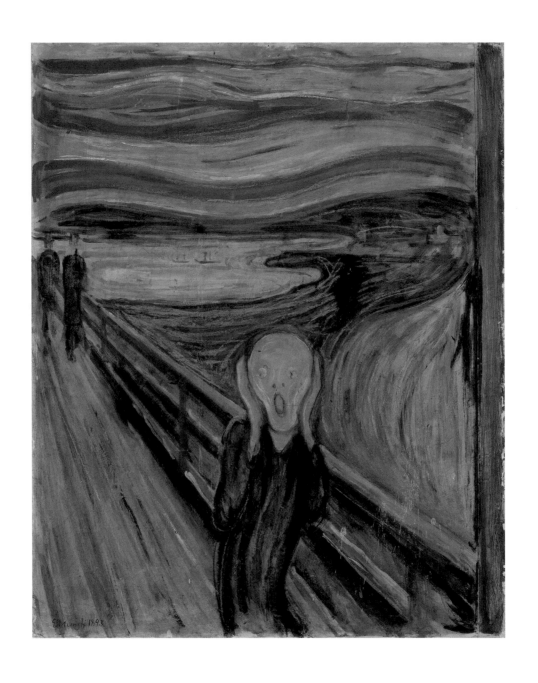

PLATE 84
The Scream. 1893
Tempera and oil on cardboard
35¹³⁄₁₆ × 28¹⁵⁄₁₆" (91 × 73.5 cm)
(NOT IN EXHIBITION)

144

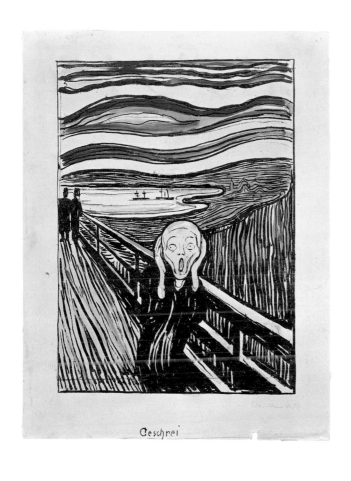

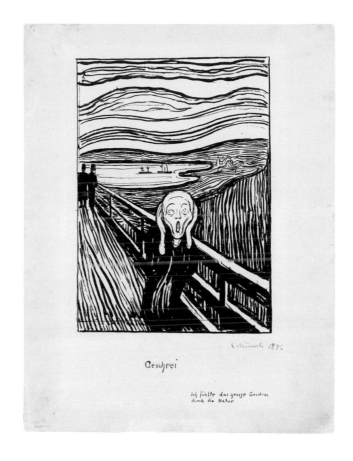

PLATE 85
The Scream. 1895
Lithograph with watercolor additions
Sheet: 17 × 12¹³⁄₁₆" (43.2 × 32.5 cm)

PLATE 86
The Scream. 1895
Lithograph
Sheet: 20¹¹⁄₁₆ × 15⅞" (52.5 × 40.3 cm)

145

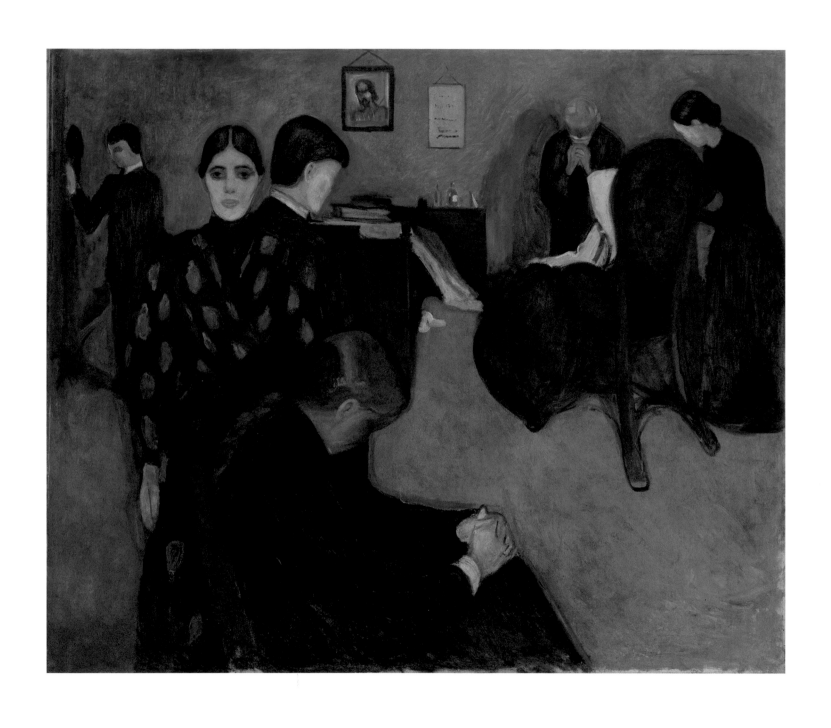

PLATE 87
Death in the Sick Room. 1893
Oil on canvas
53⁹⁄₁₆ × 63" (136 × 160 cm)

146

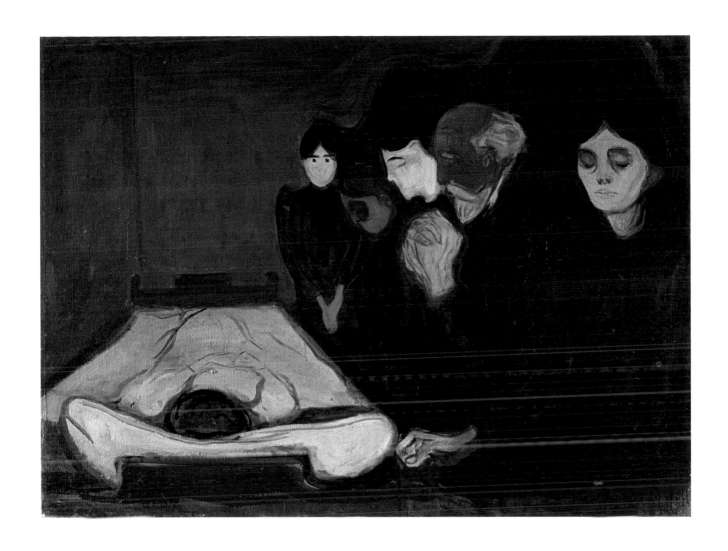

PLATE 88
By the Deathbed. 1895
Oil on canvas
35½ × 47⁷⁄₁₆" (90.2 × 120.5 cm)

PLATE 89
By the Deathbed. 1896
Lithograph
Comp.: 15⅝ × 19¹¹⁄₁₆ (39.7 × 50 cm)

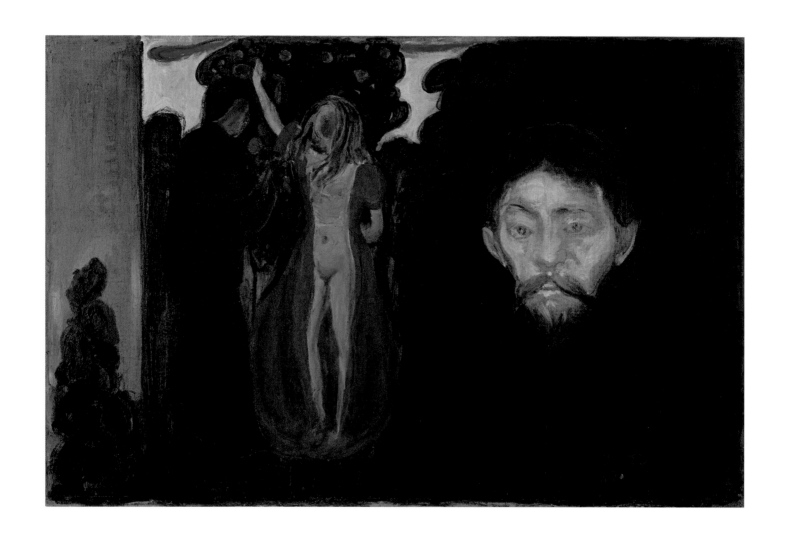

PLATE 90
Jealousy. 1895
Oil on canvas
26¼ × 39¼" (66.8 × 100 cm)
(NOT IN EXHIBITION)

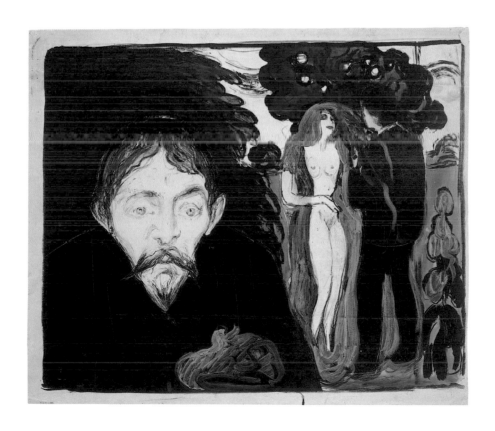

PLATE 92
Jealousy II. 1896
Lithograph with gouache and
watercolor additions
Sheet: 22 1/16 × 24 1/8" (56 × 61.2 cm)

PLATE 91
Jealousy. c. 1896
Charcoal and pastel on paper
16 1/2 × 22" (41.9 × 55.9 cm)

149

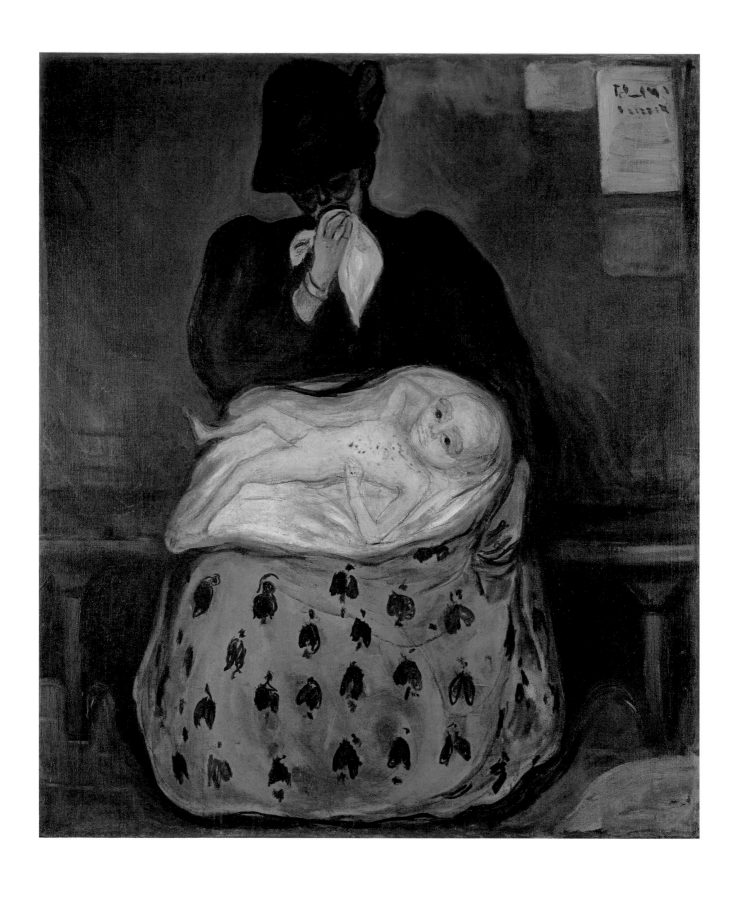

PLATE 93
Inheritance I. 1897–99
Oil on canvas
55½ × 47¼" (141 × 120 cm)

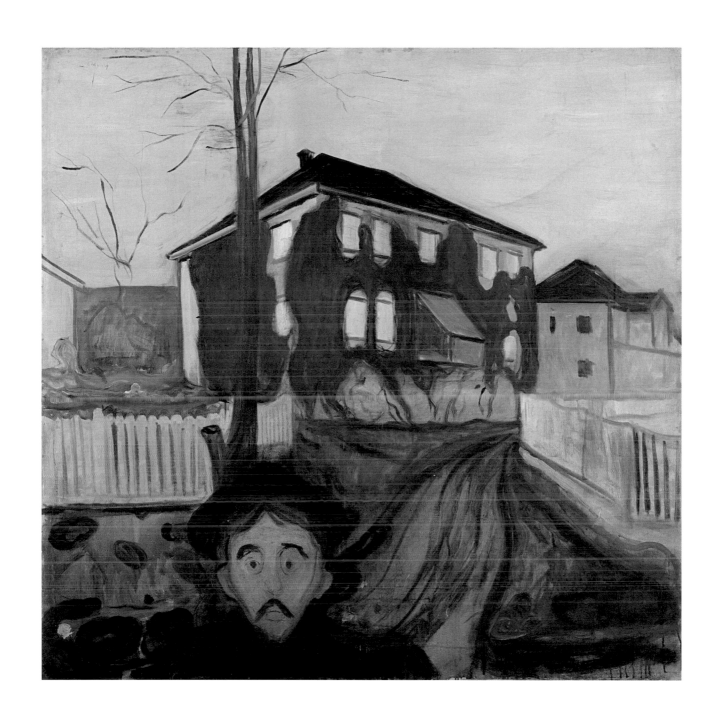

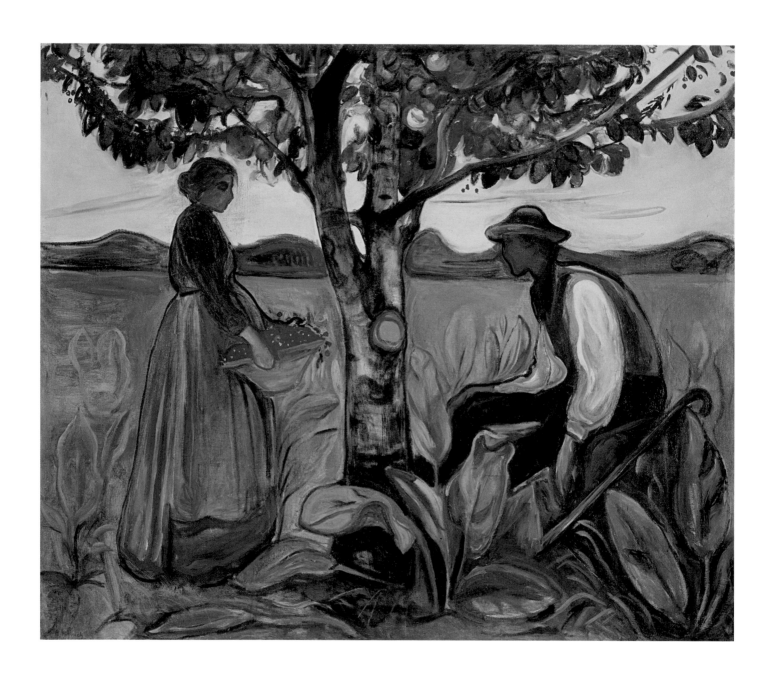

PLATE 95
Fertility. 1898
Oil on canvas
47¼ × 55⅛" (120 × 140 cm)

PLATE 96 (*opposite*)
Metabolism. 1899
Oil on canvas
68⅞ × 56⁵⁄₁₆" (175 × 143 cm)

152

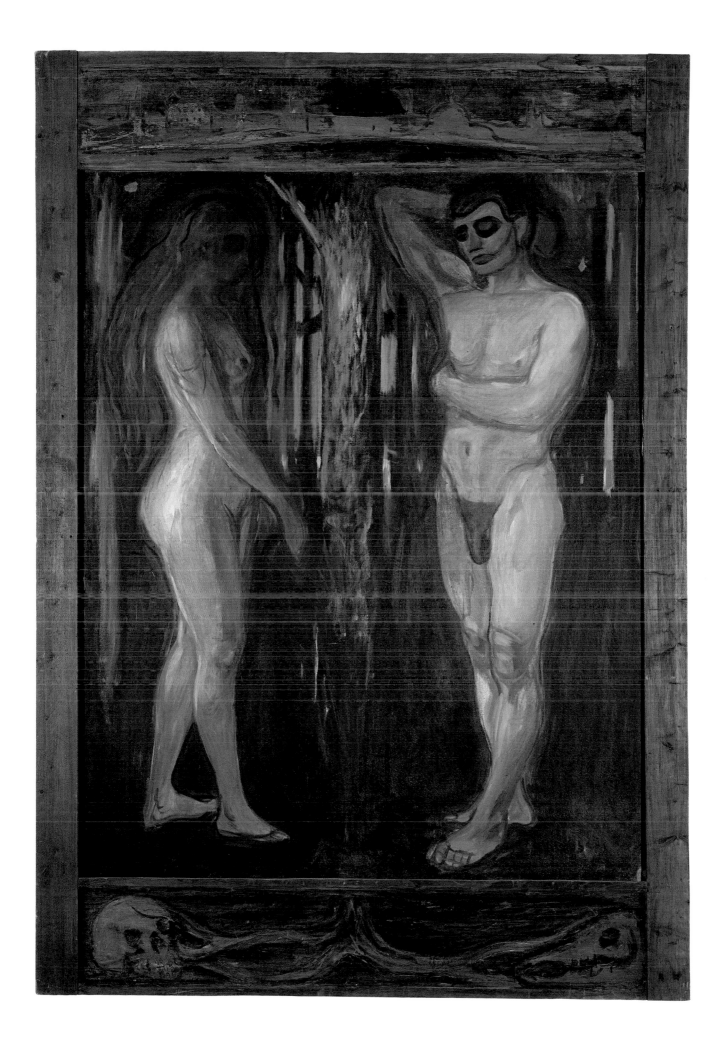

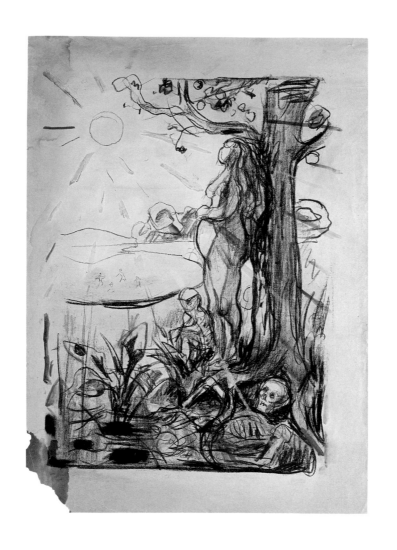

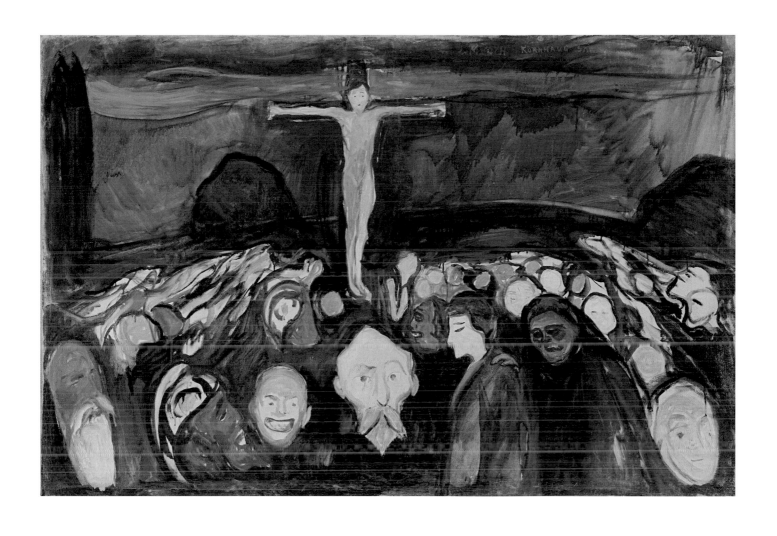

PLATE 98
Golgotha. 1900
Oil on canvas
31½ × 47¼" (80 × 120 cm)

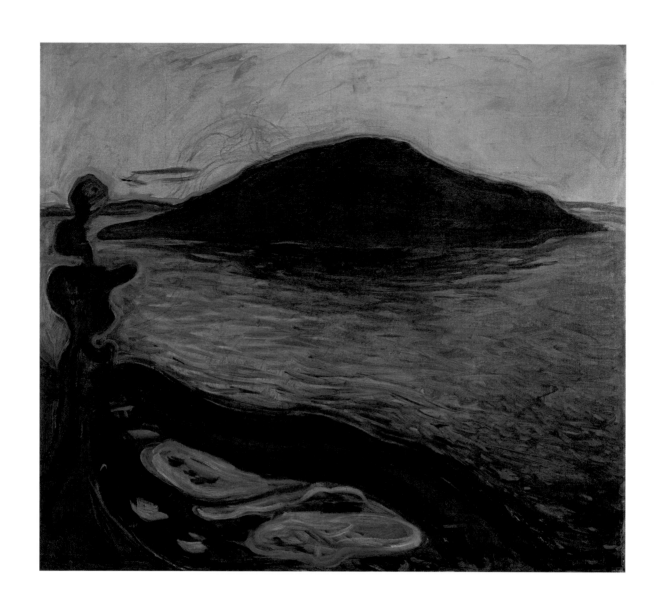

PLATE 99
The Island. 1900–01
Oil on canvas
39 × 42½" (99 × 108 cm)

156

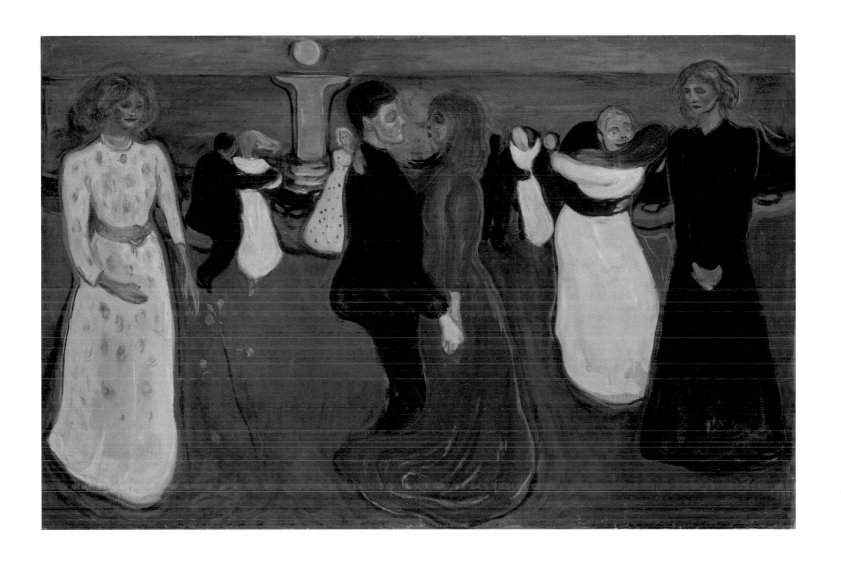

PLATE 102
Girls on the Pier. c. 1901
Oil on canvas
53⁵⁄₁₆ × 49¹⁄₁₆" (136 × 125 cm)

PLATE 103
Portrait of Ludvig Meyer's Children:
Eli, Rolf, and Karl. 1894
Oil on canvas
41³⁄₁₆ × 48⅞" (105 × 124.2 cm)

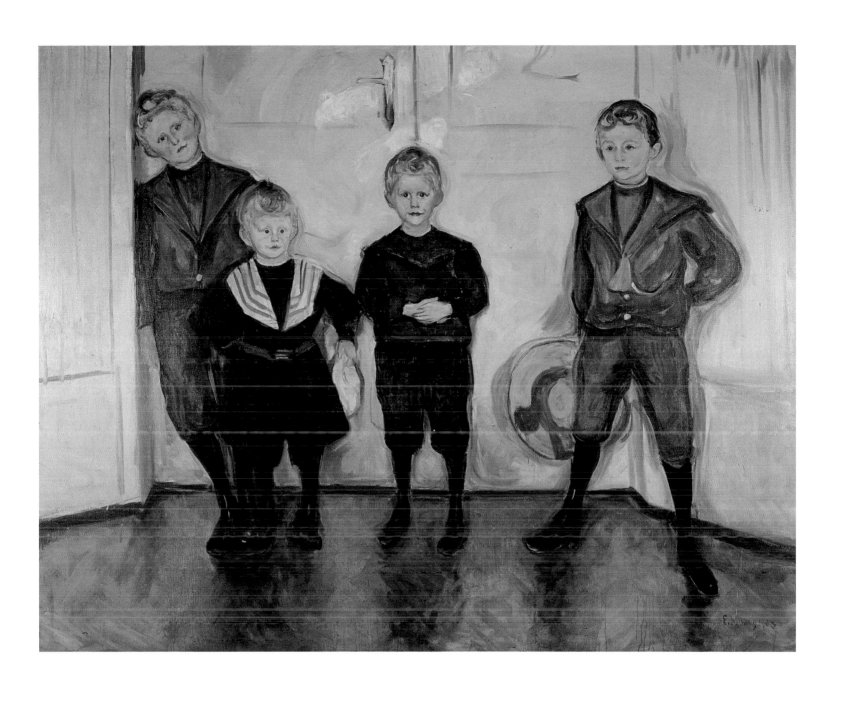

PLATE 104
The Four Sons of Dr. Linde. 1903
Oil on canvas
56¹¹⁄₁₆ × 78⁹⁄₁₆" (144 × 199.5 cm)

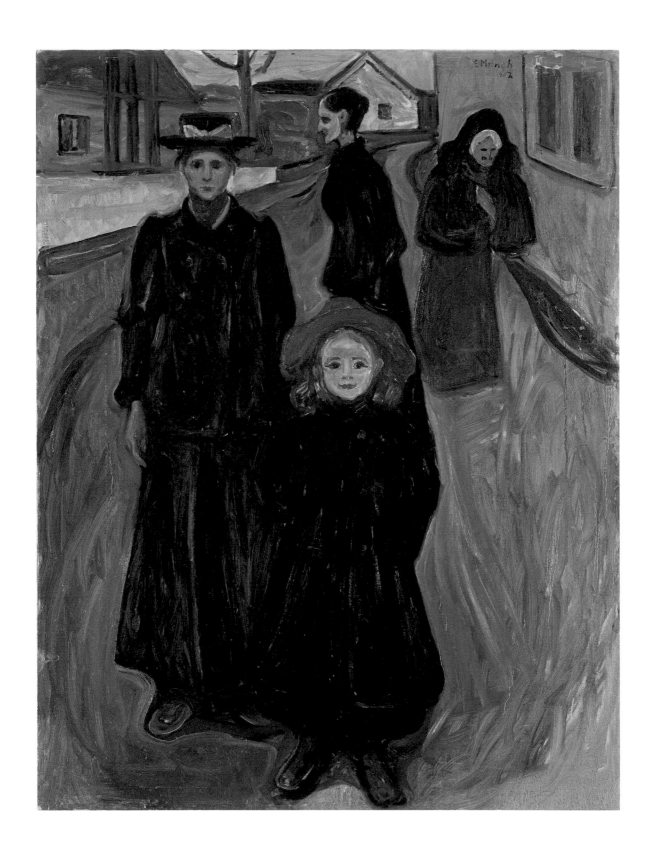

PLATE 105
Four Ages of Life. 1902
Oil on canvas
51⁵⁄₁₆ × 39½" (130.4 × 100.4 cm)

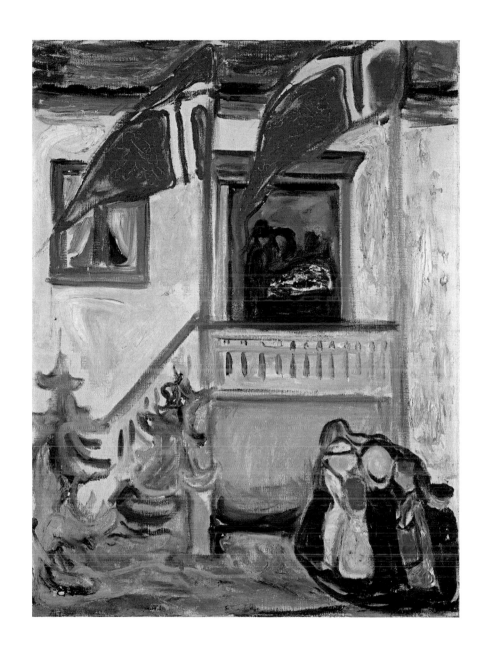

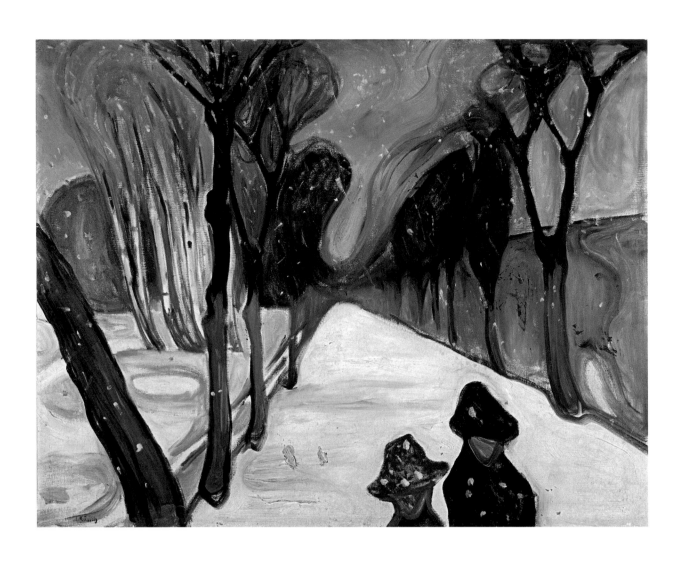

PLATE 107
The Avenue in Snow. 1906
Oil on canvas
31⅛ × 39⅜" (80 × 100 cm)

164

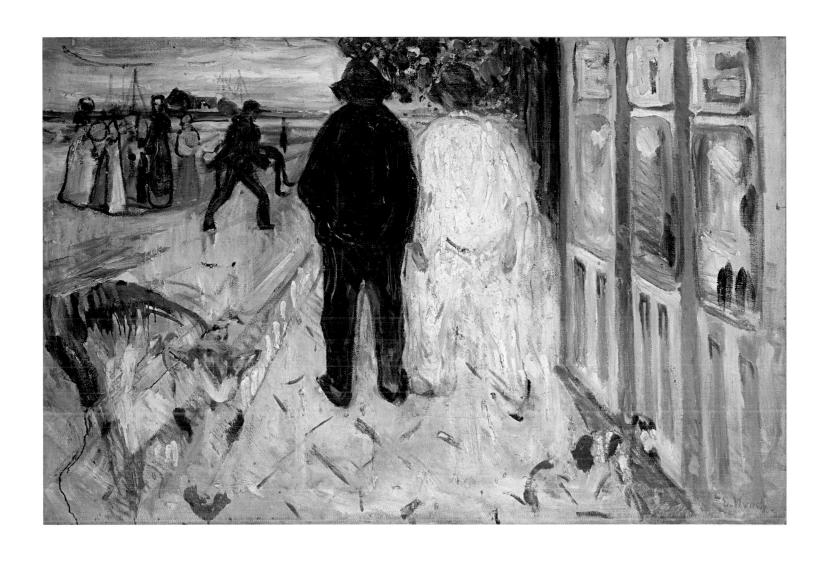

PLATE 108
The Drowned Boy, Warnemünde. 1908
Oil on canvas
33¹¹⁄₁₆ × 51⅛" (85.5 × 130.5 cm)

165

PLATE 109
Uphill with a Sled. 1911
Oil on canvas
25⁹⁄₁₆ × 44½" (65 × 113 cm)

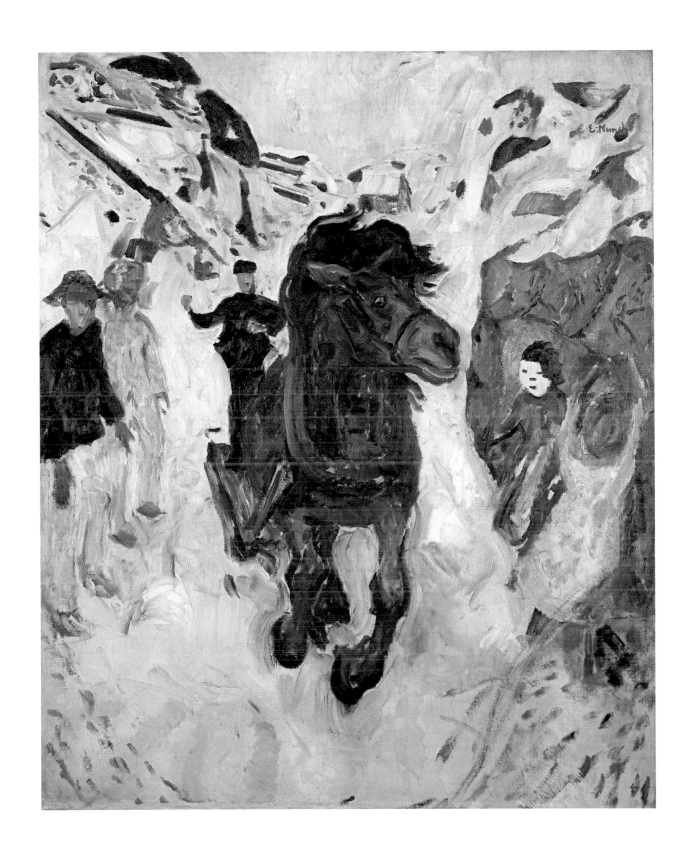

PLATE 110
Galloping Horse. 1910–12
Oil on canvas
58¼ × 47¼" (148 × 120 cm)

167

PLATE 111
Spring in the Elm Forest II. 1923
Oil on canvas
41⁵⁄₁₆ × 47¼" (105 × 120 cm)

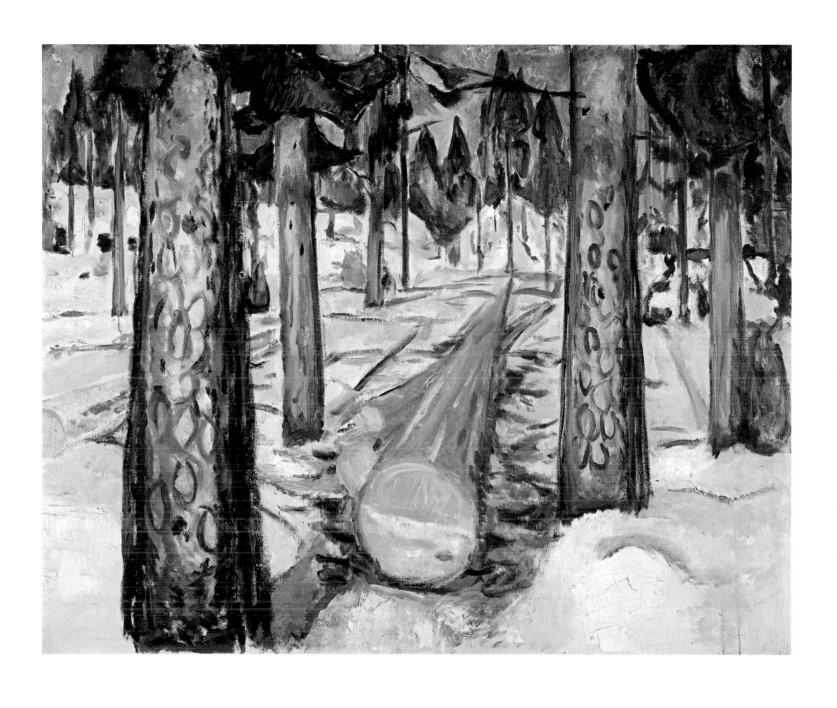

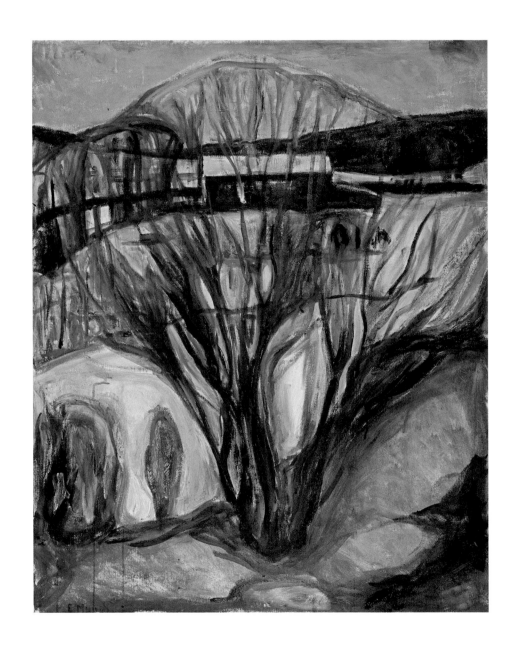

PLATE 113
Winter Night. 1924–26
Oil on canvas
39⅜ × 31½" (100 × 80 cm)

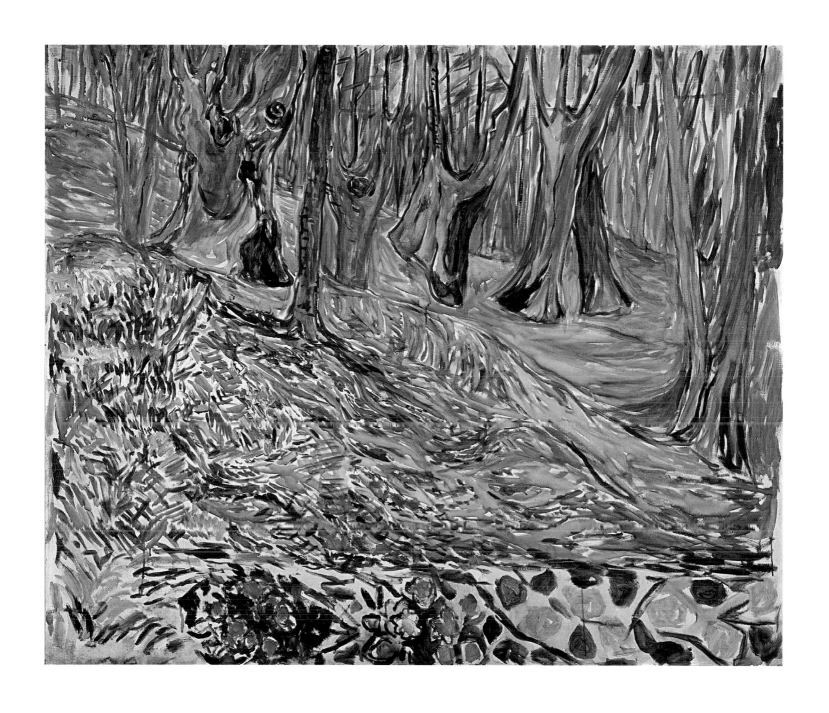

PLATE 114
Spring in the Elm Forest III. 1923
Oil on canvas
42¹⁵⁄₁₆ × 51³⁄₁₆" (109 × 130 cm)

171

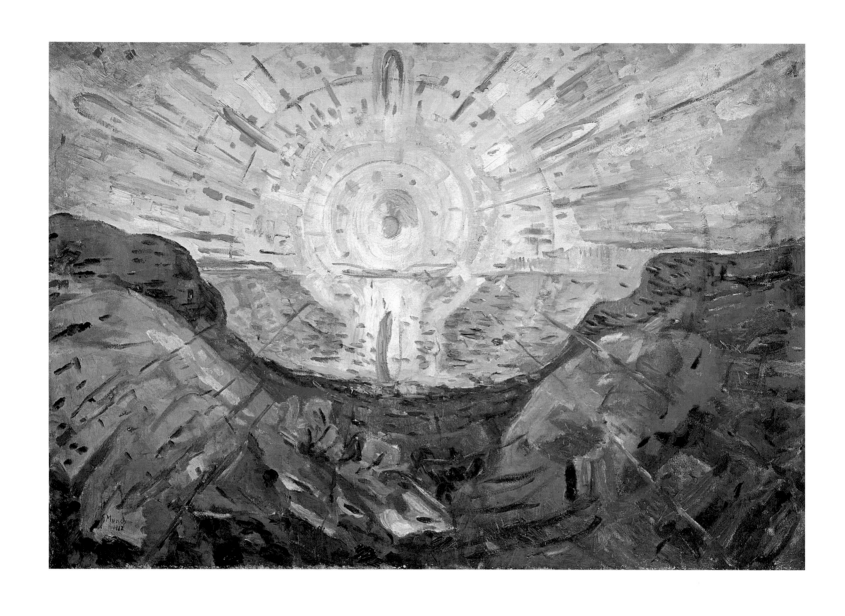

PLATE 115
The Sun (Study). 1912
Oil on canvas
48⁷⁄₁₆ × 69½" (123 × 176.5 cm)

172

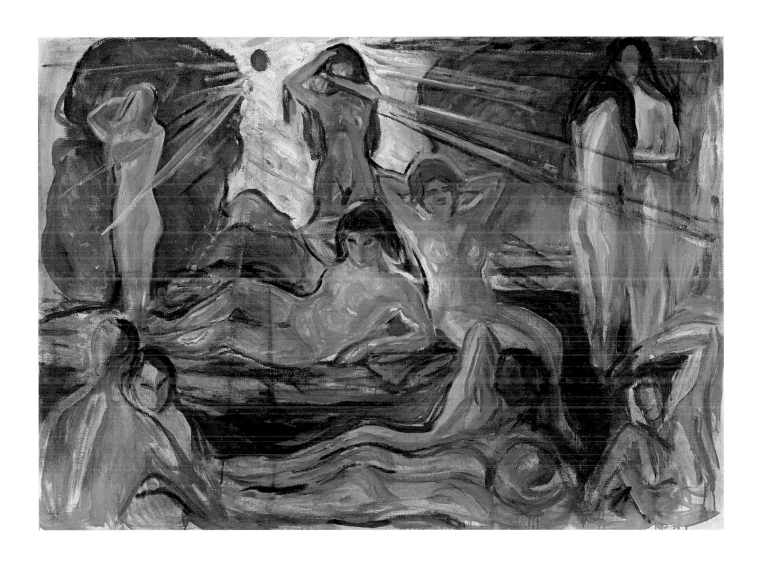

PLATE 116
Nude Figures and Sun. 1910–19
Oil on canvas
39⅛ × 54¼" (100 × 139 cm)

173

PLATE 117
Chemistry. 1911–16
14' 11⅛" × 88⅜"
(455 × 225 cm)

PLATE 118
History. 1909–16
14' 11⅛" × 38' 11⁄16"
(455 × 1160 cm)

PLATE 119
New Rays. 1911–16
14' 11⅛" × 88⅜"
(455 × 225 cm)

PLATES 117–127
Eleven Murals for Festival Hall
University of Oslo. 1909–16
Oil on canvas
(NOT IN EXHIBITION)

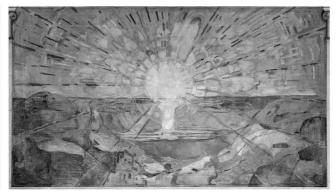

PLATE 120
*Women Reaching Toward
the Light.* 1911–16
14' 11⅛" × 64¹⁵⁄₁₆"
(455 × 165 cm)

PLATE 121
*Awakening Men in a
Flood of Light.* 1911–16
14' 11⅛" × 10' ¹⁄₁₆"
(455 × 305 cm)

PLATE 122
The Sun. 1911–16
14' 11⅛" × 25' 7⁷⁄₁₆"
(455 × 780 cm)

PLATE 123
*Spirits in the Flood
of Light.* 1911–16
14' 11⅛" × 10' ¹⁄₁₆"
(455 × 305 cm)

PLATE 124
*Men Reaching Toward
the Light.* 1911–16
14' 11⅛" × 64¹⁵⁄₁₆"
(455 × 165 cm)

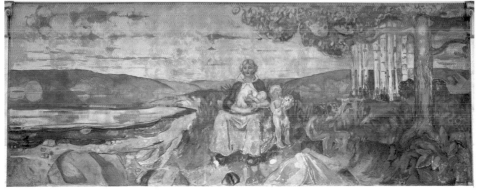

PLATE 125
Women Harvesting.
1909–16
14' 11⅛" × 88⁹⁄₁₆"
(455 × 225 cm)

PLATE 126
Alma Mater. 1911–16
14' 11⅛" × 38' 1¹¹⁄₁₆"
(455 × 1160 cm)

PLATE 127
The Fountain. 1909–16
14' 11⅛" × 88⁹⁄₁₆"
(455 × 225 cm)

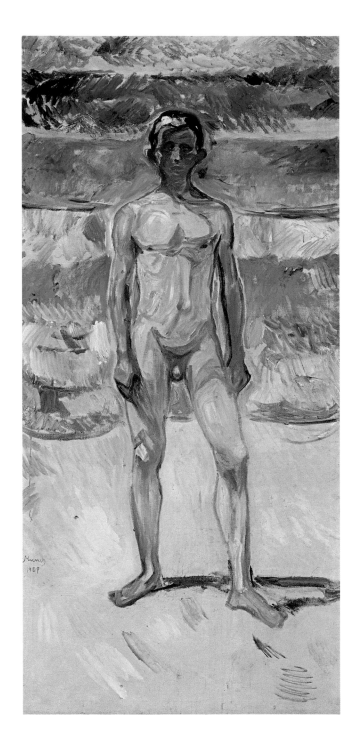

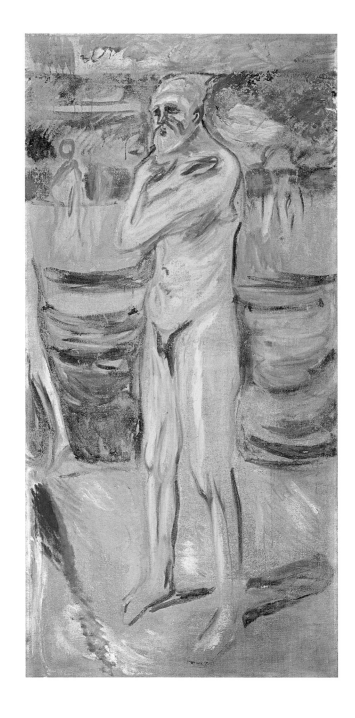

PLATE 128

Bathing Youth [The Ages of Life Triptych].
1909
Oil on canvas
81⅛ × 39⅛" (206 × 100 cm)

PLATE 129

Old Age [The Ages of Life Triptych]. 1908
Oil on canvas
78¾ × 38⅛" (200 × 97 cm)
(NOT IN EXHIBITION)

176

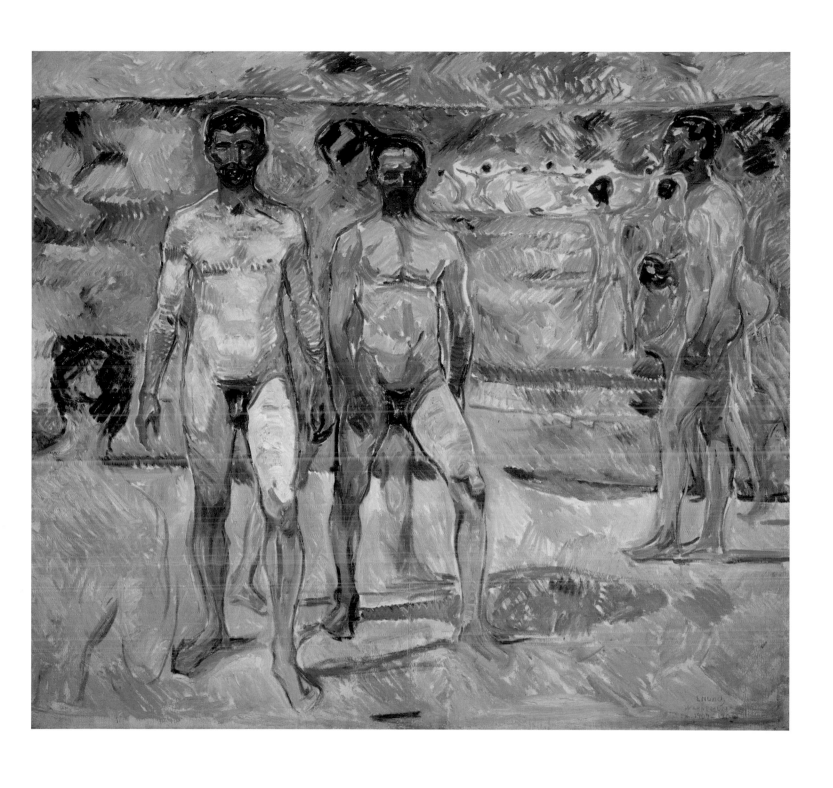

PLATE 130
Bathing Men [The Ages of Life Triptych]. 1907–08
Oil on canvas
81⅛ × 89⁹⁄₁₆" (206 × 227.5 cm)

177

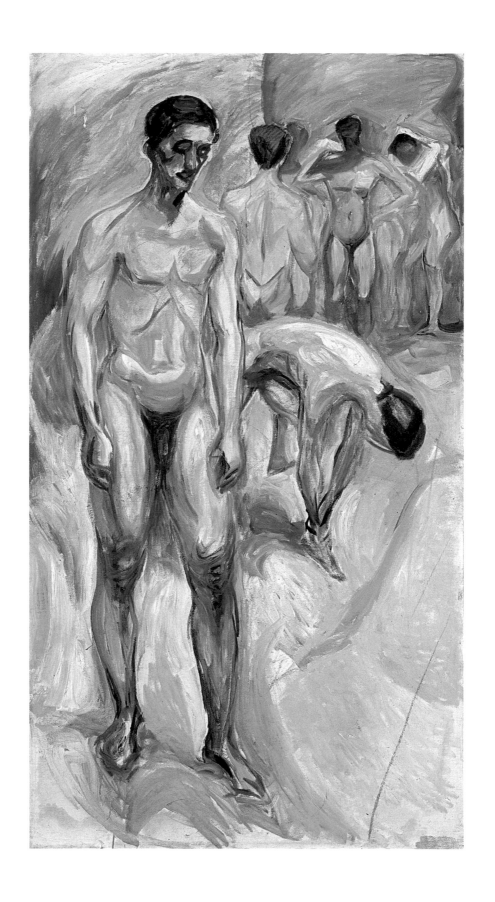

PLATE 131
Naked Men. 1923
Oil on canvas
77¹⁵⁄₁₆ × 42¹¹⁄₁₆" (198 × 108.5 cm)

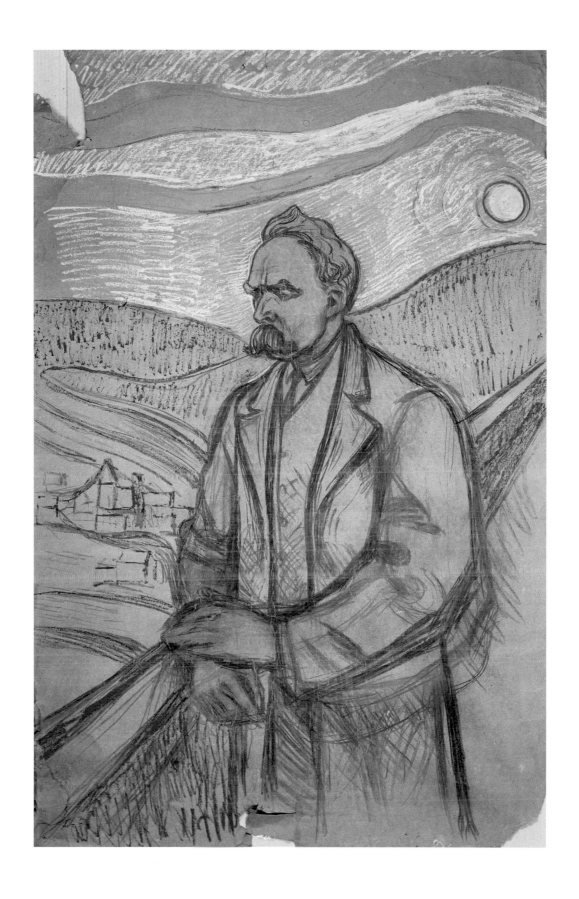

PLATE 132
Friedrich Nietzsche. 1906
Charcoal, pastel, and
tempera on paper
78¼ × 51¹⁄₁₆" (200 × 130 cm)

179

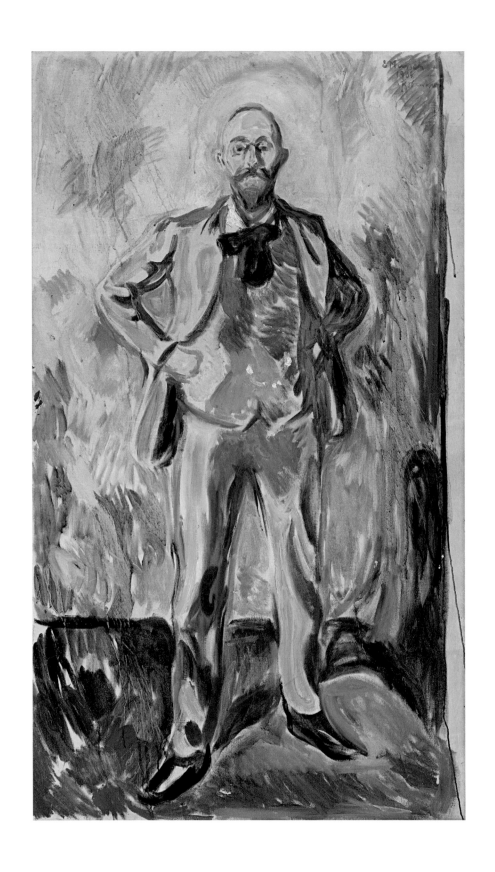

PLATE 133
Portrait of Professor
Daniel Jacobson. 1908
Oil on canvas
50⅛ × 29" (128.3 × 73.7 cm)

PLATE 134 *(opposite)*
Harry Graf Kessler. 1906
Oil on canvas
78¾ × 33⅟₁₆" (200 × 84 cm)

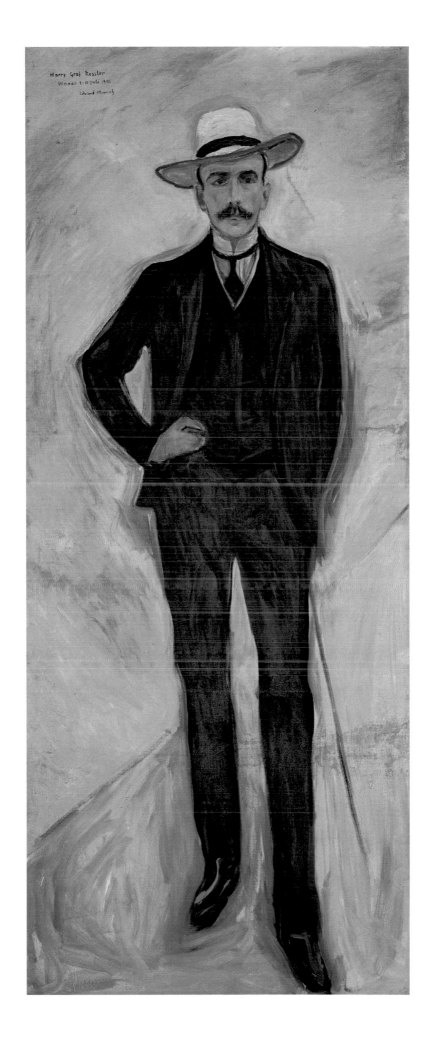

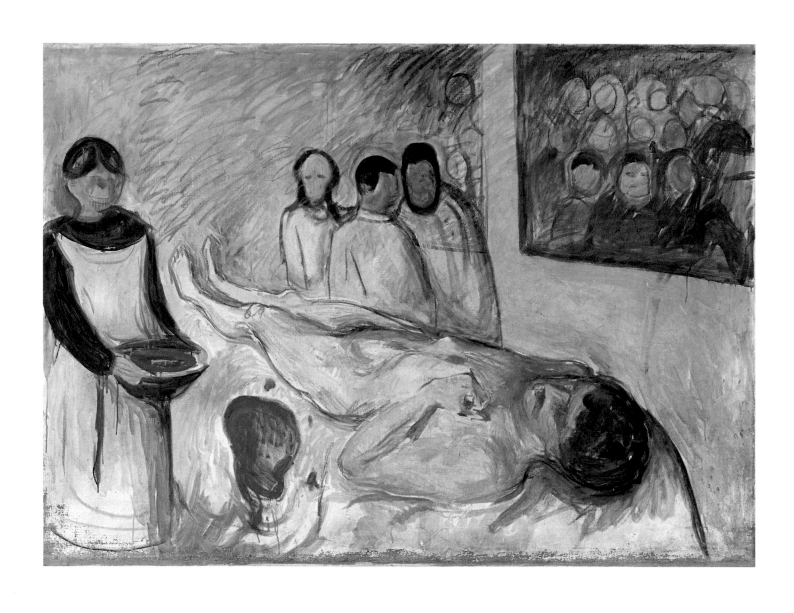

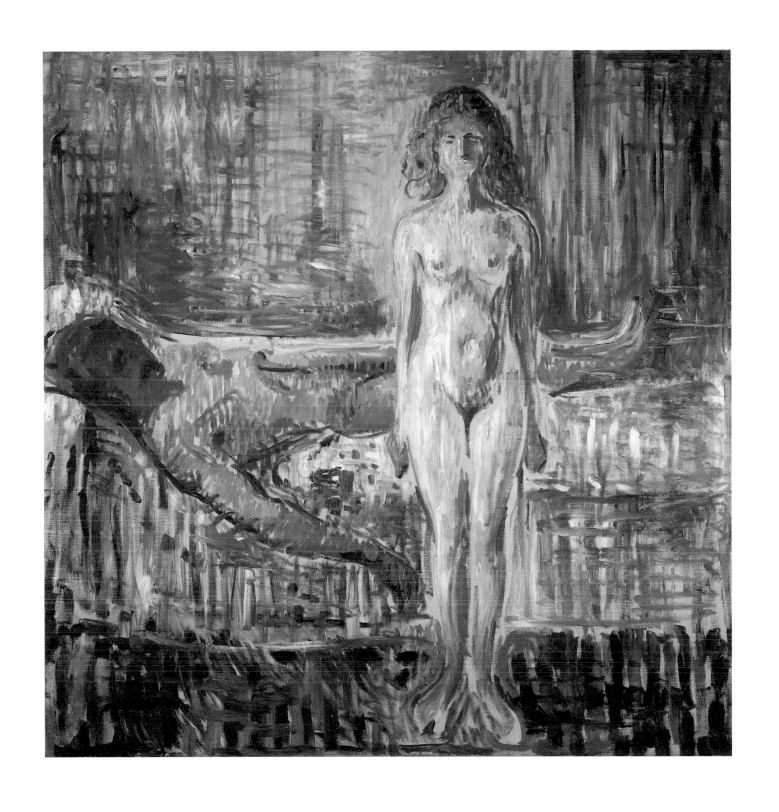

PLATE 136
Death of Marat II. 1907
Oil on canvas
60¼ × 58¹¹⁄₁₆" (153 × 149 cm)
(NOT IN EXHIBITION)

183

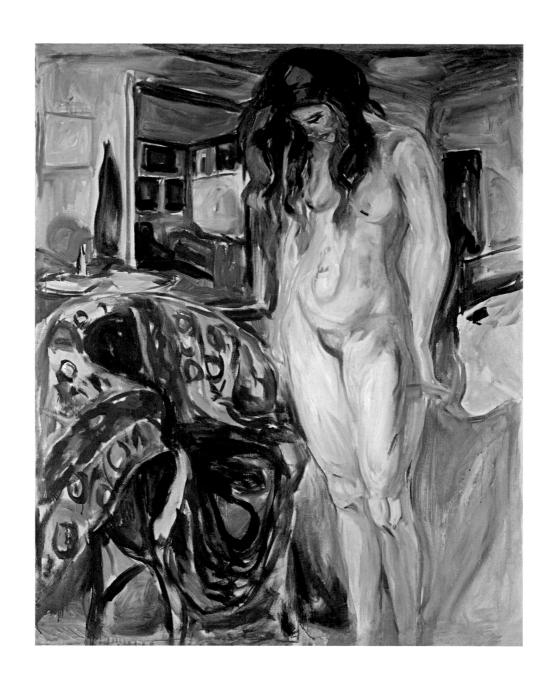

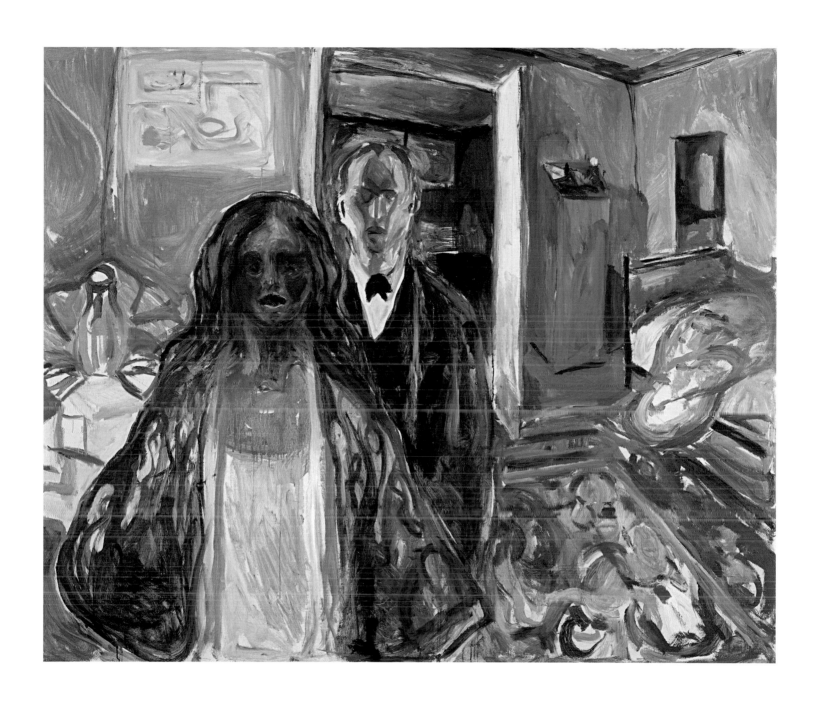

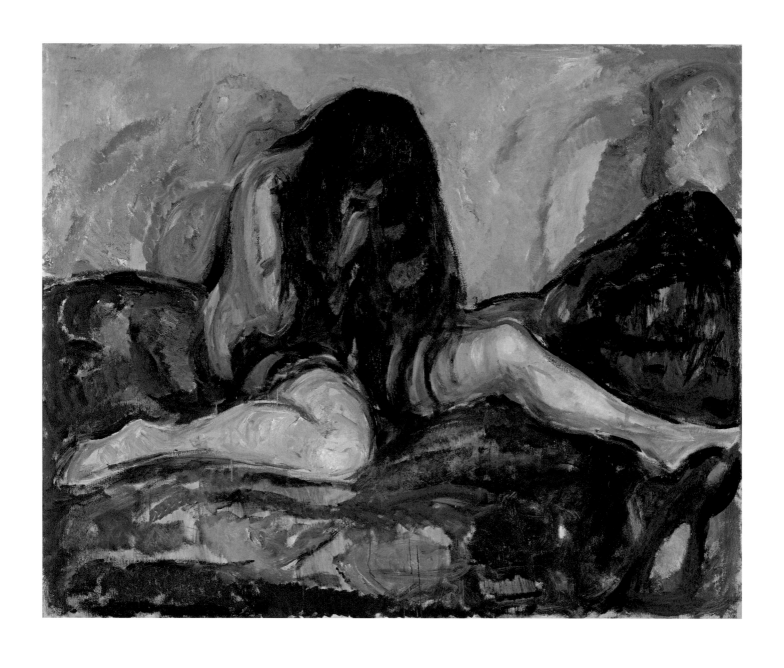

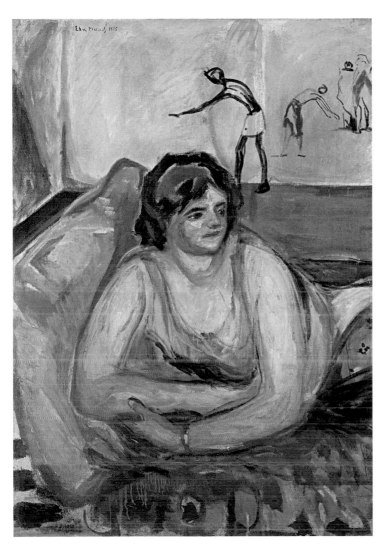
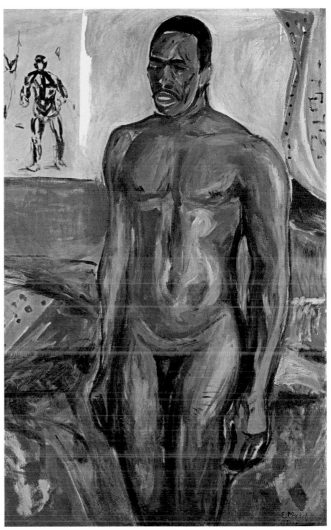

PLATE 140
Cleopatra. 1916–17
Oil on canvas
57⅝6 × 40⅛6" (145.5 × 102 cm)

PLATE 141
The Slave. 1916–17
Oil on canvas
57⅛6 × 35⅞6" (145 × 90 cm)

187

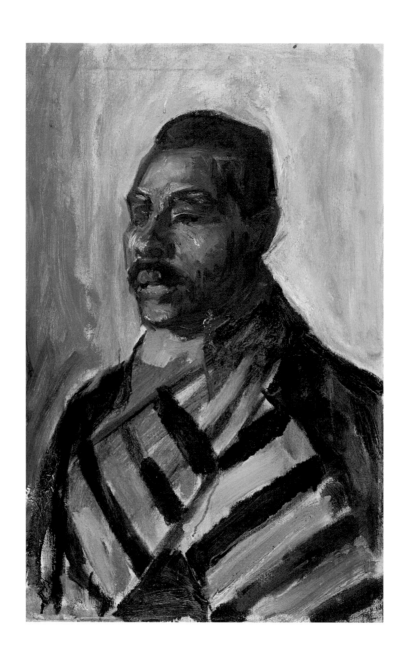

PLATE 142
*Black Man Wearing Green
Striped Scarf.* 1916–17
Oil on canvas
31⁵⁄₁₆ × 19½" (79.5 × 49.5 cm)

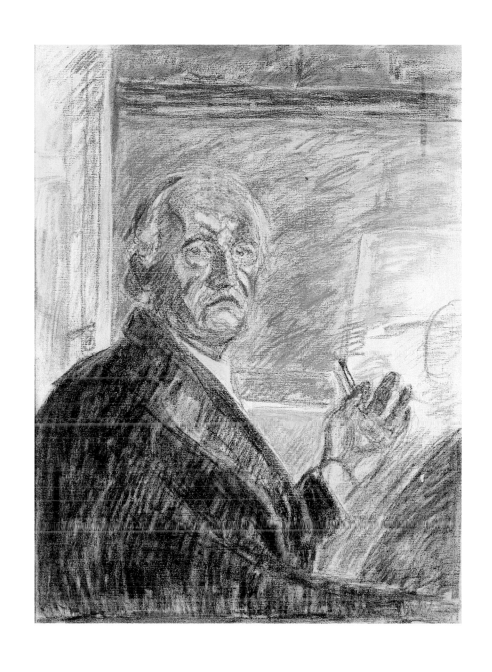

PLATE 143
Self-Portrait with Crayon. 1943
Crayon on canvas
31½ × 23⅝" (80 × 60 cm)

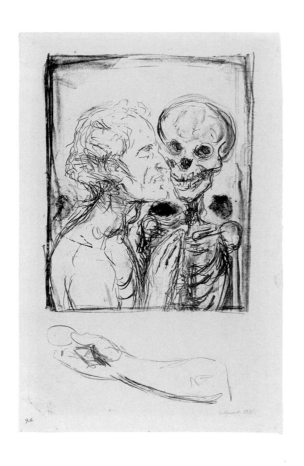

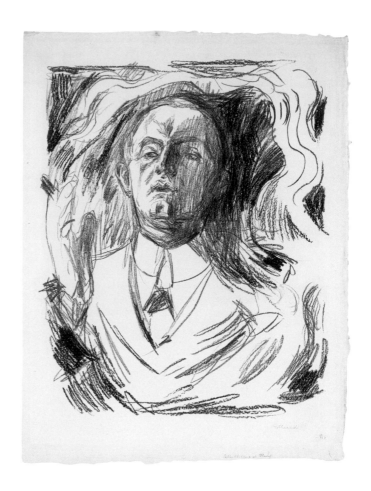

PLATE 144
Dance of Death. 1915
Lithograph
Sheet: 21¹¹⁄₁₆ × 14½"
(55.1 × 36.8 cm)

PLATE 145
Self-Portrait with Cigarette. 1908–09
Lithograph
Sheet: 26¼ × 20" (67.9 × 50.8 cm)

PLATE 146
Sphinx: Androgynous Self-Portrait. c. 1909
Pastel on paper
19⅛ × 24¹³⁄₁₆" (48.5 × 63 cm)

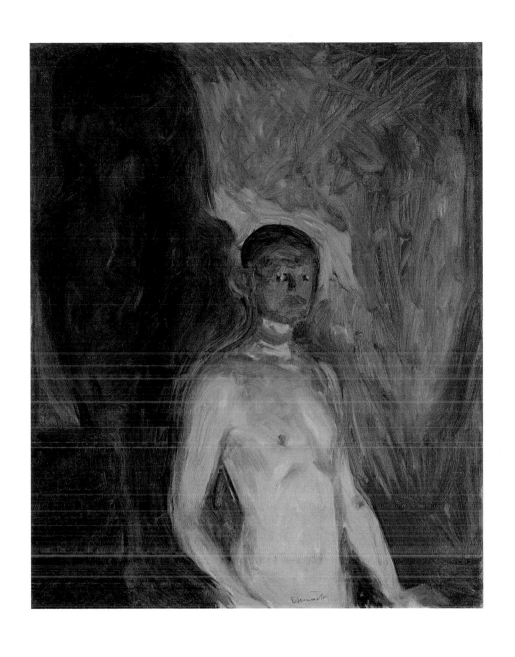

PLATE 147
Self-Portrait in Hell. 1903
Oil on canvas
32⁵⁄₁₆ × 26" (82 × 66 cm)

191

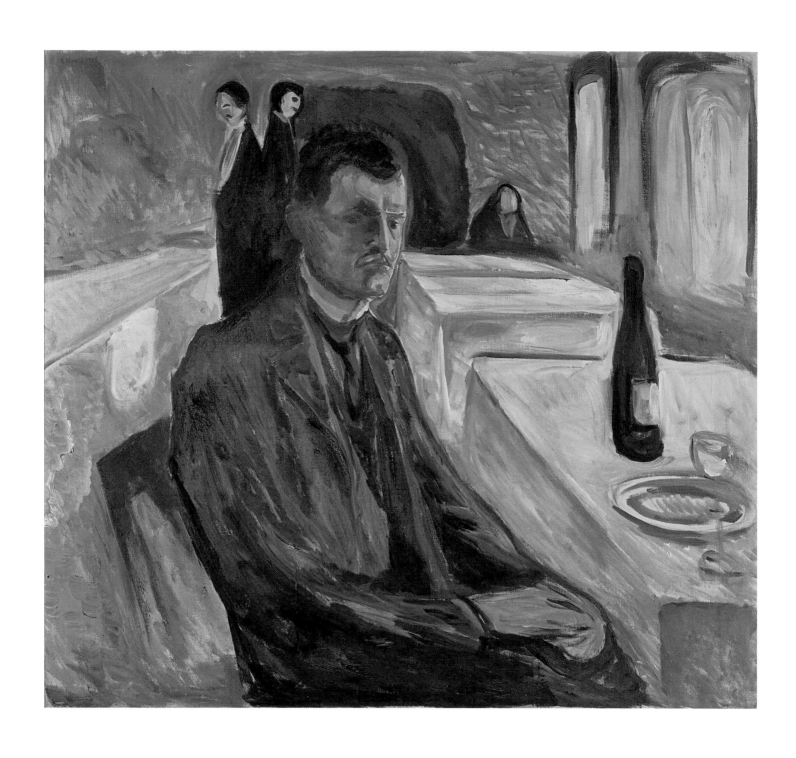

PLATE 148
Self-Portrait with a Bottle of Wine/
Self-Portrait in Weimar. 1906
Oil on canvas
43½ × 47⁷⁄₁₆" (110.5 × 120.5 cm)

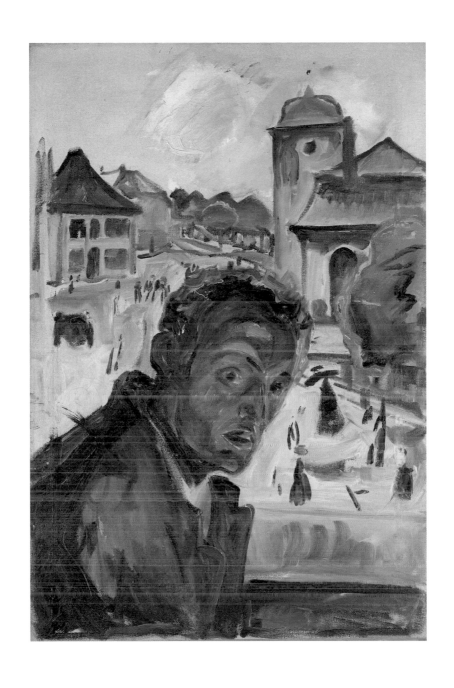

PLATE 149
Self-Portrait in Bergen. 1916
Oil on canvas
35¼ × 23⅜" (89.5 × 60 cm)

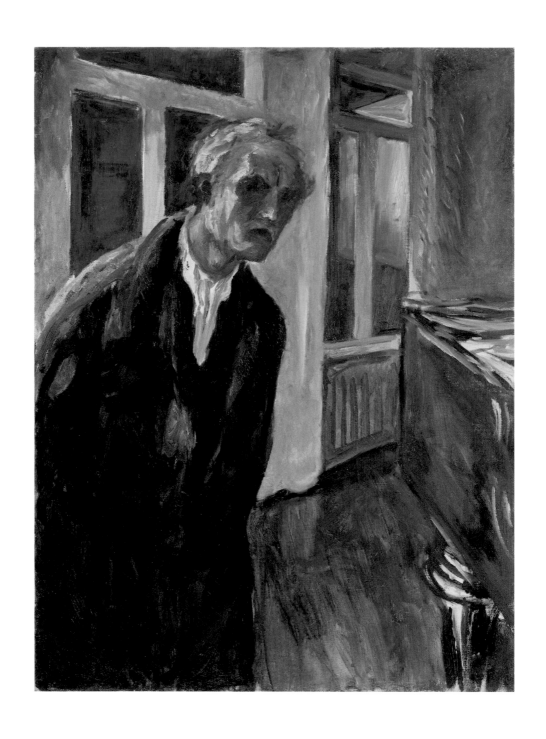

PLATE 150
*Self-Portrait: The Night
Wanderer.* 1923–24
Oil on canvas
35⁷⁄₁₆ × 26¼" (90 × 68 cm)

194

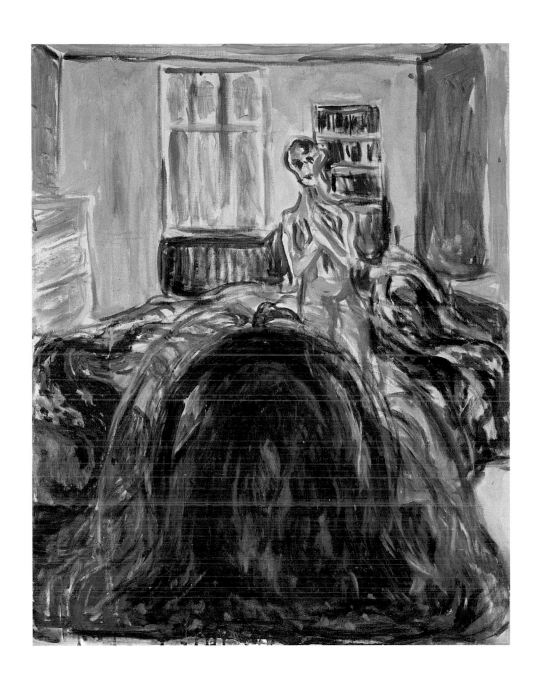

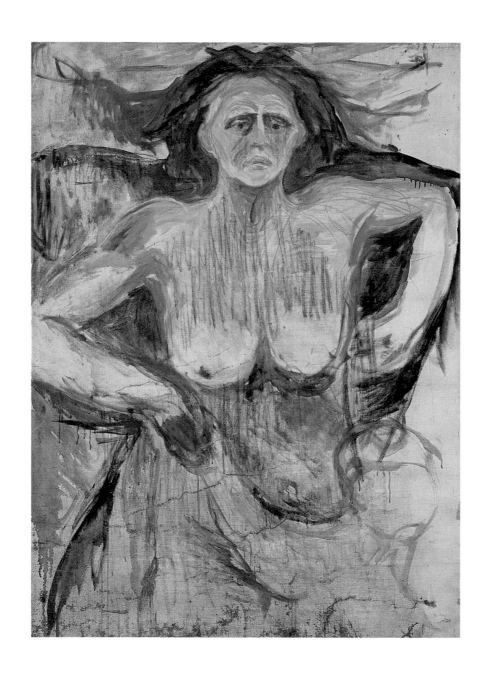

PLATE 152
Androgynous Self-Portrait. 1927
Oil on canvas
58¹¹⁄₁₆ × 40⁹⁄₁₆" (149 × 103 cm)
(NOT IN EXHIBITION)

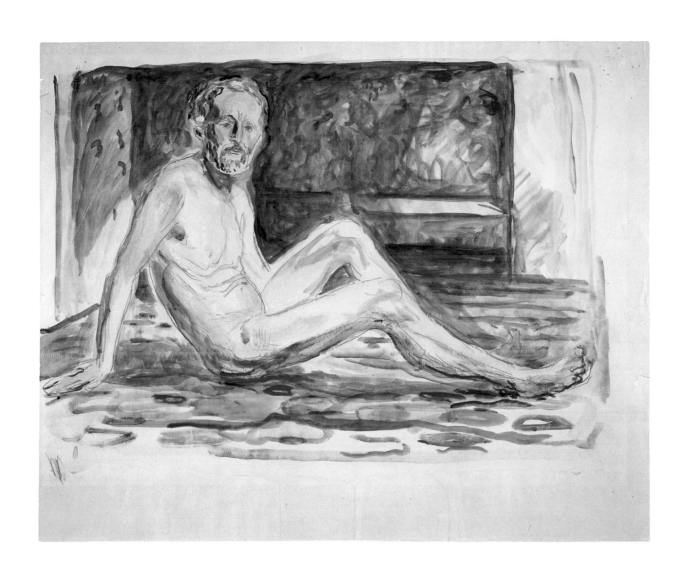

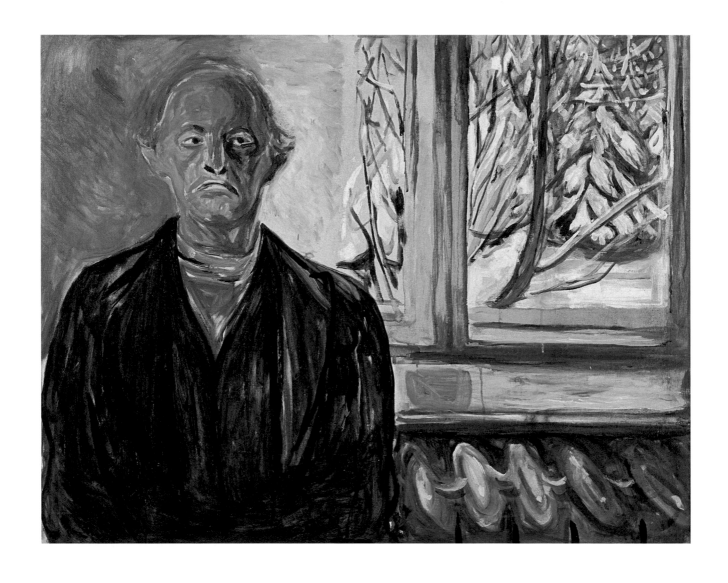

PLATE 154
Self-Portrait by the Window
c. 1940
Oil on canvas
33¹⁄₁₆ × 42½" (84 × 108 cm)

PLATE 155 *(opposite)*
Self-Portrait: Between the
Clock and the Bed. 1940–42
Oil on canvas
58⅞ × 47⁷⁄₁₆" (149.5 × 120.5 cm)

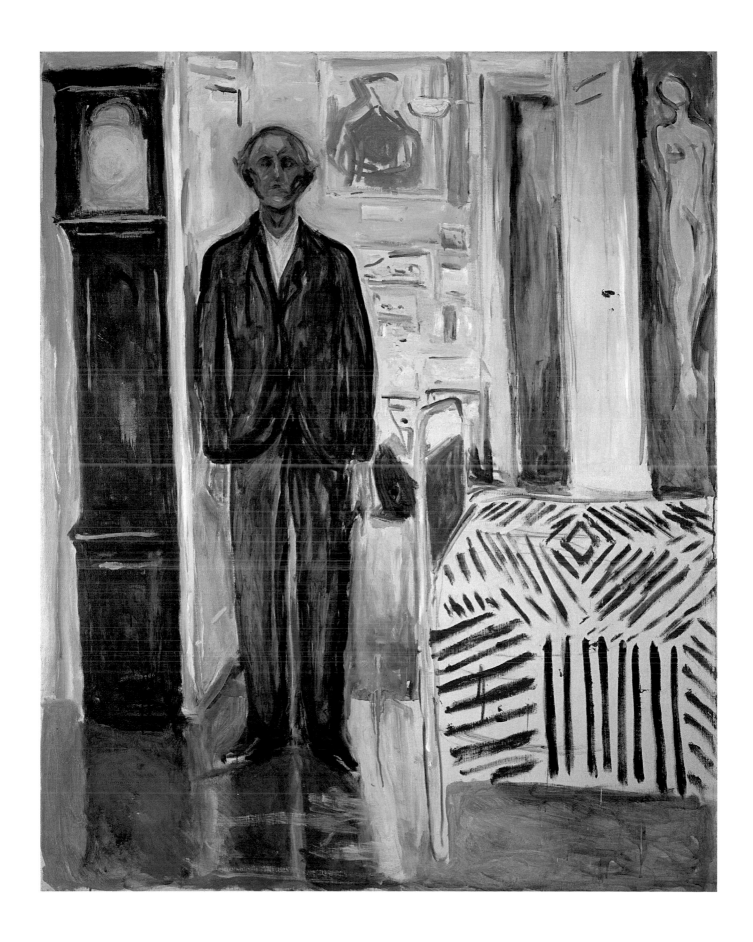

PLATE 156
Kiss in the Field. 1943
Woodcut
Comp.: 15⅞ × 19⁵⁄₁₆" (40.4 × 49 cm)

Catalogue of Plates

The images in the plate section of this volume are listed below in the sequence of the plates themselves. As in the captions, the plate number is followed by the title, date, medium, and dimensions both in feet and inches and centimeters (height before width). Works not in the exhibition are so indicated. In this listing, plate or composition (comp.) and sheet sizes are given for prints; this is followed by the owner of the work, and in most cases by a brief text giving additional information on the work and others related to it. The texts were written by Claire Gilman, and the catalogue entries compiled by Jane Panetta and Claire Gilman.

PLATE 1
Self-Portrait. 1881–82. Oil on paper glued to cardboard, 10⅛ × 7⁵⁄₁₆" (25.5 × 18.5 cm). Munch Museum, Oslo

This somber *Self-Portrait* is one of the artist's first pictures. Its smooth planes, defined contours, and high degree of finish suggest the influence of the classical sculptor Julius Middelthun, who taught at Kristiania's Royal School of Drawing in 1881 and 1882. According to Munch's sister Inger, the painting had a prominent place in the family home and, later, in her own.

PLATE 2
Laura Munch. 1880–81. Oil on paper glued to board, 7⁵⁄₁₆ × 5⅞" (18 × 15 cm). Munch Museum, Oslo

Munch's painting of his sister Laura was completed while he was attending the Royal School of Drawing in Kristiania. One of his earliest surviving studies, it manifests the dark palette, small format, and soft brush technique typical of this time. Laura is portrayed here at the age of fourteen.

PLATE 3
Karen Bjølstad in the Rocking Chair. 1883. Oil on canvas, 18½ × 16⅛"(47 × 41 cm). Munch Museum, Oslo

Along with a portrait of Munch's father in an armchair of two years earlier, this painting of his Aunt Karen, completed shortly after Munch left drawing school, is among his first to show the subject in full figure. The figure is seated in profile in front of a window; according to the artist: "In profile, a face shows racial and family characteristics; from the front it speaks more of the person." There is a strong correlation between Munch's depiction of his Aunt Karen and his memory of his mother: he paints his aunt as a woman in her late twenties or early thirties (when she is actually forty-four), close to the age of his mother when she died at age thirty.

PLATE 4
Interior with the Artist's Brother. 1883. Oil on cardboard, 20¼ × 14" (51.5 × 35.5 cm). The National Museum of Art, Architecture, and Design/National Gallery, Oslo

PLATE 5
My Brother Studying Anatomy. 1883. Oil on cardboard, 24⁷⁄₁₆ × 29½" (62 × 75 cm). Munch Museum, Oslo

This is one of two early portraits of Munch's brother Andreas at study (see plate 4). In fact, in 1883 Andreas was preparing for his matriculation exam, which he took at Kristiania's Cathedral School in 1884. Later, he studied medicine after the example of his father. This painting, with the figure in full light at the window, is somewhat macabre, with its prominently featured skull. In both portraits, Munch is concerned, above all, with the effect of light in the room: in the other picture, *Interior with the Artist's Brother*, light enters from an imagined window just beyond the picture's left edge.

PLATE 6
Self-Portrait. 1886. Oil on canvas, 13 × 9⅝" (33 × 24.5 cm). The National Museum of Art, Architecture, and Design/National Gallery, Oslo

A radical departure from Munch's previous self-portraits, this painting shows Munch attempting to break away from naturalism to embrace, instead, a more visionary, psychological mode of representation. Here, Munch adopted a highly experimental technique, applying the paint with a spatula and, in certain areas, such as the eyes, scraping it away to the bare canvas. For the area just around the head, Munch created a blurred effect by washing it with a diluent. Combined with the acidic color scheme—yellows enhanced by a subtle use of red and green—the heavily worked surface contributes to an impression of physical decay. At the same time, the scarred surface constitutes a kind of screen that serves to distance Munch's visage from the viewer.

PLATE 7
Red-Haired Girl with White Rat. 1886. Oil on canvas, 15⅛ × 9⁵⁄₁₆" (38.5 × 23 cm). Kunstmuseum, Basel

Red-Haired Girl with White Rat is one of Munch's few early portraits executed in a naturalist style that does not depict one of his family members. The model is Betzy Nielson, whom Munch also used as a model for his sister Sophie in *The Sick Child*, completed in the same year (page 223). Munch met the eight-year-old Betzy in 1885, while accompanying his father on his rounds and was moved by the girl's concern for her younger brother, who suffered from a broken leg.

PLATE 8
Girl Kindling a Stove. 1883. Oil on canvas, 38 × 26" (96.5 × 66 cm). Private collection

Munch exhibited *Girl Kindling a Stove* at the 1883 Autumn Exhibition in Kristiania; it was his second exhibition and the second painting that he had ever shown.

PLATE 9
At the Coffee Table. 1883. Oil on canvas, 17¹¹⁄₁₆ × 30⁵⁄₁₆" (45 × 77 cm). Munch Museum, Oslo

Munch painted this image of his father and aunt in the family's apartment in Olaf Ryes Plass. The apartment had bright red wallpaper; but Munch has chosen to cloak the walls and figures (particularly Aunt Karen) in a smoky blue. The atmosphere is soft, fluid, and thick with paint, as the forms of father and aunt bleed into their surroundings. He employed the color blue here for its melancholic effect.

PLATE 10
Tête-à-Tête. 1885. Oil on canvas, 26 × 29¹⁵⁄₁₆" (66 × 76 cm). Munch Museum, Oslo

This painting depicts Munch's sister Inger and his friend, the artist Karl Jensen-Hjell, in a seduction scene influenced by Munch's growing involvement with Kristiania's bohemian artist community. In Munch's painting, the cigarette smoke, which wafts across the woman's face, serves as a signifier of the illicit behavior promoted by the bohemian community. The smoke disappears into the dark and richly modulated background to create an atmosphere that is almost tactile.

PLATE 11
The Artist's Sister Inger. 1892. Oil on canvas, 67¹⁵⁄₁₆ × 48¼" (172.5 × 122.5 cm). The National Museum of Art, Architecture, and Design/National Gallery, Oslo

In a dramatic contrast with Munch's melancholic portrait of his sister Inger on the beach (plate 12), here, Inger stands, fully frontal, against a flat, nondescript ground. In fact, it would seem that Munch is less interested in showing Inger as

a psychologically resonant figure than as a study in decorative contrasts: figure against ground, dark against light, closed silhouette against open expanse. That Munch saw this painting as a formal, rather than a psychological, study is suggested by the title *Harmony in Black and Violet*, under which it was first exhibited in Kristiania.

PLATE 12
Summer Night/Inger on the Beach. 1889. Oil on canvas, 49¼ × 63¹¹⁄₁₆" (126.4 × 161.7 cm). Bergen Art Museum. Rasmus Meyers Collection

This image of Munch's sister Inger on the rocky Åsgårdstrand seashore, completed during the summer of 1889, is a breakthrough painting in that it shows Munch adopting a more elegiac style, which predominated in many of his paintings of the 1890s. The painting is inspired both by the work of Pierre Puvis de Chavannes and by Norway's own tradition of neo-romantic landscape painting.

PLATE 13
Kristiania-Boheme II. 1895. Etching and drypoint, plate: 11⅝ × 15⁷⁄₁₆" (29.5 × 39.2 cm); sheet: 17³⁄₁₆ × 23¼" (44 × 59 cm). Fogg Art Museum, Harvard University Art Museums. Gray Collection of Engravings Fund, George R. Nutter Fund, and Jakob Rosenberg Fund

In this etching, an image of the Kristiania bohemian community, Munch depicts himself and friends seated in a café. Munch is the ghostlike figure to the left; the bearded painter Christian Krohg is directly behind him. The young student Jappe Nilssen and the author and anarchist Hans Jæger flank Oda Lasson, Krohg's future wife and a woman to whom many in the group were attracted. Lasson's first husband, Jørgen Engelhardt, is depicted staring at Munch. Next to Engelhardt is the round-faced Norwegian playwright Gunnar Heiberg.

PLATE 14
The Day After. 1894–95. Oil on canvas, 45¼ × 59¹³⁄₁₆" (115 × 152 cm). The National Museum of Art, Architecture, and Design/National Gallery, Oslo

The Day After is based on an earlier version of the same subject that was completed in 1886 and destroyed in a fire sometime between 1889 and 1893. When a second version of the painting (now lost) was exhibited in Berlin in 1892, critics were horrified at the image of a loosely clad woman draped across a rumpled bed beside a table with empty bottles. "Art is in danger," a Frankfurt paper warned. Jens Thiis's decision, seventeen years later, to purchase this, third, version for Kristiania's National Gallery met with equal disapproval, with one critic declaring: "Now our citizens cannot take their daughters to the National Gallery. How much longer will Munch's harlot be allowed to sleep off her drunkenness in the state gallery?" However, the beautiful, swooning woman bears less affinity to Munch's typical rendition of prostitutes as grotesque caricatures than to his dark-haired *Madonna* (plate 60) on which the artist was at work when this version of *The Day After* was completed.

PLATE 15
Ibsen in the Grand Café. 1898. Oil on canvas, 28⅜ × 39⅛" (72 × 100 cm). Courtesy Galleri K, Oslo

Munch's first painted portrait of Henrik Ibsen shows him before the open window of the Grand Café in Kristiania, where the two first met. Munch shows Ibsen with one eye open and one eye closed. His face is heavily lined, giving the impression of marked vulnerability and suffering. Ibsen appears, in Munch's words, "just as shy and lonely as myself." Indeed, the playwright is cut off from the busy, energetic world outside the window, framed by a heavy

black curtain; only his face emerges from the dark shadows. Munch's decision to place Ibsen in front of an open window, indicated his own feelings of separation from the world, which he attributed to Ibsen as well: "I came into the world as a sick being—in sick surroundings. My youth was spent in a sickbed, and life was a brightly lit window."

PLATE 16
Portrait of the Author Hans Jæger. 1889. Oil on canvas, 42¹⁵⁄₁₆ × 33¹⁄₁₆" (109 × 84 cm). The National Museum of Art, Architecture, and Design/ National Gallery, Oslo

Munch painted this portrait of the notorious philosopher, novelist, and leader of the Kristiania Bohème immediately after Jæger's release from prison where he had served a sentence for writing a scandalous book. This is a man whose acute intelligence remains evident in his piercing gaze and strong, aristocratic, albeit slack, hand.

PLATE 17
The Sick Child. 1896. Lithograph, comp.: 16³⁄₁₆ × 23⅛" (41.4 × 58.8 cm); sheet: 16³⁄₁₆ × 26³⁄₁₆" (41.4 × 66.5 cm). Munch Museum, Oslo

PLATE 18
The Sick Child. 1896. Oil on canvas, 47¾ × 46½" (121.5 × 118.5 cm). Göteborgs Konstmuseum, Göteborg

The original version of *The Sick Child*, 1885–86 (page 223), was greeted with shock and indignation when it was unveiled in Kristiania under the title *Study*. Munch himself was unsatisfied with his attempt to capture his sister Sophie's illness at age fifteen, and had painted and repainted the image over the course of a year. In Munch's words: "I painted the picture numerous times in the space of a year—scratched it out—let it flow out into the paint—and tried over and over again to recapture

that first impression—the trembling mouth—the trembling hands. . . . I also discovered that my own eyelashes had affected the presentation of the picture—So I suggested them as shadows over the picture—In a way, the head became the picture—Wavy lines emerged—peripheries—with the head as the centre." As he describes it, the central motif functions less as an objective rendering than as a kind of memory image observed through the artist's shifting gaze. *The Sick Child*, 1885–86, is the first of six versions painted by Munch, the last executed in 1927. This 1896 version of *The Sick Child*, was commissioned by the Norwegian factory owner Olaf Schou, who wanted a "copy" of the original. Munch painted this version in Paris and exhibited it in 1896 at the Salon des Indépendants. This painting is completely different in feeling from the original, executed not in thick, dull gray impasto but in thin, luminous layers. At the same time, Munch also began working with the famous Parisian printer Auguste Clot on a series of lithographs and etchings of the head of the sick girl (plate 17). Executed in striking shades of red, as well as delicate browns and blues, they are considered to be among the finest examples of Munch's graphic work.

PLATE 19
The Seine at St. Cloud. 1890. Oil on canvas, 24 × 19⅝" (61 × 49.8 cm). The Frances and Lehman Loeb Art Center, Vassar College, Poughkeepsie, New York. Gift of Mrs. Morris Hadley (Katherine Blodgett, class of 1920), 1962.1

This painting represents one of several studies of the river Seine that Munch made while living in St. Cloud between January and May 1890. The paintings fall into roughly two types: those painted from the bank of the river and those painted from Munch's window at the hotel where he lived with the poet Emanuel Gold-

stein. *The Seine at St. Cloud* is among the more melancholic of these images, which are typically executed in light colors and in a style reminiscent of French Impressionism.

PLATE 20
Night in St. Cloud. 1890. Oil on canvas, 25⅜ × 21¼" (64.5 × 54 cm). The National Museum of Art, Architecture, and Design/National Gallery, Oslo

Night in St. Cloud is one of Munch's first paintings to fully break with naturalism, and, perhaps more than any other, it shows the direct influence of the "decadent" Symbolist milieu to which the artist was introduced in Paris. Munch had moved to St. Cloud from Paris on learning of his father's unexpected death. The news sent him into a deep depression. With its brooding figure seated before an open window, *Night in St. Cloud* visualizes the process of the artist's melancholic reflections. Munch observed: "For me, life is like a window in a cell—I shall never enter the promised land."

PLATE 21
Rue Lafayette. 1891. Oil on canvas, 36¼ × 28¾" (92 × 73 cm). The National Museum of Art, Architecture, and Design/National Gallery, Oslo

Munch completed this painting during a brief stay in Paris, and it shows the influence of recent French art, particularly the work of Gustave Caillebotte, who made a series of similar views in the 1880s. It is likely that Munch painted this image from his hotel room at 49, rue Lafayette, but it may have been painted from Caillebotte's own apartment near the intersection of boulevard Haussmann and rue Lafayette. Indeed, the painting bears a striking resemblance to Caillebotte's own *Un Balcon: Boulevard Haussmann* (1880).

PLATE 22
Roulette. 1892. Oil on canvas, 28½ × 36" (72.4 × 91.4 cm). Private collection, courtesy Ivor Braka Ltd.

Roulette is one of several paintings of the gaming tables in Monte Carlo that Munch made while he lived in Nice. He depicts the crowd around a table as a dark and faceless mass, except for the man at the front, who turns to face the viewer, seemingly beset by visions from his own tortured imagination. Indeed, gambling seems to have served as a kind of inner demon for Munch, who recalls: "A large room. Over there by the gaming table, a cluster of people—their backs are bent. A few arms and faces lit up by the lamp. Beyond lie other rooms—the same hush, the same bunch of people round the bank. It is like an enchanted castle, in which the devil is having a party. That is the gaming hell of Monaco."

PLATE 23
Military Band on Karl Johan Street. 1889. Oil on canvas, 39¹⁵⁄₁₆ × 55¼" (101.5 × 140.5 cm). Kunsthaus Zürich. (NOT IN EXHIBITION)

A military band passed along Kristiania's main thoroughfare every Sunday afternoon at two o'clock and served as a signal to strollers to gather. Munch described the moment and his painting as follows: "I made the observations while walking along Karl Johan Street one sunny day. . . . The golden trumpets flickered and sparkled in the sunshine—everything was vibrating in the blue, red and yellow—I saw everything differently under the influence of the music—The music separated the colors—I felt a sensation of joy."

PLATE 24
Karl Johan Street in Rain. 1891. Oil on canvas, 14¹⁵⁄₁₆ × 21⅝" (38 × 55 cm). Munch Museum, Oslo

An Impressionist-inspired view, *Karl Johan Street in*

Rain, is one of at least three versions of the street in rain; the others were painted in 1883 and 1885. Munch's interest in the atmospheric effects of rainy weather is evident in his attention to the reflections on the pavement. The people in the background have been reduced to delicate strokes of paint while the blurred horse and carriage in the foreground expertly convey the sense of motion.

PLATE 25
Spring Day on Karl Johan Street. 1891. Oil on canvas, 31½ × 39⅛" (80 × 100 cm). Bergen Art Museum

This view of Karl Johan Street captures the bright mood of *Military Band on Karl Johan Street* (1889; plate 23) through an even more direct Impressionist-inspired technique. A quasipointillist stroke has replaced the flat color planes of the earlier work, and the later painting is altogether softer in tone than the earlier one.

PLATE 26
Stéphane Mallarmé. 1896. Lithograph, comp.: 20⅛ × 11¼" (52.1 × 29.8 cm); sheet: 23⅞ × 15" (60.6 × 38.1 cm). Epstein Family Collection, Washington, D.C.

Munch likely completed this lithographic portrait of the French poet with the aid of a photograph (presumably one of Mallarmé taken by the French photographer Paul Nadar) that Mallarmé sent Munch shortly after he began work. The lithograph, with its floating head atop the poet's name printed in block letters, evokes a simplicity of composition and gravity of tone, similar to his lithographs of August Strindberg and himself (plates 27 and 32). Mallarmé was very pleased with the likeness, writing in a letter to the artist that he considered it a "gripping portrait, which gives me an intimate sense of myself."

PLATE 27
August Strindberg. 1896. Lithograph, comp.: 24 × 18⅛" (61 × 46 cm); sheet: 25½ × 19 5⁄16" (64.8 × 49 cm). Epstein Family Collection, Washington, D.C.

By 1896, the Swedish writer August Strindberg had become deeply interested in theories of the occult, in particular, in the notion that the individual releases auratic force lines into the atmosphere, a phenomenon that many of his paintings and photographs aimed to capture. Munch was also influenced by occult theory, and in this lithographic portrait of the author, he surrounds Strindberg's head with a schematic border, jagged on the left side and undulating on the right. Within the undulating border an impressionistic image of a naked woman appears. Munch later explained that he had wanted to "frame Strindberg with masculine and feminine lines," a pairing that he replicates in the portrait head itself, where diagonals and curves are combined. Strindberg was no happier with the lithograph than he had been with the painting of several years earlier (plate 28). He was also angry that Munch had misspelled his name as "A. Stindberg," which can be translated as "a mountain of hot air."

PLATE 28
The Author August Strindberg. 1892. Oil on canvas, 48⅛ × 35⅞" (122 × 91 cm). Moderna Museet, Stockholm. Gift of the artist, 1934

Munch's portrait of August Strindberg was the first painting that he completed in Berlin, and it was given a prominent place atop an easel at his 1892–93 exhibition at the Berlin Equitable Palace. Strindberg disliked the portrait, deeming it inelegant and impressionistic. To a colleague who thought the painting, "a good and expressive likeness," Strindberg retorted, "'To Hell with *likeness*! It should be a stylized portrait of a poet! Like the ones of Goethe!"

PLATE 29
Portrait of Julius Meier-Graefe. c. 1895. Oil on canvas, 39⅜ × 29½" (100 × 75 cm). The National Museum of Art, Architecture, and Design/ National Gallery, Oslo

In his top hat and overcoat, neatly tucked scarf and trimmed mustache, Julius Meier-Graefe, the German engineering student turned novelist turned art critic is the antithesis of the languorous Hans Jæger (plate 16). Although he was connected with the group *Zum Schwarzen Ferkel,* Meier-Graefe is known to have retained a certain distance from the group, and demonstrated a preference for cerebral rather than emotional art. He was, however, a great supporter of Munch's work, contributing to Stanislaw Przybyszewski's anthology on the artist in 1894 and producing a portfolio of Munch prints in 1895. Still, the two were more colleagues than friends. Here, Munch shows Meier-Graefe as a man of keen intelligence but a private one.

PLATE 30
Dagny Juel Przybyszewska. 1893. Oil on canvas, 58 7⁄16 × 39 3⁄16" (148.5 × 99.5 cm). Munch Museum, Oslo

The Norwegian medical student Dagny Juell (her name before her marriage) was painted by Munch in Berlin in 1893. Her body leans into the viewer's space seductively, while her eyes stare straight ahead as if in invitation. According to the Finnish writer Adolf Paul: "Blond, thin elegant . . . she tempted a man's robust strength. . . . Laughter that inspired a longing for kisses, simultaneously revealing two rows of pearl-like white teeth awaiting the opportunity to latch on! And in addition, a primeval, affected sleepiness in her movements, never excluding the possibility of a lightning attack!"

PLATE 31
*Stanislaw Przybyszewski
(with Skeleton Arm)*. 1893–94.
Tempera on canvas, 29½ × 23⅝"
(75 × 60 cm). Munch Museum,
Oslo. (NOT IN EXHIBITION)

In this painting of the Polish
mystic and medical student
Stanislaw Przybyszewski, the
sitter's body is eliminated
entirely. This motif of a disem-
bodied head floating in a vapor-
ous expanse is one that Munch
used in his own *Self-Portrait
(with Skeleton Arm)* of 1895
(plate 32), also with an arm
bone at the bottom of the
picture.

PLATE 32
*Self-Portrait (with Skeleton
Arm)*. 1895. Lithograph, comp.:
18 × 12⅝" (45.7 × 32 cm); sheet:
22¹⁵⁄₁₆ × 16¹⁵⁄₁₆" (58.3 × 43 cm).
The Museum of Modern Art,
New York. Gift of James L.
Goodwin in memory of Philip
L. Goodwin

This lithograph of the artist's
disembodied head suspended
ghostlike in a black expanse is
one of Munch's best-known
self-portraits. By positioning
one eye straight ahead and the
other staring downward and
inward, Munch depicts himself
as someone who mediates
between external expectations
and his internal world. Once
again, Munch has included a
skeletal arm at the bottom of
the image, and he has rein-
forced the sepulchral associa-
tion by including an inscription
at the top in block letters that
reads: "Edvard Munch. 1895."

PLATE 33
Blossom of Pain, cover of the
journal *Quickborn*. 1899. Letter
press and lithograph, sheet:
12⅞ × 8⁷⁄₁₆" (32.7 × 21.5 cm).
The Museum of Modern Art
Library. Gift of J. B. Neumann

This image of a flower being
nurtured by the artist's heart's
blood served as the frontispiece
for an 1899 special issue of the
German periodical *Quickborn*;
Munch provided images, and
Strindberg the texts. There are
many sources for the motif,

including a poem by Munch's
friend Emanuel Goldstein,
titled *Alruner*, or *Mandragora*,
in reference to the mandrake
plant, which was known both
for its poisonous properties
and for its healing and love-
inducing powers.

PLATE 34
Blossom of Pain. 1898. Wood-
cut, comp.: 17⁷⁄₁₆ × 13" (44.3 × 33
cm); sheet: 24½ × 18⅞" (62.2 ×
48 cm). Munch Museum, Oslo

PLATE 35
Self-Portrait with Lyre.
1896–97. Pencil and gouache
on paper, 27 × 20⅝" (68.5 ×
52.5 cm). Munch Museum,
Oslo

This image of the artist, who
strums a blood-red instrument
that resembles his own heart,
is among the darkest of
Munch's self-portraits. It is
an image that epitomizes his
interest in the connection
between artistic creation and
psychological pain. In particu-
lar, the image of the stringed
instrument suggests the
Orpheus theme, or that of the
artist who sacrifices his own
life to create new life.

PLATE 36
*Self-Portrait: Salome Para-
phrase*. 1894–98. Watercolor,
india ink, and pencil on paper,
18⅛ × 12¹³⁄₁₆" (46 × 32.6 cm).
Munch Museum, Oslo

In this drawing Munch com-
bines the motif of the disem-
bodied head with another of the
artist's favorite themes: a man's
head grasped by a woman's
hair. In this case, the artist's
head is suspended in a fiery red
inferno, and Munch is the
helpless victim caught, like
John the Baptist, by his invisi-
ble torturer. Munch made sev-
eral variations on the Salome
theme, but this is the only one
in which Munch's head is
shown alone save for the
woman's long tentacle-like hair.

PLATE 37
Self-Portrait with Cigarette.
1895. Oil on canvas, 43½ ×
33¹¹⁄₁₆" (110.5 × 85.5 cm).
The National Museum of Art,
Architecture, and Design/
National Gallery, Oslo

Completed in Berlin when
Munch was thirty-two years
old, this painting was first
exhibited at the artist's individ-
ual exhibition in Kristiania in
the autumn of 1895. Munch
stands in a room filled with
bluish smoke, his face and
hand illuminated by a strong
light from below.

PLATE 38
The Voice/Summer Night.
1893. Charcoal on wove paper,
19¹¹⁄₁₆ × 25½" (50 × 64.7 cm).
Munch Museum, Oslo

PLATE 39
*Summer Night's Dream (The
Voice)*. 1893. Oil on canvas,
34⅝ × 42½" (87.9 × 108 cm).
Museum of Fine Arts, Boston.
Ernest Wadsworth Longfellow
Fund, 59.301

Munch painted *Summer
Night's Dream (The Voice)* in
Åsgårdstrand; it depicts the
nearby Borre forest, famous
for its Viking graves. The
importance of the painting to
Munch is indicated by its
prominent placement in his
exhibition of the *Frieze of Life*
in Berlin in 1902. The *Frieze
of Life*, a somewhat changing
series of works developed over
a number of years, progresses
roughly from the dawn of love,
through love's maturity, jeal-
ousy, and anxiety, to death, and
comprises various versions of
consistent motifs in his art. In
1902, this painting began a wall
called "Seeds of Love," which
opened the narrative. Like
many of Munch's Frieze of
Life motifs, this one originated
in the artist's moonlit Åsgård-
strand strolls with his first
love Milly Thaulow. Munch
describes the moment in his
illustrated diary: "Stand on the
knoll and then I can look into
your eyes—You are taller than
me. . . . How pale you look in

the moonlight and how dark your eyes are—They are so large that they cover half the sky—I can barely see your features—but I can glimpse the whiteness of your teeth when you smile." Munch also visualized this face in a charcoal drawing executed the same year (plate 38).

PLATE 40
Moonlight. 1893. Oil on canvas, 55⁵⁄₁₆ × 53¹⁵⁄₁₆" (140.5 × 137 cm). The National Museum of Art, Architecture, and Design/National Gallery, Oslo

Moonlight depicts a solitary woman on a moonlit Nordic summer night. The woman's rigid frontality is reinforced by the shallow space, with its strict horizontals and verticals broken only by the anthropomorphic shadow above her head. This shadow is not a direct translation of the woman's contours, which raises the question as to whether it is cast by the woman herself or by some unseen second person.

PLATE 41
The Storm. 1893. Oil on canvas, 36⅛ × 51½" (91.8 × 130.8 cm). The Museum of Modern Art, New York. Gift of Mr. and Mrs. H. Irgens Larsen and acquired through the Lillie P. Bliss and Abby Aldrich Rockefeller Funds

Never officially exhibited as part of the *Frieze of Life*, this painting is, nevertheless, related to the series in mood and setting. *The Storm* is set in Åsgårdstrand in front of the Grand Hotel, whose bright windows glow like watchful eyes. A group of figures stands huddled together outside the building while a ghostlike woman in white has separated herself from the group and glides toward the water's edge. All the figures hold their hands to their heads, as if attempting to shut out the elements.

PLATE 42
Starry Night. 1893. Oil on canvas, 53⅛ × 55⅛" (135.2 × 140 cm). The J. Paul Getty Museum, Los Angeles. (NOT IN EXHIBITION)

Painted in Åsgårdstrand in 1893, *Starry Night* depicts the view from one of the windows of the Grand Hotel where Munch spent time with Milly Thaulow during the summer of 1885. Visible is Åsgårdstrand's undulating coastline as well as the Kiøsterudgården across from the hotel, with its white wood fence and massive grove of linden trees. The origin of the painting is described in one of Munch's many prose poems invoking his affair with Thaulow: "They walked across the room to the open window, and leaning out looked down into the garden . . . it was chilly out there—The trees stood like big dark masses against the air—and up there is the moon—one is barely aware of it—it will emerge later—it is so mysterious." *Starry Night* was exhibited under a variety of titles, including *Mysticism of a Summer Night* and *Evening Star*, and was shown with the *Frieze of Life* on several occasions.

PLATE 43
Mystery of the Beach. 1892. Oil on canvas, 39⅜ × 55⅛" (100 × 140 cm). Private collection

This painting is one of the few pure landscapes that Munch exhibited as part of the *Frieze of Life*. In his illustrated diary, the artist recounts his memories of strolls along the shore in a scene reminiscent of this painting: "Down here on this shore I seem to find a picture of myself—of my life—Is this because it was on the shore that we walked together that day?—The curious smell of seaweed also reminds me of her—The strange boulders which mysteriously protrude from the water taking on the shapes of weird creatures which looked like trolls that evening."

PLATE 44
Puberty. 1894–95. Oil on canvas, 59⅜ × 43⁵⁄₁₆" (151.5 × 110 cm). The National Museum of Art, Architecture, and Design/National Gallery, Oslo. (NOT IN EXHIBITION)

Although *Puberty* was not shown with the *Frieze of Life* during Munch's lifetime, similarities in theme and composition suggest that it should be considered alongside the major paintings from the cycle. The painting is unique for its sympathetic attitude toward its adolescent female protagonist who sits on the edge of a bed, naked and vulnerable, her bony knees and arms pressed tightly together. Behind the young girl looms a dark phallic shadow. The Puberty motif was one of the first that he executed in print form. The lithograph *Puberty* (1894; plate 45) is a quiet rendering that preserves the basic components of the painted motif while reinforcing the impression of vulnerability through its technique of delicate, sketchlike lines.

PLATE 45
Puberty. 1894. Lithograph, comp.: 16⅛ × 10¹¹⁄₁₆" (41 × 27.2 cm); sheet: 18¾ × 13¼" (47.7 × 33.7 cm). The Museum of Modern Art, New York. The William B. Jaffe and Evelyn A. J. Hall Collection

PLATE 46
Young Girl with Three Male Heads. c. 1898. Oil on canvas, 35⁷⁄₁₆ × 39⅜" (90 × 100 cm). Kunsthalle Bremen–Der Kunstverein in Bremen

Munch's *Young Girl with Three Male Heads* was discovered for the first time in the summer of 2004 behind Munch's painting *The Dead Mother* (1899–1900; Kunsthalle Bremen). Museum conservators had removed *The Dead Mother* from its frame for the first time in twenty years as part of a catalogue raisonné project organized by the Munch Museum. Upon examining the back of the

painting, they noticed color traces on a second canvas, previously considered to be a support canvas for *The Dead Mother*. But an X-ray showed obvious traces of a multifigure composition, and when the upper canvas was removed, a fully completed painting was revealed. *Girl with Three Male Heads* is unusual for its flat, highly decorative style complete with ornamental border and vertical green lines. While highly abstracted, the heads are vaguely recognizable as Munch himself at the left, the painter Christian Krohg in the center, and Gunnar Heiberg at the right.

PLATE 47
Young Woman on the Beach (The Lonely One). 1896. Aquatint and drypoint with graphite additions, plate: 11⅛ × 8⅜" (28.3 × 21.3 cm); sheet: 17³⁄₁₆ × 11¾" (43.7 × 29.8 cm). Epstein Family Collection, Washington, D.C.

PLATE 48
Mermaid. 1896. Oil on canvas, 39½" × 10' 6" (103 × 320 cm). Philadelphia Museum of Art. Partial and promised gift of Barbara B. and Theodore R. Aronson, 2003

This painting, Munch's first decorative assignment, was commissioned as a wall panel for the home of the Norwegian art collector Axel Heiberg (see page 229). Throughout his career, Munch made several works that refer to Nordic mythology. Once again, the painting is set on Åsgård-strand's shore and is accompanied by prose poems that reference Munch's strolls along the shore: "Out there the water is alive with hundreds of creatures—black—wet they move—raise their heads from the water—stretch out their arms—swim after one another. . . . There is a mermaid in the pillar of the moon gazing at the large round orb above the horizon—she rocks in the pillar of the moon and her hair is golden—lies back down tired

and weak and her golden hair floats on the water."

PLATE 49
The Kiss. 1892. Oil on canvas, 28¾ × 36¼" (73 × 92 cm). The National Museum of Art, Architecture, and Design/ National Gallery, Oslo

Munch began working on a painted version of *The Kiss* toward the end of 1891 in Norway. This version of 1892 is noteworthy for its bright blue color and its horizontal composition. The 1897 version (plate 51), is executed in dark brown hues broken only by the blue of the curtain. Stanislaw Przybyszewski describes Munch's image: "We see two human forms whose faces have melted together. Not a single recognizable facial feature remains; we see only the site where they melted together and it looks like a . . . puddle of liquefied flesh: there is something repulsive in it. Certainly this manner of symbolizing is unusual; but the entire passion of the kiss, the horrible power of sexuality, painfully yearning longing, the disappearance of the consciousness of the ego, the fusion of two naked individualities—all this is so honestly experienced that we can accept the repulsive-unusual."

PLATE 50
Attraction I. 1895. Etching and drypoint with watercolor additions, plate: 12¹¹⁄₁₆ × 9¹³⁄₁₆" (32.3 × 25 cm); sheet: 20¼ × 17⅛" (51.5 × 43.5 cm). Munch Museum, Oslo

Another motif related to the *Frieze of Life*, the etching and drypoint *Attraction I*, 1895, exists in print form only and shows the profile heads of a man and woman staring into each other's eyes against a landscape resembling Munch's *Starry Night* (plate 42). Notes from Munch's diaries connect the planetary themes of the painting to the emotional connection between man and woman evident in the print. Munch observes: "People's

souls are like planets. Like a star that rises from the darkness—and meets another star—only to disappear again into darkness—it is the same when a man and woman meet—drift apart—light up in love—burn up—and disappear each in their own direction."

PLATE 51
The Kiss. 1897. Oil on canvas, 39 × 31⅞" (99 × 81 cm). Munch Museum, Oslo

PLATE 52
The Kiss III. 1898. Woodcut, comp.: 15⅞ × 18¹⁄₁₆" (40.3 × 45.8 cm); sheet: 27⅜ × 24¹³⁄₁₆" (69.5 × 63 cm). Munch Museum, Oslo

Munch also made a series of prints of the Kiss motif. In this woodcut, *The Kiss III*, the couple's inky form reads as a shadow cast on the visible wood grain. The *Kiss in the Field*, executed in 1943 (plate 156), a year before the artist's death, is even more abstracted. Still connected to one another, the couple is now barely distinguishable from the landscape, which is itself defined by nothing other than the swirling lines of the natural wood grain.

PLATE 53
Towards the Forest I. 1897. Woodcut, comp.: 20⁷⁄₁₆ × 25⅝" (51.9 × 65.1 cm); sheet: 24¼ × 30¹¹⁄₁₆" (61.6 × 78 cm). Munch Museum, Oslo

This woodcut of a man and woman in a forest is one of the few prints by Munch not based on a painting. Positioned with their backs to the viewer and arms clasped about each other's waists, this couple represents the antithesis of the man and woman from *Two Human Beings (The Lonely Ones)* (plates 54 and 55). Where those two figures are separate, here man and woman are enclosed in one fluid contour. The forest stands before them, tall and dark but not impenetrable.

PLATE 54
Two Human Beings (The Lonely Ones). 1899. Woodcut, comp.: 15½ × 21⅞" (39.4 × 55.5 cm); sheet: 18¹³⁄₁₆ × 23⅝" (47.8 × 60 cm). Munch Museum, Oslo

For this print of a couple on the shore, Munch adopted a highly experimental technique in which he sawed the woodblock into two and three different parts: one for the shore, one for sea, and, in the second state, one for the figure of the woman alone. In later states, he recut the figures of the rocks and the shore and used paper stencils to create the column of moonlight. In addition, Munch experimented with different color combinations, hand-coloring, and varying amounts of ink and applied pressure in order to create wholly unique impressions with distinct emotional moods. Munch also produced an aquatint version of the motif, with the woman alone (plate 47).

PLATE 55
Two Human Beings (The Lonely Ones). 1899–1917. Woodcut, comp.: 15⁹⁄₁₆ × 22" (39.5 × 55.9 cm); sheet: 26⅝ × 32¹³⁄₁₆" (67.7 × 83.4 cm). The Museum of Modern Art, New York. Gift of Patricia P. Irgens Larsen

PLATE 56
Man's Head in Woman's Hair. 1896. Woodcut with watercolor additions, comp.: 21¹⁄₁₆ × 15¹⁄₁₆" (54.5 × 38.5 cm); sheet: 22 × 17⁵⁄₁₆" (55.9 × 43.9 cm). Munch Museum, Oslo

In this woodcut, two disembodied heads—of a man and a woman—float together; his head is wrapped in her long hair. The man's face is a peculiar fusion of Munch's and Stanisław Przybyszewski's features, a combination that renders this image more universal than individual. Munch experimented with different techniques in later states, often printing from two different woodblocks, one containing the woman's face and hair, and one containing the man's head. In

this hand-colored print, Munch has painted the hair a vivid red so that it reads as a distinct entity.

PLATE 57
On the Waves of Love. 1896. Lithograph, comp.: 12³⁄₁₆ × 16½" (31 × 41.9 cm); sheet: 15¹⁄₁₆ × 19⅝" (38.5 × 49.8 cm). Munch Museum, Oslo

PLATE 58
In Man's Brain (Reclining Woman). 1897. Rubbing from woodblock, with brush and ink additions, comp.: 14⁷⁄₁₆ × 22⅝" (36.7 × 57.5 cm); sheet: 19⁷⁄₁₆ × 25⁵⁄₁₆" (49.4 × 65 cm). National Gallery of Art, Washington, D.C. Epstein Family Fund and the Director's Discretionary Fund 2000

This image of a male head suspended beneath a floating female form fuses motifs familiar from several graphic works. Here the man's head is immersed in a kind of fluid red matrix. Woman is quite literally "in man's brain," just as man is within her power.

PLATE 59
Madonna. 1895–1902. Lithograph, comp.: 23⅞ × 17⁹⁄₁₆" (60.6 × 44.6 cm); sheet: 25¹¹⁄₁₆ × 18⅞" (65.2 × 47.9 cm). Munch Museum, Oslo

Munch made several printed versions of the Madonna motif in which he rendered a border of sperm and fetuses, as here, as well as related prints and drawings, such as the lithograph *On the Waves of Love*, 1896 (plate 57), in which the female figure bears the Madonna's features. In a related drawing, *Madonna at the Churchyard*, 1896 (plate 61), the Madonna figure stands in a deserted graveyard, reminiscent of the place where Munch's mother was buried.

PLATE 60
Madonna. 1894–95. Oil on canvas, 36⅝ × 29⅛" (93 × 74 cm). Private collection

One of Munch's best-known motifs, Madonna, was begun shortly after his relocation to Berlin, and it shows the influence of his Berlin companions in its peculiar combination of eroticism, spirituality, and death. Munch referred to the picture's religious aspect on numerous occasions, and, although it is unlikely that he supplied the painting's present title, the woman's halo speaks to his intent. Munch observed: "Your face speaks of immeasurable tenderness—moonlight glides over it so full of earthly beauty and pain for it is now that death joins hands with life to forge the chain that links the thousands of generations now dead and the thousands to come."

PLATE 61
Madonna at the Churchyard. 1896. India ink, watercolor, and crayon on paper, 22¹⁄₁₆ × 17⅝" (56 × 44.8 cm). Munch Museum, Oslo

PLATE 62
Harpy. 1898
India ink, watercolor, gouache and crayon on paper, 21¹⁵⁄₁₆ × 17⅝" (55.8 × 44.8 cm). Munch Museum, Oslo

PLATE 63
The Brooch: Eva Mudocci. 1903. Lithograph, comp. (irreg.): 23¼ × 18⅜" (60.3 × 46.7 cm); sheet (irreg.): 31¹⁵⁄₁₆ × 22⅞" (81.2 × 58.1 cm). The Museum of Modern Art, New York. Purchase

The Brooch is one of three images that Munch made of the English violinist Eva Mudocci, with whom he became friendly during his early Paris years. In fact, Munch originally titled this lithograph *Madonna* and based it on his famous painting. Mudocci, however, remains clothed, and her eyes are open and thoughtful. Munch described her large, soft eyes as seeming "two thousand years old." On Mudocci's breast is a brooch reminiscent of a piece of jewelry that she

had received from Jens Thiis in 1902. Munch was extremely attached to the print, and when he delivered the original lithographic stone to Mudocci at the Hotel Sans Souci in Berlin he attached a note that read: "Here is the stone that fell from my heart."

PLATE 64
Evening: Melancholy I. 1896. Woodcut, comp.: 16¼ × 18" (41.2 × 45.7 cm); sheet: 16¹⁵/₁₆ × 21" (43 × 53.3 cm). The Museum of Modern Art, New York. Abby Aldrich Rockefeller Fund

PLATE 65
Melancholy III. 1902. Woodcut with watercolor additions, comp.: 15¹⁄₁₆ × 18½" (38.5 × 47 cm); sheet: 19½ × 25⅜" (49.5 × 64.5 cm). Munch Museum, Oslo

Munch utilized the Melancholy motif in an unusual hand-painted woodcut of 1902, *Melancholy III*, in which he added a standing figure in the foreground and a tower in the background, and gave the seated figure a helmet. In this way, he transformed the image into a scene from Henrik Ibsen's *Pretenders*. Munch also used the Melancholy motif as the basis for the frontispiece to a new edition of poems by Emanuel Goldstein, published in 1892, in which he altered the composition by turning the figure's head to face the viewer (page 225), a compositional device that he used soon after to great effect in *The Scream* (1893; plate 84).

PLATE 66
Melancholy. 1891. Oil on canvas, 28¼ × 38½" (72 × 98 cm). Private collection

Although *Melancholy* occupies a place midway through the *Frieze of Life* narrative, it is among the earliest motifs that Munch completed. *Melancholy* (also known as *Jealousy, Evening, The Yellow Boat,* and *Jappe on the Beach*) was

inspired by news of Milly Thaulow's imminent remarriage. Here, he depicts this in terms of a love triangle involving Oda and Christian Krohg and Jappe Nilssen, which he witnessed during the summer of 1891 in Åsgårdstrand, when the earliest version (possibly this painting) was executed. It shows a melancholic figure (Nilssen) seated in profile against the Åsgårdstrand shoreline, and, in the background, a yellow boat into which Oda and Christian are about to descend. However, Munch's painting functions less as an anecdotal rendering than as a kind of memory image, or mental projection in which universal feelings of jealousy and loss have replaced a specific event. Munch made five painted versions of the Melancholy motif and several printed versions (plates 64 and 65).

PLATE 67
Separation II. 1896. Lithograph with gouache additions, sheet and comp.: 17⅞ × 24⅜" (41.1 × 62 cm). Munch Museum, Oslo

PLATE 68
Separation. 1896. Oil on canvas, 38 × 50" (96.5 × 127 cm). Munch Museum, Oslo

Although *Separation* was not included in the 1902 *Frieze of Life* exhibition in Berlin, it belongs to the group of paintings that hung on the "Flowering and Passing of Love" wall. The composition features, at the left-hand side, a sorrowful figure who stands with eyes downcast, clutching his bleeding heart, while the object of his doomed affection appears to the right. Her dress merges with the undulating coastline while her hair streams backward toward the man and curls about his neck in an evocation of love's unbreakable bonds. Munch also made several drawn and lithographic renditions, including *Separation II* (1896; plate 67).

PLATE 69
Ashes I (upper part). 1896. Lithograph with watercolor additions, sheet and comp.: 7¹¹/₁₆ × 16⁷/₁₆" (19.5 × 41.8 cm). Munch Museum, Oslo

PLATE 70
Ashes I (lower part). 1896. Lithograph with watercolor additions, sheet and comp.: 11¾ × 16⅜" (29.8 × 41.6 cm). Collection Catherine Woodard and Nelson Blitz, Jr.

PLATE 71
The Maiden and the Heart. Separation. Salome. 1895–96. Pencil and india ink on paper, 9¹³/₁₆ × 23¼" (25 × 59 cm). Munch Museum, Oslo

PLATE 72
The Woman in Three Stages. 1894. Oil on canvas, 64⁹/₁₆ × 98⁷/₁₆" (164 × 250 cm). Bergen Art Museum. Rasmus Meyers Collection. (NOT IN EXHIBITION)

Painted in Berlin in 1894, Munch's monumental *Woman in Three Stages* represents the three stages of woman, as the artist conceived her. The virginal woman appears at the left staring out to sea, while in the center woman as the embodiment of mature love stands naked facing front, her arms and legs spread wide. To the right is a darkly brooding woman, whose hollowed cheeks and eyes reveal the ravages of mourning and death. At the far right stands Munch's male contemplative, his head bowed over a blood-flower. Separated from the brooding woman by a vertical tree trunk that fills the entire frame, the man is clearly in a different realm from that of his female companions. Munch also likened his three figures to the Norns, the three goddesses of fate in Nordic mythology.

PLATE 73
The Woman II. 1895. Aquatint and drypoint with gouache and watercolor additions, plate:

11⅞ × 13¾" (30.1 × 35 cm); sheet: 14⅞ × 13½" (37.8 × 34.3 cm). Munch Museum, Oslo

PLATE 74
Ashes. 1894. Oil on canvas, 47⁷⁄₁₆ × 55½" (120.5 × 141 cm). The National Museum of Art, Architecture, and Design/ National Gallery, Oslo

Although Munch made only two versions of this painting, one during the summer of 1894 in Åsgårdstrand and one much later in the mid-to-late 1920s, it had a prominent place within the *Frieze of Life* narrative, opening the wall known as the "Flowering and Passing of Love" at his 1902 Berlin exhibition. The painting was exhibited under the title *After the Fall*, evoking its clear biblical overtones. The title *Ashes*, which Munch inscribed on the two-part lithographic version of the motif of two years later (plates 69 and 70), references the burned out log that runs along the painting's perimeter. Love is dead, the painting suggests, but its ashes remain.

PLATE 75
Vampire. 1893–94. Oil on canvas, 35¼ × 42⅞" (91 × 109 cm). Munch Museum, Oslo

Vampire was titled *Love and Pain* when the first version, now in the Göteborgs Konstmuseum, was exhibited at Munch's 1893 exhibition in Berlin. It was Stanislaw Przybyszewski who likely supplied the painting's title, describing the painting as: "A broken man with a vampire biting his neck." Munch expressed some hesitation at this title's violent implications, arguing later that the painting, in fact, represented simply "a woman kissing a man on the neck."

PLATE 76
Street Scene. 1889. Ink on paper (from the illustrated diary), 8¼ × 6⁹⁄₁₆" (21 × 16.6 cm). Munch Museum, Oslo.
(NOT IN EXHIBITION)

PLATE 77
Scene from Karl Johan Street. 1889. Pencil and crayon on paper, 14⁹⁄₁₆ × 18½" (37 × 47 cm). Munch Museum, Oslo

PLATE 78
Evening on Karl Johan Street. 1896–97. Unique lithograph with watercolor additions, comp.: 16 × 22½" (40.6 × 57.2 cm); sheet: 21¹⁄₁₆ × 26¹⁵⁄₁₆" (53.5 × 68.5 cm). Collection Catherine Woodard and Nelson Blitz, Jr.

PLATE 79
Evening on Karl Johan Street. 1892. Oil on canvas, 33¹¹⁄₁₆ × 47⅝" (85.5 × 121 cm). Bergen Art Museum. Rasmus Meyers Collection

Evening on Karl Johan Street originates in a series of notes and drawings, which Munch began in 1889 (plates 76 and 77). Both texts and drawings are anecdotal, and recount the artist's agonized roamings through the streets of Kristiania in search of his lover Milly Thaulow: "He walked up and down Karl Johan Street—it was seven o'clock in the evening and still light. . . . It was springlike. . . . Here she comes—it was as though an electric shock ran through him. . . . He could not feel his legs at all—they would not support his weight." In the painting, a woman with a bonnet and brooch in the foreground vaguely evokes the artist's descriptions of his lover, while a man in a top hat to the left may be her husband. Alone on the street, his back turned, is a fragile shadowy figure typically taken for Munch himself. In a hand-colored lithograph of the motif of 1896–97 (plate 78), Munch emphasized the unreality of the scene by coloring the print an acidic yellow and by including a row of masks along the bottom edge.

PLATE 80
Angst. 1896. Woodcut, comp.: 18¹⁄₁₆ × 14⅞" (45.9 × 37.8 cm); sheet: 19⁹⁄₁₆ × 15¾" (49 × 40 cm).

The Museum of Modern Art, New York. Riva Castleman Endowment Fund, The Philip and Lynn Straus Foundation Fund, Lily Auchincloss Fund, Nelson Blitz, Jr., with Catherine Woodard and Perri and Allison Blitz, Sarah C. Epstein Fund, Richard A. Epstein Fund, Miles O. Epstein Fund, Johanna and Leslie J. Garfield Fund, and Purchase

PLATE 81
Angst. 1894. Oil on canvas, 37 × 29⅛" (94 × 74 cm). Munch Museum, Oslo

In this painting, Munch has transposed the traumatic experience depicted in *Evening on Karl Johan Street* (plate 79) to Ljabroveien, the setting for *The Scream* (1893; plate 84), thereby uniting two of his most important motifs. Instead of the alienated individual of *The Scream*, there is a forward-marching mass that ignores the flaming sky. Munch wrote: "I saw all the people behind their masks—smiling, phlegmatic—composed faces—I saw through them and there was suffering—in them all—pale corpses—who without rest ran around—along a twisted road—at the end of which was the grave." Most of the figures in *Angst* are recognizable from *Evening on Karl Johan Street*, with the addition of a third figure whose pointed face and beard recall Stanislaw Przybyszewski.

PLATE 82
Despair. 1891–92. Charcoal and oil on paper, 14⁹⁄₁₆ × 16⅝" (37 × 42.2 cm). Munch Museum, Oslo

PLATE 83
Despair. 1892. Oil on canvas, 36¼ × 26½" (92 × 67 cm). Thielska Galleriet, Stockholm

PLATE 84
The Scream. 1893. Tempera and oil on cardboard, 35¹³⁄₁₆ × 28¹⁵⁄₁₆" (91 × 73.5 cm). The National Museum of Art,

Architecture, and Design/ National Gallery, Oslo. (NOT IN EXHIBITION)

One of the most famous paintings of the modern era, *The Scream* originated in an actual experience Munch had some years earlier on Ljabroveien, the road between Kristiania and Nordstrand: "I was walking along the road with two friends. The sun set. I felt a tinge of melancholy. Suddenly the sky became a bloody red. I stopped, leaned against the railing, dead tired and I looked at the flaming clouds that hung like blood and a sword over the blue-black fjord and city. My friends walked on. I stood there, trembling with fright. And I felt a loud, unending scream piercing nature." The first painting in which Munch tried to capture this incident was *Despair* (1892; plate 83), a painting that Munch later referred to as "the first *Scream*." It shows the artist's featureless alter ego leaning over a railing while his two companions continue along the path behind him. The painting is executed in shades of blue broken only by the red of the sky. When it was first exhibited in 1892 in Kristiania and, immediately after, in Berlin, under the title *Sick Mood at Sunset*, the painting attracted a great deal of attention. Still, Munch was not satisfied, complaining that, "The miserable means available to painting were not sufficient." Then, Munch turned the central figure toward the viewer, transforming a melancholic image into a confrontational one. In *The Scream*, Munch's figure at Ljabroveien is no longer a man but an amorphous creature personifying terror, a figure caught up in the swirling vortex of the painting, as though literally overwhelmed by the forces of nature. Frozen in an expression of unspeakable horror, the figure no longer contemplates his surroundings but appears assaulted by them. There are two painted versions of *The Scream*, this one in Oslo's National Gallery and the version recently stolen from the Munch Museum.

PLATE 85
The Scream. 1895. Lithograph with watercolor additions, comp.: 13⅞ × 9¹³⁄₁₆" (35.2 × 25 cm); sheet: 17 × 12¹³⁄₁₆" (43.2 × 32.5 cm). Munch Museum, Oslo

PLATE 86
The Scream. 1895. Lithograph, comp.: 13¹⁵⁄₁₆ × 10" (35.4 × 25.4 cm); sheet: 20¹¹⁄₁₆ × 15⅞" (52.5 × 40.3 cm). The Museum of Modern Art, New York. Matthew T. Mellon Fund

PLATE 87
Death in the Sick Room. 1893. Oil on canvas, 53³⁄₁₆ × 63" (136 × 160 cm). Munch Museum, Oslo

The importance of this painting to Munch's oeuvre is suggested by its placement at the entrance to his 1893 Berlin exhibition, where no less than three versions of the motif were shown: the painting, a pastel, and a charcoal drawing. Hidden in a voluminous black chair with its back toward the viewer, Munch's dying sister Sophie is nearly lost amidst the family group that includes Munch's father and aunt in the background, his brother Andreas at the door, and a unified foreground group consisting of Munch and his sisters Inger (standing) and Laura (seated). In all versions of this motif, Munch's family members are depicted at the present time rather than at the age they were when the event took place. Like characters in a reenactment, Munch's family appears to have gathered to recreate this painful event, all the while assuming a certain distance from their grief's original urgency.

PLATE 88
By the Deathbed. 1895. Oil on canvas, 35½ × 47⁷⁄₁₆" (90.2 × 120.5 cm). Bergen Art Museum. Rasmus Meyers Collection

In this painting of Munch's sister Sophie's death, Sophie herself is barely visible, reduced to a radically fore-shortened body seen from behind. Occupying the majority of the canvas is Munch's family—all except Munch himself—including his long-dead mother, who stands in the foreground clasping the bed post. We are, especially, made to identify with the dying girl, whose low vantage point resembles our own. By absenting himself from the scene, Munch becomes yet another vicarious witness, as if attempting to experience the girl's pain as his own. He wrote in his diary: "It was evening— [Sophie] lay red and burning hot in her bed, her eyes shone and traveled restlessly around the room—she was delirious – You dear sweet [Edvard] take this away from me it is so painful—won't you do that— she looked at him imploringly—yes, you will—Do you see that head over there—it is Death." Munch's earliest version of the motif, a pastel, first exhibited in Berlin in 1893, rendered this vision: a group of floating death's heads hover in the background and a skeleton lurks in the shadow, which envelops the family group; a later print includes masklike faces embedded in wavy lines that extend over the heads of the family members (plate 89).

PLATE 89
By the Deathbed. 1896. Lithograph, comp.: 15⅝ × 19¹¹⁄₁₆ (39.7 × 50 cm); sheet: 19¹¹⁄₁₆ × 25⅞" (50 × 65.7 cm). Epstein Family Collection, Washington, D.C.

PLATE 90
Jealousy. 1895. Oil on canvas, 26¼ × 39¼" (66.8 × 100 cm). Bergen Art Museum. Rasmus Meyers Collection. (NOT IN EXHIBITION)

This is a deliberately ambiguous Adam and Eve vignette, in the manner of much of Munch's work from this period. The painting can be

interpreted both as a testament to Adam and Eve's sinful nature and, alternatively, in a reversal of Christian doctrine, as a celebration of their actions and, therefore, of the fecundity of suffering, jealousy, and shame. The inclusion of Stanislaw Przybyszewski may also be a reference to the belief among Munch's compatriots that he had had an affair with Przybyszewski's future wife Dagny Juell. The figures in the background would then be understood to be Juell and Munch himself, and the entire composition a variant on the Melancholy motif. Nonetheless, it is certain that, as with all his Frieze of Life motifs, Munch was interested, above all, in a universal emotional expression. There are several printed versions of this motif (plate 92) as well as an impressionistic drawing (plate 91).

PLATE 91
Jealousy. c. 1896. Charcoal and pastel on paper, 16½ × 22" (41.9 × 55.9 cm). Private collection, New York

PLATE 92
Jealousy II. 1896. Lithograph with gouache and watercolor additions, comp.: 18½ × 22⁷⁄₁₆" (47 × 57 cm); sheet: 22¹⁄₁₆ × 24⅛" (56 × 61.2 cm). Munch Museum, Oslo

PLATE 93
Inheritance I. 1897–99. Oil on canvas, 55½ × 47¼" (141 × 120 cm). Munch Museum, Oslo

This painting of a syphilitic mother and her diseased child was exhibited for the first time under the title *La Mère* in its own room at the 1903 Salon des Indépendants in Paris. The public received the painting with a mixture of derision and indignation. Munch did not seem particularly troubled by the criticism; in fact, it appears to have amused him. He wrote to Max Linde: "My syphilitic child, hung in its own room, obtained the greatest success of hilarity. It was in a play full

of people laughing and crying." Munch's notes indicate that he saw himself in the figure of the doomed child. As Munch observed: "Should we sick people establish a new home with the poison of consumption eating into the tree of life—a new home with doomed children."

PLATE 94
Red Virginia Creeper. 1898–1900. Oil on canvas, 47¹⁄₁₆ × 47⅝" (119.5 × 121 cm). Munch Museum, Oslo

There is only one version of this motif, which Munch began during the late autumn and winter of 1898, and which he hung, together with the *Frieze of Life,* on the "Life Anxiety" wall at the 1902 Berlin exhibition. Like the other paintings on that wall, *Red Virginia Creeper* relies on intense coloration—in particular, the vine's vivid red—and exaggerated perspective to convey a mood of extreme tension. In the foreground is a green-faced man, who resembles Stanislaw Przybyszewski with his pointed chin and beard.

PLATE 95
Fertility. 1898. Oil on canvas, 47¼ × 55⅛" (120 × 140 cm). Private collection, courtesy Blomqvist Kunsthandel

This painting must be considered alongside other Adam and Eve motifs from the period, which include images fundamental to the *Frieze of Life,* such as *Jealousy* (1895; plate 90) and *Metabolism* (1899; plate 96). However, where these paintings emphasize the metaphysical symbolism typical of the cycle, *Fertility* has transplanted the theme into a more harmonious, everyday setting. Indeed, this image of a hard-working farm couple posed in a garden landscape has been referred to as "a gentler, affirmative version of *Metabolism.*" Still, there are elements in the work that contrast with the general sense of harmony and well-being, such as the suggestion of a sawed-off

branch at the center signifying illness and death. In a note from 1892, which relates to both *Fertility* and *Metabolism,* Munch observes: "The humid earth steamed—it smelled of rotted leaves—and how quiet everything was around me— and yet I felt how it fermented and lived—in this steaming earth with its rotting leaves— in these naked branches that would soon grow again and live, and the sun would shine on the green leaves and flowers—and the wind would bend them. . . . I felt that pleasurable feeling of walking over— becoming united with—this earth . . . and there would rise from my decaying body . . . trees and plants and flowers. And the sun would warm them and I would be in them and nothing would perish that is eternal."

PLATE 96
Metabolism. 1899. Oil on canvas, 68⅞ × 56⁵⁄₁₆" (175 × 143 cm); frame: 87⅝ × 62¹⁄₁₆" (222.5 × 158 cm). Munch Museum, Oslo

"The subject of the largest painting," Munch observed of *Metabolism* in his 1918 "Frieze of Life" manifesto, "lies somewhat outside the . . . ideas expressed in the other pictures; but its role in the frieze is as vital as a buckle is for a belt. It is a picture of life as well as of death, it shows the wood feeding off the dead and the city growing up behind the trees. It is a picture of the powerful constructive forces of life." This description is somewhat puzzling in reference to this painting of two naked figures on either side of a barren tree trunk. However, X-rays and an original photograph of Munch's 1903 Leipzig exhibition (page 231) reveal that a flowering bush originally grew between the couple and that this bush shielded a human fetus. *Metabolism's* original frame, which Munch must have removed during the work's overpainting between 1903 and 1918 and which is here restored, pairs a human and animal skull below,

and depicts the glittering city of Kristiania above. The roots of the tree extend down into the skeleton as if emerging from its core. The proximity of life and death is also the subject of a 1916 lithograph titled *Metabolism* (plate 97), in which the couple has been replaced by a pregnant woman, standing against a tree gazing at the sun; below ground, a skeleton pushes its way up into the roots of the tree.

PLATE 97
Metabolism. 1916. Lithograph with watercolor additions, comp.: 28¾ × 18⅞" (73 × 48 cm); sheet: 31¹³⁄₁₆ × 22¼" (80.8 × 57.8 cm). Munch Museum, Oslo

PLATE 98
Golgotha. 1900. Oil on canvas, 31½ × 47¼" (80 × 120 cm). Munch Museum, Oslo

Golgotha was created in the Kornhaug Sanatorium, where Munch convalesced in the autumn and winter of 1899. Undoubtedly, Munch identified with this image of a crucified Christ suspended above a leering crowd. He is, in short, the suffering artist through whose work the rest of mankind will be saved but for whom persecution is the immediate fate. Not only does the Christ figure possess Munch's features but so does the young man in profile to the right. The woman who places a hand on the young man's shoulder has been read alternately as a consoling figure—perhaps Munch's aunt—or as a demonic force, Munch's "cross in this world." Other recognizable figures are: Christian Krohg, as the man with the beard on the left; the Norwegian playwright Gunnar Heiberg, as the leering face to the right of the bailiff; and Stanislaw Przybyszewski, as the figure with the pointed beard directly beneath Christ.

PLATE 99
The Island. 1900–01. Oil on canvas, 39 × 42½" (99 × 108 cm). Private collection, Oslo

Depicted here is the Island of Ulvøy, across from Nordstrand, near Kristiania, where Munch's aunt and sister lived for a time. Munch visited them during the summer of 1899 and the winter of 1900, and, while there, he painted a number of landscapes, primarily winter scenes. *The Island* represents the "summer counterpart" to these images.

PLATE 100
The Dance of Life. 1899–1900. Oil on canvas, 49⁵⁄₁₆ × 75³⁄₁₆" (125 × 191 cm). The National Museum of Art, Architecture, and Design/National Gallery, Oslo

The Dance of Life, which Munch began while recuperating at Kornhaug Sanatorium, was one of the artist's last contributions to the *Frieze of Life*. He saw the painting as encapsulating the cycle's principal themes; as he put it, "the awakening of love, the dance of life, love at its peak, the fading of love, and finally death." In the painting, Munch documents the transition from love to death by means of three female figures: the golden-haired virgin reaching out to touch a sprouting flower at the left-hand side of the composition; a red-haired woman—Munch's erotic temptress—dancing in the center with a sober man who bears Munch's features; and, at the far right, a woman dressed in the black of mourning, her hands tightly clasped against her body as if she has left the dance once and for all. The entire scene takes place on the Åsgårdstrand shore against the glow of the Nordic summer night.

PLATE 101
Åsgårdstrand. c. 1900. Oil on canvas, 39½ × 37⅞" (100.3 × 95.6 cm). Private collection

PLATE 102
Girls on the Pier. c. 1901. Oil on canvas, 53⁹⁄₁₆ × 49¹⁄₁₆" (136 × 125 cm). The National Museum of Art, Architecture, and Design/National Gallery, Oslo

This painting of three young girls leaning over a railing and looking into the Åsgårdstrand harbor represents yet another variation on the mystical Åsgårdstrand landscape. Visible in the background is the Grand Hotel and its massive linden grove, while the grove's dark reflection fills the water below thereby infusing this seemingly optimistic painting with an ominous underside. The pier's sharply receding diagonal serves as a barrier, or threshold, between the girls and the water's murky depths. *Girls on the Pier* is one of Munch's most reworked motifs. There are no less than thirteen painted versions as well as several prints. Munch also made several compositions featuring the landscape alone, such as *Åsgårdstrand*, c. 1900 (plate 101). While distinct from the *Frieze of Life* cycle, *Girls on the Pier* was exhibited as one of six additional paintings featured in the 1902 Berlin exhibition.

PLATE 103
Portrait of Ludvig Meyer's Children: Eli, Rolf, and Karl. 1894. Oil on canvas, 41⁵⁄₁₆ × 48⅞" (105 × 124.2 cm). Kunstmuseum Bern. Gift of the Emil Bretschger Foundation

Munch was asked to paint the children of the Norwegian lawyer Ludvig Meyer in 1894. He completed the painting during an eight-day stay at the family's vacation home in Høvik, while the children's father was away. When he saw the finished work, Meyer was unsatisfied with it and refused to pay, causing Munch to file a civil suit. According to court documents, Munch asserted that the job had been strenuous and time-consuming and that the children had consistently misbehaved. Munch ultimately won the suit, with the judge declaring that

someone willing to commission a work by an artist as controversial as Munch ought to accept the results. Unlike her husband, Mrs. Meyer admired the painting and kept it when she and her husband divorced several years later.

PLATE 104
The Four Sons of Dr. Linde. 1903. Oil on canvas, 56¹¹⁄₁₆ × 78⁹⁄₁₆" (144 × 199.5 cm). Die Museen für Kunst und Kulturgeschichte der Hansestadt Lübeck

Dr. Max Linde commissioned this portrait from Munch in a letter to the artist in April 1903. His children are situated before the symmetrical white neoclassical doors against which they stand out in stark relief. The third son Helmuth's central placement anchors the painting; Hermann, the oldest boy, appears dreamy and introverted as he retires behind his youngest brother Lothar, while, at the opposite side of the frame, Theodor, the second oldest, stands tall and assertive, his feet planted wide and his arm akimbo. At the same time, Theodor's dark eyes and slightly drooping mouth betray a vulnerability that contrasts with his youngest brothers' vivid gazes. Alert and tidy, Helmuth is the only figure to look directly at the viewer, while Lothar stares with a look of eager apprehension as he clutches a handkerchief in his small fist.

PLATE 105
Four Ages of Life. 1902. Oil on canvas, 51⁵⁄₁₆ × 39½" (130.4 × 100.4 cm). Bergen Art Museum. Rasmus Meyers Collection

Four Ages of Life is one of several paintings that Munch made in the early 1900s depicting figures in an avenue. Munch was fond of the avenue as an indicator of time's passage, something that this painting's title makes explicit. In the foreground, a young girl faces forward, next to a woman of middle age. Both figures

confront the viewer head-on, as though looking out toward life and the future. In the background is the older generation, represented by a woman with a careworn face shown in profile, and, behind her, a bent-over figure, who has already turned away.

PLATE 106
The Coffin Is Carried Out. 1904. Oil on canvas, 31½ × 23⅝" (80 × 60 cm). Munch Museum, Oslo

This is an unusual painting about whose history little is known. Munch made several versions of this funerary motif including another painting of the same title of 1898–1901. Both versions of *The Coffin Is Carried Out* depict children looking on as a coffin is carried out of a house. Munch's somewhat naïve painting style and subject matter highlight his obsession with the juxtaposition between life's innocent beginning and its tragic end.

PLATE 107
The Avenue in Snow. 1906. Oil on canvas, 31½ × 39⅛" (80 × 100 cm). Munch Museum, Oslo

This painting exploits the motif of the avenue as a dramatic compositional device. In this case, the impression is one of impending doom as the lane's faceless occupants—two small children—stand huddled against the bitter cold and snow. The lane is a funneling diagonal bordered on either side by a wall of dark trees. The road's limitless white expanse suggests that there is no escape.

PLATE 108
The Drowned Boy, Warnemünde. 1908. Oil on canvas, 33¹¹⁄₁₆ × 51⅜" (85.5 × 130.5 cm). Munch Museum, Oslo

The event of this painting's title appears only incidentally in the background on the left, where a darkly clad man carries

a limp figure in his arms. The real focus of the painting is the two foreground figures, who appear with their backs to the viewer on the promenade of Am Strom outside Munch's house in Warnemünde. They are identical in every aspect except for the color of their dress, which is alternately dark and light.

PLATE 109
Uphill with a Sled. 1911. Oil on canvas, 25⁹⁄₁₆ × 44½" (65 × 113 cm). Munch Museum, Oslo

Depicting a Kragerø landscape, this painting is specifically identifiable as the immediate vicinity of Munch's home at Skrubben. Off to the left, the island of Gundersholmen merges with its reflection in the open fjord, while the mountain of Heftre rises at the right-hand side. The dark blue figure in the foreground leans into the mountain, as he pulls his sled, his body radically foreshortened in repetition of the gentle upward slope. At the far right, the man in yellow appears to exist on a separate plane so flat and indistinct is his form. His head and neck fuse with the craggy rocks and his semitransparent body reveals the white snow beneath.

PLATE 110
Galloping Horse. 1910–12. Oil on canvas, 58¼ × 47¼" (148 × 120 cm). Munch Museum, Oslo

Galloping Horse is a remarkable painting for its energy and vitality. Munch was fond of horses and owned several, including a favorite white horse named Rousseau, and he painted many images of horses during these years. In this painting, the animal's radically foreshortened body appears to burst from the canvas while, at the right-hand side, two children press themselves against the rocks so as to get out of the way. Visible at the bottom of the painting is a series of brushstrokes that, when the

canvas is fully stretched, reveals itself to be the outlines of a man's leg and a woman's skirt in rapid flight.

PLATE 111
Spring in the Elm Forest II. 1923. Oil on canvas, 41⁵⁄₁₆ × 47¼" (105 × 120 cm). Munch Museum, Oslo

Munch painted a large series of images of the elm tree forest located on the grounds of his property at Ekely. He painted the trees in different weather conditions and from different angles. The short, colorful strokes of paint that make up *Spring in the Elm Forest III* (plate 114) suggest a brilliant spring day, while this work, *Spring in the Elm Forest II,* is altogether more somber. Nature is here defined by gray, craggy trunks that cast dark shadows over the otherwise barren forest floor. With their groping, gnarled branches, the trees in *Spring in the Elm Forest II* resemble forest spirits out of some Nordic legend, while the large trunks at the left in *Spring in the Elm Forest III* seem to confront the viewer through watchful, knotted eyes.

PLATE 112
The Yellow Log. 1911–12. Oil on canvas, 50¹³⁄₁₆ × 63³⁄₁₆" (129 × 160.5 cm). Munch Museum, Oslo

The Yellow Log represents one of Munch's favorite Kragerø motifs, the forest interior, dramatized through eccentric color and composition. The most prominent element in the painting is the bright yellow log, whose extreme diagonal plunges the viewer into the forest depths. Akin to Futurist force lines, the felled log against the forest floor's blanket of white snow appears as a golden sun casting its rays over the earth. Munch's log is a vibrant, kinetic force. Culminating in the base of the tallest tree in the far distance, the log remains intimately connected to its living counterpart.

PLATE 113
Winter Night. 1924–26. Oil on canvas, 39⅜ × 31½" (100 × 80 cm). Munch Museum, Oslo

One of a number of paintings that Munch made of the farm laborer's cottage on his property at Ekely, *Winter Night* shows the house just visible above the snow-covered hills and through a fan of naked tree branches. This weblike mass clings like tendrils to the surface of the canvas much like the "eyelashes" that covered the original *Sick Child* (1885–86; page 223).

PLATE 114
Spring in the Elm Forest III. 1923. Oil on canvas, 42¹⁵⁄₁₆ × 51³⁄₁₆" (109 × 130 cm). Munch Museum, Oslo

PLATE 115
The Sun (Study). 1912. Oil on canvas, 48⁷⁄₁₆ × 69½" (123 × 176.5 cm). Munch Museum, Oslo

This painting of the life-giving sun is a study for the central panel of a decorative scheme for the University Festival Hall in Kristiania, which Munch unveiled in 1916 (plates 117–127). It is also the manifestation of Munch's growing interest in vitalist philosophy, a movement inspired by the writings of Friedrich Nietzsche, which posited a physical and spiritual interrelatedness among living things. In the Festival Hall, the sun assumed a quasireligious force for Munch, where it occupied the central place, its rays extending out into the flanking scenes (see page 235). Munch explained that in a life of nonexistent happiness, "the only possible source of anything divine [for him] was the sun and the light."

PLATE 116
Nude Figures and Sun. 1910–19. Oil on canvas, 39⅜ × 54¾" (100 × 139 cm). Munch Museum, Oslo

This painting of female bathers bears a striking resemblance

to a work titled *Peace/Rainbow* that Munch originally intended as part of his Festival Hall commission. In that painting, a counterpoint to a work titled *War,* in which male and female nudes ascend a barren slope and descend a steep cliff to enter into battle, a throng of nudes reclines on smooth blue rocks.

PLATES 117–127
Eleven Murals for Festival Hall, University of Oslo. 1909–16. Oil on canvas.
(NOT IN EXHIBITION)

Munch began working on designs to decorate the new, large auditorium (Festival Hall) of the University in Kristiania as early as the summer of 1909. Over the next seven years, through several rejections, the official acceptance of his designs in 1914, and, finally, the murals' unveiling in 1916, Munch submitted dozens of sketches, radically altering his initial theme and style along the way. The artist had originally intended to create a series of portraits of Norwegian writers and intellectuals. However, he ultimately decided that the classical university building required more universal, allegorical themes. On September 19, 1916, the Festival Hall murals were formally unveiled. In its final version, the program consists of two large panels on the long side walls, *History* and *Alma Mater* (plates 118 and 126), which flank a monumental central painting, *The Sun,* on the wall at the front of the room (plate 122). *History* depicts an old man and boy underneath a tree in a rocky setting; *Alma Mater* shows a woman dressed in traditional rural clothing seated in a gentle landscape. *The Sun* dominates the whole, a universal symbol of natural and intellectual growth. The three main panels are each flanked by smaller canvases that particularize the ensemble's universal intent. There are eight in all, four of which flank *The Sun.* On the immediate left is *Awakening Men in a Flood of Light* (plate 121), which depicts

three men in various states of sleep and waking reaching toward the sun. On the right, in *Spirits in the Flood of Light* (plate 123), a host of cherubim play within the sun's rays. Flanking these panels are two compositions featuring pairs of nudes gesturing toward the sun: *Women Reaching Toward the Light* (plate 120) and *Men Reaching Toward the Light* (plate 124), respectively. To the left of *History* is *Chemistry* (plate 117), an image of alchemical creativity in which cherubim emerge from laboratory equipment held by a nude couple, while, to the right, *New Rays* (plate 119) depicts a couple embracing amidst the sun's rays. Finally, *Alma Mater* is flanked by two paintings dealing with themes of natural abundance and rejuvenation, *Women Harvesting* and *The Fountain* (plates 125 and 127).

PLATE 117
Chemistry. 1911–16.
14' 11⅛" × 88⅜₆" (455 × 225 cm)

PLATE 118
History. 1909–16. 14' 11⅛" × 38' 1¹¹⁄₁₆" (455 × 1160 cm)

PLATE 119
New Rays. 1911–16. 14' 11⅛" × 88⅜₆" (455 × 225 cm)

PLATE 120
Women Reaching Toward the Light. 1911–16. 14' 11⅛" × 64¹⁵⁄₁₆" (455 × 165 cm)

PLATE 121
Awakening Men in a Flood of Light. 1911–16. 14' 11⅛" × 10' ¹⁄₁₆" (455 × 305 cm)

PLATE 122
The Sun. 1911–16. 14' 11⅛" × 25' 7¹⁄₁₆" (455 × 780 cm)

PLATE 123
Spirits in the Flood of Light. 1911–16. 14' 11⅛" × 10' ¹⁄₁₆" (455 × 305 cm)

PLATE 124
Men Reaching Toward the Light. 1911–16. 14' 11⅛" × 64¹⁵⁄₁₆" (455 × 165 cm)

PLATE 125
Women Harvesting. 1909–16. 14' 11⅛" × 88⅜₆" (455 × 225 cm)

PLATE 126
Alma Mater. 1911–16. 14' 11⅛" × 38' 1¹¹⁄₁₆" (455 × 1160 cm)

PLATE 127
The Fountain. 1909–16. 14' 11⅛" × 88⅜₆" (455 × 225 cm)

PLATE 128
Bathing Youth [The Ages of Life Triptych]. 1909. Oil on canvas, 81⅛ × 39⅛" (206 × 100 cm). Bergen Art Museum. Rasmus Meyers Collection

PLATE 129
Old Age [The Ages of Life Triptych]. 1908. Oil on canvas, 78¾ × 38⅜₆" (200 × 97 cm). Munch Museum, Oslo.
(NOT IN EXHIBITION)

PLATE 130
Bathing Men [The Ages of Life Triptych]. 1907–08. Oil on canvas, 81⅛ × 89⅜₆" (206 × 227.5 cm). Ateneum Art Museum/The Antell Collection, Helsinki

Munch painted the monumental *Bathing Men* during the summer of 1907 in the fishing village and popular resort town of Warnemünde, Germany, where he took up residence in search of physical and psychological restoration. Munch based the image on bathers at Warnemünde's nudist beach, whom he directed as models. In a series of photographs shot most likely with a self-timing camera, Munch stands fully or nearly nude in a variety of poses (page 233). Hands on hips and feet firmly planted, he is, like the figures in his painting, the embodiment of health, strength, and the generative power of man in nature. Like Munch's Festival Hall program, this painting can be seen as part of a growing Scandinavian cult of sun worship grounded in the writings of Nietzsche and their dissemination within the German vitalist movement. After the painting was exhibited in Hamburg in 1908, Munch decided to add side panels (plates 128 and 129),

which feature single figures, representative of youth and old age, respectively, and, together with the middle panel, constitute *The Ages of Life Triptych.* The panels were ultimately separated and sold to different institutions.

PLATE 131
Naked Men. 1923. Oil on canvas, 77¹⁵⁄₁₆ × 42¹¹⁄₁₆" (198 × 108.5 cm). Munch Museum, Oslo

A variation on the bathing motif, this painting is set in a swimming hall. Accompanying the spread of the Scandinavian cult of bathing and sun worship was a proliferation of urban bathhouses and swimming schools. Bathhouses were first introduced in Stockholm in 1883, and in Norway in 1893, by E. Leonard Hasvold who encouraged bathing as a means of increasing health and well-being.

PLATE 132
Friedrich Nietzsche. 1906. Charcoal, pastel, and tempera on paper, 78¾ × 51¹⁄₁₆" (200 × 130 cm). Munch Museum, Oslo

On July 6, 1905, the Swedish art collector Ernst Thiel commissioned from Munch a large-scale portrait of the philosopher Friedrich Nietzsche, "the man to whom I owe a greater debt of gratitude than to any other human being." Nietzsche had been dead five years when Munch received the commission, so he relied on a photograph from the philosopher's archives in Weimar taken by the photographer and graphic artist Hans Olde. For the background landscape, Munch likely used a postcard found among the philosopher's documents of the landscape around Naumburg, where Nietzsche grew up. Of both the painted portrait and this charcoal study for it, Munch wrote: "As I have hinted I have chosen to paint him in a monumental and decorative style. . . . I have

depicted him as the author of Zarathustra in his cave between the mountains. He stands on his balcony looking down into a deep valley, and over the mountains a radiant sun is rising—One may think of the point where he talks about standing in the light but wishing to be in the dark—but of many others as well."

PLATE 133
Portrait of Professor Daniel Jacobson. 1908. Oil on canvas, 50½ × 29" (128.3 × 73.7 cm). Statens Museum for Kunst, Copenhagen

Dr. Daniel Jacobson was the head of a nerve clinic outside Copenhagen where Munch underwent treatment for paranoia in the summer of 1908. Munch quickly turned his sick room into a studio and found new motifs in his surroundings and in those who attended him. Munch completed three portraits of Dr. Jacobson, one of the doctor's head and two full-length frontal images. In this version, Dr. Jacobson appears both strong and authoritative, but is painted in a swirling mass of bright colors. As Munch put it: "I painted the portrait of the doctor. When I painted, I was the master. I felt that I dominated him, who had dominated me." Jacobson was unhappy with the depiction. One day, when Munch's friend the artist Ludvig Karsten came for a visit, Dr. Jacobson declared: "In all seriousness, I am really worried about him. Just look at the picture he has painted of me. It's stark, raving mad." Karsten, however, had a different opinion: "My God—it's pure genius!"

PLATE 134
Harry Graf Kessler. 1906. Oil on canvas, 78¾ × 33¹⁄₁₆" (200 × 84 cm). Staatliche Museen zu Berlin–Nationalgalerie

Munch met Harry Graf Kessler in the late autumn of 1894, while he was living in Germany. During this time, Kessler sat for a lithographic portrait

and purchased a number of Munch's earliest etchings. Over the next fifteen years, he became one of Munch's most faithful advocates, securing for him numerous commissions. In 1904, Kessler invited Munch to Weimar, where Munch painted the first of three portraits of Kessler. Munch's 1906 portrait shows his mastery of large, full-length figures against stripped-down, brightly lit grounds.

PLATE 135
On the Operating Table. 1902–03. Oil on canvas, 42¹⁵⁄₁₆ × 58¹¹⁄₁₆" (109 × 149 cm). Munch Museum, Oslo

This painting depicts the brutal consequences of Munch's violent break-up with his fiancée Tulla Larsen in 1902, when Munch accidentally shot himself in the middle finger of his left hand while struggling with Larsen for a gun. Even more traumatic for the artist than the actual event was his trip to Kristiania's National Hospital, where the bullet was dislodged and the tip of his finger removed. In the painting, which recalls traditional anatomy-theater depictions, Munch lies nude on the hospital bed in a radically foreshortened position, his left hand tightly clenched above his heart. An enormous bloodstain is visible on the white sheet, while a nurse stands by holding the remainder in a bowl. In the background, physicians gather to discuss the situation, and a group of students observes the procedure from behind a window. When Munch exhibited the painting at Blomqvist's in September 1903, he did so as a kind of public accusation against Larsen and the friends with whom she fled to Paris following the incident.

PLATE 136
Death of Marat II. 1907. Oil on canvas, 60¼ × 58¹¹⁄₁₆" (153 × 149 cm). Munch Museum, Oslo. (NOT IN EXHIBITION)

Munch made many versions of *Death of Marat*, the earliest

in 1906. While he used models for the two figures, their features closely resemble those of his own and Tulla Larsen's. Indeed, Munch said that the motif referred to the shooting incident in his cottage in Åsgårdstrand, whose aftermath is pictured in *On the Operating Table* (plate 135). Munch's decision to associate himself with Marat here (and, in turn, with Jacques-Louis David's famous painting *The Death of Marat,* 1793) gives his suffering a heroic dimension.

PLATE 137
Model by the Wicker Chair I. 1919–21. Oil on canvas, 48¼ × 39⅜" (122.5 × 100 cm). Munch Museum, Oslo

PLATE 138
The Artist and His Model I. 1919–21. Oil on canvas, 50⅜ × 60¼" (128 × 153 cm). Munch Museum, Oslo

The Artist and His Model I is part of a larger group of paintings known as the Bedroom Series that Munch executed in Ekely, c. 1919, and that depicts the artist and his model Anna Fjeldbu. Painted shortly after Munch's recovery from influenza, the paintings show a sustained awareness of the tension between the sexes now imbued with a certain emotional distance. The artist was not known to have had intimate relationships with any of the women who modeled for him at this time, and the impersonality shows in an attention to prosaic detail that is distinct from Munch's earlier work. This remoteness is enhanced by the odd placement of the two figures one behind the other, so that neither is able to see the other's face. Notably, Munch employs a new spatial device in this painting: a main room that opens onto other rooms. A related painting, *Model by the Wicker Chair I* (plate 137), is even more dramatically alive with color and paint than *The Artist and His Model I*. In this work it is as though the room

has been set in motion with the massive female figure absorbed within the fluid atmosphere.

PLATE 139
Weeping Nude. 1913. Oil on canvas, 43½ × 53⅛" (110.5 × 135 cm). Munch Museum, Oslo

This is one of a series of motifs depicting the young Ingeborg Kaurin, who was Munch's model and housekeeper from around 1911 to 1915. She was seventeen when Munch first painted her and approximately nineteen at the time of this particular image. Munch was fond of the girl's natural warmth and nurturing disposition, although he retained an appropriate distance: "She is a very moral girl," he once observed, "makes good food, is my model."

PLATE 140
Cleopatra. 1916–17. Oil on canvas. 57⅜ × 40¾6" (145.5 × 102 cm). Munch Museum, Oslo

Included in Munch's 1918 retrospective at Kristiania's Blomqvist gallery was a painting titled *Dancer Lying Down (Cleopatra)*, which was originally part of a larger composition that included *The Slave* (plate 141). The two halves are shown together in an exhibition photograph from Munch's 1921 Blomqvist's show. It is rumored that Munch met the man depicted in the latter painting and in *Black Man Wearing Green Striped Scarf* (plate 142), Sultan Abdul Karim, through his friend and cousin Ludvig Ravensburg, who suggested that Munch employ Karim as both a servant and a model. The 1921 Blomqvist exhibition also featured a smaller work, *Cleopatra and Her Slave*, painted between 1916 and 1920.

PLATE 141
The Slave. 1916–17. Oil on canvas, 57⅜6 × 35⅞6" (145 × 90 cm). Stenersen Museum, Oslo

PLATE 142
Black Man Wearing Green Striped Scarf. 1916–17. Oil on canvas, 31⅜6 × 19½" (79.5 × 49.5 cm). Munch Museum, Oslo

PLATE 143
Self-Portrait with Crayon. 1943. Crayon on canvas, 31½ × 23⅝" (80 × 60 cm). Munch Museum, Oslo

Made the year before Munch died, this portrait shows Munch standing, facing the viewer, at work on the canvas. The artist's dark, sloping contour is visible on the interior canvas as Munch turns from his work to regard the viewer and, as was his habit, his own visage in the mirror. The canvas recalls a very similar self-portrait painted by Rembrandt in 1666 just before he died.

PLATE 144
Dance of Death. 1915. Lithograph, comp.: 19⅛ × 11¹³⁄₁₆" (48.5 × 30 cm); sheet: 21¹¹⁄₁₆ × 14½" (55.1 × 36.8 cm). Hamburger Kunsthalle, Kupferstichkabinett

This image of Munch embracing a skeleton is among his most macabre self-portraits. It is a peculiar image coming at a time when Munch generally avoided his earlier tortured subject matter to focus on more harmonious images of nature and working life.

PLATE 145
Self-Portrait with Cigarette. 1908–09. Lithograph, comp.: 22¼ × 18" (56.5 × 45.7 cm); sheet: 26¼ × 20" (67.9 × 50.8 cm). Private collection, New York

PLATE 146
Sphinx: Androgynous Self-Portrait. c. 1909. Pastel on paper, 19⅛ × 24¹³⁄₁₆" (48.5 × 63 cm). Munch Museum, Oslo

PLATE 147
Self-Portrait in Hell. 1903. Oil on canvas, 32⅜6 × 26" (82 × 66 cm). Munch Museum, Oslo

This self-portrait is generally dated to the summer of 1903 in Åsgårdstrand. Here, Munch stands, literally enveloped in the fires of hell. Behind him, a dark shadow, like a thick pillar of smoke, appears to threaten him. Munch's head is a dark red, as in some of his bathing pictures, where the red color indicates the effect of the sun upon the human body. However, in Munch's self-portrait, vitality is reconfigured as its precise opposite: eternal damnation.

PLATE 148
Self-Portrait with a Bottle of Wine/Self-Portrait in Weimar. 1906. Oil on canvas, 43½ × 47⅞6" (110.5 × 120.5 cm). Munch Museum, Oslo

This melancholic self-portrait was executed in 1906 in Weimar at the restaurant of the Hotel Rüssischer Hof, while Munch was in town for an exhibition at the Grossherzoglishes Museum. At the time, Munch was successful professionally, but he still experienced psychological unrest. *Self-Portrait with a Bottle of Wine* shows Munch before a table bearing a wine bottle, glass, and empty plate. It was one of Munch's favorite self-portraits. He wrote in 1909: "There are several self-portraits, which are self-examinations in difficult years. I think the portraits I am sending, the ones showing me with the glass, are the best. They were done during the Weimar days."

PLATE 149
Self-Portrait in Bergen. 1916. Oil on canvas, 35¼ × 23⅝" (89.5 × 60 cm). Munch Museum, Oslo

In this canvas, dated to the second of two visits that Munch made to Bergen in February of 1915 and 1916, Munch shows himself above a busy Bergen street, the hustle and bustle of the street below captured by his hurried technique and blurred forms. In terms of color and technique, Munch seems fused with his surround-

ings, although, at the same time, cut off from the scene below by the banister and by the contrast in scale between the figure and the tiny people on the street.

PLATE 150
Self-Portrait: The Night Wanderer. 1923–24. Oil on canvas, 35⁷⁄₁₆ × 26¼" (90 × 68 cm). Munch Museum, Oslo.

Self-Portrait: The Night Wanderer shows Munch, with deeply sunken eyes, walking sleeplessly through his house in Ekely. The background is oddly configured, with windows and floor meeting at a precarious angle that complements Munch's own off-kilter posture. All in all, the impression is one of severe fatigue and isolation. Many scholars have observed the connection between the Munch of this self-portrait and Henrik Ibsen's dramatic character John Gabriel Borkman, who spends his time on stage wandering aimlessly through the large empty rooms of his house. Munch's fascination with Ibsen's play is well documented. In fact, as early as 1910 Munch had begun making drawings from the play. His affinity for the text and character took on a new emphasis during the Ekely years in which he increasingly isolated himself. As Munch himself observed, "I still must walk around and feel like a John Gabriel Borkman."

PLATE 151
Self-Portrait During the Eye Disease I. 1930. Oil on canvas, 31¼ × 25³⁄₁₆" (80 × 64 cm). Munch Museum, Oslo.

On May 1930, a blood vessel burst in Munch's right eye, rendering him almost totally blind. *Self-Portrait During the Eye Disease I* is one of several attempts by Munch to record the progress of the disease. A group of drawings, consisting of a series of concentric circles painted in bright watercolor, represents a direct translation of Munch's damaged cornea

as well as of the artist's vision through this cornea. Munch made the drawings by covering his damaged eye for a period of time, and then staring at a piece of paper through glasses of different strengths and different colored lenses. In this painting, he stands in his bedroom at Ekely confronted by the mass of pooling blood that obscures his vision.

PLATE 152
Androgynous Self-Portrait. 1927. Oil on canvas, 58¹¹⁄₁₆ × 40⁹⁄₁₆" (149 × 103 cm). Munch Museum, Oslo. (NOT IN EXHIBITION)

PLATE 153
Self-Portrait as Reclining Nude. 1933–34. Pencil and watercolor on paper, 27⁹⁄₁₆ × 33⁷⁄₈" (70 × 86 cm). Munch Museum, Oslo

Self-Portrait as Reclining Nude takes as its subject Munch's frank encounter with aging. His nude body is frail and sunken, but his furrowed brow and piercing eyes are forceful. In a letter to Jens Thiis around the time this work was painted, Munch observed: "I haven't appeared in public since I was last in your house. My hair is now down to my shoulders and my beard reaches my chest. Every morning I can employ a marvelous free model by painting my own skinny body in front of the mirror. I use myself for all the Biblical characters like Lazarus, Job, Methuselah, etc."

PLATE 154
Self-Portrait by the Window. c. 1940. Oil on canvas, 33⁷⁄₁₆ × 42½" (84 × 108 cm). Munch Museum, Oslo

Self-Portrait by the Window is a study in extreme contrasts: Munch's bright red face against the icy green outside and his columnar form against the window's emphatic horizontality. Does this pairing of opposites signify defiance of old age, or is Munch's fiery visage simply

an indication of the hell that awaits him? Even Munch's own figure is divided, with the left side of his face illuminated while the right remains in shadow. Moreover, his eyes look in two different directions; the split gaze suggests a kind of frantic indecision.

PLATE 155
Self-Portrait: Between the Clock and the Bed. 1940–42. Oil on canvas, 58⅞ × 47⁷⁄₁₆" (149.5 × 120.5 cm). Munch Museum, Oslo

In this last major self-portrait, the artist stands, pale yet resolute, just inside his bedroom at Ekely. Behind him, his studio glows a bright yellow, its walls lined with paintings and sketches. Munch places himself between studio and bedroom, between his public and private realms, and between two symbols of death, the clock and the bed. The artist's tall, thin figure is echoed by the standing clock to his right, which signifies the passage of time, and the muse-like female figure behind the bed, which represents woman, a major motif in his work. Within the shadow in front of the figure, the artist has inscribed a cross.

PLATE 156
Kiss in the Field. 1943. Woodcut, comp.: 15⅞ × 19⁵⁄₁₆" (40.4 × 49 cm); sheet: 24¼ × 26¹⁄₁₆" (61.6 × 66.2). Munch Museum, Oslo

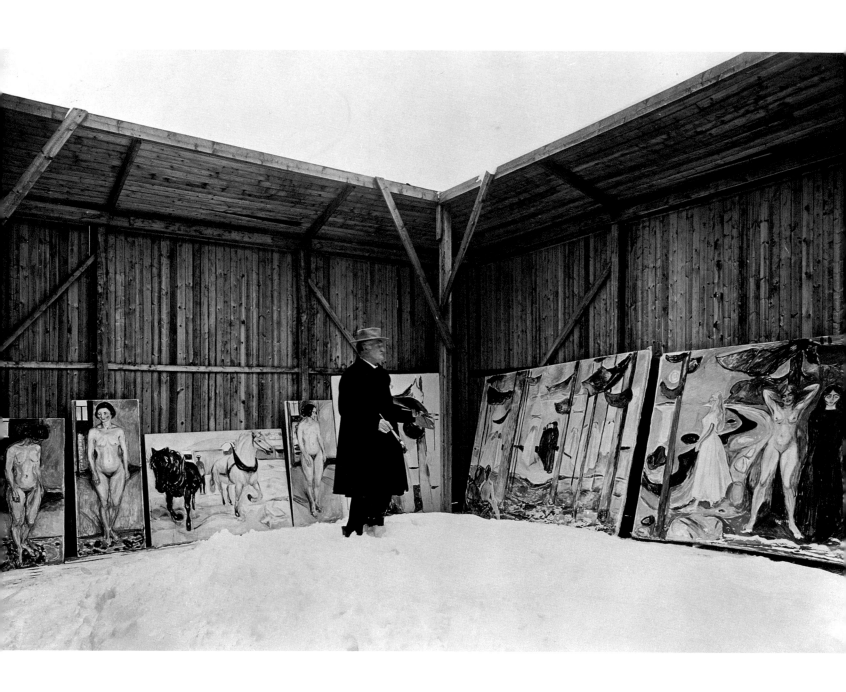

Chronology

Compiled by Claire Gilman

This overview of Munch's life and work is indebted to the following sources. Munch's early exhibition catalogues were essential, as was information provided by the Munch Museum and the National Gallery in Oslo. Secondary texts that proved particularly useful are the writings of Patricia G. Berman, Arne Eggum, Reinhold Heller, Jan Kneher, Lars Roar Langslet, Carla Lathe, Elizabeth Prelinger, Ragna Thiis Stang, Michael Parke-Taylor, Bente Torjusen, Gerd Woll, and Tina Yarborough; the following exhibition catalogues were also valuable: Munch et la France, Munch und Deutschland, Munch und Warnemünde, Edvard Munchs Livs-frise, *and* Edvard Munch: Theme and Variation. (*See Bibliography.*) *Munch's own statements are taken from these sources and from Poul Erik Tøjner's* Munch in His Own Words. *Photographs were provided with the generous assistance of the Munch Museum and Oslo Bymuseum archives as well as Frank Høifødt. The principal source for Munch's extensive travels is Johan H. Langaard and Reidar Revold's* A Year by Year Record of Edvard Munch's Life.

1863
Edvard Munch is born on December 12 at Engelhaug farm near Løten, in Hedmark (about seventy-five miles north of what is now Oslo), to Dr. Christian Munch and Laura Cathrine Bjølstad Munch. His parents, who married in 1861, at forty-four and twenty-two years of age, respectively, are from very different backgrounds but share a deep religious conviction. His maternal grandfather is a sea captain and merchant in a family that is "strong-willed, but rotten . . . with tuberculosis," according to Munch; his father, an army doctor, belongs to "a family of poets," churchmen, and intellectuals that includes his brother, the well-known historian P. A. Munch.

Munch is the second of five children: his siblings are Johanne Sophie (born

OPPOSITE: Munch painting in his open-air studio, Ekely, c. 1920s

1862), Peter Andreas (born 1865), Laura Cathrine (born 1867), and Inger Marie (born 1868).

1864
The family moves to Kristiania (now Oslo), and resides at Nedre Slott Street 9. Dr. Munch works as a surgeon at the nearby Akershus Fortress army headquarters.

1868
Following the birth of Inger, the family moves to Pilestredet 30, then at the edge of the city, where, just after Christmas, Munch's mother dies of consumption. Munch later recalls his mother. "The tall female figure stood beside them [Edvard and Sophie], large and dark against the window. She said she would be leaving them, had to leave them—and asked if they would be sad when she was gone—and they had to promise her to abide by Jesus, then they would meet her in Heaven."

Munch's maternal aunt, Karen Bjølstad, who had moved in with the family after Inger was born, takes over the care of the children (see plate 3). Aunt Karen is a responsible and caring woman, who encourages the children in drawing and other artistic activities.

1875
The family moves again, to Thorvald Meyer Street 48 in the working-class district of Grünerløkka just outside Kristiania.

1877
Early in the year, Munch becomes seriously ill. He suffers from hallucinations and coughs up blood. While recovering at home, he spends much of his time drawing. When he is better, he begins to visit Kristiania's Art Association. In the summer, he makes his first "professional" images: a series of drawings and watercolors of the surrounding houses and countryside.

In the autumn, the family moves to Fossveien 7, where, on November 9, Munch's elder sister Sophie dies of

Englehaug farm, Løten, Hedmark, where Munch was born in 1863

Dr. Christian Munch, Edvard Munch's father, n.d.

Carte-de-visite photograph of Edvard Munch at age eighteen months, 1865

Laura Cathrine Bjølstad Munch, Edvard Munch's mother, with her children: left rear, Johanne Sophie; left front, Peter Andreas; center, Inger Marie; right rear, Edvard; right front, Laura Cathrine, summer 1868

tuberculosis at age fifteen. Munch is particularly close to Sophie, and her death affects him profoundly.

1879
Munch enters Kristiania's Technical College.

1880
In January, Munch makes his first painting: a copy of a portrait of his great-grandfather by Peder Aadnes that hangs above the Munch family sofa. He begins his first original painting, *Old Aker Church* (1881; Munch Museum, Oslo), on Thursday, May 25. On November 8, he notes in his diary: "I have now withdrawn again from the Technical College. I have in fact made up my mind to become a painter." A few weeks later, he begins attending courses at the Royal School of Drawing, including, the following autumn, a class conducted by the sculptor Julius Middelthun.

1882
In January, the family moves to Olaf Ryes Plass 4, directly opposite their first home in Grünerløkka. Here, Munch develops an interest in intimate family scenes, and paints, among other such compositions, *Karen Bjøl-stad in the Rocking Chair* and *At the Coffee Table* (dated 1883; plates 3 and 9). In February, Munch sells his first two works at auction, and also purchases back a third work that does not sell.

In the autumn, Munch leaves art school and rents a studio with six fellow students at Stortings Plass, near Karl Johan Street, in the center of Kristiania. The well-known naturalist painter Christian Krohg has a studio in the same building and advises the students on their work free of charge. Munch begins to associate regularly with a group of young naturalists. Although admired by Krohg, Munch suffers from the criticism of other established painters and critics.

1883
Munch takes part in his first exhibition, Kristiania's Industry and Art Exhibition, June to October.

In the autumn, the family moves to an apartment complex adjoining their previous home on Fossveien. Munch participates in the second annual Autumn Exhibition, which had been inaugurated the previous year by Kristiania's artistic commu-nity in protest against shows by the restrictive Art Association. He exhibits *Girl Kindling a Stove* (plate 8). Gunnar Heiberg, a Norwegian playwright, praises the painting, although he also echoes the prevail-ing sentiment that it lacks finish.

Munch reads Feodor Dostoevski's novel *Crime and Punishment* (1866), which appears in Norwegian transla-tion, and writes enthusiastically about it to his friend Olav Paulsen.

1884
At the Autumn Exhibition, Munch exhibits *Morning: Girl at the Bedside* (1884; Bergen Art Museum. Rasmus Meyer Collection), a painting that he had completed during the late sum-mer while attending the naturalist painter Frits Thaulow's "Open-Air Academy" in Modum, outside Kris-tiania. The exhibition also contains three paintings by Thaulow's brother-in-law, Paul Gauguin. Two of them, *Madame Mette Gauguin in Evening Dress* (1884) and *Basket of Flowers* (1884), later enter the collec-tion of Kristiania's National Gallery.

In December, Munch begins to culti-vate the Kristiania bohemian set, a coterie centered around Christian Krohg and the anarchist author Hans Jæger, an advocate of free love, who openly attacks society and its institutions.

1885
Financed by Thaulow, Munch travels, via Antwerp, to Paris for a three-week stay during the spring. In Antwerp, he exhibits *Portrait of the Artist's Sister Inger* (1884; National Gallery, Oslo) in the Norwegian section of the World's Fair.

While in Paris, Munch visits the Salon and the Louvre. It is possible that Munch sees work by some of the Impressionists on this trip.

Upon his return home, Munch com-pletes a bohemian seduction scene titled *Tête-à-Tête*, which uses his sister Inger and the painter Karl Jensen-Hjell as models (plate 10). He also completes a full-length portrait of Hjell, which reveals the influence of Edouard Manet and Diego Veláz-quez, most likely filtered through the lessons of Krohg, who is a Manet devotée. Kristiania critics condemn the painting as derivative of Impres-sionism and even Jæger labels it, "a trifle too arrogant and mischievous in its portrayal."

Fossveien 7, Kristiana, where the Munch family lived from 1877 to 1882. Photograph by Inger Munch, c. 1920

Karl Johan Street, Kristiania, looking toward the Royal Palace, n.d.

Edvard Munch, at age twenty-two, in a photo-graph for admittance card to World's Fair, Antwerp, 1885

That summer, Munch spends time in the vicinity of Borre on the Kristiania Fjord where he meets Milly Ihlen Thaulow, the wife of Frits's cousin Captain Carl Thaulow. Munch and Mrs. Thaulow begin a short but heated affair. Recollections of their secret trysts in the Borre forest, near Åsgårdstrand, as well as of the relationship's speedy demise back in Kristiania, subsequently form the subject of many of Munch's best-known motifs.

Munch begins to experience dissatisfaction with naturalism's stylistic limitations and observes to the bohemian writer Hermann Colditz: "Perhaps some other painter can depict chamber pots under a bed better than I can. But put a sensitive, suffering young girl into the bed, a girl consumptively beautiful with a blue-white skin turning yellow in the blue shadows—and her hands! Can you imagine them? Yes that would be a real accomplishment." He begins work on *The Sick Child* (1885–86).

In the autumn, Munch moves with his family for the last time—to Schous Plass 1.

Following its publication on December 11, Hans Jæger's novel, *Fra Kristiania Bohêmen* (*From Kristiania Bohemia*), a testament to free love, is confiscated by the police, and Jæger is sentenced to prison.

1886
Munch's ties to the bohemian community (known as the Kristiania Bohème, after Jæger's book) expand. The group now includes Oda Krohg, Christian Krohg, Oda's first husband Jørgen Engelhardt, the teenage journalist Jappe Nilssen, Gunnar Heiberg, and Karl Jensen-Hjell. Munch participates in the Autumn Exhibition with four paintings, including *Portrait of the Artist's Sister Inger* (1884), and *The Sick Child* under the title *Study* (1885–86). A storm of protest results, with only Jæger and Krohg showing support.

1887
In the Autumn Exhibition, Munch exhibits six paintings (landscapes and portraits).

1888
During the summer, Munch travels through Norway and visits Åsgårdstrand. He spends much time at the seaside resort over the course of his life, and its coastline is featured in many of his paintings.

Munch makes a brief trip to Copenhagen to attend the Nordic Exhibition, where he exhibits three paintings, *Portrait of the Artist's Sister Inger* (1884), *Dr. Christian Munch on the Sofa* (1881; Munch Museum, Oslo), and *In the Digs/Bohemian* (lost). While in Copenhagen, he meets the Danish painter Johan Rohde, who has an important collection of modern French art. Munch sees the work of such French artists as Claude Monet, Edouard Manet, Alfred Sisley, Pierre Puvis de Chavannes, and Jules Bastien-Lepage on view at the French Exhibition, which runs concurrently with the Nordic show.

1889
In April, Munch organizes his first individual exhibition at the Student Union in Kristiania. He exhibits sixty-three paintings and forty-seven drawings. The pictures that receive the most attention are the monumental *Spring* (1889; National Gallery, Oslo), a more prosaic view of the Sick Child theme, and the new, large *Portrait of the Author Hans Jæger* (plate 16). Krohg writes enthusiastically: "He paints, or rather regards, things in a way that is different from that of other artists. He sees only the essential, and that, naturally, is all he paints. . . . Art is complete once the artist has really said everything that was on his mind, and this is precisely the advantage Munch has over painters of the other generation, that he really knows how to show us what he has felt, and what has gripped him, and to this he subordinates everything else." The young art critic Andreas Aubert suggests that Munch be given a two-year state scholarship, which Munch applies for and receives.

Over the summer, Munch rents a house in Åsgårdstrand, where he spends time with his sisters and various members of the Kristiania Bohème, such as Oda and Christian Krohg, Gunnar Heiberg, the poet Sigurd Bødtker, the painter Hans Heyerdahl, as well as the lawyer Ludvig Meyer and the young officer Georg Stang. He begins work on three large canvases on which he experiments with various styles, among them French Impressionism and more typically Scandinavian atmospheric painting. Munch

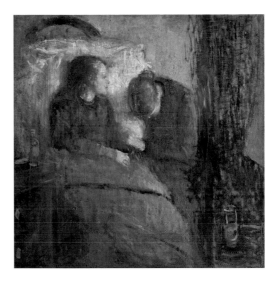

Edvard Munch. *The Sick Child.* 1885–86. Oil on canvas. The National Museum of Art, Architecture, and Design/National Gallery, Oslo

View of Åsgårdstrand, n.d.

House in Åsgårdstrand, where the Munch family stayed during the summer of 1889. Laura is in the doorway, Edvard is at the easel with a study for *Summer Night/Inger on the Beach,* and Inger stands by the gate holding a kitten.

exhibits one of these paintings, *Summer Night/Inger on the Beach,* at the Autumn Exhibition in Kristiania (plate 12). The painting is acquired by the Norwegian naturalist painter Erik Werenskiold.

In October, supported by his state scholarship, Munch moves to the Hôtel de Champagne, Paris, and enrolls in Léon Bonnat's art school. He becomes further acquainted with the work of the contemporary avant-garde including Paul Gauguin, Vincent van Gogh, Georges Seurat, Paul Signac, and Henri de Toulouse-Lautrec, whose work he sees at the exhibition of the Groupe Impressioniste et Synthétiste at Café Volpini and at the Salon des Indépendants, where van Gogh shows *Starry Night, Arles* (1888; Musée d'Orsay, Paris).

Shortly after his arrival in Paris, Munch meets the Danish poet Emanuel Goldstein, who introduces him to Symbolist philosophy and aesthetics, in particular, to the writings of Albert Aurier. Soon after meeting Goldstein, Munch withdraws from art school and dedicates himself to his diary notations.

On December 4, Munch receives a letter from his aunt with news of his father's death due to heart failure. He is unable to return home and sinks into a profound depression. He observes in his diary: "Those at home: my aunt, my brother, my sisters, believe that death is no more than sleep, that my father sees and hears, that he lives in glory and happiness up there, that in time we shall meet him there. I, however, can do nothing but let my grief run out into the day that dawns and then rushes on." And again: "And I live with the dead—with my mother, my sister, my grandfather, and my father—mostly with him."

At the end of December, Munch leaves Paris for nearby St. Cloud, where he seeks mental quietude as well as escape from an outbreak of cholera in the capital city. Here he lives in isolation save for continued contact with Goldstein. He writes his notorious "St. Cloud Manifesto" in which he explicitly rejects his naturalist roots and calls for an art dedicated to human emotion rather than objective fact. In the manifesto, he proclaims: "No longer would interiors, people who knit and read be painted. There should be living

people who breath and feel, suffer and love."

1890

Munch moves in with Goldstein and Georg Stang at St. Cloud's Hôtel Belvédère. During this period, Munch completes the melancholic *Night in St. Cloud* (plate 20), while continuing to work in a modified Impressionist technique.

On May 29, Munch returns home via Antwerp and spends the summer in Åsgårdstrand and Kristiania. Here, Munch casts off his depression and paints the brightly colored *Spring Day on Karl Johan Street* (dated 1891; plate 25), which is executed in a manner akin to Seurat's pointillism. This painting reflects a newly optimistic mood. Munch observes: "I love life . . . even if I must be sick."

At the Autumn Exhibition in Kristiania, Munch shows ten paintings, including *Night in St. Cloud* and *Spring Day on Karl Johan Street* as well as a number of French landscapes. Critics are generally disapproving of his new French influence and his poor attempts at mastering it. The exhibition also features work by Claude Monet, Edgar Degas, and Camille Pissarro.

In November, Munch receives another government grant and sails for France. He is hospitalized with rheumatic fever for two months in Le Havre. In December, he is informed that five of the works that he had shown at the Autumn Exhibition have been destroyed in a fire at a Kristiania depository. These most likely include early versions of *The Day After* and *Summer Night's Dream (The Voice)*. Munch is paid a generous sum in compensation for the loss, which he gives to his family, who suffer financial hardship owing to his father's death.

During a trip to Kristiania, Richard A. McCurdy, president of the Mutual Life Insurance Company in New York, discovers Munch's paintings. He arranges to purchase *Absinthe* (1890; Private collection)—a pastel that shows two figures, likely Jappe Nilssen and Hans Jæger in a smoke-filled café—on the condition that it be renamed *Confession*. It is the first painting by Munch to be bought by an American.

Hôtel Belvédère, St. Cloud, where Munch stayed from January to June, 1890

1891

From January to April, Munch convalesces from rheumatic fever in Nice.

Munch makes his way from Nice to Paris, where he resides at 49, rue Lafayette and where he completes the Gustave Caillebotte–inspired painting *Rue Lafayette* (plate 21). It is possible that Munch visits Caillebotte's studio at this time. Munch visits the Salon des Indépendants where he sees the work of van Gogh, who is represented by six paintings, Signac, who shows *Opus 217. Against the Enamel of a Background Rhythmic with Beats and Angles, Tones, and Tints, Portrait of M. Felix Fénéon in 1890* (1890; The Museum of Modern Art, New York), and Seurat, who exhibits *The Circus* (1891; Musée d'Orsay, Paris).

During the summer in Åsgårdstrand, Munch learns of Milly Thaulow's divorce and subsequent remarriage to an actor, and his feelings of loneliness intensify. He resumes making entries in an illustrated diary he began a few years earlier, and begins his first studies for the paintings that ultimately comprise his *Frieze of Life*. Munch's painful memories are exacerbated by a love triangle that he witnesses between Oda and Christian Krohg, and Jappe Nilssen. In response, Munch completes his first version of the painting *Melancholy* (plate 66), which he exhibits at the Autumn Exhibition.

Munch writes the first version of the text that would form the basis for *The Scream* (plates 84–86). It recounts an experience that Munch had had some years earlier on Ljabroveien, the road between Kristiania and Nordstrand, when the sky suddenly appeared blood red and he heard "an unending scream piercing nature." He makes a preliminary drawing of the subject, as well as a preliminary version of *The Kiss*.

On one of his many visits to the Grand Café in Kristiania, Munch approaches the dramatist Henrik Ibsen, who rudely dismisses him.

In late autumn, having received another state scholarship, Munch leaves Norway in the company of the painter Christian Skredsvig. He makes his way to Nice via Copenhagen (where he visits Emanuel Goldstein and Johan Rohde), Hamburg (where he sees Arnold Böcklin's paintings at the Kunsthalle), Frank-furt, Basel, and Geneva as well as a brief trip to Italy. (Munch later writes to Rohde that he esteems Böcklin almost more than any contemporary painter.) In Nice, Munch becomes newly obsessed with the experience on Ljabroveien, and he makes his first painted version, which he titles *Despair* (dated 1892; plate 83). He also executes numerous studies of his Melancholy motif in preparation for a frontispiece for Goldstein's new edition of poems *Alruner* (a reference to the mandrake root or *alrune*, the main ingredient in a love potion). Before returning to Norway, he completes preliminary studies for *Vampire, Summer Night's Dream (The Voice), Moonlight, The Storm*, and *Jealousy*, and begins a new version of *Melancholy* (inspired by his sketches for Goldstein) in which he alters the posture of the main figure so that he faces out toward the viewer (1892; National Gallery, Oslo).

The National Gallery in Kristiania acquires its first work by Munch, *Night in Nice*, and Munch takes part in his first exhibition in Germany, at the Glaspalast, Munich.

Munch's sister Laura is diagnosed with hysteria and committed to the Gaustad Mental Hospital in Kristiania.

1892

In March, Munch returns to Kristiania, where he works on sketches for collections of poems by the Norwegian poets Vilhelm Krag and Sigbjørn Obstfelder (both projects unrealized). For the Krag commission, Munch begins with the painting *Two Human Beings (The Lonely Ones)* (1891–92; lost), reducing the image of the couple on the shore to the figure of the woman alone. The drawing can, in turn, be seen as a precedent for the 1896 aquatint *Young Woman on the Beach (The Lonely One)* (plate 47). Krag is enthusiastic about many of Munch's paintings and includes a poem titled *Night: Painting by Edvard Munch*, inspired by Munch's *Night in St. Cloud* (plate 20), in his first edition of poems. For Obstfelder, Munch most likely produces a version of *Despair*.

On September 14, Munch's second individual show opens at the Tostrup Building in Kristiania. Here, for the first time, Munch shows a select grouping of his Frieze of Life motifs. The six paintings include: the first *Kiss*, the version of *Melancholy* based

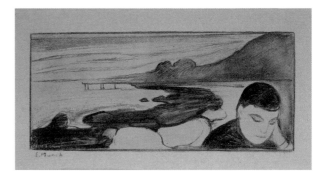

Edvard Munch. *Melancholy*. 1892. Reproduction after a drawing in Emanuel Goldstein's *Alruner*, 1892. Library of the Munch Museum, Oslo

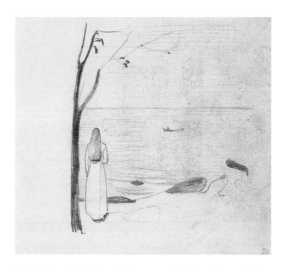

Edvard Munch. *The Lonely One*. 1892. Sketch made for Vilhelm Krag's first book of poems. Pencil on paper. Munch Museum, Oslo

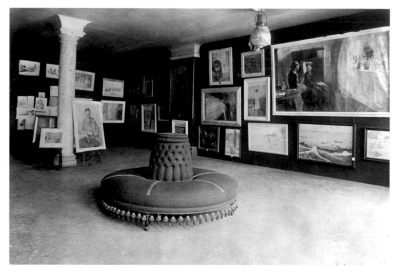

Installation view of Munch's work at The Equitable Palace, Berlin, December 1892–January 1893. Visible at the right are *Spring* (1889; The National Museum of Art, Architecture, and Design/National Gallery, Oslo), and *Mystery of the Beach* (1892); behind the seating can be seen *The Day After* (destroyed) and below it *Tête-à-Tête* (1885). Also on this wall are *The Artist's Sister Inger* (1892) and *Rue Lafayette* (1891). In the far corner is *The Kiss* (1892); *The Author August Strindberg* (1892) rests on an easel next to the column

on the Goldstein vignette, *Night in St. Cloud,* and *Despair* (exhibited under the title *Sick Mood at Sunset*) (plates 20 and 83). In response to the last painting, Krag publishes a poem in *Dagbladet* which concludes: "Not clouds near sunset's glow is it,/Not a reflection of the day now done:/But flickering fire and pouring blood,/ flaming swords and molten streams,/ It is doomsday dread and pangs of death,/A blazing text in the hall of night,/—all life's unfathomable horror." The show also includes *The Artist's Sister Inger* (plate 11), exhibited under the title *Harmony in Black and Violet.*

In October, Munch receives an invitation from the Norwegian painter Adelsteen Normann to exhibit at the Berlin Art Association (Verein Berliner Künstler). The exhibition features approximately the same works as had been shown at Tostrup. It is Munch's first exhibition in the German capital city. With few exceptions, the public reacts with shock and indignation, and soon after the opening, several members of the Art Association call for a meeting with Kaiser Wilhelm II, who is himself dismayed by the "French influence" evident in Munch's work. The next day, it is resolved by a vote of 120 to 104 that the exhibition should be officially closed.

Among those who rally around Munch is Theodor Wolff, the *Berliner Tageblatt* theater critic, who decries the assault on Munch's artistic freedom, and the painter Walter Leistikow, who observes: "In the exhibition, there were paintings that were so beautiful, so profound, so intense . . . so entirely written with all his soul. . . . I liked best his dusk-filled interiors, so mysterious and silent." Far from being put off by the negative press, Munch relishes the attention. "Never have I had such an amusing time," he writes to his aunt Karen. "It's incredible that something as innocent as painting should have created such a stir." Immediately following the exhibition's closing, Munch signs a contract with the art dealer Eduard Schulte to show the work in Düsseldorf and Cologne. The audience turnout is enormous, and only a month later, in December, the exhibition reopens in Berlin at the fashionable Equitable Palace, where Munch receives a hefty sum in admission fees. This time, the exhibition includes a new entry, Munch's *The Author August Strindberg,* his first painting produced in Germany (plate 28).

1893

During the winter, Munch relocates to Berlin, where he takes rooms at the Hotel Hippodrom in Charlottenburg. In April, he rents a studio at Mittelstrasse 11, where he works diligently on his Love and Death motifs, which he continues to formulate as a coherent group. While Munch admires the work of renowned German Symbolists like Arnold Böcklin and Max Klinger (whose graphic series *A Love* can be understood as a vague precedent for the *Frieze of Life*), as well as the Belgian Symbolist Ferdinand Knopff, whose work is exhibited in Berlin in 1893 and 1894, he spends more time with the Berlin literary avant-garde. In particular, he begins to associate with a group of bohemian intellectuals who meet regularly in a wine cellar and who call themselves *Zum Schwarzen Ferkel* (The Black Piglet).

Among those affiliated with the group are the Polish medical student and novelist Stanislaw Przybyszewski, the engineering student turned art critic Julius Meier-Graefe, as well as Strindberg and such familiar figures as Christian Krohg and Gunnar Heiberg. Much like the Kristiania Bohème, the group celebrates sexual love, although with a new emphasis on violence.

May brings about the disintegration of the *Zum Schwarzen Ferkel* due largely to Munch's introduction of Dagny Juell to the group on March 9. Juell is a young Norwegian medical student and the daughter of a doctor. Przybyszewski, Strindberg, and Meier-Graefe all fall in love with her, and the resulting rivalry drives a bitter wedge among the members of the group, causing them to disperse and, in several cases, to leave Berlin. Przybyszewski, however, never abandons his pursuit, and, in September, he and Juell marry. Munch returns to Norway, where he resides in the peaceful village of Nordstrand on the Kristiania Fjord. He continues to work on his Frieze of Life motifs.

Munch paints the first of the works known as *The Scream* (plate 84). In the swirling sky of this version of *The Scream* is penciled the following inscription: "Could only have been painted by a madman!"

Returning to Berlin, Munch organizes a large exhibition in rented rooms on the fashionable Unter den Linden. Here, for the first time, Munch shows both Love and Death motifs. The Love paintings are grouped together under the title *Study for a Series on "The Love,"* and include: *Summer Night's Dream/The Voice* (plate 39), a new version of *The Kiss*, *Vampire* (as *Love and Pain*) (1893; Göteborgs Konstmuseum), *Madonna* (as *The Face of the Madonna*), *Melancholy* (as *Jealousy*), and *The Scream* (as *Despair*) (plate 84). The centerpiece of the exhibition is the monumental *Death in the Sick Room* exhibited as *A Death* (plate 87).

Willy Pastor, a Berlin correspondent, is particularly impressed with the exhibition and writes a lengthy article in which he presents Munch as an integral part of the transition from naturalist to Symbolist painting. Munch is so pleased with the review that he sends a copy home to his family. Przybyszewski also writes

an article on the show titled "Psychischer Naturalismus" (Psychic Naturalism). In it, he compares Munch's painting to French and Belgian Symbolist literature, in particular to the work of Charles Baudelaire and Stéphane Mallarmé.

1894

Munch returns to Norway in May, accompanied by Przybyszewski and his wife. He settles in Filtvedt, where he remains until September. While there, he receives a commission for illustrations for *Pan*, the Berlin periodical devoted to international modernism in art and literature founded by Julius Meier-Graefe. Although the commission is never realized, it is likely that Munch becomes interested in printmaking through his involvement with Meier-Graefe and the *Pan* group. He makes his first etchings and lithographs.

In July, the first collection of essays on Munch, *Das Werk des Edvard Munch*, is published by S. Fischer Verlag. It contains articles by Przybyszewski, Meier-Graefe, Pastor, and the young German literary critic Franz Servaes, and focuses on Munch's sensitivity to human psychological complexity.

At the instigation of Professor Helge Bäckström, Dagny Juel Przybyszewska's sister's husband, Munch is invited in September by Stockholm art dealer August Theodor Blanche to stage an exhibition on the premises of the Art Association in Kungsträdgården. The exhibition opens on October 1, and is Munch's largest to date. It comprises a group of Love paintings, assembled under the title *Studies for a Mood Series: "Love,"* as well as an unlabeled series of Death motifs. The exhibition also debuts his monumental *The Woman in Three Stages* (plate 72), an image depicting the three aspects of woman.

In October, Munch returns to Berlin where he resides at Englischestrasse 121. He writes home to his aunt: "I have a large number of acquaintances here, but nonetheless I have the feeling that I will soon have had enough of Berlin, and that I will either go to Paris or home to Norway. Berlin is, in any case, not an art centre by a long shot." In late autumn, Munch finds a new patron in Count Harry Graf Kessler, the director of the Art Academy and Ducal Museum in Weimar.

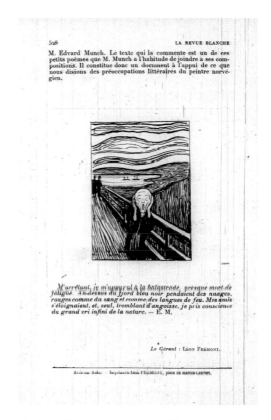

The first publication of Munch's 1895 lithograph *The Scream*, in *La Revue blanche*, December 1, 1895

In February, Munch moves to Hotel Stadt Köln, Mittelstrasse, Berlin. In March, a version of the Stockholm exhibition opens at Ugo Barroccio's gallery at Unter den Linden 16. Munch exhibits fourteen paintings from the Love group accompanied in the catalogue by a brief explanation: "The paintings are moods, impressions of the life of the soul, and together they represent one aspect of the battle between man and woman, that is called love." Munch shares the gallery with the Finnish artist Axel Gallén-Kallela, whom he has recently met. Gallén-Kallela, who has not yet developed his own fantastical style, feels overshadowed by Munch and ultimately regrets his decision to show with him.

Przybyszewski publishes his novel *Vigilien* (The Vigil), with a study by Munch as the cover illustration.

In June, in collaboration with Eberhard von Bodenhausen, Meier-Graefe releases a portfolio of eight engravings by Munch, many of them based on paintings that had found a positive reception in Germany. The prints, which include versions of *Two Human Beings (The Lonely Ones)* and *Night in St. Cloud* as well as some genre scenes, depict quieter, less provocative motifs. Despite an enthusiastic introduction by Meier-Graefe, the project fails as a commercial undertaking. Still, Munch begins another ambitious printmaking project at this time—converting all of his Love motifs into lithographs.

Munch leaves Berlin for Norway on June 26, traveling via Amsterdam. He spends the summer in Nordstrand and Åsgårdstrand, and in October he organizes a large show of his work at the Blomqvist gallery in Kristiania. Here, he arranges the Madonna motif as a separate group within the Love series, calling the group *Loving Woman*. The exhibition generates the most negative press to date, culminating in a debate at the Students' Union, where Munch's art and mental state are termed abnormal by a young doctor of psychology, Johan Scharffenberg. The poet Sigbjørn Obstfelder comes to Munch's defense, praising *Madonna* as "the essence of his art. . . . an earthly Madonna—the woman born with pain."

The National Gallery purchases Munch's *Self-Portrait with Cigarette* (plate 37), a painting that had been the object of great controversy at the Blomqvist exhibition.

In December, a lithograph of *The Scream*, with its accompanying text, is printed in the Paris periodical *La Revue blanche*. The next month, the American essayist Vance Thompson is inspired by the issue and publishes a drawing that he makes after Munch's lithograph in the magazine *M'lle New York*. The image is accompanied by a brief text in which Thompson proclaims Munch's "spermatozoidal and spiritual" painting as unfit for young girls. It is the first American article devoted to Munch.

On December 15, Munch's brother Andreas dies.

1896

On February 26, Munch travels to Paris, and rents a studio in Montparnasse. In April, he participates in the Salon des Indépendants, where he shows ten paintings including a second version of *The Sick Child* (plate 18), painted for the Norwegian industrialist Olaf Schou. In June, he shows at Siegfried "Samuel" Bing's Salon de l'Art Nouveau, which specializes in paintings by the Nabis. The exhibition is reviewed by August Strindberg, now in Paris, in the June 1 issue of *La Revue blanche*, as a free-verse poem on the individual motifs.

Through Strindberg, Munch meets the English composer Frederick Delius, who becomes a lifelong friend. He is also introduced to a circle of artists and critics, many of them Scandinavian, that gather around William François Molard, an employee of the French Ministry of Agriculture, and of Norwegian descent. At Molard's, Munch becomes reacquainted with the art of Gauguin, who was Molard's neighbor and maintained a studio at his home for a time. Gauguin had left behind a substantial body of work, including several important woodcuts from his Tahitian diary *Noa Noa*, which Munch is able to see. Through Meier-Graefe, Munch acquires an edition of Henri de Toulouse-Lautrec's lithographic series *Elles*. Also, Munch is introduced to the poet Stéphane Mallarmé.

Over the course of the year, Munch receives several important commissions. He contributes the lithograph

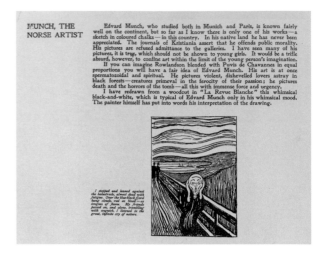

The first American article on Munch, with a drawing by the author, Vance Thompson, after the 1895 lithograph *The Scream*, in *M'lle New York*, January 10, 1896

Program design by Munch for Henrik Ibsen's *Peer Gynt*, at Lugné Poë's Théâtre de l'Oeuvre, Paris, November 1896. Lithograph. Munch Museum, Oslo

Program design by Munch for Henrik Ibsen's *John Gabriel Borkman*, at Lugné Poë's Théâtre de l'Oeuvre, Paris, November 1897. Lithograph. The Museum of Modern Art, New York. Purchase Fund

Angst to the initial volume of Ambroise Vollard's *Les Peintres Graveurs* and is asked to provide illustrations for Charles Baudelaire's *Les Fleurs du Mal*. The project is ultimately terminated due to the publisher's unexpected death. In addition, he begins a series of portrait etchings of Norwegian artists for Axel Heiberg, a Norwegian patron of the arts (unrealized), and contributes an etching of Norwegian novelist Knut Hamsun to the September issue of *Pan*.

Munch also receives his first theatrical commission: to design the programs for Henrik Ibsen's *Peer Gynt* and *John Gabriel Borkman*, performed at Lugné Poë's Théâtre de l'Oeuvre in November 1896 and 1897, respectively. For the former, Munch depicts Solveig and Mother Aase against a Norwegian mountain landscape. His design for the latter, possibly modeled on a photograph of Ibsen and on a woodcut by the French artist Félix Vallotton, shows Ibsen's face in front of a lighthouse. These commissions rekindle Munch's interest in graphics. In particular, he begins introducing color into his lithographs, aided by the printer Auguste Clot, under whose direction he completes a famous series of lithographs after *The Sick Child* (plate 17). Munch also produces lithographic portraits of Mallarmé and Strindberg (plates 26 and 27), which he prints from the same block six weeks apart. Strindberg is dissatisfied with his portrait; this results in a temporary breach of friendship between artist and subject.

In August, Munch flees to Knocke-sur-mer, Belgium, to recover from deteriorating physical and mental health; there he sees Hans Jæger and Jæger's close friend, the Norwegian novelist and poet Alfred Hauge.

In the autumn, during a brief trip to Kristiania, Munch receives his first decorative commission: a trapezoidal wall panel depicting a mermaid for the home of Axel Heiberg (plate 48).

1897
In March, Munch travels from Paris to Brussels for an exhibition at La Libre Esthétique and, in April, back to Paris where he exhibits ten paintings at the Salon des Indépendants. In June, he leaves Paris to spend the summer in Åsgårdstrand, where he buys his own house.

In September, Munch goes to Kristiania for an extensive exhibition at the Diorama Center that includes eighty-five paintings, sixty-nine prints, and thirty studies. The exhibition is greeted favorably. Among the works exhibited is a series of approximately twenty-five lithographs and woodcuts that Munch groups together. The series comprises motifs from the *Frieze of Life*, including images after well-known paintings like *The Kiss* and *Madonna*, (plates 49, 51, and 60) as well as new subjects found only in print form, many of which display Munch's growing interest in themes of regeneration and transubstantiation.

In the fall, Strindberg publishes his largely autobiographic novel *Inferno*, in which Munch figures as a "Danish painter."

1898
Munch spends most of the winter in Kristiania, where he shares a studio with Alfred Hauge. In March, he makes his way via Copenhagen to Berlin (Hotel Jansen, Mittelstrasse), and then on to Paris, 13, rue des Beaux Arts. He spends the summer in Åsgårdstrand and the autumn in Kristiania.

Munch is encouraged by Jæger to produce a vignette for the Norwegian Labor Party newspaper, *Social Demokraten*. For the cover of the May 1 issue, Munch isolates the head of the figure from *The Scream* while his "student" Thorolf Holmboe contributes a fist holding a torch. Nils Collett Vogt's "Mayday Song" is printed alongside. Due to reader protest, the image is withdrawn.

In July, Munch probably meets Tulla Larsen, the beautiful daughter of a wealthy Kristiania wine merchant. While their affair begins peacefully enough, it causes Munch severe emotional turmoil long before its violent end in 1902. A letter from this time confirms Munch's increasingly pessimistic view of life: "It is an unhappy event when an earth mother [Tulla Larsen] meets someone such as me, who finds the earth too miserable to breed children: [I am] the last generation of a dying race. . . . I have been given a unique role to play on this earth: the unique role given to me by a life filled with sickness, ill-starred circumstances and my profession as an artist. It is a life that contains nothing even resembling happiness, and moreover does not even desire happiness."

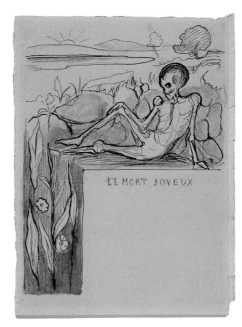

Edvard Munch. *Le Mort Joyeux* (sketch for Charles Baudelaire's *Les Fleurs du Mal*). 1896. Pencil and india ink on paper. Munch Museum, Oslo

Munch's panel *Mermaid* (1896) installed in the hallway of Axel Heiberg's house in Sandvika, n.d.

Munch's *The Scream* adapted for political use in the newspaper *Social-Demokraten*, May 1, 1898.

1899

Munch continues to reside in Kristiania. In January, at the instigation of Strindberg's German translator, Emil Schering, a special issue of the German periodical *Quickborn* is published, featuring texts by Strindberg accompanied by Munch prints and drawings (plates 33 and 34).

In April, Munch travels to Berlin, Paris, Nice, and Florence with Tulla Larsen. In Florence, he falls ill. Larsen goes back to Paris, while Munch continues on to Rome where he renews a study of Renaissance art begun in Florence. Munch is particularly impressed by Raphael's paintings and by Michelangelo's Sistine ceiling. He returns to Åsgårdstrand via Paris, where he visits Meier-Graefe.

In June, Munch resides at Nordstrand, then Åsgårdstrand, with Larsen. Here he begins his first studies for *Girls on the Pier* (c. 1901; plate 102). Over the summer, Munch exhibits at the Venice Bienniale.

That autumn, suffering from severe bouts of influenza and bronchitis as well as from alcohol abuse, Munch escapes to the Kornhaug Sanatorium in Gudbrandsdalen, Norway. Shortly after arriving, he writes to Larsen: "My dear friend! . . . Once you understand me, you will see how impossible it was, the way you were with me, and how it would slowly kill me were my loneliness taken away from me. Then you will also understand that the marriage which still may come to pass must be the kind that I indicated. We must live as brother and sister. . . . You could make engravings. And I would get books for you, so that you could cultivate your spirit, which currently is totally undeveloped."

While at Kornhaug, Munch works on two pivotal paintings: *Golgotha* (1900) and *The Dance of Life* (1899–1900), another variant on the three stages of woman as personified by Larsen (plates 98 and 100). This painting is Munch's final major contribution to the *Frieze of Life*.

1900

In March, Munch leaves the Kornhaug Sanatorium and goes to Berlin, where he meets Larsen. Together they travel to Florence and Rome before Munch checks in, once again, to sanatoriums in Switzerland and Como, Italy. Munch declares an end

to his relationship with Larsen.

In the autumn, Munch goes to Kristiania but soon leaves for Nordstrand, where he seeks solace from his recent emotional upheaval in a series of quiet, winter landscapes. In December, he returns to Kristiania for a comprehensive exhibition at the Diorama Center. Also in December, Munch has an exhibition at Arno Wolfframm's gallery, Dresden, for which he receives excellent reviews.

1901

Munch travels restlessly between Norway and Germany. He writes to his aunt: "I have returned to my old ways down here, and can live in peace, something that was impossible in Kristiania where I know too many people. . . . Tulla is quiet now."

Over the summer, while in Åsgårdstrand, Munch paints the first version of *Girls on the Pier* for the Norwegian collector Olaf Schou (plate 102).

Also in the summer, he participates in the International Exhibition at the Glaspalast, Munich, and, in October, at an exhibition at the Hollænder Building, Kristiania, where he shows over seventy paintings and thirty prints. Two of the landscapes are purchased by Kristiania's National Gallery, and the exhibition receives almost unanimously favorable reviews. In November, Munch shows two paintings, including *Angst* (1894; plate 81), at the Vienna Secession.

Munch receives news that Dagny Juel Przybyszewska has been murdered by one of her husband's students. Upon her death, Munch publishes the following statement in *Dagbladet*: "Proud and free she moved among us, encouraging and sometimes comforting as only a woman can."

Toward the end of the year, Munch moves to Berlin where he rents a studio at Lützowstrasse 82.

1902

In Berlin, during the winter and spring, Munch gains increasing patronage and international success. Through the German illustrator Hermann Schlittgen, Munch befriends Albert Kollmann, an art lover and spiritual mystic, who becomes one of his major patrons in later years. Munch paints a portrait of Kollmann with flaming red beard

Tulla Larsen and Edvard Munch, c. 1899

Munch in his Berlin studio at Lützowstrasse 82, 1902. Visible in the background is *Evening on Karl Johan Street* (1894–95). Photograph taken by Munch with his new automatic Kodak camera

Installation view of Munch's work at the Blomqvist gallery, Kristiania, autumn 1902. Visible in the center is a version of *Women on the Pier*, and at the right a portrait of his friend Aase Nørregaard. Photograph by Munch

against an acid green ground. Through Kollman, Munch meets the optician Dr. Max Linde, who buys the painting *Fertility* (1898; plate 95) and renames it *Earth's Blessing*.

At the Berlin Secession, Munch is invited to display the entire *Frieze of Life* cycle as well as six other paintings. Munch hangs the paintings on a white canvas runner that spans all four walls of the Secession's large entry room. While he dislikes the height, claiming that it causes the paintings to lose "their intimate touch," he praises the "symphonic effect" that results from the pictures being shown, in all "their likeness and their difference," in a single row and frame.

Munch divides the motifs into four groups on four different walls. The left-hand wall bears the subtitle "The Seeds of Love," and includes, among other works, *The Kiss* (plate 49), *Summer Night's Dream (The Voice)* (plate 39), and *Madonna* (1893–94; Munch Museum, Oslo). The front wall, subtitled "The Flowering and Passing of Love," features *Vampire* (version unknown), *Jealousy* (1895; plate 90), *Melancholy* (version unknown), and *The Dance of Life* (plate 100), while the right-hand wall, called "Life Anxiety," includes *The Scream* (plate 84), *Angst* (plate 81), and *Evening on Karl Johan Street* (plate 79). The back wall is devoted to Death pictures, among them, *Death in the Sick Room* (1893; National Gallery, Oslo) and *Metabolism* (plate 96). Munch later terms *Metabolism*, "as vital as a buckle is for a belt."

The exhibition is a major achievement for Munch, who observes in his diary: "Three horrible years had passed. New life—New hate. His great finished Frieze hung at the Berlin Exhibition." Furthermore, the show cements Munch's vision of the cycle as a decorative ensemble and, at its close, he refuses to break the paintings apart, offering them for sale, instead, as a whole. No one accepts his offer and Munch sends the exhibition to Leipzig, Kristiania, and Prague.

Munch purchases a camera and begins taking experimental pictures of himself and his surroundings.

Upon his return to Norway in June, Munch reunites with Tulla Larsen. In an attempt to get Munch to commit once and for all, Larsen summons

him, feigning suicide with a gun. In the ensuing encounter, the gun goes off, and the bullet lodges in the middle finger on Munch's left hand. He is hospitalized and the tip of his finger removed, while Larsen flees to Paris, accompanied by Gunnar Heiberg, Sigurd Bødtker, and their wives as well as the painter Arne Kavli, whom Larsen marries within the year.

Upon his release, Munch departs for Germany. In the fall, he visits Dr. Linde in Lübeck and begins a graphic portfolio of Linde's house, family, and gardens known as the Linde Portfolio. Munch bases the etchings on his photographs. Dr. Linde's book *Edvard Munch und die Kunst der Zukunft* (Edvard Munch and the Art of the Future), in which he compares Munch's work to Auguste Rodin's, is published at the year's end.

In Berlin, in December, Munch meets Gustav Schiefler, who begins cataloguing the artist's prints.

1903
In January, while living at the Hotel Hippodrom, Munch exhibits at Paul Cassirer's gallery. Dr. Max Linde's book is presented at the exhibition. In March, Munch travels to Leipzig for the reopening of his Berlin *Frieze of Life* exhibition at P. H. Beyer & Sohn and from Leipzig to Paris, where he resides at Hotel d'Alsace, rue des Beaux Arts, and, subsequently, at the home of composer Frederick Delius. His exhibition at the Salon des Indépendants attracts great attention, and Munch meets the violinist Eva Mudocci, a friend and model of Henri Matisse's, who becomes Munch's close friend.

In April, Munch returns to Lübeck where he commences a portrait of Dr. Linde's four sons based on an earlier painting of four young girls in Åsgårdstrand.

Munch spends the summer in Åsgårdstrand, September in Lübeck, and then goes to Berlin.

In November, he becomes a member of the Sociétè des Artistes Indépendants, in France. In Berlin, he participates in a second exhibition at the Cassirer gallery, where he shares the main room with portraits by the Spanish painter Francisco Goya. Munch shows new paintings, including *Fertility* and *The Four Sons of Dr. Linde* (plates 95 and 104).

Installation view of Munch exhibition of the *Frieze of Life* at P. H. Beyer & Sohn, Leipzig, 1903. Above the bust is *Metabolism* (1899); to the right are *The Voice/Summer Night* (1893; Munch Museum, Oslo), *Eye in Eye* (1894; Munch Museum, Oslo), and *Dance on the Shore* (1900–02; Narodnie Galerie, Prague)

Detail view of Edvard Munch's *Metabolism*, at his exhibition of the *Frieze of Life* at P. H. Beyer & Sohn, Leipzig, 1903

1904

Munch sells eight hundred prints at an exhibition of graphic art organized by the Kunstfreunde in Hamburg. Munch's success continues as he accepts many portrait commissions from wealthy German industrialists, bankers, and aristocrats.

In the winter, Munch signs an exclusive contract with the publisher Bruno Cassirer (a cousin of Paul Cassirer) to sell his graphic work in Germany, and he also signs with Commeter in Hamburg for the right to sell his paintings. In January, the Berlin Secession honors Munch by electing him to full membership, and Munch presents twenty paintings at the Vienna Secession. Along with Swiss painter Ferdinand Hodler, he is given a *salon d'honneur*, or, a room of his own.

In the spring, Munch accepts an invitation from Harry Graf Kessler to come to Weimar. He is offered a studio at the Art Academy, which is equal to the award of a professorship, but the offer is rescinded because of Munch's excessive drinking and his general psychological unrest. Munch paints Kessler's portrait.

Also this summer, Munch completes a monumental painting, *Bathing Men* (Munch Museum, Oslo)—his largest work to date—and, in August, he travels to Lübeck to paint two full-length portraits of Dr. Linde. At the end of August, he goes to Copenhagen for an individual show, where, for the first time, he has a section devoted exclusively to portraits.

Munch spends October in Kristiania, where he has a retrospective at the Diorama Center that includes Frieze motifs and, once again, focuses on portraits. In November, he returns to Berlin, Hotel Stadt Riga, and on November 22, travels to Lübeck.

1905

On June 7, Norway officially becomes independent from Sweden. (Although Norway had been forced into a "personal union" with Sweden in 1814, the country had, at that time, declared its independence and drawn up its own constitution.)

During the early summer, Munch lives in Åsgårdstrand. Following a violent dispute over a woman with the painter Ludvig Karsten, he leaves Norway for Taarbæk, Denmark, and does not return again until 1909.

While in Taarbæk, Munch receives several important commissions, including a portrait of Friedrich Nietzsche (plate 132), from the Swedish art collector and banker Ernst Thiel, and a portrait of the Chemnitz manufacturer Herbert Esche and his family.

1906

During, the winter, on the advice of Dr. Linde, Munch finally decides to seek treatment at several spas in Thuringia (Bad Kösen and Bad Elgersburg). There, he experiences a lameness in his arms before recovering his physical and mental health.

He remains in the clinic at Bad Kösen until the summer, when he travels to Berlin to complete a frieze for the, small second-floor foyer of Max Reinhardt's new Kammerspiel theater, as well as set designs for productions of Henrik Ibsen's *Ghosts*, held at the theater that year. The frieze, which is executed in translucent tempera on unprimed canvas, depicts romantic encounters along the Åsgårdstrand shore.

1907

Munch continues to work on the Reinhardt frieze in Berlin, where he also makes set designs for a production of *Hedda Gabler*.

At Paul Cassirer's, Munch shows the Nietzsche portrait for the first time. The centerpiece of the exhibition is, most likely, *Still Life: The Murderess* (1906; Munch Museum, Oslo), one of a series of paintings on the theme of the Death of Marat, in which Munch is represented as the slain anarchist and Tulla Larsen, his murderess Charlotte Corday (plate 136). Munch takes part in three additional exhibitions in Berlin: another at Cassirer's in September, where he shows with Paul Cézanne and Henri Matisse, and two at the Berlin Secession.

In the spring, after brief trips to Stockholm and Lübeck, where, with the aid of Dr. Max Linde, Munch terminates his contracts with Bruno Cassirer and Commeter, he moves to the fishing village and resort town of Warnemünde, Germany. Of this move, Munch observes: "Here I have regained a sense of peace. . . . Fresh air and good financial affairs have done great things for me."

In Berlin in December, Munch finishes the Reinhardt frieze.

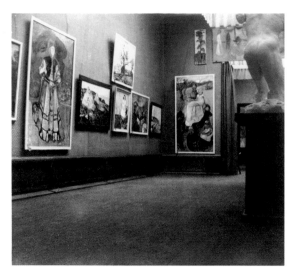

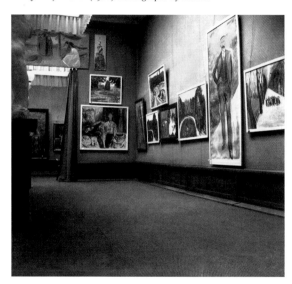

Two installation views of Edvard Munch exhibition at the Paul Cassirer gallery, Berlin, 1907. Visible to the right of the doorway is *Still Life: The Murderess* (1906; Munch Museum, Oslo), and on the right-hand wall is *Harry Graf Kessler* (1906). Photographs by Munch

Edvard Munch. *Desire* (Panel 6, from the Frieze for the Max Reinhardt Theater, Berlin). 1906–07. Tempera on canvas. Staatliche Museen zu Berlin–Nationalgalerie

Gustav Schiefler completes the first volume of his catalogue of Munch's graphic work, which is published in Berlin by Bruno Cassirer.

1908

In February, Munch makes a short trip from Berlin to Paris for an exhibition at the Salon des Indépendants, where he shows four paintings, including *Death of Marat II* (1907; plate 136), and a study for the Reinhardt frieze. During the spring and summer, he resides at Warnemünde, where he paints *Mason and Mechanic* (Munch Museum, Oslo), the first in a series of paintings featuring the theme of modern work and industry.

In March, Munch's longtime admirer Jens Thiis becomes director of the National Gallery, and inaugurates a series of purchases of Munch paintings, as does Rasmus Meyer, a collector from Bergen.

On October 3, Munch checks himself into a psychiatric clinic run by Dr. Daniel Jacobson. He paints Dr. Jacobson no less than three times and develops the illustrated fable *Alpha and Omega*. He also works on a compilation of writings from 1902 to 1908, which he calls "The Diary of the Mad Poet."

Munch decides to break up the *Frieze of Life*, and sells many of its components separately, some to the National Gallery, some to Olaf Schou (who donates his paintings to the museum in 1909 and 1910), and some to Rasmus Meyer.

In Norway, Munch is honored as a Knight of the Royal Order of Saint Olav for artistic achievement.

1909

In March, while continuing to reside at the clinic, Munch organizes his first exhibition in Kristiania in five years, a large retrospective at Blomqvist's, which is well received. Jens Thiis purchases five major paintings for the National Gallery, including *The Day After, Puberty,* and *Ashes* (plates 14, 44, and 74). Also, at this time, Olaf Schou allows Thiis to choose works from his extensive collection of Norwegian art. Thiis selects seven paintings by Munch, including the second version of *The Sick Child* (1896; plate 18), and the original *Girls on the Pier* (c. 1901; plate 102). (In 1931, Thiis exchanges the former for the first version of 1885–86 (page 223).

In May, Munch leaves the clinic and returns to Norway, where he remains, barring brief trips, for the rest of his life. He rents the Skrubben property in Kragerø, where he sets up a large open-air studio, and looks to the gardens, woods, and rocky coast, as well as to studio models, for his motifs.

During the summer, Munch begins work on designs (also known as the Aula decorations) for a competition to decorate the main auditorium, or Festival Hall, of the Royal Frederiks University at Kristiania (later University of Oslo), a competition he learns about from his cousin, the painter Ludvig Ravensberg, on his trip home from Dr. Jacobson's clinic. The studies Munch produces reflect his new interest in the healing powers of nature. Munch finds sources for many of his scenes in the people and landscape of Kragerø. Over the next few years, he submits numerous drafts and versions before settling on the final ensemble, which is ultimately unveiled in 1916.

In June, Munch makes short trips to Kristiania and Bergen, where Rasmus Meyer makes large purchases and, in August, to Lübeck, Travemünde, Warnemünde, and Berlin.

1910

After spending the first half of the year in Kragerø, Munch buys the Nedre Ramme estate at Hvitsten on the eastern shore of the Kristiania Fjord. Hvitsten's summery climate differs dramatically from Kragerø's rugged landscape, and Munch dedicates himself to images of swimming and sunbathing as well as to images of the surrounding wildlife.

1911

Barring a brief trip to Germany, Munch lives for most of the year at Hvitsten, where he continues to rest and recuperate before transferring to Kragerø in the autumn. In April, at the Diorama Center in Kristiania, Munch organizes one of his largest individual shows to date. The exhibition features more than 100 paintings and 170 prints. Olaf Schou purchases three paintings from the show, including *Death in the Sick Room* (1893), *The Scream* (1893), and *The Dance of Life* (1899–1900), which he donates to the National Gallery (plates 84 and 100).

In August, Munch stages another exhibition at the Diorama Center,

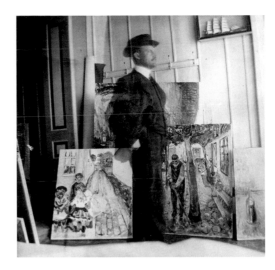

Munch, in a double-exposure, with three paintings, in the hallway of his house in Warnemünde, 1907. Through the artist's clothes can be seen part of *The Sick Child* (1896); at the left is *Children on the Street* (1907; Munch Museum, Oslo), and at the right is *Old Man, Warnemünde* (1907; Munch Museum, Oslo). Photograph by Munch

Munch at the nudist beach in Warnemünde, summer 1907. On his easel is *Bathing Men*, the central panel of *The Ages of Life Triptych* (1907–08). Photograph by Munch

Munch reclining near the bathtub at Dr. Jacobson's clinic in Copenhagen, 1908–09. Photograph by Munch, titled *Marat in the Bath*

Munch in front of an early version of *History* for the University Festival Hall murals at his outdoor studio at Skrubben, Kragerø, n.d. Seated, left to right, are Munch's housekeeper Inga Stärk, Ludvig Ravensberg, Lars Field, Halvdan Nobel Roede, and Ida Roede (whose portrait is at the far right). Next to Munch is *Jens Thiis* (1909; Munch Museum, Oslo), followed by *Christian Sandberg* (1901; Munch Museum, Oslo)

where he exhibits designs for the murals for the Festival Hall, including four large draft versions of *History*, one of *Researchers*, and one of *The Sun*. There is strong support for Munch, but the jury votes unanimously that none of the work should be accepted as is.

1912

On January 30, Munch is asked to participate in a survey of Expressionism at the Sonderbund International Exhibition in Cologne. The Sonderbund show, which runs from May through September, is enormous, with 160 artists participating. Munch is given a room situated next to the German section rather than the Norwegian, and displays thirty-two paintings.

While in Cologne, Munch meets Curt Glaser, director of the Berlin Königliches Kupferstichkabinett (Berlin Royal Museum of Copper Engraving).

In December, Munch participates in the *Exhibition of Contemporary Scandinavian Art*, at the American Art Galleries in New York. It is Munch's first exhibition in the United States. He exhibits six works, including *The Sick Child* (1896; plate 18), *Summer Night* (1906), *Portrait of Hermann Schlittgen* (1904; Munch Museum, Oslo), *Starry Night* (1893–97; Von der Heydt Museum, Wuppertal), *In the Orchard* (1908; Munch Museum, Oslo), and *In the Garden* (1904; Carnegie Museum of Art, Pittsburgh).

1913

In February, at the invitation of the American artist Walt Kuhn, who had seen the Sonderbund exhibition, Munch sends eight prints to the *International Exhibition of Modern Art* held at the 69th Regiment Armory in New York—the Armory Show. They include versions of *Vampire*, *Moonlight*, *Two Human Beings (The Lonely Ones)*, *Madonna*, and *Sin (Nude with Red Hair)*.

In the spring and summer, Munch travels extensively, visiting Berlin, Frankfurt, Cologne, Paris, London, Stockholm, Hamburg, Lübeck, and Copenhagen.

In the autumn, he resides among Kragerø, Hvitsten, and Jeløya, devoting most of his time to large-scale paintings of working people. He sends new versions of the Festival Hall paintings to the Autumn Exhibition of the Berlin Free Secession, a group of predominantly Expressionist painters who had broken with the more conservative Berlin Secession.

1914

News of Munch's success at the Berlin Free Secession is communicated to Norway, and, on May 29, by a vote of three to two, the University Commission officially reverses its earlier (1911) rejection of Munch's proposed designs for the Festival Hall murals.

Also in May, Munch participates in the Tivoli Festival in Kristiania, an exhibition that coincides with the famous Jubilee Exhibition, organized by Christian Krohg, which features older and more recent Norwegian art. The purpose of the exhibition is to celebrate the country's industrial progress on the occasion of the Centennial of the declaration of Norway's Constitution.

Munch painting in the street in Kragerø, 1911

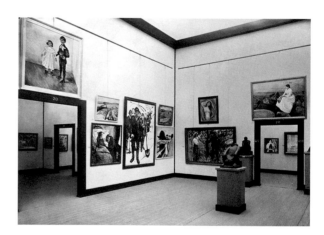

Installation view of Munch's room in the Sonderbund International Exhibition, Cologne, 1912. Visible are *Erdmute and Hans Herbert Esche* (1905; Kunsthaus Zürich) above the left-hand doorway; the three large paintings to the right of the doorway are: *The Sick Child* (1907; Thielska Galleriet, Stockholm), *Workers in Snow* (1910; Private collection, Tokyo), and *Girls on the Pier* (1905; Walraf-Richartz Museum, Cologne). On the adjoining wall is *Madonna* (1894; Hamburger Kunsthalle), *Adam and Eve* (1908; Munch Museum, Oslo), and, above the right-hand doorway, *Summer Night/Inger on the Beach* (1889).

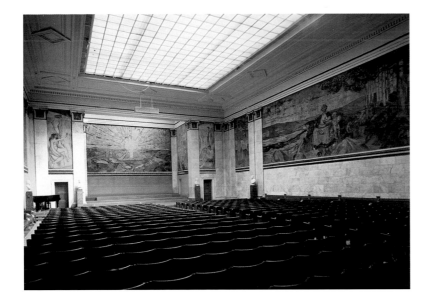

Partial view of Munch's murals installed at the Festival Hall, Royal Fredericks University, Kristiania (now the University of Oslo), 1916

An entire room at the National Gallery is dedicated to Munch, and the artist's fiftieth birthday is celebrated in a special issue of the Norwegian periodical *Kunst og Kultur*.

In August, World War I begins.

1915

While living in Hvitsten, Munch participates in the San Francisco Panama-Pacific International Exhibition, with nine paintings and fifty-seven prints. The selection is made by Jens Thiis. Prior to the opening, Thiis sends a letter to Munch advising him to "do what you can for yourself and for Norway's representation in S[an] Francisco." Munch receives a gold medal in recognition of his graphic work. In August, he makes a trip from Elverum to Trondheim, returning in September to Jeløya.

He continues to secure his home market by focusing on the kind of rural images then in vogue in a medium-sized retrospective at Blomqvist's gallery in October. Winter landscapes from Kragerø are interspersed with images of rural labor and portraits, while a single wall is devoted to bathing scenes from Hvitsten. Critics describe these images as evidence of a newly strengthened Norwegian people: "Here is the person, the free person, happy in the sun, happy with life, at one with nature."

In November, Munch travels to Copenhagen for the Nordic Exhibition at the Charlottenborg Palace, where he shows nineteen paintings. Also in November, the print dealer

J. B. Neumann opens his new gallery space on the Kurfürstendamm in Berlin with a retrospective of Munch prints, accompanied by a catalogue with an essay by Curt Glaser. Neumann had shown prints by Munch at his previous gallery, Graphisches Kabinett, Berlin, but this show of Munch's work is his most extensive to date.

Probably in this year Munch works in earnest on a ledger of texts, prints, and drawings, begun in the early 1900s, which he titles "The Tree of Knowledge of Good and Evil." The album, which may not have been intended for publication, was not largely known until after his death. It contains actual prints and drawings, many from the 1890s, related texts as well as reminiscences of childhood, and selections from Munch's 1908 "The Diary of the Mad Poet."

1916

In January, Munch buys property at Ekely in Skøyen, where he remains for the rest of his life. In February, he travels to Bergen for an exhibition of paintings.

On September 19, the Festival Hall murals are formally unveiled. In its final version, the Aula program consists of two large side panels, *History* and *Alma Mater*, which flank a monumental painting of *The Sun* (plates 118, 122, and 126). Munch's ensemble represents the culmination of his interest in Nietzschean vitalism. In seeking the commission he had explained: "My aim was to have the decorations form a closed, independent ideal world, whose pictorial

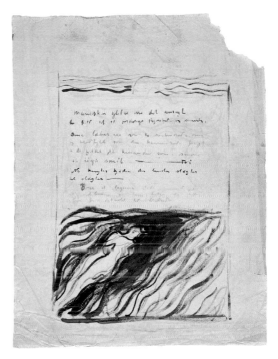

Edvard Munch. *Lovers in Waves* (page from the ledger titled "The Tree of Knowledge of Good and Evil"). *1912–15*. Watercolor, gouache, india ink, and pencil. Munch Museum, Oslo

expression should be at once peculiarly Norwegian and universally human."

1917
In March, Munch participates in the Exhibition of Contemporary Norwegian Art in Stockholm, where he shows thirty-seven paintings and eleven designs for the Festival Hall murals.

In October, following visits to Bergen and Göteborg, Munch has a large print retrospective at Blomqvist's in Kristiania that includes over six hundred works. In November, he mounts an individual show at Georg Kleis gallery in Copenhagen. He shows a variety of prints as well as recent paintings. Although some critics admire the work, others express nostalgia for the early, more psychological Munch.

Curt Glaser publishes the first monograph on Munch, *Edvard Munch*, issued by Bruno Cassirer, Berlin.

1918
In February, Munch stages an enormous exhibition at Blomqvist's featuring approximately fifty-seven paintings that, almost without exception, have never before been shown. The exhibition consists primarily of portraits and images of labor, but Munch also includes new versions of his *Frieze of Life* paintings, including a late *The Sick Child* (1907; Tate Gallery, London), which he installs amidst paintings of nudes and portraits of women. He also includes a 1915 version of *Jealousy* (Munch Museum, Oslo) and a new painting titled *The Death of the Bohemian* (1917–18; Munch Museum, Oslo), which depicts the death of Hans Jæger. This is the first time that Munch includes new versions of the *Frieze of Life* paintings in a major exhibition, and it suggests his desire to establish unity between his older and more recent work.

In October, Munch has another exhibition at Blomqvist's. It represents the first staging of the *Frieze of Life* in over ten years. On the occasion of the opening on October 15, Munch publishes a declamatory defense of the cycle in the newspaper *Tidens Tegn* titled, simply, "Livs-Frisen" (Frieze of Life). This is the first time that Munch himself uses the *Frieze of Life* title to describe his paintings. In the exhibition, he combines original

and later versions of his motifs. He also incorporates paintings not typically considered part of the cycle, such as *Fertility* (1898; plate 95), in which a rural couple faces each other in a garden. Critics are nearly unanimous in their negative response. Munch constructs large, outdoor, wood "studios" in which to hang his paintings, which he reworks incessantly. It is likely that sometime in the spring or summer of 1919 Munch puts together a booklet titled *Livs-Frisen* (Frieze of Life) in an attempt to allay the criticism surrounding his exhibition once and for all.

1919
Munch falls victim to the Spanish flu. He documents his illness and recovery in several self-portraits. Also this year, Munch creates a series of paintings depicting the artist and his model (plate 138).

In November, Munch has his first individual exhibition in the United States, an exhibition of prints at the Bourgeois Galleries, New York. Many of the prints have been shown previously in San Francisco, and their pessimistic tone receives mixed reviews. The catalogue essay by Christian Brinton portrays Munch as a misunderstood artist, largely unknown in America, but the subject of controversy in Norway.

1920
Munch takes brief trips to Berlin and Paris.

1921
Munch travels to Berlin, Wiesbaden, and Frankfurt.

On April 3, at Cassirer's, in Berlin, Munch has his first major postwar exhibition in Germany. He shows twenty-four paintings and ninety prints, primarily of new work as well as some works from German private collections.

Johan Throne Holst, founder of the Freia Chocolate Factory in Rodeløkka, Kristiania, invites Munch to paint a series of murals for the factory. Munch plans on decorating two rooms, the first, with images modeled on the unrealized Linde frieze and set in Åsgårdstrand, and the second with motifs from the life of the urban worker. Only the former is carried out.

Edvard Munch. *Self-Portrait, Spanish Influenza.* 1919. Oil on canvas. The National Museum of Art, Architecture, and Design/National Gallery, Oslo

1922

In April, Munch travels via Bad Nauheim and Wiesbaden to Berlin, and, in June, to Zürich for his first individual show in Switzerland, at the Kunsthaus Zürich. Over the summer, Munch completes the murals for the Freia Chocolate Factory.

1923

During the spring, Munch travels to Göteborg, where he is given an entire room at the Nordic Exhibition at the Konsthalle. From there he goes to Berlin, for an exhibition at the Academy of Art, where he becomes a member.

Munch is named an honorary member of the Bavarian Academy of Fine Arts (Bayerische Akademie der Bildenden Künst).

1924

J. B. Neumann's Printroom opens in New York. The inaugural exhibition features Munch alongside a range of artists including Eugène Delacroix, Honoré Daumier, Vincent van Gogh, Paul Cézanne, and James Ensor.

1925

In August, Munch journeys through the Gudbrandsdal Valley near Lillehammer to the Western Fjord provinces of Åndalsnes and Molde. On August 8, the International Exhibition opens at the Kunsthaus Zürich, where Munch is represented by fourteen paintings.

Kristiania is officially renamed Oslo.

1926

In May, Munch travels to Munich for an exhibition at the Glaspalast, where he shows seventeen paintings and over thirty works on paper.

In October, he leaves Ekely once again, first for an exhibition in Copenhagen and then for a major retrospective at the Kunsthalle Mannheim. Among the seventy-four paintings exhibited is *Self-Portrait with Palette* (1926; Private collection), which the Kunsthalle purchases the next year. On his way to and from the exhibition, Munch makes stops in Berlin, Chemnitz, Leipzig, Halle, Heidelberg, and Paris.

Munch is represented at the Carnegie International Exhibition in Pittsburgh, which opens on October 15. He exhibits three paintings, including one of Dr. Daniel Jacobson.

Munch's sister Laura dies.

1927

Munch travels to Berlin for a major retrospective at the Nationalgalerie, in which the entire museum is cleared to make room for his paintings. In the summer, the exhibition reopens at the National Gallery, Oslo, with some additional works.

Munch participates in the Carnegie International. With five paintings, it is his largest showing at the annual exhibition. The catalogue contains an entry on "The Art of Norway and Sweden," which singles out Munch for his "great compositions" in which "he gives synthetic expressions of life, chiefly touching the mysteries of love and death."

Munch completes his sixth version of *The Sick Child*.

1928

In September, Munch participates in an exhibition at the Royal Society of British Artists in London.

1929

Following a major print exhibition in Stockholm in February, a print retrospective is held at Blomqvist's in May. In the catalogue, Munch includes some written excerpts under the title "1889–1929 Brief Selections from My Diary," among them, a version of the famous "St. Cloud Manifesto" of 1889. It is likely that a pamphlet of brief texts titled "The Genesis of the Life Frieze" also dates to this time. Among other items, this pamphlet contains the second and better known version of the 1889 St. Cloud text.

William R. Valentiner, director of the Detroit Institute of Arts and an expatriate German art historian, purchases for the museum Munch's *Boy in Blue*, c. 1900. It is the first painting by Munch known to enter an American public institution.

1930

In May, a blood vessel ruptures in Munch's right eye, rendering him almost totally blind, as his left eye is already very weak. When the eye improves in August, Munch charts the disease in a set of drawings, and in painted (plate 151) and photographic self-portraits.

1931

Munch's Aunt Karen dies at age ninety-two.

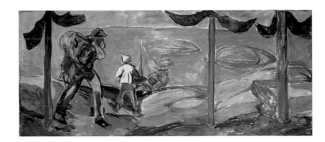

Edvard Munch. *Freia Frieze I*. 1922. Oil on canvas. Freia Chocolate Factory, Oslo

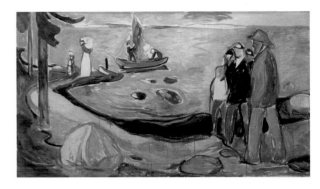

Edvard Munch. *Freia Frieze XI*. 1922. Oil on canvas. Freia Chocolate Factory, Oslo

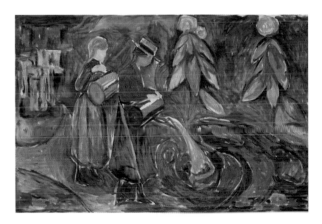

Edvard Munch. *Freia Frieze IV*. 1922. Oil on canvas. Freia Chocolate Factory, Oslo

Over the course of the year, numerous exhibitions of Munch's work are held in Germany. Munch again revisits his Frieze of Life motifs in earnest, completing several new versions.

1932

In February, Munch exhibits, along with works by Paul Gauguin, at the Kunsthaus Zürich.

Munch is awarded the Goethe Medal for Science and Art by the German president Paul von Hindenburg.

1933

On the occasion of his seventieth birthday, Munch is named Knight of the Grand Cross of the Order of Saint Olav. Increasingly, Munch withdraws from society except for the company of a few close friends such as the journalist Christian Gierløff; his doctor, the anatomist Prof. Kristian Schreiner, and the banker and writer Rolf Stenersen.

Pola Gauguin, son of the painter Paul Gauguin, publishes the first biography devoted to Munch in the Norwegian language; this is followed by a biography of the artist by Jens Thiis.

1934

Munch is awarded the medal of the French Legion of Honor.

Munch presents *The Author August Strindberg* (1892; plate 28) to the National Museum in Stockholm.

1936

In October, at The London Gallery, Munch has his first major exhibition in the British capital city.

1937

In the autumn, Munch visits Göteborg, Sweden.

Despite Munch's efforts to distance himself from politics, the impact of the developing war reaches him when eighty-two of his works, dating from after World War I, are declared "degenerate" by the Nazis and are confiscated from German museums and private collections. In addition, works by Munch (no longer identifiable) are included in the *Degenerate Art* (*Entarte Kunst*) exhibition in Munich, which opens on July 19.

1938

Munch rejects a plan by Jens Thiis to establish a Munch Museum in Tullinløkka, Oslo.

An auction is held at the Hotel Bristol in Oslo in which 333 prints by Munch, from a German collection, are auctioned; at the same time fourteen paintings and thirty-one prints that had been confiscated by the Nazis from German museums are auctioned at Oslo's Harold Holst Halvorsen Gallery.

Munch celebrates his seventy-fifth birthday.

1939

September 1, World War II begins.

1940

Munch begins work on his last self-portraits (plates 154 and 155).

On April 9, the German army occupies Oslo. Munch refuses all contact with them as well as with their Norwegian collaborators.

In his will, dated April 18, Munch bequeaths his paintings, lithographs, drawings, etchings, woodcuts—as well as diaries and other documents, books, lithographic stones, etching plates, and woodblocks—to the city of Oslo. The bequest later forms the Munch Museum, Oslo, which opens to the public one hundred years after the artist's birth, in 1963.

1942

In December, Munch has his first large-scale exhibition in the United States: a show of prints held at The Brooklyn Museum. The exhibition consists of thirty-four prints borrowed exclusively from American public institutions and galleries.

1943

On December 12, Munch celebrates his eightieth birthday, an event that is honored throughout Norway. The Norwegian Nazi collaborators approach Munch about organizing a major retrospective of his work, but Munch refuses. Late in December, an explosion on a German ship in the harbor results in numerous casualties. The windows at Ekely are blown out, and Munch refuses to take shelter in the basement. Shortly thereafter, he contracts pneumonia.

1944

On January 23, Munch dies peacefully in his house at Ekely during the afternoon.

Munch in his winter studio in Ekely on his seventy-fifth birthday, 1938. Visible on the wall behind the artist is *Death in the Sick Room* (1893; Munch Museum, Oslo)

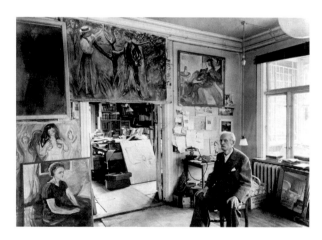

Munch in his home in Ekely at age eighty, 1943. Above the doorway is *Adam and Eve* (1908; Munch Museum, Oslo)

Headstone that marked Munch's grave until 1993

Selected Exhibitions

Listed below is a selection of exhibitions in which Edvard Munch's works were shown during his lifetime and after his death in 1944 up to the present time. Exhibition titles are given in italics, when known. Both individual and group shows are given; individual shows without titles are indicated by the artist's name in brackets. English translations of exhibition titles are given when appropriate. Translations for repeated venues are given on the first mention. Dates of exhibitions are given wherever possible.

1883

Industry and Art Exhibition (Kunst-og Industriutstillingen), Kristiania, June–October.

Autumn Exhibition (Høstutstillingen), Kristiania.

1884

Autumn Exhibition, Kristiania.

1885

World's Fair, Antwerp, spring.

Autumn Exhibition, Kristiania.

1886

Autumn Exhibition, Kristiania.

1887

Autumn Exhibition, Kristiania.

1888

Autumn Exhibition, Kristiania.

Nordic Exhibition (Den Nordiske Industri-, Landbrugs- og Kunstudstilling), Copenhagen.

1889

[Edvard Munch]. Student Union (Studentersamfundets), Kristiania, April 20–May 12.

World's Fair, Paris, May.

Autumn Exhibition, Kristiania.

1890

Autumn Exhibition, Kristiania.

1891

Autumn Exhibition, Kristiania.

Glaspalast, Munich.

1892

[Edvard Munch]. Tostrup Building (Tostrupgården), Kristiania, September 14–October 4.

Berlin Art Association (Verein Berliner Künstler), Berlin, November 5–12. Travels to Eduard Schulte, Düsseldorf, November; Eduard Schulte, Cologne, November–December; The Equitable Palace (Equitable-Palast), Berlin, December 26–January, 1893; Georg Kleis, Copenhagen, February 24–March 14, 1893; Museum der Stadt, Breslau, April 23–May 7, 1893; Victoriahaus, Dresden, May 19–June 2, 1893; Schrannenpavillon, Munich, June–September, 1893.

1893

[Edvard Munch]. Unter den Linden, Berlin, December.

1894

[Edvard Munch]. Art Association (Kunstföreningen), Kungsträdgården, Stockholm, October 1–31.

1895

[Edvard Munch]. Ugo Barroccio, Unter den Linden, Berlin, March 16–24.

[Edvard Munch]. Blomqvist, Kristiania, October.

1896

[Edvard Munch]. Salon de l'Art Nouveau at Samuel Bing, Paris, June.

Salon des Indépendants, Paris, April 1–May 31.

1897

[Edvard Munch]. Diorama Center (Dioramalokalet), Kristiania, September 15–October 17.

La Libre Esthétique, Brussels, February 25–April 1.

Salon des Indépendants, Paris, April 3–May 31.

Scandinavian Exhibition, St. Petersburg.

1898

[Edvard Munch]. Arno Wolfframm, Dresden, November 10–December 9.

Free Exhibition, Copenhagen, March.

Salon des Indépendants, Paris, May.

1899

Venice Biennale, summer.

1900

[Edvard Munch]. Diorama Center, Kristiania, December.

[Edvard Munch]. Arno Wolfframm, Dresden, December.

1901

[Edvard Munch]. Holländer Building (Hollændergården), Kristiania, October.

International exhibition, Glaspalast, Munich, summer.

Vienna Secession, November–December.

1902

[Edvard Munch]. Blomqvist, Kristiania, October.

Berlin Secession, March–April.

International "Black and White" Exhibition, Rome, June.

Vienna Secession, November–December.

1903

[Edvard Munch]. Paul Cassirer, Berlin, January.

[Edvard Munch]. P. H. Beyer & Sohn, Leipzig, February–March.

[Edvard Munch]. Paul Cassirer, Hamburg, April.

[Edvard Munch]. Blomqvist, Kristiania, September.

Salon des Indépendants, Paris, March 20–April 25.

Paul Cassirer, Berlin, November.

Berlin Secession, November.

Kunstfreunde, Hamburg, November–January, 1904.

1904

[Edvard Munch]. Free Exhibition, Copenhagen, September 4–30.

[Edvard Munch]. Diorama Center, Kristiania, October.

Vienna Secession, January–March 6.

Salon des Indépendants, Paris, February 21–March 24.

Paul Cassirer, winter 1904–05.

1905

[Edvard Munch]. Winkel & Magnussen, Copenhagen, January.

[Edvard Munch]. Manes Art Association, Galerie Manes, Prague, February 5–March 12.

Commeter, Hamburg, May.

1906

[Edvard Munch]. Kunstverein, Magdeburg, January.

[Edvard Munch]. Emil Richter, Dresden, February.

[Edvard Munch]. Commeter, Hamburg, March.

[Edvard Munch]. Kunsthütte, Chemnitz, March

[Edvard Munch]. Folkwang-Museum, Hagen, October.

[Edvard Munch]. Grossherzoglishes Museum für Kunst und Kunstgewerbe, Weimar, November.

Salon des Indépendants, Paris, March.

Berlin Secession, April 21–September.

Nordic Exhibition, Copenhagen, October.

1907

[Edvard Munch]. Paul Cassirer, Berlin, January–February.

Berlin Secession, April.

Venice Biennale, summer.

Paul Cassirer, Berlin, September–October.

Berlin Secession, December–January, 1908

1908

[Edvard Munch]. Louis Bock und Sohn, Hamburg, June.

[Edvard Munch]. Kunstforeningen, Copenhagen, November 22–December 20.

Salon des Indépendants, Paris, March 20–May 2.

Berlin Secession, April. Mannheim, September 26–October 20.

Berlin Secession, winter.

1909

[Edvard Munch]. Ateneum, Helsinki, January 3–31.

[Edvard Munch]. Blomqvist, Kristiania, March.

[Edvard Munch]. Kunstforeningen, Bergen, summer.

Berlin Secession, November 27–January 9, 1910.

1910

[Edvard Munch]. Diorama Center, Kristiania, March 5–April 7.

Salon des Indépendants, Paris, March 18–May 1.

Berlin Secession, April–September.

Berlin Secession, November–January 1911.

1911

[Edvard Munch]. Diorama Center, Kristiania, April.

[Edvard Munch]. Diorama Center, Kristiania, August.

International Exhibition (Esposizione Internazionale), Rome, April.

1912

[Edvard Munch]. Thannhauser, Munich, February 13–March 10.

[Edvard Munch]. Artists' Association (Kunstnerforbundet), Kristiania, March 12–April 1.

Künstlerbund Hagen, Vienna, January–February.

Salon des Indépendants, Paris, March 20–May 16.

Sonderbund, Cologne, May 25–September 30.

J. B. Neumann, Graphisches Kabinett, Berlin, November.

Exhibition of Contemporary Scandinavian Art, American Art Galleries, New York, December 10–25. Travels to Albright Gallery, Buffalo, January 4–26, 1913; Toledo Museum of Art, February 1–16, 1913; Art Institute of Chicago, February 22–March 16, 1913; Museum of Fine Arts, Boston, March 24–April 21, 1913.

Berlin Secession, November–December.

1913

[Edvard Munch]. Ernst Arnold, Dresden, August. Travels to Ernst Arnold, Breslau, September.

[Edvard Munch]. Konstnärshuset, Stockholm, September.

[Edvard Munch]. Commeter, Hamburg, November–December.

International Exhibition of Modern Art, 69th Regiment Armory, New York, February 17–March 15.

Autumn Exhibition (Herbstausstellung), Berlin Free Secession, November.

J. B. Neumann, Graphisches Kabinett, Berlin, December.

1914

[Edvard Munch]. Fritz Gurlitt, Berlin, February.

[Edvard Munch]. Berlin, Amsler und Ruthard, March.

Tivoli Festival (Tivoli Festivitetslokale), Kristiania, May–June.

1915

[Edvard Munch]. Artists' Association, Kristiania, March–April.

[Edvard Munch]. Blomqvist, Kristiania, October.

[Edvard Munch]. J. B. Neumann, Berlin, November–December.

Panama-Pacific International Exhibition, San Francisco, February–December.

Artists' Autumn Exhibition (Kunstnernes Efteraarsudstilling), Copenhagen, October.

Nordic Exhibition (Den Norske Kunstudstilling), Charlottenborg Palace, Copenhagen, November–December.

1916

[Edvard Munch]. Kunstforeningen, Bergen, February.

[Edvard Munch]. Blomqvist, Kristiania, October.

1917

[Edvard Munch]. Blomqvist, Kristiania, October.

[Edvard Munch]. Georg Kleis, Copenhagen, November.

Exhibition of Contemporary Norwegian Art (Austellung der norwegischen Künstler), Liljevalchs Konsthall, Stockholm. March–April.

1918

[Edvard Munch]. Blomqvist, Kristiania, February.
Frieze of Life, Blomqvist, Kristiania, October.

1919

[Edvard Munch]. Blomqvist, Kristiania, October.

[Edvard Munch]. Bourgeois Galleries, New York, November 29–December 20.

Berlin Secession, November–December.

1920

Cassirer, Berlin, March.

Munch und die Brücke, Kunsthalle, Bremen, October–November.

1921

[Edvard Munch]. Blomqvist, Kristiania, January.

[Edvard Munch]. Paul Cassirer, Berlin, April 3. Travels to Ernst Arnold, Dresden, May–June; Gerstenberger, Chemnitz, June; and Caspari, Munich, July.

[Edvard Munch]. Commeter, Hamburg, June–July.

1922

[Edvard Munch]. Kunsthaus Zürich, June 18–August 2. Travels to Bern, August–September; Basel, October.

1923

Nordic Exhibition (Nordisk Konst), Göteborgs Konsthalle, Göteborg, March.

Academy of Art (Akademie der Künst), Berlin, May 1–26.

1924

[Edvard Munch]. Neue Galerie, Vienna, March 8–April 15.

Neumann's Printroom, New York.

1925

International Exhibition (Internationale Kunstausstellung), Kunsthaus Zürich, August 8–September 23.

1926

[Edvard Munch]. Kunsthalle, Mannheim, November 7–January 9, 1927.

Glaspalast, Munich, June 1–October 1.

Carnegie International Exhibition, Pittsburgh, October 15–December 6.

1927

[Edvard Munch]. Nationalgalerie, Berlin, March 15–May 15.

[Edvard Munch]. National Gallery, Oslo, June 8–July 27.

Carnegie International Exhibition, Pittsburgh, October 13–December 4. Travels to The Brooklyn Museum, January 9–February 19, 1928; the Palace of the Legion of Honor, San Francisco, April 2–May 13, 1928.

1928

[Edvard Munch]. J. B. Neumann Graphisches Kabinett, Munich, April.

Royal Society of British Artists, London, September 25–October 2.

1929

[Edvard Munch]. Nationalmuseum, Stockholm, February.

[Edvard Munch]. Blomqvist, Oslo, May.

[Edvard Munch]. Kunsthütte, Chemnitz, November 15–December 11.

[Edvard Munch]. Kunstverein, Leipzig, December 15–January 12, 1930.

1930

[Edvard Munch]. Commeter, Hamburg, August 22–September 30.

1931

[Edvard Munch]. Kunsthaus, Bielefeld, March 8–April 6.

[Edvard Munch]. Alfred Flechtheim, Berlin, April 18–May 12.

Detroit Institute of Arts, February.

Kunsthalle, Bern, August 30–September 7.

Carnegie International Exhibition, Pittsburgh, October.

1932

Kunsthaus Zürich, February 20–March 20.

1933

[Edvard Munch]. National Gallery, Oslo, December 12.

Carnegie International Exhibition, Pittsburgh, October 19–December 10.

1934

[Edvard Munch]. Commeter, Hamburg, January.

Carnegie International Exhibition, Pittsburgh, October 18–December 9.

1935

[Edvard Munch]. Samlerens Kunstudstilling, Copenhagen, June.

1936

[Edvard Munch]. The London Gallery, London, October 21–November 14.

Exhibition of Contemporary Norwegian Paintings, International Art Center, New York, January 26–February 26.

1937

[Edvard Munch]. Kungl Konstakademien, Stockholm, March.

[Edvard Munch]. Stedelijk Museum, Amsterdam, May 1–June 20.

[Edvard Munch]. Kunstforeningen, Bergen, October 24–November 7.

World's Fair, Paris, June.

Degenerate Art (Entarte Kunst), Munich, opens July 19.

Carnegie International Exhibition, Pittsburgh, October 14–December 5.

1942

[Edvard Munch]. The Brooklyn Museum, Brooklyn, New York, December 18–February 22, 1943.

1944

[Edvard Munch]. Nationalmuseum, Stockholm, and Göteborgs Konstmuseum, Göteborg, February.

1946

Edvard Munch, Fogg Art Museum, Harvard University, Cambridge, Massachusetts, February 5–March 20.

Edvard Munchs tresnitt: av Kunstnerens gave til Oslo by, lånt til utstilling av Oslo Kommune, National Gallery, Oslo, March–April.

Edvard Munch, Rathaus, Copenhagen, April 8–25 (retrospective).

1947

Edvard Munch, Liljevalchs Konsthall, Stockholm, January 4–February 2 (retrospective).

Edvard Munch: utstilling i Göteborgs Konstmuseum, Göteborgs Konstmuseum, Göteborg, February 25–March 16 (retrospective).

1950

Edvard Munch, Fogg Art Museum, Harvard University, Cambridge, Massachusetts, April 18–May 27; organized with the Institute of Contemporary Art, Boston, April 19–May 19 (retrospective). Travels to Phillips Gallery, Washington, D.C., May 28–June 20; The Museum of Modern Art, New York, June 30–August 13; Detroit Institute of Arts, September 1–9; Minneapolis Institute of Arts, October 12–November 9; Colorado Springs Fine Arts Center, November 23–December 21; Los Angeles County Museum, January 4–February 1, 1951; M. H. De Young Memorial Museum, San Francisco, February 10–March 10, 1951; Carnegie Institute, Pittsburgh, March 24–April 21, 1951; Art Institute of Chicago, May 7–June 10, 1951; City Art Museum of St. Louis, June 18–July 15, 1951.

Edvard Munch, Kleeman Gallery, New York, June.

Edvard Munch, 1863–1944: Etchings, Woodcuts, Lithographs, Arts Council of Great Britain, London.

1951

Edvard Munch: An Exhibition of Paintings, Etchings, and Lithographs, Arts Council of Great Britain, Brighton (a version of the 1950 Fogg Art Museum exhibition). Travels to Glasgow; Tate Gallery, London; Gemeentemuseum Den Haag, December 13–February 15, 1952; Petit-Palais, Paris, March–April, 1952.

Ausstellung Edvard Munch, 1863–1944, Cologne, Hamburg, Lübeck, summer (paintings).

1952

Edvard Munch, Kunsthaus

Zürich, June 22–August 17 (retrospective).

Edvard Munch: Peintures, œuvre gravé, Palais des Beaux-Arts, Brussels, October 11–November 2.

1954

Edvard Munch, Haus der Kunst, Munich, November 12–December 31 (retrospective). Travels to Wallraf Richartz-Museum, Cologne, January 23–February 20, 1955.

Edvard Munch, 1863–1944: Wood-cuts, Etchings, and Lithographs, National Gallery, Cape Town; Johannesburg Art Gallery.

1957

Edvard Munch: A Selection of His Prints from American Collections, The Museum of Modern Art, New York, February 6–March 3.

1958

Edvard Munch, Kunstmuseum, Bern, October 7–November 30 (retrospective).

Edvard Munch, Museum Boijmans–Van Beuningen, Rotterdam, December 10–February 8, 1959.

1959

Edvard Munch: Malarstwo i grafika, Muzeum Narodowe, Warsaw, November–December.

Edvard Munch, 1863–1944: Ausstellung veranstaltet vom Kulturamt der Stadt Wien, Akademie der Bildenden Künste, Vienna.

1960

Edvard Munch: Etchings, Lithographs, Woodcuts, Bezalel National Museum, Jerusalem, April–May.

Vystavka graviur Edvarda Munka, The State Hermitage Museum, St. Petersburg.

1962

The Graphic Art, Edvard Munch, 1863–1944, National Gallery of Canada, Ottawa.

Edvard Munch, Frankfurter Kunstverein, Franfurt am Main, November 9–January 6, 1963.

1964

The Graphic Work of Edvard Munch, 1863–1944, Scottish National Gallery of Modern Art, Edinburgh, August 15–September 15. Travels to City Art Gallery, York, September 28–October 17; The New Metropole Art Centre, Folkestone, October 31–November 21; City Art Gallery, Bristol, November 28–December 28; Usher Art Gallery, Lincoln, January 2–23, 1965.

1965

Edvard Munch, Galerie Beyeler, Basel (paintings, drawings, prints).

Edvard Munch, Solomon R. Guggenheim Museum, New York, October 1965–January 1966 (retrospective).

1966

Edvard Munch, Museum Zu Allerheiligen, Schaffhausen, March 30–June 9.

Edvard Munch, 1863–1944, Worth Ryder Gallery, Kroeber Hall, University of California, Berkeley, November 21–December 18 (prints).

1969

Edvard Munch: Lithographs, Etchings, Woodcuts, Los Angeles County Museum of Art, January 28–March 9.

E. Munch, Musée des Arts Décoratifs, Paris, March–April.

Grabados de Munch, Centro de Artes Visuales del Instituto Torcuato Di Tella, Buenos Aires, July 3–August 3.

Munch/Nolde: The Relationship of Their Art: Oils, Watercolors, Drawings, and Graphics, Marlborough Fine Art Ltd., London, and Marlborough New London Gallery, July–August.

Edvard Munch: The Graphic Work: A Loan Exhibition from the Munch-Museet, Oslo, Duke University Art Museum, Durham, North Carolina, November 16–December 18.

The Work of Edvard Munch from the Collection of Mr. and Mrs. Lionel C. Epstein, The Phillips Collection, Washington D.C.

1970

Edvard Munch: Alpha and Omega: 22 Original Lithographs, 1909, Irving Galleries, Milwaukee, May 3–June 1.

Edvard Munch. Das zeichnerische Werk, Kunsthalle, Bremen, May 3–June 28. Travels to Museum Boijmans–Van Beuningen, Rotterdam, September 17–November 1.

1972

Edvard Munch: The Epstein Collection, Allen Memorial Art Museum, Oberlin College, Ohio, April 28–May 21.

Edvard Munch: The Graphic Work, Walker Art Gallery, Liverpool. Travels to The Art Gallery and Museum, Glasgow; The Art Gallery and Museum, Aberdeen; Scottish National Gallery of Modern Art, Edinburgh; City Art Gallery, Manchester; The City Museum and Art Gallery, Birmingham; City Art Gallery, Bristol; The Graves Art Gallery, Sheffield; City Art Gallery, Leeds; The Ferens Art Gallery, Kingston-upon-Hull; The Laing Art Gallery and Museum, Newcastle-upon-Tyne.

1973

The Prints of Edvard Munch, The Museum of Modern Art, New York, February 13–April 29.

Edvard Munch: 1863–1944, Haus der Kunst, Munich, October 6–December 16. Travels to Hayward Gallery, London, January 8–March 3, 1974; Musée National d'Art Moderne, Paris, March 22–May 12, 1974.

1975

Edvard Munch, Konsthall, Malmö, March 22–May 25 (retrospective).

1976

Munch und Ibsen, Kunsthaus Zürich, February 29–April 11.

Edvard Munch, The Sarah Campbell Blaffer Gallery, of the University of Houston, April 9–May 23. Travels to The New Orleans Museum of Art, June 11–July 18; Witte Memorial Museum, San Antonio, July 28–September 12 (paintings, drawings, prints).

Edvard Munch, Louisiana Museum for Moderne Kunst, Humlebæk, Denmark, October 11–January 4, 1977.

Edvard Munch: The Major Graphics, Smithsonian Institution, Washington, D.C. Travels to museums in the United States, as part of Norway's activities commemorating the United States Bicentennial.

1977

Edvard Munch, Liljevalchs Konsthall/Kulturhuset, Stockholm, March 25–May 15 (retrospective).

Munku hanga ten/Exhibition of Edvard Munch's Prints, The Museum of Modern Art, Kamakura, December 6–January 29, 1978. Travels to six other Japanese museums.

1978

Edvard Munch, Der Lebensfries für Max Reinhardts Kammerspiele, Nationalgalerie, Berlin, February 24–April 16.

Edvard Munch and Heinrich Ibsen, Stensland Gallery, St. Olaf College, Northfield, Minnesota, March 16–April 23.

Klinger und Munch: Weltanschauung und Psyche in Bilderzyklen der Jahrhundertwende, Kunsthalle, Kiel, April 26–May 24.

Edvard Munch. Arbeiterbilder 1910–1930, Kunstverein, Hamburg, May 11–July 9. Travels to Württembergischer Kunstverein, Stuttgart, July 19–August 27; Staatliche Kunsthalle, Berlin, September 4–27; Kunstverein, Frankfurt, November 24–January 21, 1979.

Edvard Munch: Symbols and Images, National Gallery of Art, Washington, D.C., November 11–February 19, 1979 (retrospective).

Die Brücke–Edvard Munch, Malmö Konsthall, December 9–February 18, 1979.

1979

Edvard Munch: Gemälde und Zeichnungen aus einer norwegischen Privatsammlung, Kunsthalle Kiel, January–April.

The Masterworks of Edvard Munch, The Museum of Modern Art, New York, March 15–April 24.

Frederick Delius og Edvard Munch, Munch Museum, Oslo, April 2–May 13.

Edvard Munch: Målningar och grafik, Amos Andersons Konstmuseum, Helsinki, August 18–October 21.

Edvard Munch: Malerier fra Eventyrskoven, Kastrupgårdsamlingen, Kastrup, Denmark, September 16–October 14.

Edvard Munch and His Literary Associates, University of East Anglia, Norwich, England, October 6–28. Travels to Hatton Gallery, University of Newcastle-upon-Tyne, November 5–30; Crawford Center for the Arts, University of St. Andrews, December 8–January 6, 1980.

1980

James Ensor, Edvard Munch, Emil Nolde, Norman Mackenzie Art Gallery, University of Regina, Regina, Saskatchewan. Travels to Glenbow Alberta Institute, Calgary, Alberta, May 3–June 15; Winnipeg Art Gallery, Winnipeg, Manitoba, July 4–August 17.

Edvard Munch. Lieb, Angst, Tod: Themen und Variationen: Zeichnungen und Graphiken aus dem Munch-Museum Oslo, Kunsthalle, Bielefeld, September 28–November 23 (drawings, prints). Travels to Kaiser Wilhelm Museum, Krefeld, January 25–March 15, 1981; Pfalzgalerie, Kaiserslautern, March 29–May 10, 1981.

1981

Alpha und Omega: Together with "The First Human Beings," "Burlesque Motifs," "The City of Free Love," "The History of the Passion," and Other Caricatures, Munch Museum, Oslo, March 21–August 31.

Edvard Munch, The National Museum of Art, Tokyo, October 9–November 23 (retrospective).

Edvard Munch: Paradox of Women: An Exhibition of Prints from the Epstein Collection, Aldis Browne Fine

Arts, New York, October 28–December 5. Travels to McNay Art Institute, San Antonio, January–February, 1982; Abilene Fine Arts Museum, Abilene, March–April, 1982; University Art Galleries, University of Southern California, Los Angeles, September–October, 1982.

1982

Edvard Munch: Expressionist Paintings, 1900–1940, Elvehjem Museum of Art, University of Wisconsin, Madison, August 25–29. Travels to Minnesota Museum of Art, Landmark Center, St. Paul, December 2–January 23, 1983; Newport Harbor Beach Museum, Newport Beach, California, February 5–March 27, 1983; Seattle Art Museum, Volunteer Park, Seattle, April 14–June 12, 1983.

Northern Light: Realism and Symbolism in Scandinavian Painting: 1880–1910, The Brooklyn Museum, Brooklyn, New York, November 10–January 6, 1983. Travels to Corcoran Gallery of Art, Washington, D.C., September 8–October 17, 1982; The Minneapolis Institute of Arts, February 6–April 10, 1983.

1983

The Prints of Edvard Munch: Mirror of His Life, Allen Memorial Art Museum, Oberlin College, Ohio, March 1–27.

Edvard Munch: Master Printmaker. An Examination of the Artist's Works and Techniques Based on the Philip and Lynn Straus Collection, Neuberger Museum of Art, State University of New York at Purchase, New York; and Busch-Reisinger Museum, Harvard University Art Museums, Cambridge, Massachusetts.

1984

The Mystic North, Art Gallery of Ontario, Toronto, January 13–March 11. Travels to Cincinnati Art Museum, March 31–May 13.

Edvard Munch: Alpha and Omega, Its Gestation and Resolution: Prints from the Collection of Sarah G. and Lionel C. Epstein, Sarah Lawrence Col-

lege Gallery, Bronxville, New York, October 2–November 18.

Munch and the Workers, Newcastle Polytechnic Gallery, October 8–November 30. Travels to Aberdeen Art Gallery, January 12–February 2, 1985; The Barbican, London, February 14–March 31, 1985; City Art Centre, Edinburgh, April 18–May 18, 1985; Ulster Museum, Belfast, May 30–June 24, 1985; Walker Art Gallery, Liverpool, July 4–August 18, 1985.

Edvard Munch. Höhepunkte des malerischen Werks im 20. Jahrhundert, Kunstverein, Hamburg, December 8–February 3, 1985 (prints).

1985

Edvard Munch: Sein Werk in Schweizer Sammlungen, Kunstmuseum, Basel, June 9–September 22.

Edvard Munch, Palazzo Reale and Palazzo Bagatti Valsecchi, Milan, December 4–March 16, 1986 (retrospective).

1986

Edvard Munch, Vancouver Art Gallery, May 31–August 4.

Dreams of a Summer Night: Scandinavian Painting at the Turn of the Century, Hayward Gallery, London, July–October.

Edvard Munch: Death and Desire: Etchings, Lithographs, and Woodcuts from the Munch Museum, Oslo, Art Gallery of South Australia, North Terrace, Adelaide, September 4–October 13. Travels to Art Gallery of New South Wales, Sydney; Queensland Art Gallery, Brisbane; National Gallery of Victoria, Melbourne; Tasmanian Museum and Art Gallery, Hobart; Art Gallery of Western Australia, Perth.

Encounters in Space: Double Images in the Graphic Art of Edvard Munch, Franklin and Marshall College, Lancaster, Pennsylvania, September 26–October 26. Travels to Hood Museum of Art, Dartmouth College, Hanover, New Hampshire, November 8–January 4, 1987; Jewitt Art Center, Wellesley College, Wellesley, Massachusetts, February 7–March 22, 1987.

Edvard Munch: Mirror Reflections, The Norton Gallery of Art, West Palm Beach, Florida.

1987

Edvard Munch, Centre Cultural de la Fundació Caixa de Pensions, Barcelona, January 27–March 22 (retrospective).

Edvard Munch: aus dem Munch Museum Oslo: Gemälde, Aquarelle, Zeichnungen, Druckgraphik, Fotografien, Villa Stuck, Munich, April 28–May 7. Travels to Salzburg, July 16–October 4; Brücke-Museum, Berlin, October 15–December 6.

Edvard Munch, Museum Folkwang Essen, September 18–November 8. Travels to Kunsthaus Zürich, November 19–February 14, 1988.

1988

Edvard Munch: maler og fotograf/kunstneren og fotografiet, Louisiana Museum for Moderne Kunst, Humlebæk, Denmark, February 20–May 15.

Edvard Munch. Sommernacht am Oslofjord, um 1900, Städtische Kunsthalle, Mannheim, February 27–April 17.

Edvard Munch: Pintor noruego, Centro Cultural/Arte Contemporaneo, Mexico City (retrospective)

Ensor, Hodler, Kruyder, Munch: Wegbereiders van hzet modernisme/Pioneers of Modernism, Museum Boijmans–Van Beuningen, Rotterdam.

1989

Munch and Photography, Hatton Gallery, Newcastle University, May 2–June 10; organized with Newcastle Polytechnic Gallery, May 2–June 16. Travels to The City Art Centre, Edinburgh, August 5–September 16; City Art Gallery, Manchester, September 23–November 5; The Museum of Modern Art, Oxford, January 14–March 14, 1990.

1990

Edvard Munch: Master Prints from the Epstein Family Collection, National Gallery of Art, Washington, D.C., May 27–September 3. Travels to Hon-

olulu Academy of Arts, September 12–October 28; Los Angeles County Museum of Art, November 22–January 6, 1991; Center for the Fine Arts, Miami, January 19–March 3, 1991; Indianapolis Museum of Art, March 23–May 5, 1991; Nelson-Atkins Museum of Art, Kansas City, May 26–July 7, 1991; High Museum of Art, Atlanta, August 17–November 10, 1991; The Dixon Gallery and Gardens, Memphis, November 30–January 12, 1992.

Edvard Munch Prints: The Charles & Evelyn Kramer Collection at the Tel Aviv Museum of Art, Tel Aviv, autumn.

1991

Munch og Frankrike/Munch et la France, Musée d'Orsay, Paris, September 24–January 5, 1992. Travels to Munch Museum, Oslo, February 3–April 21, 1992.

1992

Edvard Munch: The Frieze of Life, The National Gallery, London, November 12–February 7, 1993.

1993

Edvard Munch and His Models, 1912–1944, University Art Museum and Pacific Film Archive, University of California at Berkeley, January 20–March 21.

Edvard Munch und seine Modell, Galerie der Stadt Stuttgart, April 17–August 1.

1994

Edvard Munch: Portretter, Munch Museum, Oslo, January 23–May 3.

Munch und Deutschland, Kunsthalle der Hypo-Kulturstiftung, Munich, September 23–November 27. Travels to Hamburger Kunsthalle, Hamburg, December 9–February 12, 1995; Nationalgalerie, Berlin, February 24–April 23, 1995.

1995

Edvard Munch and Harald Sohlberg: Landscapes of the Mind, National Academy of Design, New York, October 12–January 14, 1996.

Edvard Munch, 1895: første år som grafiker/First Year as a Graphic Artist, Munch Museum, Oslo.

Art Noir: Camera Work by Edvard Munch, Akseli Gallen-Kallela, Hugo Simburg, August Strindberg, Gallen-Kallelan Museo, Espoo.

1996

Munch og etter Munch: eller maleres standhaftighet/Munch after Munch: or the Obstinacy of Painters, Stedelijk Museum, Amsterdam, April 15–June 9.

Edvard Munch: The Soul of Work: A Joint Nordic Exhibit. Norwegian Industrial Workers Museum, Rjukan, April 28–July 27. Travels to The Workers Museum, Copenhagen, August 5–October 20; The National Gallery of Iceland, Reykjavik, November 9–January 17, 1997.

Close to the Surface: The Expressionist Prints of Edvard Munch and Richard Bosman, The Columbus Museum, Columbus, Georgia, May 19–August 11.

Edv. Munch: Grafikk fra 1896/Prints from 1896, Munch Museum, Oslo, summer.

Love, Isolation, Darkness. The Art of Edvard Munch, Bruce Museum of Arts and Science, Greenwich, Connecticut, September 28–January 5, 1997.

1997

The Symbolist Prints of Edvard Munch: The Vivian and David Campbell Collection, Art Gallery of Ontario, Toronto, February 28–May 25.

Edvard Munch, Setagaya Art Museum, Tokyo, April 5–June 8 (retrospective).

Munch and Women: Image and Myth, San Diego Museum of Art. Travels to Portland Art Museum, Oregon; Yale University Art Gallery, New Haven.

1998

Lumière du monde, lumière du ciel, Musée d'art moderne de la Ville de Paris, February 7–May 17.

Edvard Munch og Henrik Ibsen, Kunstforeningen, Copenhagen, August 15– October 25.

Edvard Munch, Museo d'Arte Moderna della Città di Lugano, Villa Malpensata, Lugano, September 19–December 13 (retrospective).

Munch og Ekely: 1916–1944, Munch Museum, Oslo, November 22–February 28, 1999.

1999

Munch og Warnemünde, Munch Museum, Oslo, March 17–May 24. Travels to Kunsthalle, Rostock, June 13–August 29; Ateneum, Helsinki, October 1–January 30, 2000.

Edvard Munch: Dal realismo all'espressionismo. Dipinti e opere grafiche dalla Galleria Nazionale di Oslo, Sala Bianca di Palazzo Pitti, Florence, October 30–February 13, 2000.

Edvard Munch in Chemnitz, Kunstsammlungen, Chemnitz, November 14–February 20, 2000.

2000

Edvard Munch: Paintings, Galleri Faurschou, December– January, 2001. Travels to Mitchell-Innes and Nash, New York, March–April, 2001; de Pury and Luxembourg Art, Zürich, May–June, 2001.

2001

Edvard Munch: Psyche, Symbol, and Expression, McMullen Museum of Art, Boston College, February 5–May 20.

Munch og Kvinnen/Munch and Women, Kunstmuseum, Bergen, September 11–January 27, 2002.

Edvard Munch: l'io e gli altri, Galleria d'Arte Moderna e Contemporanea, Palazzo Forti, Verona, September 15– January 6, 2002.

Da Dahl a Munch: Romanticismo, realismo e simbolismo nella pittura di paesaggio norvegese, Palazzo dei Diamanti, Ferrara, October 26– January 13, 2002.

2002

After the Scream: The Late

Paintings of Edvard Munch, High Museum of Art, Atlanta, February 9–May 5.

Im Blickfeld: Edvard Munch, Das Kranke Kind, Hamburger Kunsthalle, Hamburg, March 1–May 20.

Edvard Munch, Göteborgs Konstmuseum, Göteborg, September 28–January 6, 2003 (retrospective).

Edvard Munchs Livsfrise: En rekonstruksjon av utstillingen hos Blomqvist 1918, Munch Museum, Oslo, October 15– January, 15, 2003.

Edvard Munch: 1912 in Deutschland, Kunsthalle Bielefeld, November 24–February 16, 2003.

2003

Edvard Munch: Vampir, Kunsthalle, Würth, Schwäbisch Hall, January 25–January 6, 2004.

Edvard Munch: Theme and Variation, Albertina, Vienna, March 15–June 22 (retrospective).

Edvard Munch: Die Graphik im Berliner Kupferstichkabinett, Kulturforum am Potsdamer Platz, Berlin, April 12– July 13. Travels to Westfälisches Landesmuseum für Kunst und Kulturgeschichte, Münster, November 9–February 1, 2004.

Edvard Munch und Lübeck, Museum für Kunst und Kulturgeschichte der Hansestadt, Lübeck, August 3–October 19.

2004

The Frieze of Life: Edvard Munch, National Gallery of Art, Victoria, October 11–January 12, 2005 (retrospective).

2005

Munch by Himself, Moderna Museet, Stockholm, February 19–May 15. Travels to Munch Museum, Oslo, June 11– August 28; Royal Academy of Arts, London, September 17– December 11.

Munch: 1863–1944, Complesso del Vittoriano, Rome, March 10–June 19 (retrospective).

Edvard Munch's Mermaid, Philadelphia Museum of Art, September 24–December 31.

Lenders to the Exhibition

Kunstmuseum, Basel
Bergen Art Museum, Bergen
Staatliche Museen zu Berlin–Nationalgalerie, Berlin
Kunstmuseum Bern
Museum of Fine Arts, Boston
Kunsthalle Bremen–Der Kunstverein in Bremen
Fogg Art Museum, Harvard University Art Museums,
 Cambridge, Massachusetts
Statens Museum for Kunst, Copenhagen
Göteborgs Konstmuseum, Göteborg
Hamburger Kunsthalle, Hamburg
Ateneum Art Museum, Helsinki
Die Museen für Kunst und Kulturgeschichte der
 Hansestadt Lübeck
The Museum of Modern Art, New York
Munch Museum, Oslo
The National Museum of Art, Architecture, and
 Design/National Gallery, Oslo
Stenersen Museum, Oslo
Philadelphia Museum of Art, Philadelphia
The Frances Lehman Loeb Art Center, Vassar
 College, Poughkeepsie, New York
Moderna Museet, Stockholm
Thielska Galleriet, Stockholm
National Gallery of Art, Washington, D.C.

Catherine Woodard and Nelson Blitz, Jr., New York
Epstein Family Collection, Washington, D.C.
Galleri K, Oslo
Private collections (eight)

Book illustrations by Edvard
Munch: Cover of Pola Gauguin's
Edvard Munch, 1933; cover of
Stanislaw Przybyszewski's
Vigilien, 1894; page from the
journal *Quickborn*, 1899

Selected Bibliography

This Selected Bibliography is divided into four sections. The first section, Writings by the Artist, *consists of published writings by Munch. The second section,* Monographs, *is made up of books and exhibition catalogues about Munch, and the third section,* Works Including the Artist, *of important books and catalogues that include Munch. The fourth section,* Articles, *lists articles about Munch that have appeared both in periodicals and books. Each section lists publications alphabetically by author or title, then chronologically under an author with multiple works. The entries were compiled by Jane Panetta.*

Writings by the Artist

Holland, J. Gill, ed. *The Private Journals of Edvard Munch: We Are Flames Which Pour Out of the Earth*. Madison: University of Wisconsin Press, 2004.

Tøjner, Poul Erik. *Munch in His Own Words*. Munich: Prestel Verlag, 2001.

Torjusen, Bente. *Words and Images of Edvard Munch*. Chelsea, Vt.: Chelsea Green, 1986.

Monographs

Achenbach, Sigrid. *Edvard Munch: Die Graphik im Berliner Kupferstichkabinett*. Berlin: Staatliche Museen zu Berlin and G+H Verlag, 2003.

Anderson, Katherine E. "The Landscapes of Edvard Munch: A Medium of Communication and the Continuation of a Tradition." Unpublished M.A. thesis, Michigan State University, 1985.

Arnold, Matthias. *Edvard Munch*. Hamburg: Reinbek, 1986.

Ausstellung Edvard Munch. Munich: Die Galerie Caspari, 1921.

Ausstellung Edvard Munch. Zurich: Verlag de Zürcher Kunstgesellschaft Kunsthaus am Heimplatz, 1922.

Austellung Edvard Munch. Munich: Haus der Kunst, 1955.

Ausstellung Edvard Munch, 1863–1944. Cologne: Kurt Lauterhahn, 1951.

Bardon, Annie, Arne Eggum, Timo Huusko, and Gerd Woll. *Munch og Warnemünde: 1907–1908*. Oslo: Munch Museum, 1999.

Berman, Patricia G. *Edvard Munch: Mirror Reflections*. West Palm Beach: Norton Gallery of Art, 1986.

———. "Monumentality and Historicism in Edvard Munch's University of Oslo Festival Hall Murals." Unpublished Ph.D. dissertation, New York University, 1989.

Berman, Patricia G., and Jane van Nimmen. *Munch and Women: Image and Myth*. Alexandria: Art Services International, 1997.

Bimer, Barbara S. T. "Edvard Munch's Fatal Women: A Critical Approach." Unpublished M.A. thesis, North Texas State University, 1985.

Bischoff, Ulrich. *Edvard Munch: 1863–1944*. Translated by Michael Hulse. Cologne: Benedikt Taschen Verlag, 2000.

———. *Edvard Munch, 1863–1944*. New York: Barnes & Noble Books, 2001.

Bjerke, Øivind Storm, and Achille Bonito Oliva. *Munch: 1863–1944*. Milan: Skira, 2005.

Bjørnstad, Ketil. *The Story of Edvard Munch*. Translated by Torbjørn Støverud and Hal Sutcliffe. London: Arcadia Books, 2001.

Bøe, Alf. *Edvard Munch*. New York: Rizzoli, 1989.

———. *Edvard Munch*. Oslo: Aschehoug, 1992.

Brennecke, Detlef. *Die Nietzche-Bildnisse Edvard Munchs*. Berlin: Berlin Verlag, 2000.

Brinton, Christian, ed. *Exhibition of Etchings, Lithographs, and Woodcuts by Edvard Munch of Christiana, Norway*. New York: Bourgeois Galleries, 1919.

Bruteig, Magne. *Munch: Dessins*. Antwerp: Fonds Mercator, 2004.

———. *Munch: Tegneren*. Oslo: Aschehoug, 2004.

Chiappini, Rudy. *Edvard Munch*. Lugano: Museo d'Arte Moderna; Milan: Skira, 1998.

Cordulack, Shelley Wood. "Edvard Munch's *Frieze of Life* in the Context of Nineteenth-Century Physiology." Unpublished Ph.D. dissertation, University of Illinois at Urbana-Champaign, 1996.

———. *Edvard Munch and the Physiology of Symbolism*. Madison, N.J.: Fairleigh Dickinson University Press, 2002.

Cortenova, Giorgio, and Arne Eggum. *Edvard Munch: L'io e gli altri*. Milan: Electa, 2001.

Deknatel, Frederick B. *Edvard Munch, 1863–1944: Etchings, Lithographs, Woodcuts*. New York: Buchholz Gallery, 1944.

———. *Edvard Munch*. New York: The Museum of Modern Art, 1950.

E. Munch. Oslo: National Gallery, 1933.

E. Munch. Paris: Musée des Arts Décoratifs, 1969.

Edvard Munch. Berlin: Nationalgalerie, 1927.

Edvard Munch. Chemnitz: Kunsthütte zu Chemnitz, 1929.

Edvard Munch. Copenhagen: Raadhushallen København, 1946.

Edvard Munch. Stockholm: Liljevalchs Konsthall, 1947.

Edvard Munch. Zürich: Kunsthaus Zürich, 1952.

Edvard Munch. Rotterdam: Museum Boijmans–Van Beuningen, 1958.

Edvard Munch: Basel: Galerie Beyeler, 1965.

Edvard Munch. New York: Solomon R. Guggenheim Foundation, 1965.

Edvard Munch. Stockholm: Liljevalchs Konsthall, 1977.

Edvard Munch. Tokyo: The National Museum of Modern Art, 1981.

Edvard Munch. Vancouver: Vancouver Art Gallery, 1986.

Edvard Munch. Barcelona: Centre Cultural de la Fundació Caixa de Pensions, 1987.

Edvard Munch. Tokyo: Setagaya Art Museum, 1997.

Edvard Munch. Göteborg: Göteborgs Konstmuseum, 2002.

Edvard Munch, 1864–1944. London: Arts Council of Great Britain, 1950.

Edvard Munch: 1863–1944. Bern: Buchdruckerei Eicher & Co., 1958.

Edvard Munch, 1863–1944. London: Arts Council of Great Britain, 1974.

Edvard Munch: 1863–1944. Warsaw: Muzeum Narodowe, 1977.

Edvard Munch, 1895: First Year as a Graphic Artist. Translated by Ruth Waaler. Oslo: Munch Museum, 1995.

Edvard Munch: Alpha en Omega. Amersfoort: De Zonnehof Amersfoort, 1986.

Edvard Munch: Death and Desire; Etchings, Lithographs, and Woodcuts from the Munch Museum, Oslo. Adelaide: Art Gallery of South Australia, 1986.

Edvard Munch: The Frieze of Life. Melbourne: National Gallery of Art, Victoria, 2004.

Edvard Munch: Grafikk fra 1896. Oslo: Munch Museum, 1996.

Edvard Munch: The Graphic Work: A Loan Exhibition from the Munch Museum, Oslo, 1972–1973. Liverpool: The Walker Art Gallery, 1973.

Edvard Munch: Lieb, Angst, Tod: Themen und Variationen: Zeichnungen und Graphiken aus dem Munch-Museum Oslo. Bielefeld: Kunsthalle, 1980.

Edvard Munch und Lübeck. Lübeck: Museum für Kunst und Kulturgeschichte der Hansestadt Lübeck, 2003.

Edvard Munch I Nasjonalgalleriet. Oslo: National Gallery, 1998.

Edvard Munch: Paintings from the Munch Museum, Oslo. Newcastle upon Tyne: Polytechnic Art Gallery, 1980.

Edvard Munch: Pinto noruego. Mexico City: Centro Cultural Arte Contemporaneo and Fundacion Cultural Televisa, 1988.

Edvard Munch Prints: The Charles & Evelyn Kramer Collection at the Tel Aviv Museum of Art. Tel Aviv: Tel Aviv Museum of Art, 1990.

Edvard Munch und seine Modelle. Stuttgart: Galerie der Stadt Stuttgart and G. Hatje, 1993.

Edvard Munch, Selvportretter. Oslo: Munch Museum, 1963.

Edvard Munch: Sommernacht am Oslofjord, um 1990. Mannheim: Städtische Kunsthalle, 1988.

Edvard Munch: Symbols and Images. Washington, D.C.: National Gallery of Art, 1978.

Edvard Munch: Utstilling i Göteborgs Konstmuseum. Göteborg: Göteborgs Konstmuseum, 1947.

Edvard Munch: Utstilling i Nasjonalgalleriet, 1927. Oslo: National Gallery, 1927.

Edvard Munch: Vampir. Schwäbisch Hall: Kunsthalle Würth; Künzelsau: Swiridoff Verlag, 2003.

Edvard Munch. Das zeichnerische Werk. Bremen: Kunsthalle Bremen, 1970.

Edvard Munchs tresnit: Av Kunstnerens gave til Oslo by, lånt til utstilling av Oslo Kommune. Oslo: National Gallery, 1946.

Eggum, Arne. *Der Linde-Fries: Edvard Munch und Sein Erster Deutscher Mäzen, Dr. Max Linde.* Lübeck: Der Senat der Hansestadt Lübeck, 1982.

———. *Edvard Munch, Expressionist Paintings, 1900–1940.* Madison: University of Wisconsin Press, 1982.

———. *Edvard Munch: Paintings, Sketches, and Studies.* Oslo: J. M. Stenersens Forlag, 1984.

———. *Edvard Munch og Hans Modeller: 1912–1943.* Oslo: Munch Museum, 1988.

———. *Munch and Photography.* New Haven: Yale University Press, 1989.

———. *Edvard Munch: Portretter.* Oslo: Munch Museum and Labyrinth Press, 1994.

———. *Edvard Munch: The Frieze of Life: From Painting to Graphic Art.* Oslo: J. M. Stenersens Forlag, 2000.

Eggum, Arne, and Sissel Biørnstad, eds. *Alpha and Omega Together with "The First Human Beings," "Burlesque Motifs," "The City of Free Love," "The History of the Passion," and Other Caricatures.* Oslo: Munch Museum, 1981.

Eggum, Arne, and Gerd Woll. *Edvard Munch: Malerier fra Eventyrskoven.* Kastrup: Kastrupgårdsamlingen, 1979.

Eggum, Arne, Gerd Woll, and Jan Bauch. *Edvard Munch a Ceské Umení: Obrazy a Grafika Ze Sbírek Muzea E. Muncha v Oslo.* Prague: Národní Galerie, 1982.

Eggum, Arne, Gerd Woll, and Marit Lande. *Munch at the Munch Museum, Oslo.* London: Scala Books; Oslo: Munch Museum, 1998.

Eggum, Arne, Gerd Woll, and Petra Pettersen. *Munch og Ekely: 1916–1944.* Oslo: Munch Museum and Labyrinth Press, 1998.

Eggum, Arne, et al. *Edvard Munch, 1863–1944.* Madrid: Ministerio de Cultura, 1984.

Eggum, Arne, et al., eds. *Briefwechsel: Edvard Munch/Gustav Schiefler,* Vol. 1 (1902–1914). Hamburg: Verlag Verein für Hamburgische Geschichte, 1987.

———. *Briefwechsel: Edvard Munch/Gustav Schiefler,* Vol. 2 (1915–1935/43). Hamburg: Verlag Verein für Hamburgerische Geschichte, 1990.

Epstein, Sarah G., and Jane van Nimmen. *The Prints of Edvard Munch: Mirror of His Life.* Oberlin, Ohio: Allen Memorial Art Museum, Oberlin College, 1983.

Epstein, Richard A., Mary Delahoyd, and Jane van Nimmen. *Edvard Munch: Alpha and Omega, Its Gestation and Resolution: Prints from the Collection of Sarah G. and Lionel C. Epstein.* Bronxville: Sarah Lawrence College, 1984.

Fagioli, Marco. *Edvard Munch: 1863–1944.* Santarcangelo di Romagna: Idea Libri, 2003.

Fern, Alan Maxwell, and Jane van Nimmen. *The Work of Edvard Munch from the Collection of Mr. and Mrs. Lionel C. Epstein.* Washington, D.C.: The Phillips Collection, 1969.

Gauguin, Pola. *Edvard Munch.* Oslo: Gyldendal Norsk Forlag, 1933.

———. *Grafikeren Edvard Munch.* Trondheim: F. Brun, 1946.

Gerner, Cornelia. *Die "Madonna" in Edvard Munchs Werk: Frauenbilder und Frauenbild im ausgehenden 19. Jahrhundert.* Morsbach: Norden M. Reinhardt, 1993.

Glaser, Curt. *Edvard Munch.* Berlin: Bruno Cassirer, 1917. Reprint, 1922.

Gløersen, Inger Alver. *Lykke huset: Edvard Munch og Åsgårdstrand.* Oslo: Gyldendal Norsk Forlag, 1970.

———. *Munch as I Knew Him.* Hellerup, Denmark: Edition Bløndal, 1994.

The Graphic Work of Edvard Munch. London: Shenval Press, 1964.

Guenther, Peter W. *Edvard Munch.* Houston: The Sarah Campbell Blaffer Gallery of the University of Houston, 1976.

Halvorsen, Åshild T., Anne-Lise Walsted, and Erik Haatvedt, eds. *Edvard Munch: The Soul of Work: A Joint Nordic Exhibit.* Rjukan: Norwegian Industrial Workers Museum, 1996.

Heise, Carl Georg. *Edvard Munch: Die Vier Söhne des Dr. Max Linde.* Stuttgart: P. Reclam, 1956.

Heller, Reinhold. "The Portrait Art of Edvard Munch." Unpublished M.A. thesis, Indiana University, 1965.

———. "Edvard Munch's Life Frieze: Its Beginnings and Origins." Unpublished Ph.D. dissertation, Indiana University, 1969.

———. *Edvard Munch: The Scream.* New York: Viking Press, 1973.

———. *Munch: His Life and Work.* Chicago: University of Chicago Press, 1984.

Hodin, J. P. *Edvard Munch.* New York: Oxford University Press, 1972. Reprint, 1996.

Hogestatt, Eje. *Edvard Munch.* Malmö: Malmö Konsthall, 1975.

Howe, Jeffrey, ed. *Edvard Munch: Psyche, Symbol, and Expression.* Boston: McMullen Museum of Art, Boston College, 2001.

Høifødt, Frank. *Munch in Oslo.* Oslo: N.W. Damm & Søn, 2002.

Jensen, Jens Christian, and Ulrich Bischoff. *Edvard Munch: Gemälde und Zeichnungen aus einer norwegischen Privatsammlung.* Kiel: Kunsthalle zu Kiel der Christian-Albrechts-Universität, 1979.

Kellein, Thomas, ed. *Edvard Munch. 1912 in Deutschland.* Bielefeld: Kunsthalle Bielefeld, 2002.

Kirkeby, Per. *Munch.* Hellerup: Edition Bløndal, 1997.

Kneher, Jan. *Edvard Munch im seinen Ausstellungen zwischen 1892 und 1912.* Worms: Wernersche Verlagsgesellschaft, 1994.

Krieger, Peter. *Edvard Munch: Der Lebenfries für Max Reinhardts Kammerspiele.* Berlin: Nationalgalerie Berlin, Staatliche Museen Preussischer Kulturbesitz, 1978.

Kurosaki, Akira. *Moonshine: A Study of the Paper Used for Edvard Munch's Color Woodcut.* Kyoto: Kyoto Seika University, 1993.

Lande, Marit. *På sporet av Edvard Munch–mannen bak mytene.* Oslo: Messel Forlag, 1996.

Langaard, Johan H., and Reidar Revold. *The Drawings of Edvard Munch.* Oslo: Kunsten Idag, 1958.

———. *Edvard Munch: The University Murals, Graphic Art, and Paintings.* Oslo: Forlaget Norsk Kunstreproduksjon, 1960.

———. *Edvard Munch: Fra År til År; En Håndbok/A Year by Year Record of Edvard Munch's Life: A Handbook.* Oslo: H. Aschehoug, 1961.

———. *Edvard Munch: Masterpieces from the Artist's Collection in the Munch Museum in Oslo.* New York: McGraw-Hill Book Company, 1964.

———. *The Munch Museum: The Building and Its Collections,* Oslo: Kunsten Idag, 1966.

Lange, Marit. *Da Dahl a Munch: Romanticisimo, realismo, e simbolismo nella pittura di paesaggio norvegese.* Ferrara: Palazzo dei Diamanti, 2001.

Lieberman, William S. *Edvard Munch: A Selection of His Prints from American Collections.* New York: The Museum of Modern Art, 1957.

———. *Edvard Munch: Lithographs, Etchings, Woodcuts.* Los Angeles: Los Angeles County Museum of Art, 1969.

Linde, Max. *Edvard Munch und die Kunst der Zukunft.* Berlin: F. Gottenheimer, 1902. Reprint, 1905.

Lippincott, Louise. *Edvard Munch: Starry Night.* Malibu: J. Paul Getty Museum, 1988.

Loshak, David. *Munch.* New York: Knickerbocker Press, 1999.

Love, Isolation, Darkness: The Art of Edvard Munch. Greenwich, Conn.: Bruce Museum of Arts and Science, 1996.

Madsen, Stephan Tschudi. *An Introduction to Edvard Munch's Wall Paintings in the Oslo University Aula*. Oslo: Oslo University Press, 1959.

Magnaguagno, Guido, ed. *Edvard Munch*. Essen: Museum Folkwang Essen, 1987.

März, Roland. *Edvard Munch: Melancholie aus Dem Reinhardt-Fries 1906/07*. Berlin: Kulturstiftung der Länder, 1998.

The Masterworks of Edvard Munch. New York: The Museum of Modern Art, 1979.

Mössinger, Ingrid, Beate Ritter, and Kerstin Drechsel, eds. *Edvard Munch in Chemnitz*. Cologne: Wienand, 1999.

Muller, Hannah B. *Edvard Munch: A Bibliography*. Oslo: Mallingske Boktrykkeri, 1951.

Müller-Westermann, Iris. *Munch by Himself*. Stockholm: Moderna Museet, 2005.

Munch und Deutschland. Stuttgart: Verlag Gerd Hatje, 1994.

Munch et la France. Paris: Réunion des Musées Nationaux, 1991.

Munch og Kvinnen/Munch and Women. Bergen: Bergen Kunstmuseum, 2001.

Munch at the Munch Museum, Oslo. London: Scala Books, 2004.

Munch and Photography. Newcastle upon Tyne: The Newcastle Polytechnic Gallery, 1989.

Munch og Warnemünde, 1907–1908. Oslo: Kunsthalle Rostock, Munch Museum, and Labyrinth Press, 1999.

Nicosia, Fiorella. *Edvard Munch*. Florence: Giunti, 2003.

Noto Campanella, Filippo, and Gianni Tibaldi. *Psicologia E Psicopatologia Dell'espressionismo: Edvard Munch*. Milan: Libreria Cortina, 1989.

Øverland, Arnulf. *Edvard Munch*. Kristiania: Berg & Høgh, 1921.

Perron, Janine. *Edvard Munch: Paintings*. Copenhagen: Galleri Faurschou, 2000.

Plahter, Leif Einar. *Munch under Overflaten: Teknisk Undersøkelse*

Av Fire Malerier Av Edvard Munch/Below the Surface of Edvard Munch: Technical Examination of Four Paintings by Edvard Munch. Oslo: National Gallery, 1994.

Prelinger, Elizabeth. *Edvard Munch: Master Printmaker. An Examination of the Artist's Works and Techniques Based on the Philip and Lynn Straus Collection*. New York: W. W. Norton; Cambridge, Mass.: Busch-Reisinger Museum, Harvard University, 1983.

———. *After the Scream: The Late Paintings of Edvard Munch*. Atlanta: High Museum of Art; New Haven and London: Yale University Press, 2002.

Prelinger, Elizabeth, and Michael Parke-Taylor. *The Symbolist Prints of Edvard Munch: The Vivian and David Campbell Collection*. Toronto: Art Gallery of Ontario; New Haven: Yale University Press, 1996.

Prideaux, Sue. *Edvard Munch: Behind the Scream*. New Haven: Yale University Press, 2005.

The Prints of Edvard Munch. New York: The Museum of Modern Art, 1973.

Przybyszewski, Stanislaw, ed. *Das Werk des Edvard Munch*. Berlin: S. Fischer Verlag, 1894.

Ravenal, Carol. *Edvard Munch: Paradox of Women*. New York: Aldis Browne Fine Arts, 1981.

Read, Herbert. *Edvard Munch*. London: London Gallery, 1936.

Sarvig, Ole, and Elizabeth Pollet. *The Graphic Works of Edvard Munch*. Lyngby: Hamlet, 1980.

Schiefler, Gustav. *Verzeichnis des graphischen Werks Edvard Munchs bis 1906*. Berlin: E. Cassirer, 1907. Reprint 1974.

———. *Edvard Munch*. Hamburg: Galerie Commeter, 1913.

———. *Edvard Munch: Vortrag in Der Gesellschaft Hamburgischer Kunstfreunde Hamburg 1916*. Berlin: Verlag Graphisches Kabinett J. B. Neumann, 1916.

———. *Edvard Munchs graphische Kunst*. Dresden: E. Arnold, 1923.

———. *Edvard Munch: Das graphische Werk, 1906–1926*. Berlin: Euphorin Verlag, 1928.

Schneede, Uwe M. *Edvard Munch: Arbeiterbilder 1910–*

1930. Hamburg: Kunstverein, 1978.

———. *Edvard Munch: Höhepunkte des malerischen Werks im 20. Jahrhundert*. Hamburg: Kunstverein in Hamburg; Göteborg: Göteborgs Konstmuseum, 1984. Reprint, 1998.

———. *Edvard Munch: The Early Masterpieces*. New York: W. W. Norton, 1988.

———. *Im Blickfeld: Edvard Munch, Das Kranke Kind*. Hamburg: Hamburger Kunsthalle, 2002.

Schröder, Klaus Albrecht, and Antonia Hoerschelmann, eds. *Edvard Munch: Theme and Variation*. Vienna: Albertina; Ostfildern-Ruit: Hatje Cantz, 2003.

Schütz, Barbara, et al. *Edvard Munch*. Essen: Museum Folkwang; Zürich: Kunsthaus Zürich, 1987.

Scognamiglio, Giovanna. *Edvard Munch 1863–1944*. Turin: Universita degli Studi, 2002.

Selz, Jean. *E. Munch*. New York: Crown Publishers, 1974. Reprint 1988.

Shimoyama, Hajime. *Munch by Munch*. Tokyo: Nihon Keizai Shimbun, 1993.

Smith, John Boulton. *Munch*. Oxford: Phaidon, 1977. Rev. and enl. ed. (with James Malpas) London: Phaidon, 1992.

Sommer, Achim, and Nils Ohlsen. *Edvard Munch: Bilder Aus Norwegen*. Ostfildern-Ruit: Hatje Cantz Verlag, 2004.

Sorenson, Gunnar, et al. *Edvard Munchs Livsfrise: En rekonstruksjon av utstillingen hos Blomqvist 1918*. Oslo: Munch Museum and Labyrinth Press, 2002.

Stang, Nicolas. *Edvard Munch*. Oslo: Johan Grundt Tanum Forlag, 1972.

Stang, Ragna Thiis. *Edvard Munch: The Man and His Art*. New York: Abbeville Press, 1977. Reprint, 1979.

Stang, Ragna Thiis, and Pål Hougen. *E. Munch*. Paris: Presses Artistique, 1969.

Stenersen, Rolf E. *Edvard Munch. Close-up of a Genius*. Oslo: Sem and Stenersen, 1945. Reprint, 1994.

Stenersen's Munch: Edvard Munch i Stenersensmuseet. Oslo: Stenersenmuseet, 2003.

Steward, James. *Edvard Munch and His Models, 1912–1944*. Berkeley: University of California Press, 1993.

Straumann, Agatha, ed. *Edvard Munch, Sein Werk in Schweizer Sammlungen*. Basel: Kunstmuseum Basel, 1985.

Sweeney, Jane, ed. *Edvard Munch: Master Prints from the Epstein Family Collection*. Washington, D.C.: National Gallery of Art, 1990.

Thiis, Jens, Henrik Grevenor, and Johan H. Langaard. *Edvard Munch og hans samtid; Slekten, Livet og Kunsten Geniet*. Oslo: Gyldendal Norsk Forlag, 1933.

———. *Edvard Munch*. Berlin: Rembrandt Verlag, 1934.

Thurmann-Moe, Jan. *Edvard Munch's Kill or Cure Treatment: Experiments with Technique and Materials / Edvard Munchs "Hestekur": Eksperimenter med teknikk og materialer*. Oslo: Munch Museum, 1995.

Timm, Werner. *The Graphic Art of Edvard Munch*. Greenwich, Conn.: New York Graphic Society, 1969.

Timm, Werner, and Marianne Brosemann. *Edvard Munch, 1863–1944*. Berlin: Berlin Kupferstichkabinett 1963.

Urbanek, Walter. *Edvard Munch: Lebensfries; 46 Graphiken*. Munich: R. Piper, 1955.

Væring, Ragnvald, and Johan Henrik Langaard. *Edvard Munch Selvportretter*. Oslo: Gyldendal Norsk Forlag, 1947.

Werner, Alfred. *Graphic Works of Edvard Munch*. New York: Dover Publications, 1979.

Willoch, Sigurd. *Edvard Munch Etchings*. Oslo: Johan Grundt Tanum Forlag, 1950.

Wilson, Mary Gould. "Edvard Munch: A Study of His Form Language." Unpublished Ph.D. dissertation, Northwestern University, 1973.

Wittlich, P. *Edvard Munch*. Prague: Odeon, 1988.

Woll, Gerd. *Edvard Munch: Monumental Projects, 1909–1930*. Lillehammer: Lillehammer Art Museum, 1993.

———. *Edvard Munch: The Complete Graphic Works*. New York: Harry N. Abrams, 2001.

Woll, Gerd, and Joachim Uhlitzsch. *Edvard Munch, 1863–1944*. Dresden: Staatliche Kunstsammlungen Dresden, 1983.

Wood, Mara-Helen. *Munch and the Workers*. Newcastle upon Tyne: Newcastle Polytechnic Gallery, 1984.

Wood, Mara-Helen, ed. *Edvard Munch: The Frieze of Life*. London: National Gallery, 1992.

Yarborough, Tina [Bessie Rainsford]. "Exhibition Strategies and Wartime Politics in the Art and Career of Edvard Munch, 1914–1921." Unpublished Ph.D. dissertation, University of Chicago, 1995.

Zarobell, John, ed. *Edvard Munch's Mermaid*. University Park: Pennsylvania State University Press, 2005.

Works Including the Artist

Ahtola-Moorhouse, Leena, Carl Tomas Edam, Birgitta Schreiber, and Diana Phelan. *Dreams of a Summer Night: Scandinavian Painting at the Turn of the Century*. London: Arts Council of Great Britain, 1986.

Aspects of Expressionism: Edvard Munch to Otto Dix. Chicago: R. S. Johnson Fine Art, 2000.

Ausstellung Edvard Munch, Paul Gauguin. Zürich: Kunsthaus Zürich, 1932.

Bertheux, Maarten, ed. *Munch og etter Munch: Eller maleres standhaftighet / Munch and after Munch: Or the Obstinacy of Painters*. Amsterdam: Stedelijk Museum, 1996.

Bjerke, Øivind Storm. *Edvard Munch and Harald Sohlberg: Landscapes of the Mind*. New York: National Academy of Design, 1995.

Boe, Alf, John Bolton Smith, Lionel Carey, and Arne Eggum. *Frederick Delius og Edvard Munch*. Oslo: Munch Museum, 1979.

Dedichen, Jens. *Tulla Larsen og Edvard Munch*. Oslo: Dreyer, 1981.

Digby, George Wingfield. *Meaning and Symbol in Three Modern Artists: Edvard Munch, Henry Moore, Paul Nash*. London: Faber and Faber, 1955.

Dittmann, Reidar. *Eros and Psyche: Strindberg and Munch in the 1890s*. Ann Arbor: UMI Research Press, 1982.

Dittman, Reidar, and Pål Hougen, eds. *Edvard Munch and Henrik Ibsen*. Translated by Reidar Dittman. Northfield, Minn.: St. Olaf College, 1978.

Edebau, Frank Patrick, Arne Eggum, and Martin Urban. *James Ensor, Edvard Munch, Emil Nolde*. Regina, Saskatchewan: Norman Mackenzie Art Gallery, 1980.

Edvard Munch and His Contemporaries: Important Norwegian Paintings. London: Mayfair Fine Art, 1990.

Eggum, Arne, and Sissel Biørnstad. *Die Brücke–Edvard Munch*. Malmö: Malmö Konsthall, 1978.

Epstein, Sarah G., and Charles T. Butler. *Close to the Surface: The Expressionist Prints of Edvard Munch and Richard Bosman*. Columbus, Ga.: The Columbus Museum, 1996.

Friedman, Martin L., and Henning Bender. *The Frozen Image: Scandinavian Photography*. Minneapolis: Walker Art Center; New York: Abbeville Press, 1982.

Gether, Christian, et al. *Echoes of the Scream*. Ishøj: Arken Museum for Moderne Kunst, 2001.

Goldstein, Emanuel. *Alruner*. Copenhagen: Jakob H. Mansas, 1892. Frontispiece illustration by Munch.

Grêlé, Sophie, ed. *Lumière du Monde, Lumière du Ciel*. Paris: Paris-Musées, 1998.

Hougen, Pål, and Ursula Perucchi-Petri. *Munch und Ibsen*. Zürich: Kunsthaus Zürich, 1976.

Klinger und Munch: Weltanschauung und Psyche in Bilderzyklen der Jahrhundertwende. Kiel: Kunsthalle zu Kiel, 1978.

Lange, Marit, and Sidsel Hellisen. *Edvard Munch: Dal realismo all'espressionismo. Dipinti e opere grafiche dalla Galleria Nazionale di Oslo*. Livorno: Sillabe, 1999.

Langslet, Lars Roar. *Henrik Ibsen, Edvard Munch: To Genier Møtes/Two Geniuses Meet*. Oslo: J. W. Cappelen Forlag, 1994.

Lathe, Carla. *Edvard Munch and His Literary Associates*. Norwich, England: Library, University of East Anglia, 1980.

Maur, Karin von. *Munch, Nolde, Beckmann: Private Kunstschätze aus Süddeutschland*. Heidelberg: Edition Braus, 2004.

Munch/Nolde: The Relationship of Their Art. London: Marlborough Fine Art, 1969.

Nasgaard, Roald. *The Mystic North: Symbolist Landscape Painting in Northern Europe and North America, 1890–1940*. Toronto: Art Gallery of Ontario, 1984.

Norwegian Visions of Winter. Oslo: De norske Bokklubbene, 1994.

Paszkiewicz, Piotr, ed. *Totenmesse: Modernism in the Culture of Northern and Central Europe*. Warsaw: Institute of Art, Polish Academy of Sciences, 1996.

Pekari, Mikko, and Tuomo-Juhani Vuorenmaa. *Art Noir: Camera Work by Edvard Munch, Akseli Gallen-Kallela, Hugo Simberg and August Strindberg*. Espoo: Gallen-Kallelan Museo; Helsinki: Musta Taide, 1995.

Przybyszewski, Stanislaw. *Vigilien*. Berlin: S. Fischer, Verlag, 1894. Cover illustration by Munch.

Quickborn. Berlin: Deutscher Kunstverlag, 1899. Journal with cover and illustrations by Munch, texts by August Strindberg.

Rosenblum, Robert. *Modern Painting and the Northern Romantic Tradition: Friedrich to Rothko*. New York: Harper & Row, 1975.

Schoon, Talitha, and Karel Schampers. *Ensor, Hodler, Kruyder, Munch: Wegbereiders van het Modernisme/Pioneers of Modernism*. Rotterdam: Museum Boijmans–Van Beuningen, 1988.

Shepherd-Barr, Kirsten. *Ibsen and Early Modernist Theatre, 1890–1900*. Westport, Conn.: Greenwood Press, 1997.

Smith, John Boulton. *Norwegian Romantic Landscape, 1820–1920*. London: Morley Gallery, 1976.

Söderberg, Rolf. *Edvard Munch and August Strindberg: Photography as a Tool and an Experiment / Edvard Munch, August Strindberg: Fotografi Som Verktyg Och Experiment*. Stockholm: Alfabeta Bokförlag, 1989.

Stenersen, Rolf. *Munch-Picasso-Klee*. Stockholm: Moderna Museet, 1964.

Varnedoe, Kirk. *Northern Light: Realism and Symbolism in Scandinavian Painting, 1880–1910*. Brooklyn: The Brooklyn Museum, 1982.

———. *Northern Light: Nordic Art at the Turn of the Century*. New Haven: Yale University Press, 1988.

Articles

Balmas, Paolo. "The Importance of Munch Today." *Flash Art (International Edition)*, no. 110 (January 1983): 28–31.

Berman, Patricia G. "Edvard Munch's *Self-Portrait with Cigarette*: Smoking and the Bohemian Persona." *Art Bulletin* 75, no. 4 (December 1993): 627–646.

———. "Body and Body Politic in Edvard Munch's Bathing Men." In Kathleen Adler and Marcia Pointon, eds. *The Body Imaged: The Human Form and Visual Culture since the Renaissance*. Cambridge: Cambridge University Press, 1993: 71–83, 195

———. "(Re-) Reading Edvard Munch: Trends in the Current Literature." *Scandinavian Studies* 66, no. 1 (winter 1994): 45–67.

———. "The Invention of History: Julius Meier-Graefe, German Modernism, and the Genealogy of Genius." In Françoise Forster-Hahn, ed. *Imagining Modern German Culture: 1889–1910*, Washington, D.C.: National Gallery of Art, 1996: 91–105.

———. "Edvard Munch's Peasants and the Invention of Norwegian Culture." In Berit I. Brown, ed. *Nordic Experiences: Exploration of Scandinavian Cultures*. Westport, Conn.: Greenwood Press, 1999: 213–233

———. "Making Family Values: Narratives of Kinship and Peasant Life in Norwegian Nationalism." In Michelle Facos and Sharon L. Hirsh. *Art, Culture, and National Identity in Fin-de-Siècle Europe*. Cambridge: Cambridge University Press, 2003: 207–228.

Boe, Roy A. "Jealousy: An Important Painting by Edvard Munch." *The Minneapolis Institute of Arts Bulletin* 55, no. 1 (January–February 1956): 3–11.

——. "Edvard Munch's Murals for the University of Oslo." *Art Quarterly* 23, no. 3 (autumn 1960): 232–246.

Ciardi, Nives. "Edvard Munch: Immagini Dietro L'occhio." *Domus*, no. 653 (September 1984): 88.

Dorra, Henri. "Munch, Gauguin, and Norwegian Painters in Paris." *Gazette des Beaux-Arts*, no. 88 (November 1976): 175–180.

"Edvard Munch: The Epstein Collection." *Allen Memorial Art Museum Bulletin* 29, no. 3 (spring 1972).

Feinberg, Larry J. "Symbolism and the Romantic Tradition." *Allen Memorial Art Museum Bulletin* 43, no. 1 (summer 1988): 5–20.

Gomez, Joseph A. "Peter Watkins's Edvard Munch." *Film Quarterly* 30, no. 2 (winter 1976–77): 38–46.

Hagen, Charles. "Dark Mirror: The Photographs of Edvard Munch." *Aperture*, no. 145 (autumn 1996): 12–17.

Håkansson, Tore. "Strindberg and the Arts." *Studio International* 181, no. 929 (January 1971): 62–67.

Heller, Reinhold. "The Iconography of Edvard Munch's *Sphinx*." *Artforum* 9 (October 1970): 72–80.

——. "Edvard Munch and the Clarification of Life." *Allen Memorial Art Museum Bulletin* 29, no. 3 (spring 1972): 121–133.

——. "Edvard Munch's *Vision* and the Symbolist Swan." *Art Quarterly* 36, no. 3 (autumn 1973): 209–249.

——. "Edvard Munch's *Night*, The Content of Autobiography and the Aesthetics of Decadence." *Arts Magazine* 53 (October 1978): 80–105.

——. "Concerning Symbolism and the Structure of Surface." *Art Journal* 45 (summer 1985): 145–153.

Hodin, J. P. "A Madonna Motif in the Work of Munch and Dali." *The Art Quarterly* 16, no. 2 (summer 1953): 106–114.

——. "Edvard Munch: Founder of Expressionism." *Studio* 166, no. 847 (1963): 180–183.

Hoffman, Edith. "Some Sources for Munch's Symbolism." *Apollo* (February 1965): 87–93.

Jaworska, Wadysawa. "Edvard Munch and Stanislaw Przybyszewski." *Apollo* (October 1974): 312–317.

Jayne, Kristie. "The Cultural Roots of Edvard Munch's Images of Women." *Woman's Art Journal* 10 (spring/summer 1989): 28–34.

Karpinski, Caroline. "Munch and Lautrec." *The Metropolitan Museum of Art Bulletin* (November 1964): 125–130.

Kennedy, R. C. "On Expressionism." *Art International* 13, no. 8 (October 1969): 19–23.

Kisch-Arndt, Ruth. "A Portrait of Felix Auerbach by Munch." *The Burlington Magazine* 106, no. 732 (March 1964): 131.

Kultermann, Udo. "La Bataille des Sexes. Le Thème du Baiser dans l'Oeuvre d'Edvard Munch." *Art Press (International)*, no. 11 (1974): 4–7.

Kunitz, Daniel. "Edvard Munch Paintings 1892–1917 at Mitchell-Innes & Nash Gallery." *New Criterion* 19, no. 8 (April 2001): 51.

Langaard, Johan H. "Munch i Amerika." *Kunst og Kultur* 35, no. 2 (1952): 55–64.

Lathe, Carla. "Edvard Munch and the Concept of 'Psychic Naturalism.'" *Gazette des Beaux-Arts* 121 (March 1979): 135–146.

——. "Edvard Munch's Dramatic Images, 1892–1909." *Journal of the Warburg and Courtauld Institutes* 46 (1983): 191–206.

Loshak, David. "Space, Time and Edvard Munch." *Burlington Magazine* 131 (April 1989): 273–282.

Messel, Nils. "Edvard Munch and His Critics in the 1880s." *Kunst og Kultur* 77, no. 4 (1994): 213–227.

O'Connor, John, Jr. "The Message of Edvard Munch (1863–1944): The Great Norwegian Artist in Retrospect." *Carnegie Magazine* (April 1951): 119–23.

Ottesen, Bodil. "The Flower of Pain: How a Friendship Engendered Edvard Munch's Predominant Artistic Metaphors." *Gazette des Beaux-Arts* 6, no. 124 (October 1994): 149–158.

Overy, Paul. "Munch: Melodrama and Modernism." *Studio International* 198 (December 1985): 16–19.

Peck, William. "Recent Publication in the Field of Art: John H. Langaard and Reider Revold, *Edvard Munch, the University Murals, Graphic Art and Paintings*. Oslo, Forlaget Norsk Kunstreproduksion." *The Art Quarterly* 25, no. 1 (spring 1962): 102–105.

Prelinger, Elizabeth. "When the Halted Traveler Hears the Scream in Nature: Preliminary Thoughts on the Transformation of Some Romantic Motifs." In *Shop Talk: Studies in Honor of Seymour Slive*, Harvard University Art Museums (1995): 198–203.

——. "Music to Our Ears? Munch's *Scream* and Romantic Music Theory." In Marsha L. Morton and Peter L. Schmunk, eds. *The Arts Entwined: Music and Painting in the Nineteenth Century*. New York: Garland Publishing, 2000: 209–225

Salda, F. X. "The Violent Dreamer: Some Remarks on the Work of Edvard Munch." *The Journal of Aesthetics and Criticism* 28, no. 2 (winter 1969): 149–154.

Schjeldahl, Peter. "Edvard Munch: The Missing Master." In Malin Wilson, ed. *The Hydrogen Jukebox: Selected Writings of Peter Schjeldahl, 1978–1990*. Berkeley: University of California Press, 1979: 19–36.

Schneede, Uwe. "Vampir von Edvard Munch." *Kunst und Antiquitäten*, no. 11 (1990): 46–47.

Sherman, Ida L. "Edvard Munchs 'Pubertet' og Felicien Rops." *Kunst og Kultur* 59, no.4 (1976): 243–258.

Smith, John Boulton. "Strindberg's Visual Imagination." *Apollo* 92, no. 104 (October 1970): 290–300.

——. "Edvard Munch, European and Norwegian." *Apollo* 99, no. 143 (January 1974): 45–49.

Stabell, Waldemar. "Edvard Munch og Eva Mudocci." *Kunst og Kultur* 50, no. 4 (1967): 209–236.

Steinberg, Norma S. "Munch in Color." Harvard University Art Museums Bulletin III, no.3 (1995).

Strawser, Michael J., II. "Dionysian Painting: A Nietzschean Interpretation of Munch." *Konsthistorisk Tidskrift* 61, no. 4 (1992): 161–72.

Strindberg, August. "L'exposition Edvard Munch." *La Revue blanche* 10 (1896): 525–526.

Templeton, Joan. "The Munch-Ibsen Connection: Exposing a Critical Myth." *Scandinavian Studies* 72, no. 4 (winter 2000): 445–462.

Varnedoe, Kirk. "Christian Krohg and Edvard Munch." *Arts Magazine* 53 (April 1979): 88-95.

Weisberg, Gabriel P. "S. Bing, Edvard Munch and L'Art Nouveau." *Arts Magazine* 61 (September 1986): 58–64.

Whitford, F. "Edvard Munch: Scene, Symbol and Allegory." *Studio*, no. 187 (February 1974): 57–60.

Wilson, Mary G. "Edvard Munch's *Woman in Three Stages*. A Source of Inspiration for Henrik Ibsen's *When We Dead Awaken*." *The Centennial Review* 24, no.4 (1980): 492–500.

Wykes-Joyce, Max. "Edvard Munch and His Contemporaries." *Arts Review* (London) 42 (June 15, 1990): 326.

Wylie, Harold, and Mavis Wylie. "Edvard Munch: A Study of Narcissism and Artistic Creativity." *American Imago*, no. 4 (1980): 413–433.

Photograph Credits

Joerg P. Anders, Bildarchiv Preussischer Kulturbesitz/Art Resource, New York: 181, 232 bottom.

Thomas E. Aslaksby © The National Museum of Art, Architecture, and Design/National Gallery, Oslo: 18.

Kelly Benjamin, Department of Imaging Services, The Museum of Modern Art, New York: 55, 61 (The Museum of Modern Art, New York. Riva Castleman Endowment Fund, The Philip and Lynn Straus Foundation Fund, Edward John Noble Foundation Fund, Mary Ellen Meehan Fund, Donald B. Marron Fund, Johanna and Leslie J. Garfield Fund, Richard A. Epstein Fund, Miles O. Epstein Fund, Sarah C. Epstein Fund, and The Cowles Charitable Trust).

Bergen Art Museum: 87, 135 top, 147 top, 148, 162, 176 left.

Ricardo Blanc © 2005 Board of Trustees, National Gallery of Art, Washington, D.C.: 125 bottom.

Karen Blindow: 117.

Courtesy Ivor Braka, Ltd., London: 97.

Martin Bühler, Kunstmuseum Basel: 83 bottom left.

Philip Charles: 52, 100 right.

Works by James Ensor are covered under the following copyright: © 2006 Artists Rights Society (ARS), New York/SABAM, Brussels: 45

© The J. Paul Getty Museum: 45, 114.

Gemeentemuseum Den Haag: 41

Thomas Griesel, Department of Imaging Services, The Museum of Modern Art, New York: 123 bottom, 140.

Mark Gulezian: 100 left, 118, 147 bottom.

Frank Høifødt: 238 bottom.

Jaakko Holm/Central Art Archives: 177.

Christoph Irrgang, © Hamburger Kunsthalle/bpk: 190 top left.

Geir S. Johannessen, Fotograf Henriksen a.s.: 139.

Katya Kallsen, © 2004 President and Fellows of Harvard College: 88.

Kate Keller, Department of Imaging Services, The Museum of Modern Art, New York: 145 right.

Paige Knight, Department of Imaging Services, The Museum of Modern Art, New York: 10 center left, 105, 116 bottom, 228 center.

Kunsthaus Zürich: 98 top.

J. Lathion © National Gallery, Norway: 10 top center, 70 right, 71, 82 top, 83 top left, 86, 89, 91, 95, 96, 102, 109, 112, 116 top, 120 top, 136, 144, 157, 159, 223 top, 236.

Peter Lauri, CH Bern: 160.

The Frances Lehman Loeb Art Center, Vassar College: 94.

Erich Lessing/Art Resource, New York: 90.

Courtesy Library of Congress, Washington, D.C.: 227.

Robert Lorenzson: 131, 158.

Tord Lund: 143.

Mitchell-Innes & Nash: 115.

Moderna Museet, Stockholm: 74, 101.

Department of Imaging Services, The Museum of Modern Art, New York: 59, 246.

Inger Munch/Oslo City Museum: 222 top.

© Munch Museum (Andersen/de Jong): 10 top left, 10 top right, 10 center, 10 center right, 10 bottom left, 10 bottom center, 10 bottom right, 12, 13, 14, 19, 22, 26, 36, 40, 43, 44, 45 top left, 45 bottom left, 46 top, 46 bottom, 70 left, 72, 80, 81 top, 81 bottom, 82 bottom, 83 right, 84, 85, 92, 98 bottom, 103, 104, 106 right, 107, 108, 110, 120 bottom, 121 top, 121 bottom, 122, 123 top, 124, 125 top, 126, 128 left, 128 right, 130 bottom, 132, 133, 134 top, 134 bottom, 135 bottom, 137, 138 top left, 138 top right, 141, 142, 145 left, 146, 149 bottom, 150, 151, 153, 154, 155, 156, 161, 163, 164, 165, 166, 167, 168, 169,

170, 171, 172, 173, 174 left, 174 center, 174 right, 175 top far left, 175 top near left, 175 top center, 175 top near right, 175 top far right, 175 bottom left, 175 bottom center, 175 bottom right, 176 right, 178, 179, 182, 183, 184, 185, 186, 187 left, 187 right, 188, 189, 190 bottom, 191, 192, 193, 194, 195, 196, 197, 198, 199, 200, 225 top, 225 bottom, 228 center, 228 bottom, 229 top, 235 bottom.

Munch Museum Photo Archives: frontispiece, 29, 34, 64, 69 left, 69 right, 73 left, 73 right, 220, 221 top, 221 center left, 221 center right, 221 bottom, 222 bottom, 223 center, 223 bottom, 224, 226, 229 center, 229 bottom, 230 top, 230 center, 230 bottom, 231 top, 231 bottom, 232 top, 232 center, 233 top, 233, center, 233 bottom, 234 top, 234 center, 234 bottom, 238 top, 238 center, 246 left, 246 center, 255.

© 2006 Museum of Fine Arts, Boston: 111.

The New York Public Library, Astor, Lennox and Tilden Foundations: 228 top.

NIKU, 2004: 237 top, 237 center, 237 bottom.

Lars Noord: 93.

Mali Olatunji, Department of Imaging Services, The Museum of Modern Art, New York: 58, 113.

Ole Tobias Olsen/Oslo City Museum: 16.

Tom Powel Imaging, New York: 127.

Scala/Art Resource, New York: 152.

Rosa Smith, Department of Imaging Services, The Museum of Modern Art, New York: 106 left.

SMK Foto: 180.

Olaf Væring/Oslo City Museum: 222 center.

© O. Væring Eftf. AS, Norway: 235 top.

Anders B. Wilse: 255.

Graydon Wood, Philadelphia Museum of Art: 119.

John Wronn, Department of Imaging Services, The Museum of Modern Art, New York: 129, 130 top, 190 top right.

Werner Zellien: 99.

Zindman/Fremont, New York, New York: 149 top.

Index of Illustrations

This index is divided into three sections: Works by Munch, Works by Other Artists, *and* Photographs. *The first section includes works by Munch that appear in the plate section, the essays, the chronology, and other parts of the book. The second section lists works by other artists whose works are discussed in the various texts. The third section groups the documentary photographs used throughout the volume.*

254

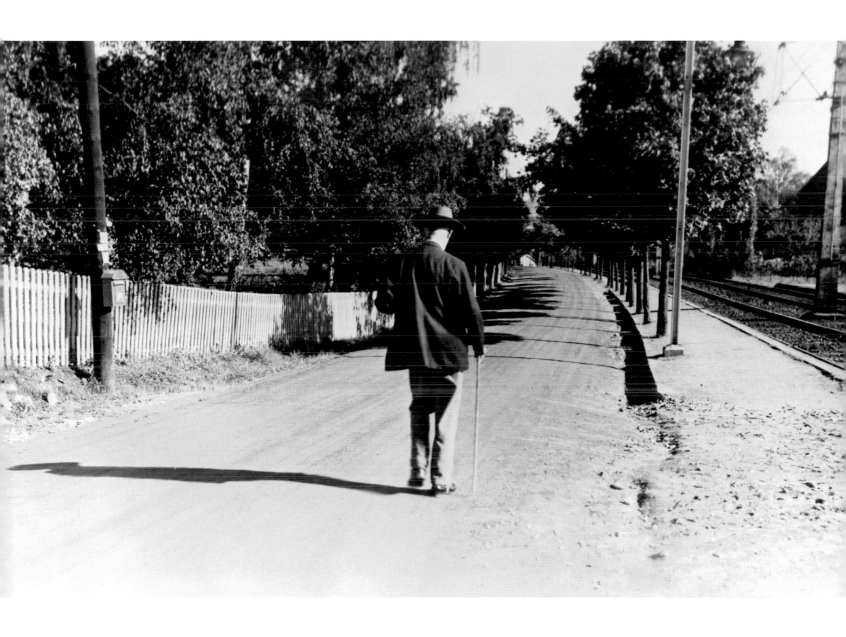

Munch at Skøyen, near Ekely, 1935